9HEADS

9 Heads — a guide to drawing fashion

by Nancy Riegelman

Published by 9 Heads Media in association with Art Center College of Design, Pasadena, California, USA
Mailing address: 9 Heads Media, PO Box 27457, Los Angeles CA 90027–0457, USA
Website: www.9heads.com
Copyright © 2000 Nancy Riegelman

First printing 2000
Second Printing 2001
Printed in Hong Kong

Publisher's Cataloging-in-Publication Data

Riegelman, Nancy

9 Heads — a guide to drawing fashion/ Nancy Riegelman 1st edition
352 p. 33 x 23 cm
LCCN: 00-106285
PH ISBN 0-13-094192-1

1. Fashion Drawing 2. Drawing — technique I Title

Lib. Cong. Class. No. TT509 DDC 741.672

"This book is dedicated to the memory of my dear friend Paul McDonough and my aunt Ruthann Askey." N.R.

Nancy Riegelman was born in San Francisco. She attended the University of California at Berkeley, UCLA and Art Center College of Design in Pasadena, Ca., where she studied drawing and fine arts.

Nancy teaches fashion drawing at the Fashion Institute of Design and Merchandising (FIDM) in Los Angeles and international style at Art Center College of Design. She has been visiting professor at the University Premila Polytechnic in Bombay, India, Seibu University in Tokyo, Japan, the Paris Fashion Institute and the Central Academy of Art & Design in Beijing, China.

Nancy is also a fine artist who has exhibited in museums in the USA and overseas. Nancy Lives in Los Angeles.

a guide to
drawing fashion

Nancy Riegelman

9HEADS

contents

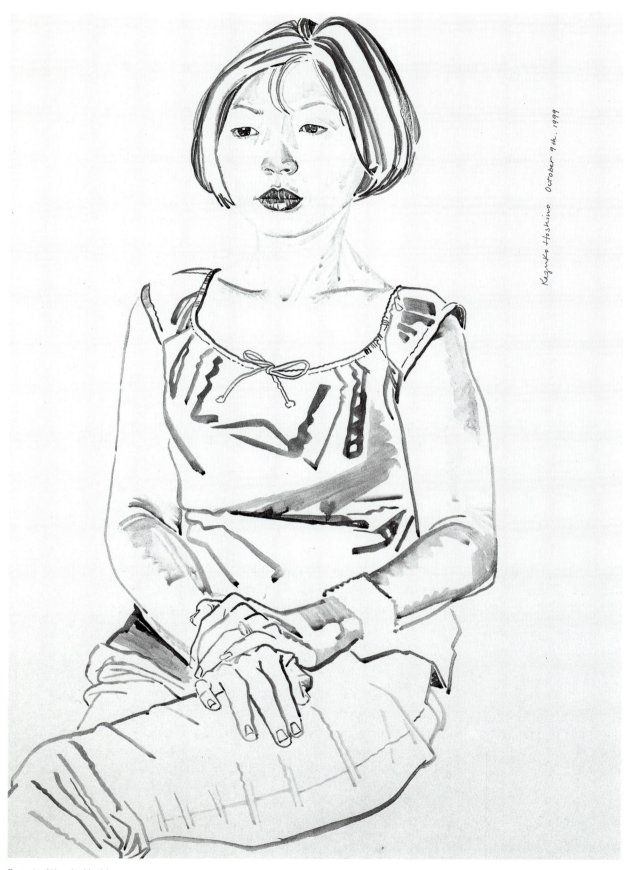

Kazuko Hoshino October 9th. 1999

Portrait of Kasuko Hoshino
Don Bachardy, 1999

foreword

Drawing, once such an important and vital skill for communicating throughout the arts and sciences, has for a number of decades in our country suffered a sharp and widespread decline: it has come to be regarded as somehow outmoded and of no direct relevance to the challenges of modern technology, design and art. Acquiring the skills of drawing has been gradually denied to all but a privileged few who are able to study art and design at an advanced level. We are, all of us, poorer for this decline, spiritually, and, what is not yet fully realized, economically.

This book makes a bold stand against this decline, providing a comprehensive treatment of drawing as applied in a specific, but important, area of modern life: fashion. It teaches by example, the power of drawing as a means of communication and expression radiating from almost every page. More than this, it also teaches detailed drawing technique in a clear, rigorous and progressive manner which will make it accessible to all, as well as providing a near-encyclopedic source of reference for those interested in fashion. It is a book which will benefit those who have the most immediate and pressing need to acquire drawing skills—students of fashion, art and design—but it is also an empowering book which will open up the advantages of drawing to many others, highlighting and addressing this glaring omission from the skills taught by our public education system.

As well as an effective instructional guide, this book is a beautiful work of individual and collaborative effort. The esthetic values it embodies stand as an example for those writing in the area of art and design and are a tribute to all whose work is included here.

Richard Koshalek

Art Center College of Design,
Pasadena, California

ALL THE VASTNESS OF THE UNIVERSE
WAS IN THE CIRCLE OF HER PUPILS.

OPEN WIDE.

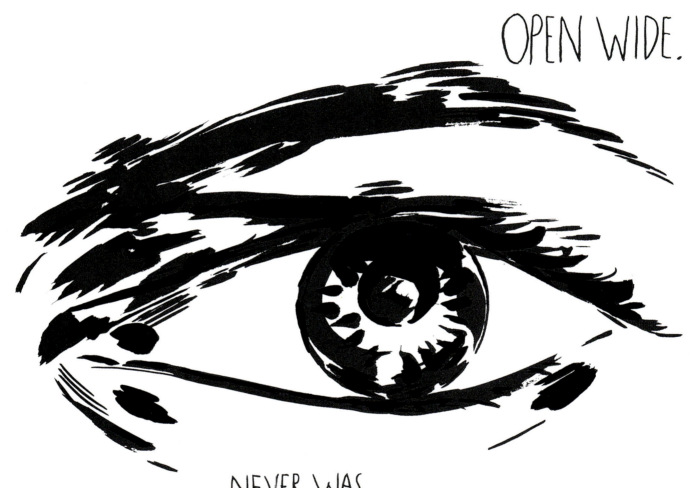

NEVER WAS
IMMENSE LOVE MORE POWERFULLY
SIGNIFIED BY ANY EARTHLY
CREATURE.

BUT SHE SMILED HER SLIGHT, CONCEALING SMILE.

No title (All the Vastness)
Raymond Pettibon, 1990

introduction

FASHION DRAWING IN THE MODERN WORLD

In Leonardo da Vinci's famous drawings, the height of the human body is shown as equivalent to eight heads—a measure which closely corresponds to reality. Michelangelo, on the other hand, drew idealized "larger than life" figures with elongated legs and torsos and body proportions equal to nine heads. The modern fashion figure is, like Michelangelo's, a figure of idealized proportions suggesting elegance and beauty. Its length is equal to nine heads, the title of this book.

These 9/1 proportions were also adopted by Fibonacci, a Renaissance architect who suggested that the proportions 5-3-1 (a total of nine) were the ideal proportions for a building and also reflected many of the forms of nature (trees or the orbits of the planets, for example). The Fibonacci scale is used extensively throughout this book as a conceptual model for drawing the fashion croquis.

9 Heads is about fashion drawing, but in order to learn how to draw fashion it is first necessary to learn how to draw the human figure, and the first section of the book is dedicated to this task. The remainder of the book deals mainly with how to draw a wide range of modern garments and accessories and the types of techniques used to render them convincingly and elegantly in different fabric designs and textures. This content will immediately make the book of interest to those directly involved in fashion: designers, fashion professionals, teachers and students of fashion. The book has been written and drawn, though, with a wider audience in mind, not only for those with a professional interest in fashion and art, but for anyone with a desire to learn to draw the human figure, for those interested in modern fashion and for the many people who simply love drawing and wish to learn more.

Fashion drawing has changed considerably over the last twenty to thirty years. Fashion illustration was once a popular way of marketing fashion by depicting simple stories showing the featured clothes in a social setting. It has been largely replaced by photography, now almost exclusively used in advertising and reporting. Fashion drawing has shifted away from capturing gesture and mood towards being functional and schematic. It has become more technical and more closely tied to markets, which have grown vastly in size and diversity. Fashion drawing is now mainly geared to communicating detailed information on the construction and proportions of the garment and how the finished garment looks. Nowadays, a large part of learning how to draw modern fashion is learning how to communicate detailed information about garments clearly, accurately and in a pleasing, elegant manner.

As mentioned, when drawing fashion, a knowledge of how to draw the figure—the fashion *croquis*—is essential. Clothes sheath the figure, clinging to it or falling away from it as it moves, changes shape and attitude. Unless one can convincingly represent the figure underneath, it is difficult to capture the essence and vitality of the clothes themselves. This book lays out, in depth, the essential principles and rules involved in drawing the human figure.

This "back to basic principles" treatment of figure drawing might not have been necessary twenty or thirty years ago, but unfortunately in the United States formal tuition in drawing was removed from most high school curricula in the 1960s. As a result, recent generations have grown up with little education in the basic skills of drawing. The effect of this neglect of drawing in our high schools has been particularly felt in the fashion and design schools across the nation, where an explosion of interest in fashion over the last ten years has brought ever-increasing numbers of new students. Most of the young people entering these schools have received no formal education in drawing and have a pressing need to acquire drawing skills which would have been better acquired at an earlier age. One of the principal aims of this book is to attempt to make up for this gap in our high school

educational system by providing an intensive grounding in drawing the figure, the indispensable foundation for all good fashion drawing.

A number of recent books have had considerable commercial success suggesting that the secret key to learning how to draw is learning how to "see" objects in the same way an artist sees them. This concept, which like so many others in art has also existed since the time of Da Vinci, is important, and this book strives to show the reader how to perceive things in order to be able to draw them accurately. Learning to "see" objects in a certain way is, however, only one part of the process of learning how to draw. The other part of the process, which is by far the more important, and which itself assists in learning this ability to look and see as artists see, is acquiring the body of skills and techniques which form the discipline of drawing. This book concentrates on teaching those skills and techniques which actually allow us to draw what we see. It is this discipline which is at the heart of drawing and is the essence of being able to draw well.

Learning the discipline of drawing, in much the same way as one learns other disciplines, such as speaking a foreign language or playing a musical instrument, is a step-by-step process involving concentration, persistence, constant practice and an investment of time and effort. Luckily, drawing becomes pleasurable at a fairly early stage, and increasingly so as one's skill level develops.

The method this book employs is an empirical one, based on the observed geometrical shapes and proportions of the body. The human form—and this is particularly the case for the idealized, elongated shapes of the fashion figure—is of fixed proportions, just as the Renaissance artists discovered. Each part of the body has a fixed proportional relationship to every other part. Just as they focused on the proportions of the body, the great artists of the Renaissance also often found that the shape of the different parts of the body could be thought of as naturally occurring two- and three-dimensional geometric forms—rectangles, cubes, cylinders, for example. This method of focusing on the proportions and the geometric shape of each part of the body, as a guide to drawing the figure, is as effective today as it was hundreds of years ago. Learning to draw the figure in this way, often with the help of scales and rulers, yields results quickly and helps develop powerful skills and technique. With practice the reader will soon learn to draw elegant, realistic figures with little effort.

A common beginner's mistake in drawing the figure is to begin by drawing the outline, the edge of the figure. For beginners this almost invariably results in distorted, ill-proportioned figures. When showing how to draw the human form, this book focuses on the framework, the solid underlying structure of the figure. It is a similar technique to the way a building is constructed: first the frame is built and then the outer layer is added. In drawing the figure, first the basic, well-proportioned shapes of its parts are sketched out, then the outer layer is drawn in. When drawing fashion, where a drawing has to reflect the proportions and elegance of the garment, it is essential to have this strong sense of the perfectly proportioned figure underneath.

People acquire drawing skills in different ways: engineers or architects, for example, who have to be precise in their thinking and calculations, are likely to learn how to draw in a different way from a young fashion designer. Some people learn more by studying images and others need to learn rules and principles. A small (in fact extremely small) number of people can draw intuitively. This book tries to balance the visual image and the written word, providing information in both forms. The drawings themselves have the most to teach, and should be studied closely, but labels and captions are provided for many so that the drawings can be interpreted quickly and accurately. The text provides fuller explanations and instructions and can serve as a basis for classroom lectures when used by teachers. Readers will naturally favor the method most suited to their way of learning.

Having mentioned some of the things this book is about, one thing which it is not about should also be mentioned here: it is not about learning different styles of drawing. Students of drawing will soon discover their own styles based on individual preferences and aptitudes and/or the way they are taught. It will soon become apparent to the reader, however, that although the book does not favor a particular style, it strongly embraces the values of clarity, elegance, economy of line and beauty of design, the same values which are embodied in beautiful garments. These qualities are independent of style and are immediately recognizable in any well-executed drawing.

The basic technical drawing of fashion, that which serves as the first stage in the design/production process, is the *flat*. This two dimensional line drawing gives an in-scale, fully proportioned "blueprint" of the front and, often, the back view of a garment. For many types of garments this drawing is a key component of the specification sheets which give the directions for the design and production of the garment. As the production process has fragmented into a number of distinct stages, each stage often taking place at some physical distance from other stages and involving different personnel, tools and skills, it is increasingly important for those involved in each stage to have clear, unambiguous information to guide them. This is what the flat provides.

Given the importance of the flat throughout fashion, particularly in the sports, active and casual wear markets, a large part of this book is dedicated to how the flat is drawn. It is essential for those involved in fashion production to have a good grasp of this process. The book also contains a large number of examples of flats. These can be used by the reader for inspiration, consultation, copying, or scanning into a computer and using as starting points for individual designs.

Drawings of finished garments and accessories are used extensively throughout the fashion industry by designers and by all those involved in presenting a garment to "inside" audiences—the different departments and committees involved in a fashion house's design and production process. Such drawings capture the mood, line, texture, drape and silhouette of a garment. Much of this book is devoted to a detailed treatment of the techniques which are used in creating drawings of this type—including how to draw a wide variety of different garments, the detailing of garments, the drape of garments, the different fabrics and designs, and the accessories which accompany the garment. A particular emphasis in the book is placed on how to draw with accuracy the details of garments and the accompanying accessories, as well as the garments themselves. It is hoped that the reader will continually refer to the chapter on accessories and the Encyclopedia of Details in order to make sure that those parts of his or her fashion drawings are drawn as well and accurately as the garments themselves.

When one is involved in the sometimes less exciting, repetitive exercises of mastering a discipline—whether practicing scales on the piano or conjugating the verbs of a foreign language—to hear a beautifully played piano sonata or, perhaps, the sweet tones of a native speaker, can be a source of inspiration and refreshment. It also helps to have an idea of the goal towards which one is headed. The same applies when learning to draw. To provide some inspiration and perhaps also some insight into where fashion drawing can lead one in a professional career, the book includes interviews with professionals who use fashion drawing in their daily work and shows some examples of their work. These designers and illustrators are of different nationalities and from varied backgrounds. Their professional goals and the ways in which they work are also quite different. It is hoped that the reader will find this section an enjoyable and interesting diversion from the other parts of the book.

No modern book on drawing fashion would be complete without a discussion, however brief and schematic, on the role of the computer. One often

hears in fashion schools today, from both students and faculty, the view that drawing is no longer relevant in the world of fashion, as illustration has shifted to photography, and design is moving increasingly to the computer. This view is far from the truth, as any teacher of computer courses in fashion design will attest. Armed with polished drawing skills, the student will find that a computer becomes a formidable tool, allowing almost infinite numbers of design configurations to be explored with a minimum of effort. Without this firm grasp of the theory and practical techniques of drawing, coloring and rendering, however, efforts on the computer will usually amount to little. The chapter on the use of the computer in fashion drawing provides a brief introduction to the subject, but above all tries to put it in some perspective, allowing the reader to appreciate some of the technical and esthetic issues involved.

As we have discussed above, many areas of fashion drawing are now technical and functionally oriented. No matter how technical or functional it might be, though, every drawing, and every act of drawing, contains a part of ourselves and gives us satisfaction and a sense of achievement. The best drawings are almost always made when we are drawing for the sheer love of drawing, but all our drawings will benefit when drawn with at least a little love.

Fashion drawing can be a source of great pleasure at all levels of proficiency. To develop technique and advance our skills, we must practice at every opportunity and continually observe the world in all its aspects and complexity. Art galleries, museum exhibitions, art and fashion books in the local library, magazines, specialty clothing stores, the cultural life of the community are all areas rich with possibilities for detailed observation and

sources of inspiration. At the same time as developing our technique and skills, we must strive to continually develop and educate our own artistic and design sensibilities, focusing on our tastes, preferences, likes and dislikes and, just as importantly, how we can articulate them and explain and justify them to others.

A beautiful drawing is executed with a confident and graceful gesture which itself originates from a clearly conceived idea. This act of drawing is profoundly enjoyable and satisfying. Let's begin.

MATERIALS

Turquoise graphite pencil
Mechanical pencil
Ebony pencil
Micron pen .005
Marker
Sponge
Brush
Blender
Lead
Eraser
Watercolor
Tape
Cutting surface
Ruler
11" x 18" or 14" x 17" newsprint
11" x 18" white bond pad
A dozen soft lead drafting pencils (2B)
Felt tip pens
Tracing paper
Posture: Sit like a ballerina

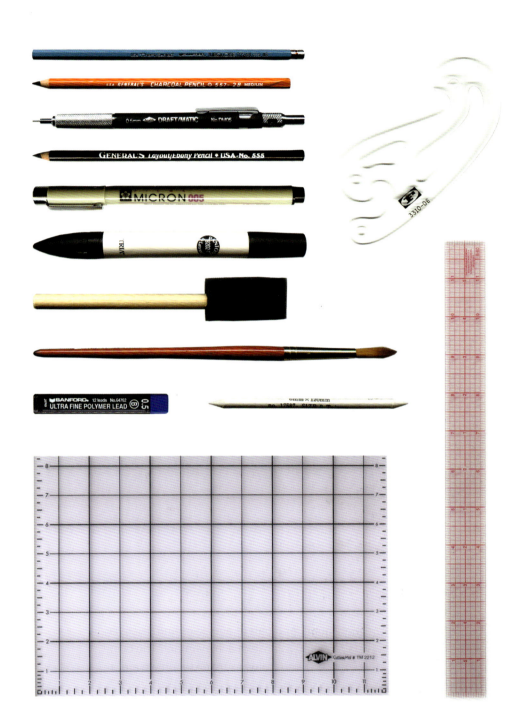

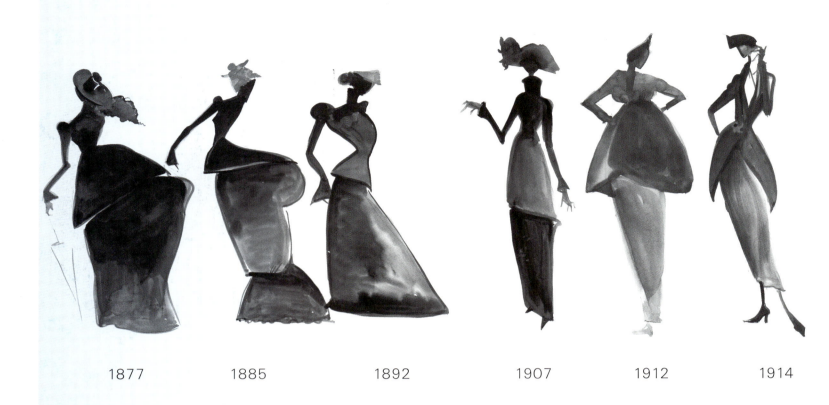

1877 1885 1892 1907 1912 1914

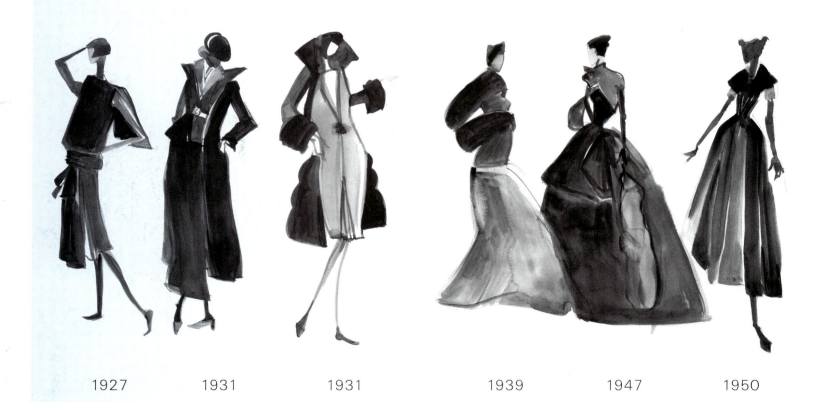

1927 1931 1931 1939 1947 1950

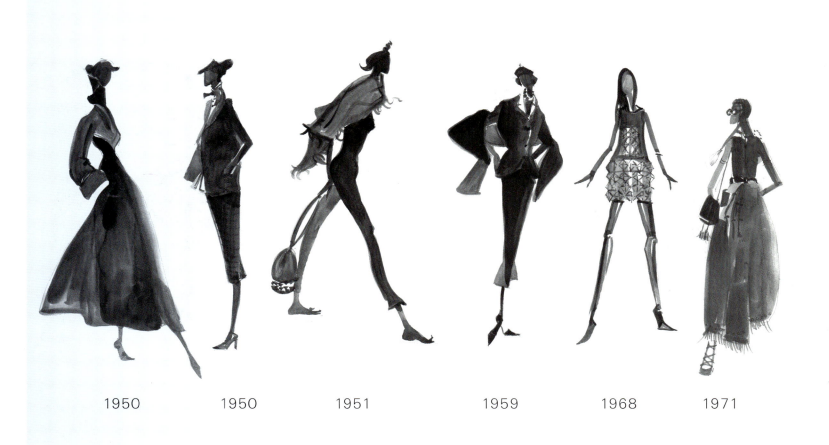

1950 1950 1951 1959 1968 1971

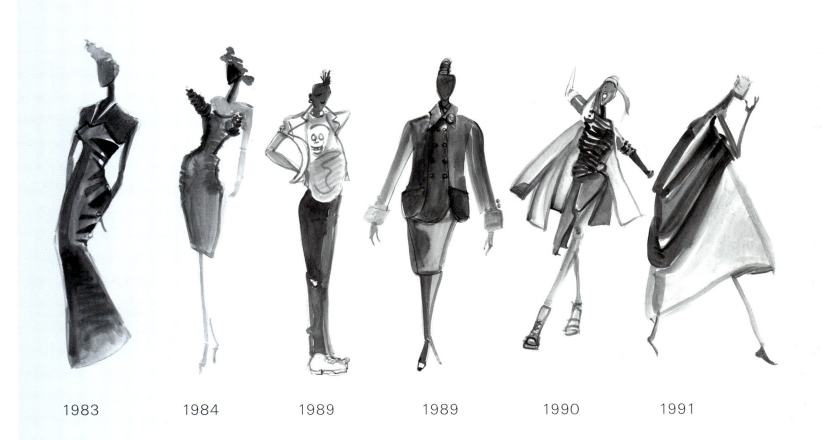

1983 1984 1989 1989 1990 1991

chapter one:
proportions of the croquis

the croquis

INSPIRATION

Drawing is a form of thinking, and each individual's thinking is unique. When we draw we see more and know more of the world we live in. When we see more and know more, this inspires our drawing and breathes life into it.

Drawing starts in the imagination. The mental picture is the map which serves as our guide to what we want to explore and develop. Our drawings belong only to us. They are the expression of our thinking about what we are drawing. Learning to draw is learning to understand and order our thinking. Our line begins to define our idea and our feeling. Drawing is a skill which comes with practice. Drawing is like music and with time the hand will come to dance on the page. Copy the exercises in this book and move slowly, step by step. Mistakes will be made but they will often become our successes.

DRAWING FASHION

In drawing fashion, all the elements are designed to highlight and emphasize the clothing. We choose to draw a figure of exaggerated height because exaggeration makes the figure seem larger than life and gives it an air of importance. The 'croquis' (the French word for sketch, now used to refer to any drawing of the elongated fashion figure) is a nine-head figure, each proportion of which is measured in relation to the length of the head. As mentioned in the Introduction, in reality the proportions of the human figure are equivalent to eight heads; the fashion figure is equivalent to nine. This makes the fashion figure appear to have longer legs and a shorter pelvis. Like music, drawing has rhythms, melodies, harmonies and counterpoint. It can reflect an infinite variety of moods and settings. We use heavy, medium and light lines, sparse areas and areas which are dense with detail. Sometimes the figure fills the page, sometimes we place it dramatically in relation to the space around it to heighten the visual impact. We should always remember

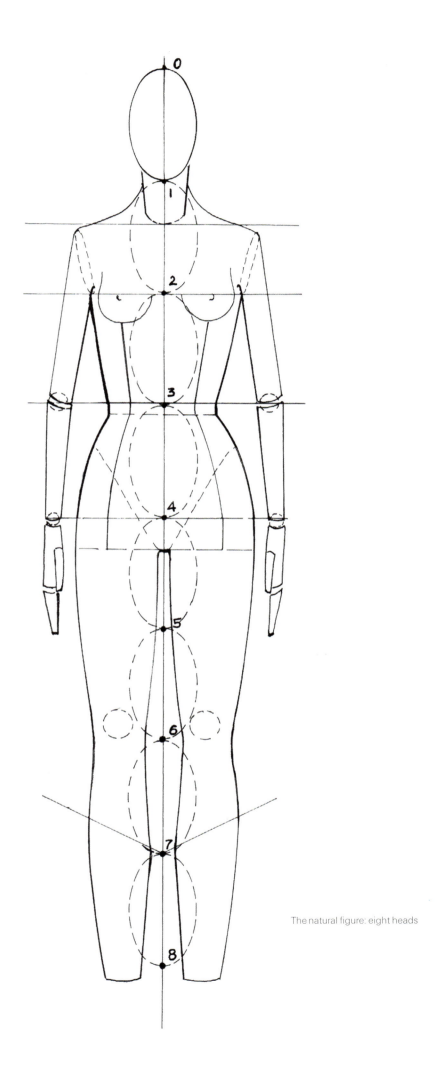

The natural figure: eight heads

the croquis

that we are striving to express beauty, grace, elegance, energy and vitality.

PREPARING TO DRAW
Sit comfortably in a chair. Sit straight up with good posture like a ballet dancer. Keep the pad straight in front of you, hold the pencil lightly. To keep the wrist free to move on the page keep the weight on the forearm and rest the forearm on the desk or a flat surface. If your hand shakes when you begin to draw (this is very common) try the following exercise: randomly place two dots on a piece of paper, three inches or so apart. Put your pencil on one dot and without stopping rapidly draw a line to the other dot. Repeat this exercise until you feel confident the line is smooth.

PLANNING THE FIGURE ON THE PAGE
To begin, we must plan the placement of the figure on the page. It is a general rule that the figure should fill the page so that all details can be clearly seen. The position of the figure on the page is indicated by using a line which runs from top to bottom through the center of the figure; this line runs between the eyes, down the nose, through the neck, the bosom, the tummy, the crotch, the legs and is called the *axis line*. Place points where you wish to locate the top of the head and bottom of the legs and connect these dots. Start from the top and work down to avoid smudging. To draw a straight line can be difficult. You may use a ruler, but to acquire freedom and proficiency you may try to create a line connecting the dots from end to end using your eye and hand. Touch the page with the sharp point of your pencil on your uppermost dot and move quickly to your bottom dot. Do not watch your pencil move, move ahead to the end of the line. Next, divide your line into nine equal sections so that we can begin to draw the figure. Please fill the page top to bottom. Small figures are like whispers.

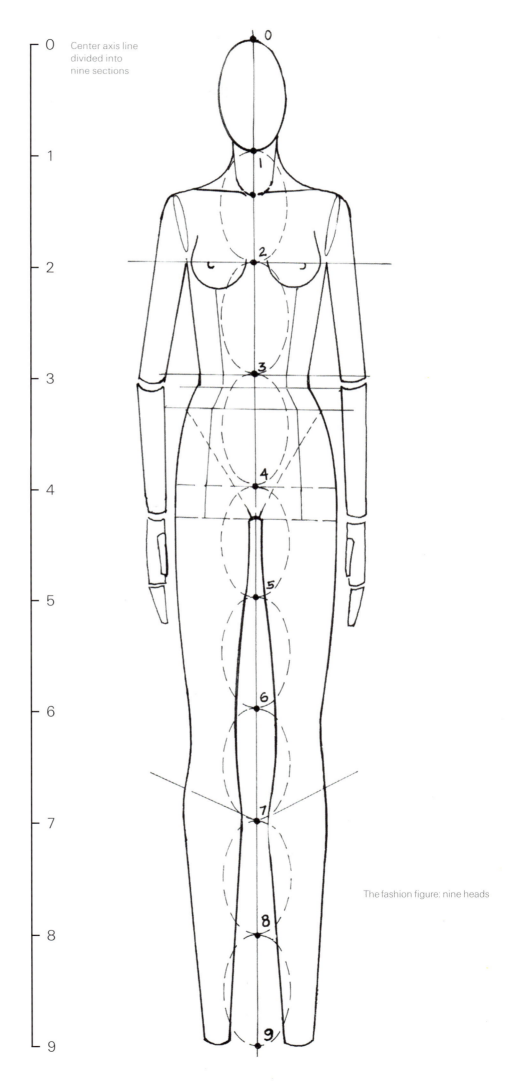

Center axis line divided into nine sections

The fashion figure: nine heads

the croquis
front view

1. Beginning with the head, place an oval the shape of an egg in the first section between 0 and 1 (see croquis. p.19). To draw this oval symmetrically, place 2 dots on the axis line at 0 and 1, and dots on either side of the axis line mid-way between 0 and 1, approximately ¾" apart. (Symmetrical means balanced, or that both sides are equal). Practice in the air with your hand before connecting the dots. This oval represents the head and is slimmer than a real head. Think of it as egg-shaped rather than as a hot-dog or watermelon.

2. Move from dot to dot to create a symmetrical oval.

3. Draw the neck next, moving half way down the axis line between 1 and 2. The neck is slimmer than the head.

4. Take the length of the head and the neck (1½ heads), and turn it sideways: this is the width of a woman's shoulders. Draw the shoulder line slightly above the base of the neck.

5. The armhole is half a head length. It slants inwards in order to give us enough area in which to fit the arm. The armhole ends at 2.

6. 2 is also the apex of the bust. Place a dot at number 2 at an equal distance from the axis (center line).

7. The waist is at number 3 and can be drawn at approximately three-quarters heads width (decide for yourself whether you wish to make the waist thin, very thin, or super skinny).

8. The next dot is just below the waist at 3¼. It is the point at the top of the pelvis and is called the *ilium*. (Tap yourself at your side just below your waist and you will feel this bone). It is very important to establish this point on the figure in order to make an accurate drawing or pattern from that drawing. The ilium is the point at which a woman's hip begins to differ from a man's. At this point a man's hip becomes a vertical line whereas a

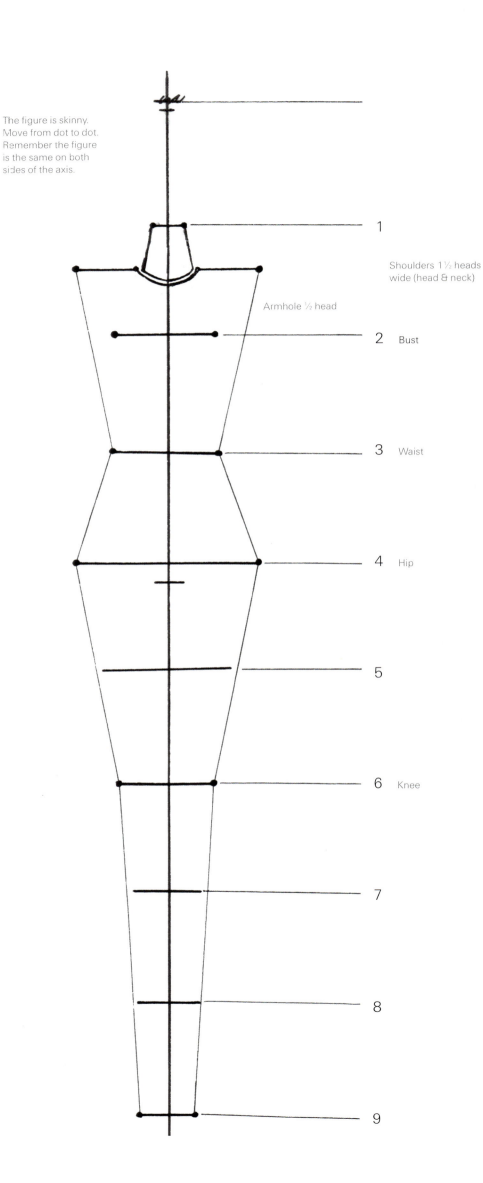

The figure is skinny. Move from dot to dot. Remember the figure is the same on both sides of the axis.

1

Shoulders 1½ heads wide (head & neck)

Armhole ½ head

2 Bust

3 Waist

4 Hip

5

6 Knee

7

8

9

the croquis
front view

woman's hip extends out at a diagonal. (Remember when women tried to fit into men's jeans? Men's jeans did not fit the woman's ilium and pelvis because the patterns used to make the jeans were too straight and did not mold around the beautiful curves of the female form.)

9. Our next point of reference is at the hip which is at number 4 and is the same width as the shoulders— 1½ heads, remember?

10. Next, mark the crotch at 4¼ between the center of the legs.

11. Now, travel a long distance down to the knee at 6. By following the straight line from the crotch, move down to number 6 and place a point which will mark the knee. The knee is one half a head in width. The next job is to connect the hip to the knee. Do this in one movement, without stopping, using an elegant line. Try not to make chicken scratches!

12. Our next point is at 7½. This point marks the calf (a large muscle called the *gastrocnemius*). Move your line from the knee to the calf making the calf just a bit wider than the knee. Now make the long glide down to the ankle.

13. Slide from the calf back to a very thin ankle at 9 (or, if you wish, just above number 9 for a sporty, younger looking croquis).

14. Add the arms connecting the armhole to the elbow. Tap yourself at your waist and you will see that this is where your elbow fits. Remember, the waist is at 3 and the elbow is at 3. Finish your croquis placing the wrist at 4. Tap yourself again and you'll see an excellent fit. A helpful proportion to remember is that the upper arm is one and a half heads and the lower arm is one. Congratulations! You have just drawn a croquis.

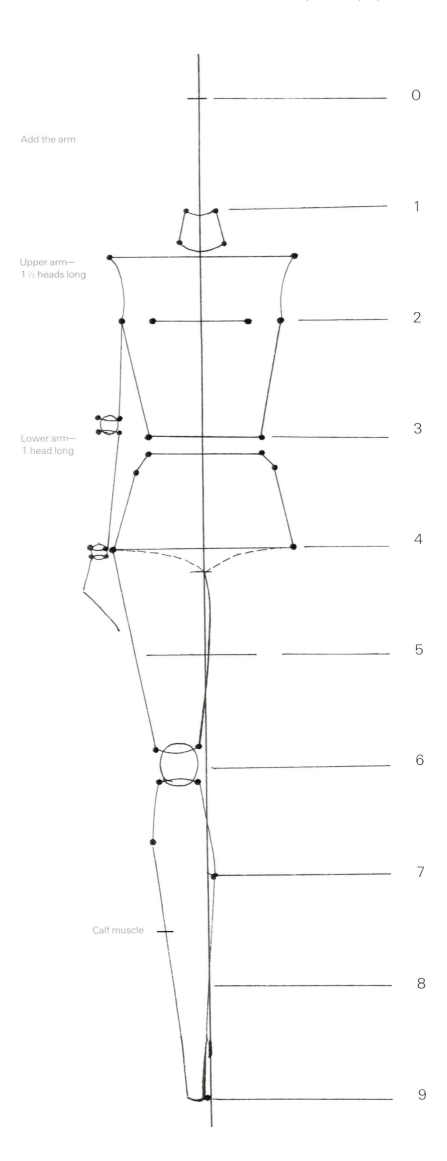

Add the arm

Upper arm— 1½ heads long

Lower arm— 1 head long

Calf muscle

0
1
2
3
4
5
6
7
8
9

the croquis
front view

LINE QUALITY

An important aspect of drawing the figure is the quality—the thickness—of the line. A thick, bold line will give the figure a strong, graphic presence and make it appear to have physical weight on the page. A thin line will do the opposite, making the figure appear light and ethereal. A common mistake is to move the pencil slowly down the page with little strokes, called chicken scratches. This is a definite "do not do" as it gives the illusion of texture as opposed to a structural basis for the figure.

No chicken scratches!

There is one other line which has an intrinsic elegance and expressiveness which is sometimes called a nuanced line. A nuance is a slight or subtle change of color or meaning; a nuanced line is one which changes subtly from thick to thin or from dark to light. We use this line to express quality of light. Light is made up of electromagnetic waves called photons (from which we get the word photography). Photons are either absorbed by or bounce off every object we view. However, light does not bend. Think of the inside of your nose or ear—it's dark in there. A nuanced line is able to express both areas of the body which are flat, and therefore well lit, using a thin line indicating light, and also areas which are bent and do not receive light, with a thicker line, indicating shadow. A nuanced line is thicker round the chin, armhole, waistline, crotch, elbow, knee and ankle, thinner along the length of the arm and leg, the outside curve of the hip, the side of the neck. Create a nuanced line by pressing down on and lifting up on your pencil with one fluid movement. It is cheating to lift the pencil from the page every time you wish to vary the thickness of the line; the line should be made in one continuous movement.

A nuanced line is an elegant line.

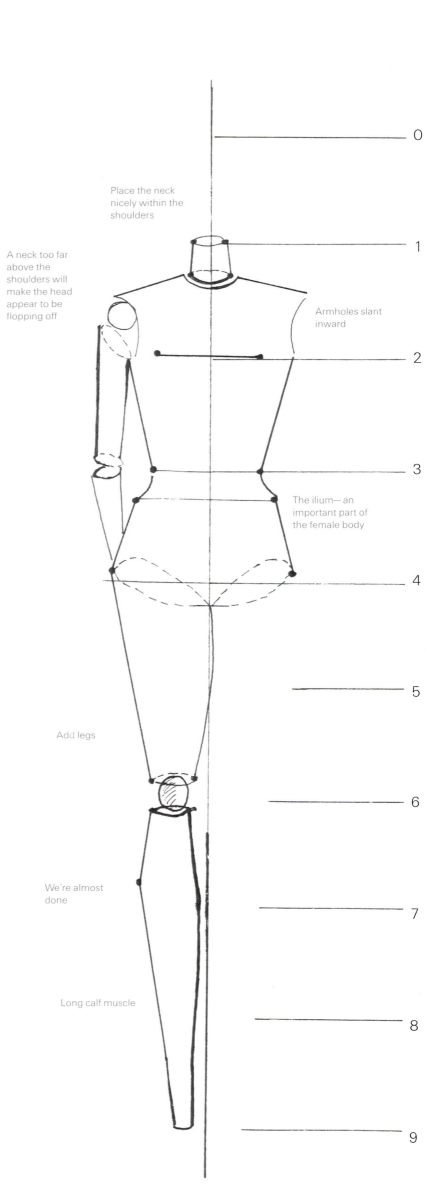

Place the neck nicely within the shoulders

A neck too far above the shoulders will make the head appear to be flopping off

Armholes slant inward

The ilium— an important part of the female body

Add legs

We're almost done

Long calf muscle

0

1

2

3

4

5

6

7

8

9

the croquis
front view

EXERCISE

We need to practice to draw well. Try the following exercises to gain speed and to learn the croquis measurements:

1. Draw the figure five times with a light line. Use a mechanical pencil.
2. Draw the figure five times using a dark line. Use a soft pencil, 3B or 4B.
3. Draw the figure with a line which is nuanced. (Do you remember, a nuanced line indicates lightand shadow?) Light does not bend; therefore, our line will be darker as it bends around the corners of the body.
4. Draw the figure and fill in with a variety of patterns (a pattern is an image which is continuously repeated—stripes, dots, flowers, musical notes, etc.). Use color or black and white. Neatness is important.
5. Make a croquis out of cardboard or paper, make a croquis doyley, a croquis cookie or simply repeat the earlier exercises until you become completely familiar with the proportions of the figure.
6. It is very helpful to keep an "idea book" in which we record all the things that inspire us, from images from fashion magazines to the wrapper of a candy bar, those things which feed the imagination and help define taste. Collect as much information as possible from all areas of life and organize it in your book according to your own taste and ideas. This is your book: design it as you wish. Try to be as neat as possible. A glue stick is helpful. Try to collect at least one hundred images from many different sources. These might include sports/body building magazines, interior design images, cookbooks, fabric swatches, poetry, butterflies, flowers, trees, plants, buildings amongst others. Include an area in the back of your book devoted to things you hate. This is an excellent way of distinguishing your likes and dislikes. It is also interesting that in the future we often come to like the things we once hated. Use this book as a tool to help you learn to draw. You can trace figures, hairstyles and clothing; you may also use your book as a reference when trying to draw details of the figure.

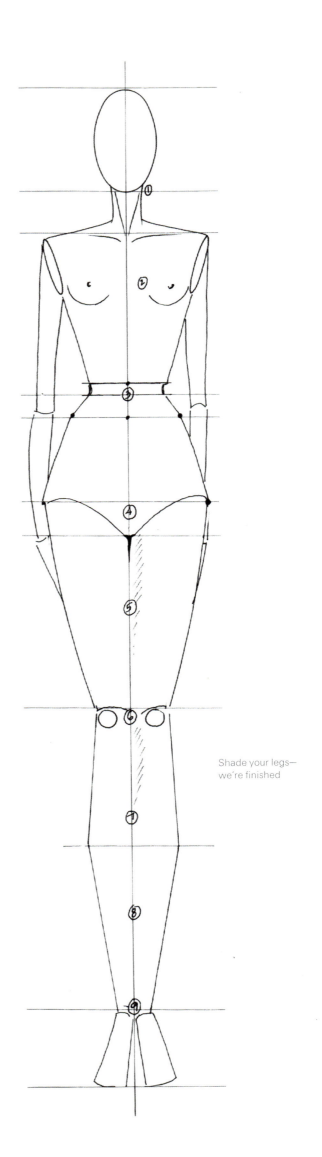

Shade your legs—
we're finished

the croquis
back view

The proportions of the back view are the same as the front view, as you might imagine.

1. One small difference between the back view and the front view is that in the back view the neck is turned up and fits inside the skull. If you touch the back of your skull you will feel the soft part where the skull begins. The neck will appear shorter but is still half a head.

2. The shoulder blades extend from the shoulders, of course, to number 2 , where we place the bust in the front view.

3. The hip is round and ends at 4. Do not draw dark lines under the hip as this is a soft, full area of the body and black lines create flat areas.

4. The rest of the back view of the figure remains the same as the front view with the understanding that from the back we see the elbows and the backs of the feet. .

EXERCISE
Draw 10 back views .

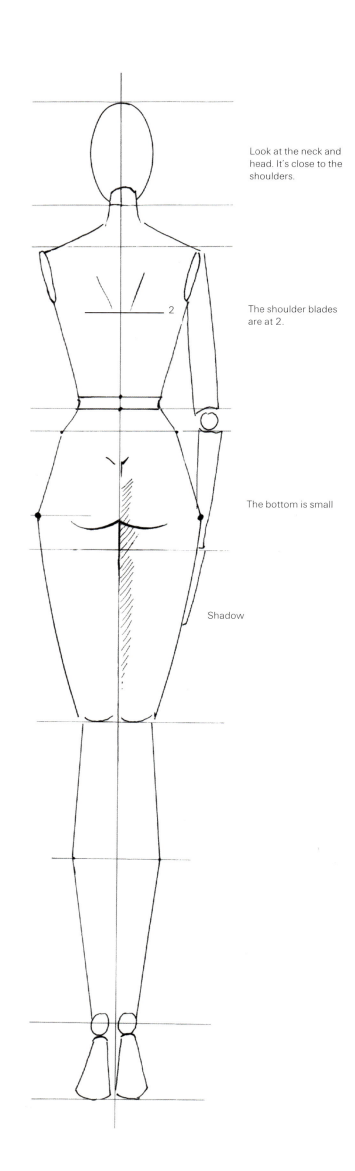

Look at the neck and head. It's close to the shoulders.

The shoulder blades are at 2.

The bottom is small

Shadow

the croquis side view

1. The side view is based on diagonals. Let's begin by practicing with a line exercise: draw a quick sketch to loosen your wrist. Scribble a figure with one line moving the figure forward and back—head forward, neck back; upper torso forward, lower torso back; upper leg forward, lower leg back. Try to draw fifteen croquis in three minutes—fast, fast fast. Do not pay attention to the proportions or outline of the figure. What you are doing is creating a mark which expresses the movement and dynamics of the body. This is called a *gesture drawing*.

2. We will now begin to draw the side view, which is based on diagonals. Psychologically, horizontal and vertical lines appear to be at rest whereas diagonal lines seem to be off balance, and we respond to them as indicating movement. Let's begin a side view figure which will use diagonals and create a feeling of grace and movement.

3. Begin with the head slanted forward, balanced with the axis line.

4. The neck extends from the back of the head and is a half a head, as you might remember. Use axis line for balance.

5. The upper torso is tipped forward. Use an oval or a rectangle and balance with the axis line. Be careful not to tip the oval too far forward or the croquis will appear pregnant!

6. The lower torso tips backwards, creating a curve in your backbone—the *lumbar* region.

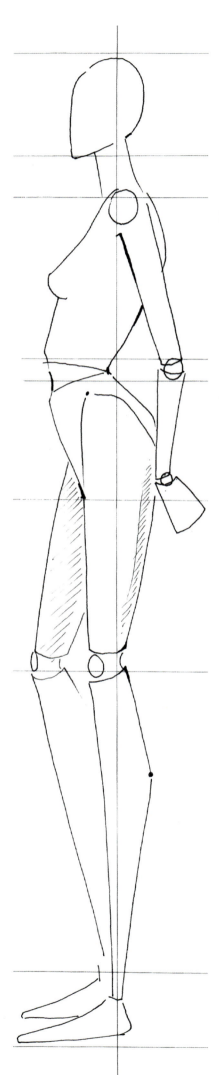

Let's begin to bend the figure. Diagonals = movement

This figure has rhythm

the croquis
side view

7. The legs extend from the ilium to the knee with a straight bone in front and the full muscle in the back at 7 ½.

8. In side view, the shoulder appears directly in front of the neck when the arm is at rest. When the arm bends the shoulder pivots, moving forward as the arm moves back and backwards as the arm extends forwards.

9. There are variations on the side view. If the side view figure is drawn with the pelvis thrust forward, the entire upper body appears to lean backwards. There is one continous diagonal moving forward from the shoulders to the waist, continuing from the waist to the hip. At least one ankle returns to the axis line; otherwise, the figure appears off-balance and in real life would fall down.

10. To begin to show movement, bend the upper leg out from the hip, moving from number 4 at the hip, through number 5, ending at number 6, the knee. From the knee, return the line back to number 9 at the ankle.

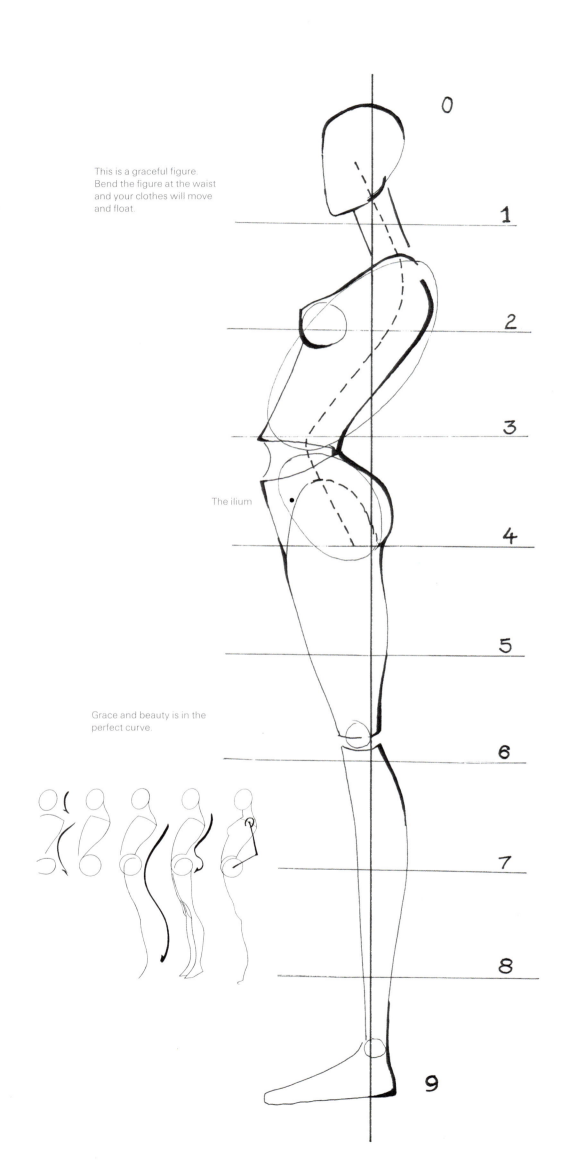

This is a graceful figure. Bend the figure at the waist and your clothes will move and float.

The ilium

Grace and beauty is in the perfect curve.

the croquis
side view

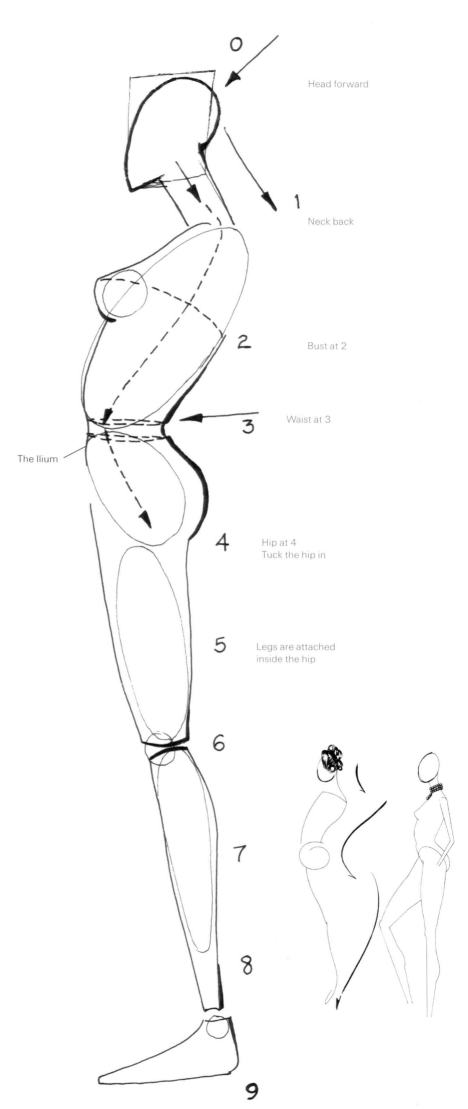

0 Head forward

1 Neck back

2 Bust at 2

3 Waist at 3

The Ilium

4 Hip at 4
 Tuck the hip in

5 Legs are attached
 inside the hip

6

7

8

9

perspective

Let's look at perspective so that we may understand and draw more challenging figures.

Perspective is a system for depicting space in a three-dimensional manner on a two-dimensional surface—the paper or canvas. It was developed during the Renaissance from ideas which had been present since Greek and Roman times. The Church used it extensively to represent in painting and drawing vast distances such as heaven and hell.

Perspective is one of the more challenging aspects of drawing (which is why man drew in a flat, distorted way for thousands of years) but it is important to master in order to draw in a pleasing, realistic manner. It often takes time to fully understand all the complexities of perspective and how to represent it, and the reader should return to this section many times to refresh his or her understanding. Gradually, with practice, drawing the fashion figure perfectly proportioned and in perspective will become second nature.

Understanding perspective involves understanding two techniques. The first technique shows how to depict an object at a particular point in space viewed from different angles and heights. It also shows how to represent the object as it inclines towards us or reclines away from us. This technique is called *foreshortening*. The second technique shows how to depict an object in relation to other objects which are at different distances from the drawing's viewpoint. This technique is called *linear perspective*.

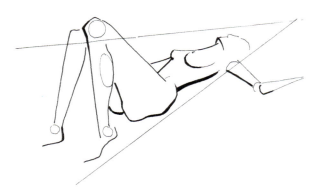

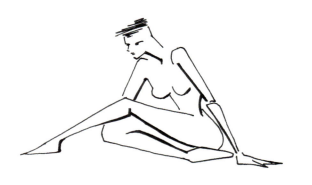

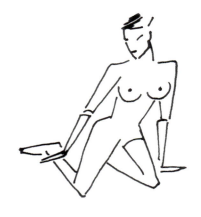

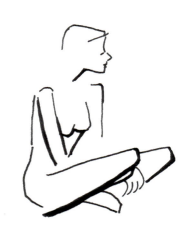

perspective

Let's examine the first technique, fore-shortening, in more detail. Our perception of an object changes as we view it from different angles. If the object itself is at a fixed point, then the angle at which we view it changes as we move around the object. For example, we can walk around a mannequin displaying a garment in a store and see different views. We see in fact, the front, front three-quarter, side, back three-quarter and back views in succession. If on the other hand we ourselves are stationary, not moving, for example if we are sitting viewing a fashion show, then if the object moves—a model turns round to show off a garment—then we also see front, front three-quarter, side, back three-quarter and back views as she turns around. When we perceive an object (let's think of a figure) in three quarter view, its proportions are different from those when seen from the front or back view. This effect, as mentioned, is called foreshortening or, sometimes, simply *perspective*. We reproduce this effect in our drawing to give a realistic three-dimensional representation of an object viewed from different angles.

Object viewed at different angles

Front	Front three-quarter	Side	Back three-quarter	Back

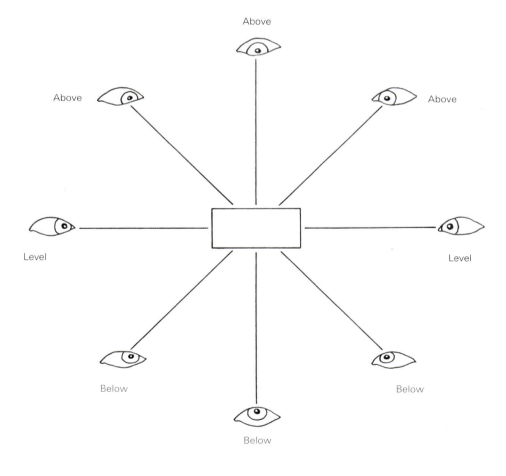

Above

Above

Above

Level

Level

Below

Below

Below

Eye level

perspective

Our perception of an object also changes according to the point of view. If an object is fixed and we ourselves move up and down, then, if our eyes are above the object, we see it from above, if our eyes are below the object, from below, and if we are level with the object at eye level. Looking up at a fashion model on the catwalk, we see her from below; sitting in a lifeguard's chair on the beach we see the bathers from above; playing poker we see the other players at eye level. The same effects occur if we are fixed and an object moves above us or below us. Just as the proportions of an object change as we see an object from different angles, so shifts in eye level also cause our perceptions of the object to change. This effect is also called foreshortening and is reproduced when we draw in order to give a realistic three-dimensional appearance.

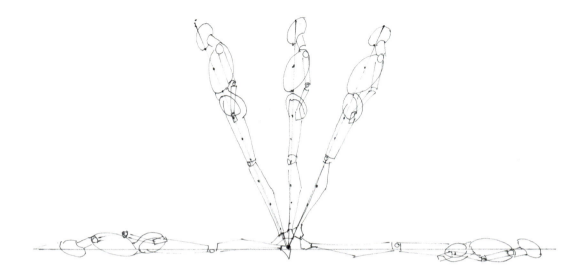

Inclining and reclining figure

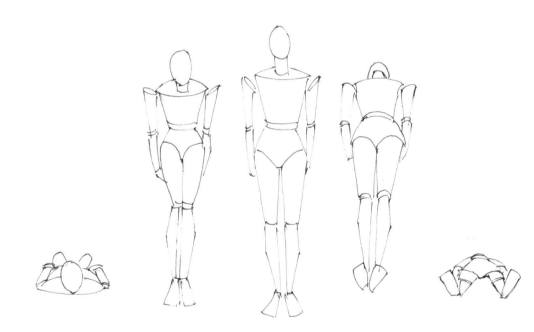

Foreshortening of the inclining and reclining figure

perspective

The second technique is what is referred to as *linear perspective*. This technique shows us how to depict objects, or different parts of the same object, which are at different distances from the point from which they are being viewed. Linear perspective states that the proportions of an object diminish in scale as it recedes in space. Two tools are employed to help achieve this effect. One is the *vanishing point*—the point on the horizon at which parallel lines which extend from the top and bottom of an object appear to converge. The other is the parallel lines themselves, called *vanishing lines*. The figure placed within these receding vanishing lines becomes smaller and smaller as it gets closer to the vanishing point. To give an example of this: Betty and Jill are identical twins. They share a wardrobe, so when they have a fight they have to take a walk on the beach to make up so they can continue to share their lovely clothes. How do we show this? Have a look at the example in the drawing.

Let's move on to discuss a view of the figure which involves the foreshortening effect of perspective, the three-quarter view.

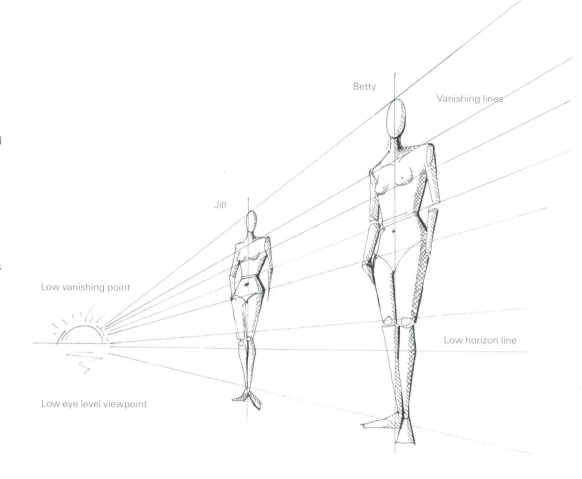

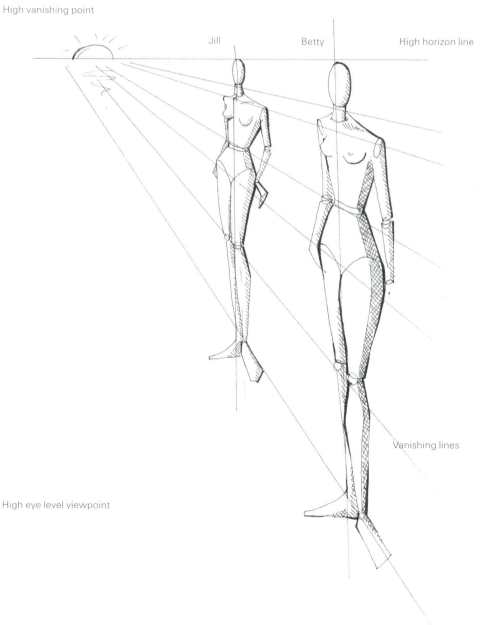

31

the croquis
three-quarter view

1. The three-quarter view is the depiction of a figure which is partially turned away from us. Because we are seeing both the front and the side of the figure, part of the figure appears to be fore-shortened, or in perspective. The three-quarter view is used frequently because it conveys more information than the side, front or back views separately. From this view the figure appears three-dimensional—we can see both its front and side. It is frequently used in fashion drawing because it allows us to see side seams, armholes, openings, bows and a variety of details that cannot be seen from the other viewpoints.

2. In drawing the three-quarter view the axis line moves over to one side so we see less of one side of the figure and more of the other. Three-quarters of the figure remains on one side of the axis line and one quarter is on the other side.

3. Slant all horizontal lines—shoulder, waist, hip—at an angle to express depth (refer to the explanation of vanishing lines above). Notice that the vanishing point can be fixed in different locations in the composition to suggest a higher or lower point of view.

EXERCISE
Draw ten side view figures and ten three-quarter figures. Look for these views in a magazine. Trace the edge of each figure.

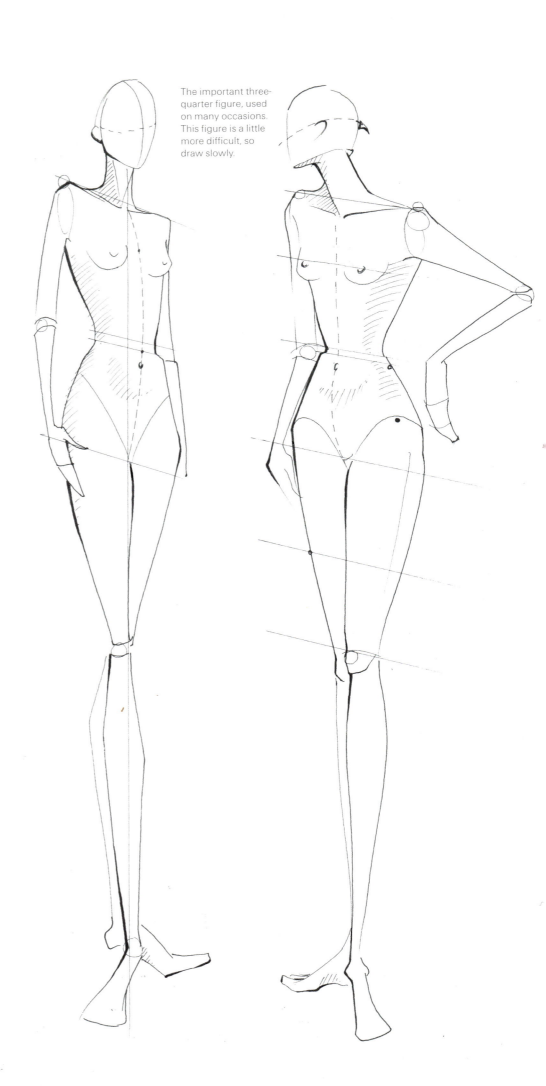

The important three-quarter figure, used on many occasions. This figure is a little more difficult, so draw slowly.

the croquis
three-quarter view

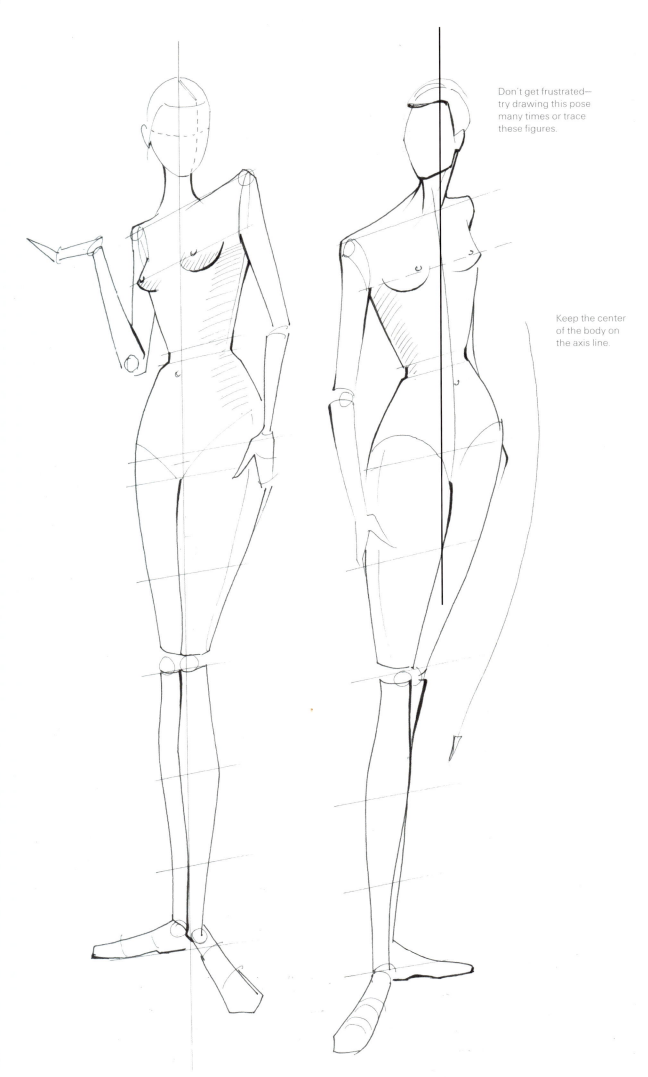

Don't get frustrated—
try drawing this pose
many times or trace
these figures.

Keep the center
of the body on
the axis line.

the croquis
complete figure

Complete front, back, side and three-quarter view figures.

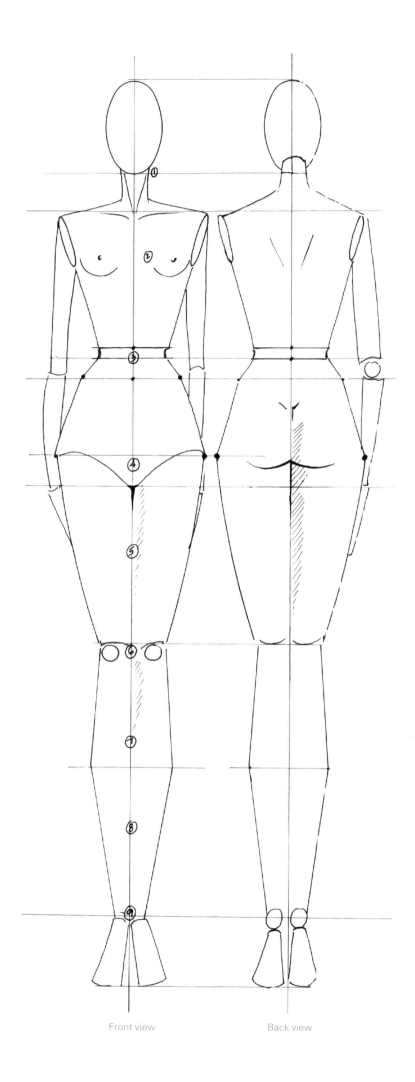

Front view Back view

the croquis
complete figure

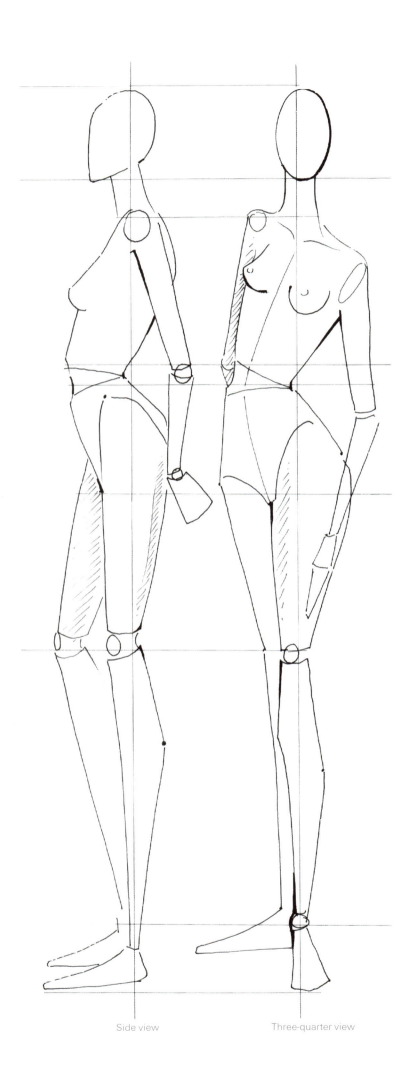

Side view Three-quarter view

muscles

Muscles are long on the outside, extending the full length of our arms and legs, from shoulder to elbow and elbow to wrist, hips to knee and knee to ankle. The muscles on the inside of our arms and legs are short—they are used for pulling, as opposed to pushing. Try flexing your arm to see the shape of the muscle on the inside, called the *bicep*. The neck muscle extends from the ear to the center of the collarbone (*clavicle*). The arm blends into the muscular curve of the bustline (the *pectoralis*).

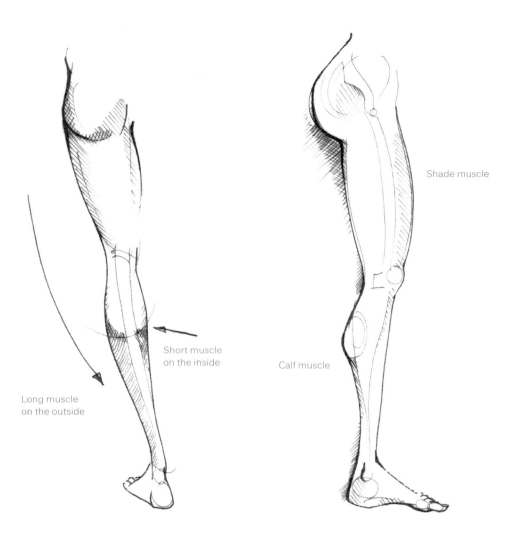

Short muscle
on the inside

Long muscle
on the outside

Shade muscle

Calf muscle

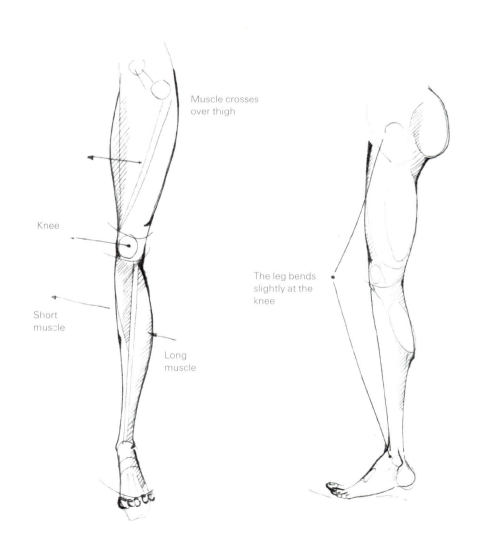

Muscle crosses
over thigh

Knee

Short
muscle

Long
muscle

The leg bends
slightly at the
knee

shading

All drawing can be thought of as combinations of circles, squares and rectangles, known as shapes. Shapes do not exist in the real world as they have only height and width—they are only two dimensional and do not have depth. In creating a drawing which appears to have depth, and therefore appears more life-like, we add shading. As we discussed earlier on, light cannot bend and is made up of electro-magnetic waves called photons. To create three-dimensional forms we use this idea of light and shadow in the following manner:

1. Sphere. A sphere is a circle with three dimensions. We start with a highlight at the top—a dot of light. This light becomes shadow and covers the rest of the sphere. If we rest the sphere on a table top it casts a round shadow known as a cast shadow. The point at which the sphere touches the table is very black and is known as the *tangency*. Draw this area with a black line as no light enters it. There is another light source we can investigate which is called *reflective light*. It appears to come from a secondary light source and will appear within the cast shadow and the sphere. Reflected light appears on a sequined gown, on the surface of the ocean at night or any reflective surface when it is moving.

2. Cube. The cube is a three-dimensional square. Start by drawing the square with four equal sides, draw parallel lines that slant to the right for the top of the cube and a third parallel line to indicate the side of this form. Only the top remains lit: the sides appear to have shade. The base of the cube is dark as it is tangent with the table top. Cast shadows appear to have the same shape as the cube and reflective light extends out in any direction.

3. Cylinder. The cylinder is a three-dimensional rectangle. It is a very important form as we use it to express arms, legs, fingers, the neck, the nose, toes and lips, the drapes and folds of fabric.

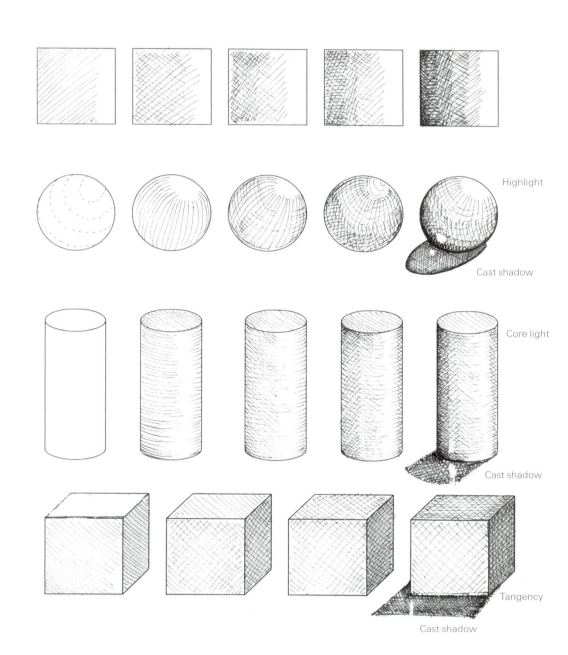

Shading changes a two-dimensional shape into a three-dimensional form.

shading

Shadows are, literally, areas without—beyond the reach of— light. In drawing, we work from light to dark tones to show the transition from the areas which receive most light, and are brightest, to the areas which receive little or no light and are in the deepest shadows.

In a drawing, it is the artist who decides on the direction of the light source. For the human figure, once this decision is made, shadows will tend to appear around the bust, the head, including eye sockets, base of nose, base of mouth, cheekbones, under the chin and jaw line, under the hair line, around the neck, behind the ears, around the tummy, under the arms and armholes, between the fingers, around the legs and crotch and, if you wish, between the toes.

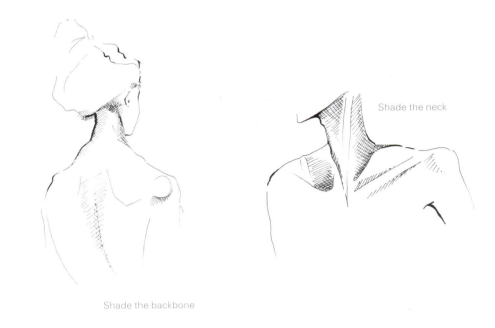

Shade the neck

Shade the backbone

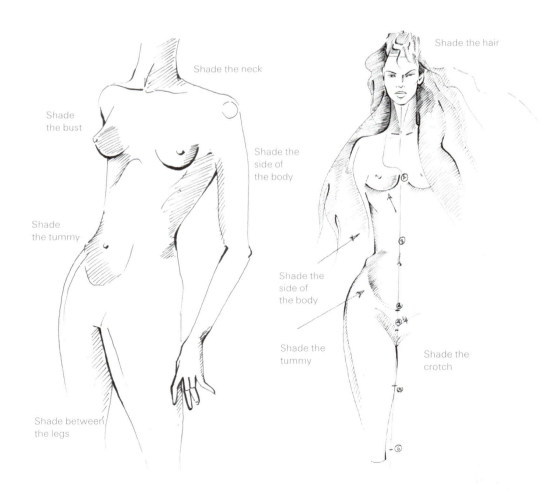

Shade the neck

Shade the hair

Shade the bust

Shade the side of the body

Shade the tummy

Shade the side of the body

Shade the tummy

Shade the crotch

Shade between the legs

face

The face is an oval; remember, it is an egg shape rather than a hot-dog or watermelon. We look at the face in real life to see mood, expression, intelligence. The face in fashion should not be so important; it is a complement to the clothing. It is beautiful, but smaller than in real life. It is extremely important to measure carefully, for the smallest shift in the eye or mouth can make the face appear to look insane or like a cartoon!

1. Draw a horizontal line across the axis line, cutting the face exactly in half. This is the eye level. Never place the eyes above this line as the face will appear extremely old. When we are babies our eye level is only one third up from the bottom of our head; we have extremely large brains as we are geniuses at birth. Our eye level moves up at maturity and stops at one half. This is true for men and women.

2. Cut the head in half for the eye level, take the remaining distance between the eyes and the bottom of the head and cut this in half again. This point is the bottom of your nose.

3. Take the distance between the bottom of your nose and the bottom of your head and cut this in half. This point is the bottom of your mouth. It is important to place the mouth close to the nose. The jaw lines up between the center of the mouth and the chin is directly under the mouth, no wider or smaller than the mouth. It is important to make the chin the same size as the mouth. We tend to draw the way we ourselves look—men have larger jaws and chins and sometimes make women appear to look like men by enormous chins!

4. The ear rests between the eye and the nose.

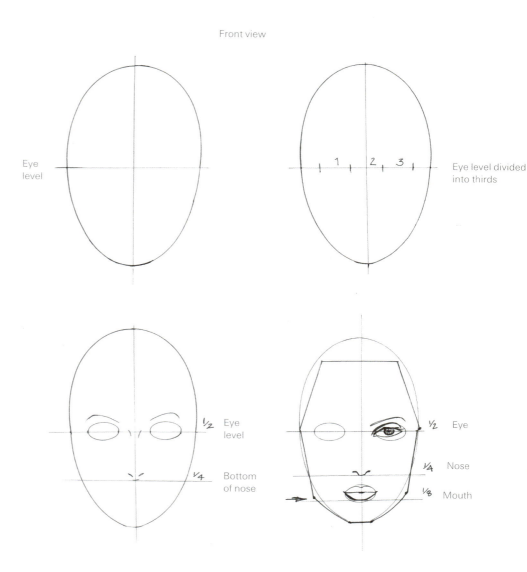

Front view

Eye level

Eye level divided into thirds

½ Eye level

¼ Bottom of nose

½ Eye

¼ Nose

⅛ Mouth

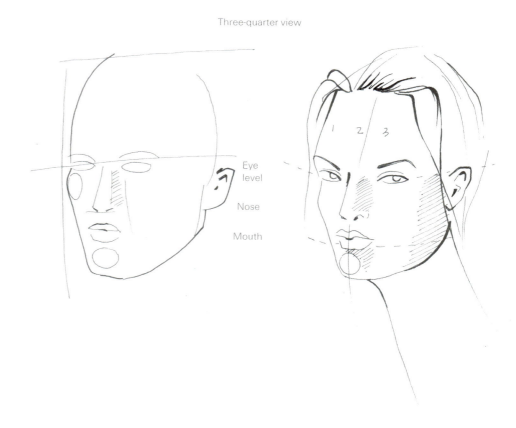

Three-quarter view

Eye level

Nose

Mouth

5. The hair line is approximately ⅛ to ¼ from the top of the head and extends across the eyes—like an umbrella for the eyes—and then moves down from the eyes to the ears. The outside silhouette (edge) of the hair cascades from the top of the head, the crown, moves close to the skull to the eye level and then falls softly to the shoulders.

Slim down the hair and head so that the eyes float down to the clothes. Draw the hair as simple shapes. Fill in the shape with tone, using a darker tone closer to the face. The edges of the hair may be broken up to indicate whether the hair is curly or straight. Curly hair is made of shapes like commas which move forward and back, becoming closer together at the bottom because of gravity. Blonde hair can be drawn by adding shading around the hair and not inside the hair. Look for the direction in which the hair is styled around the head, always drawing the hairstyle in the direction in which the hair is combed. It is a common mistake to draw a silhouette of the hair as if the hair were symmetrical. This looks artificial and makes the person appear as if they were wearing a helmet and not a hair style. The bottom of the hair should not be drawn as a straight line as the hair bends around the head and ends at a diagonal sloping in towards the chin. Drawing your hair with a straight line at the bottom will make your hairstyle look like Cleopatra's wig.

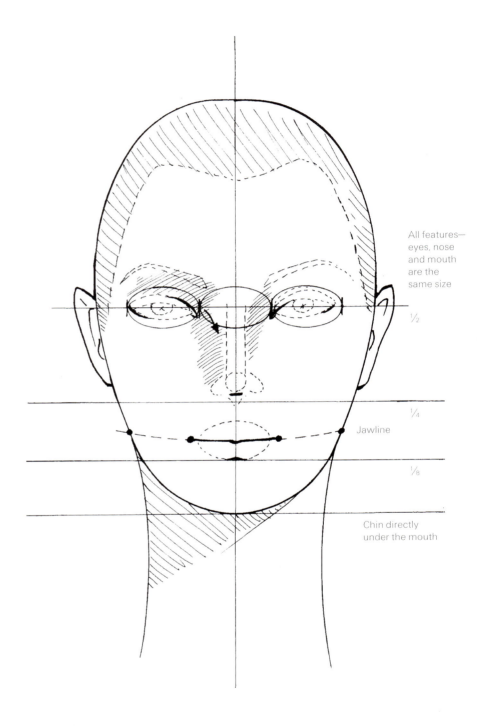

All features—
eyes, nose
and mouth
are the
same size

½

¼

Jawline

⅛

Chin directly
under the mouth

face
front view

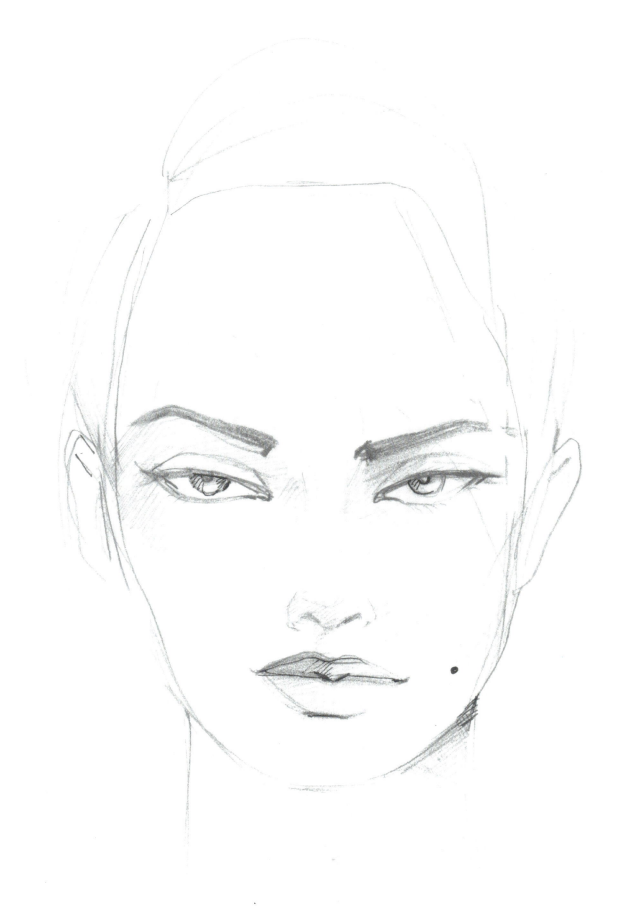

The finished face is eye-catching
and a little provocative.

face
three-quarter view

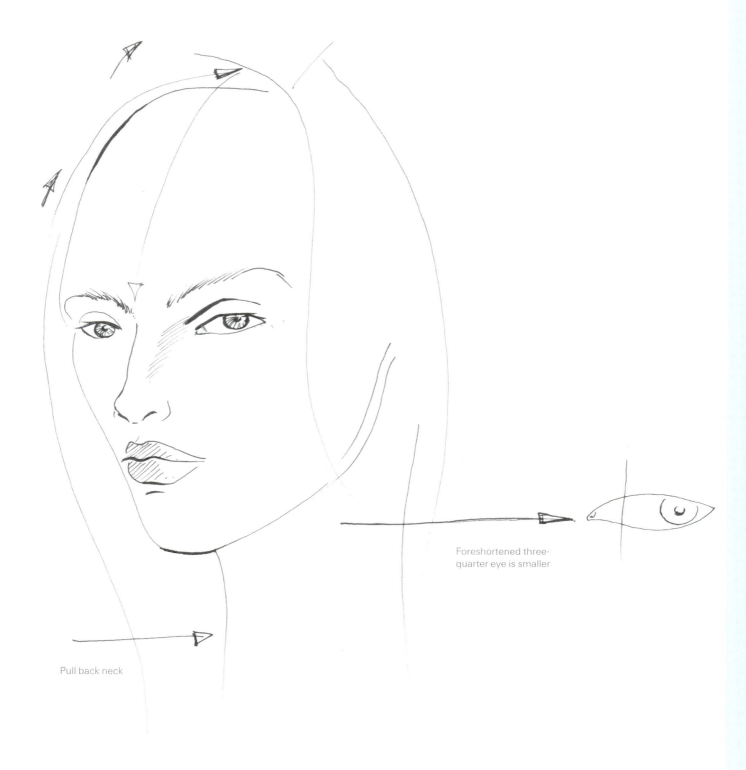

Pull back neck

Foreshortened three-quarter eye is smaller

face
side view

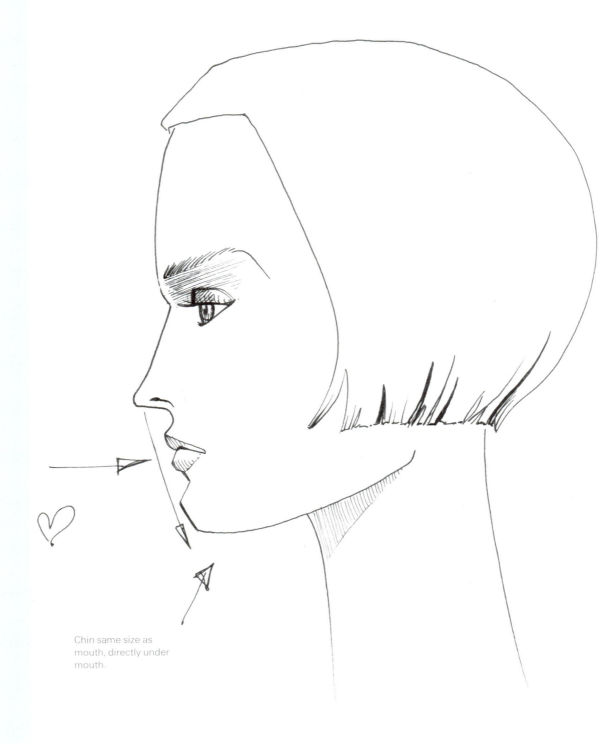

Chin same size as
mouth, directly under
mouth.

face
side view
three-quarter view

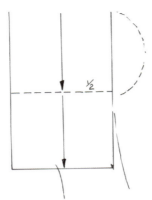

1. Rectangle plus arc

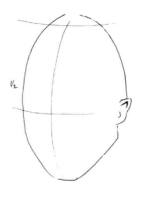

1. Oval with axis line

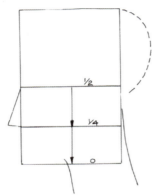

2. Add nose

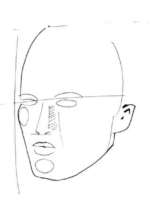

2. Add position of eyes, nose and mouth

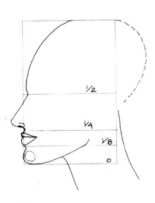

3. Add mouth and jawline

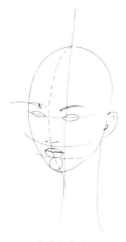

3. Add features— eyes, nose and mouth

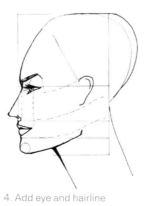

4. Add eye and hairline

4. Add hair and shading

face
different angles

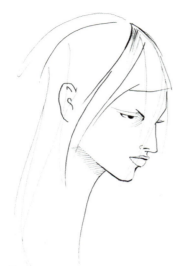

Three-quarter head
looking down

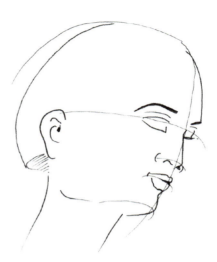

Three-quarter head
tilted

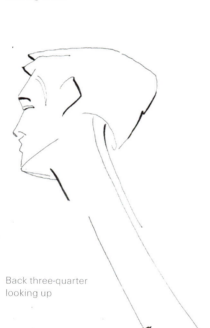

Back three-quarter
looking up

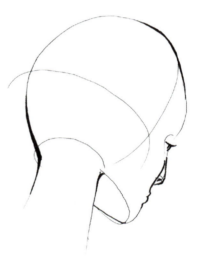

Back three-quarter
looking down

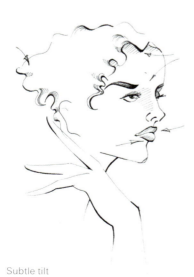

Subtle tilt

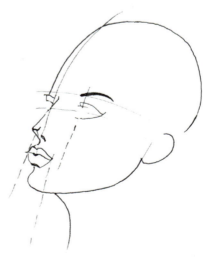

Side view looking up,
tilting back

face
different angles

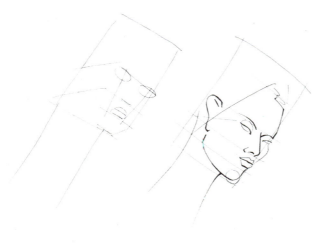

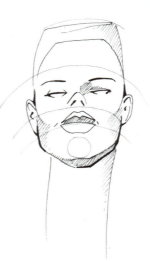

Three-quarter tilted down

Head bent back

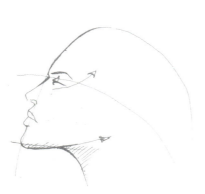

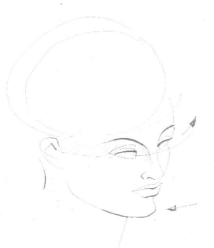

Side head looking up

Three-quarter head bent forward

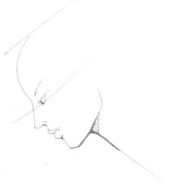

Side head looking down

Back three-quarter head looking up

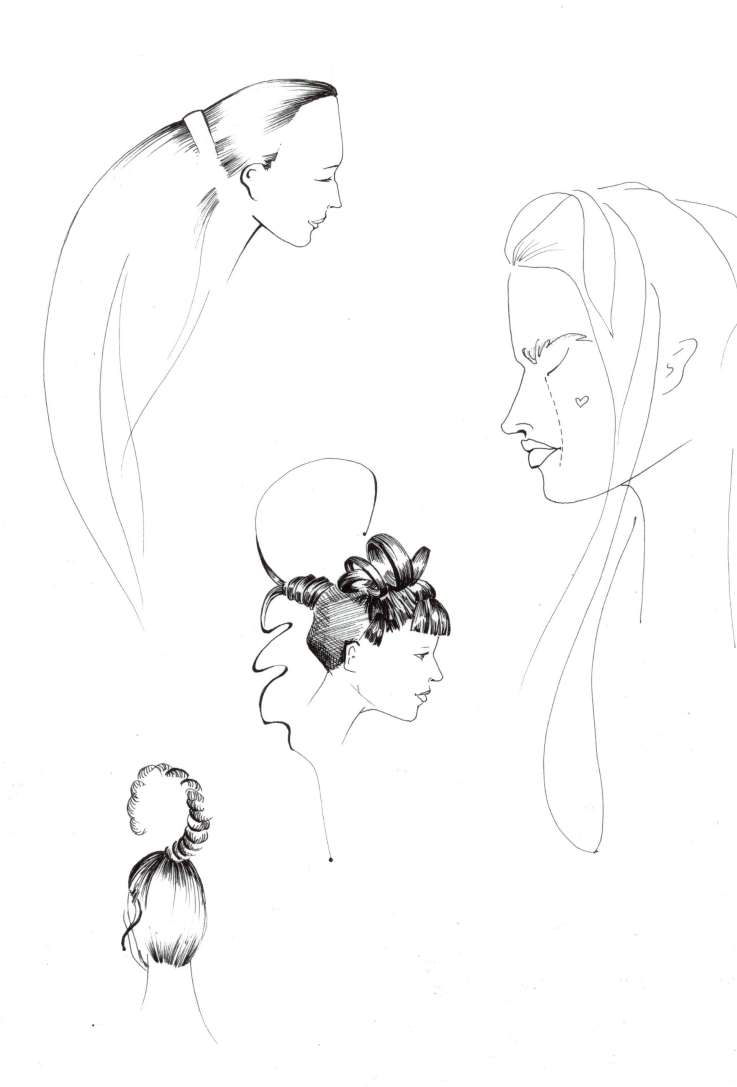

eyes

The eye must be drawn with care and precision because it expresses so much of the emotion of the face. Slanting the eye down makes the face appear sad, drawing a straight eye makes a person appear bored, drawing the eye up at the outer edge makes the person appear happy.

1. The eye is shaped like an almond or goldfish.

2. Beginning at eye-level (½ of the head), draw the eye slanting upwards.

3. There are five eye lengths at eye level. The eyes are positioned one eye length from each edge of the face and there is one eye length between them—the "third eye".

4. The eye is slim and can be drawn in thirds. Starting with the inner edge of the eye, closest to the nose, draw the line of the eye up for a third of the distance, flatten it out as it stretches over the eyeball for one third and down for the final third. The lower part of the eye arcs up to the outer point of the eye.

5. The eyeball itself is one third of the eye and sits slightly under the eyelid. The upper part of the eyeball is slightly darker because a shadow is cast from the eyelid onto the eyeball. The pupil is the darkest point of the eye with often a pinpoint of light on it. The outer edge of the eyeball is also dark.

6. Remember that the whites of the eyes are slim. There is a second line that can be drawn at the lower edge of the eye to indicate that the eye is recessed in the eye socket. The upper edge of the eye is often drawn with a darker line to give it drama and sophistication. Longer eyes give a sense of sophistication to the face, rounder eyes make a person appear younger.

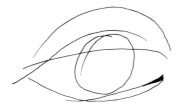

The eyeball sits within the eye and is practically covered by the eyelid

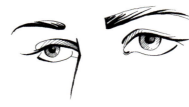

Three-quarter eyes

The eye is shaped like a goldfish

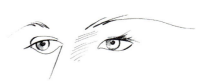

More three-quarter eyes

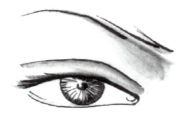

The eye turns up at the outer corner

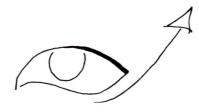

Positioning of three-quarter eyes

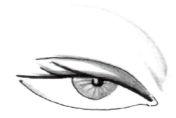

The complete eye

Eyes as seen when head tilts back

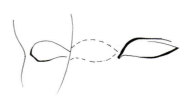

More eyes

eyes
eyebrows

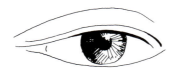

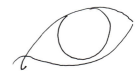

7. Lashes can be drawn with curved lines that sweep outwards from the upper and lower edges of the eye. Eyelids are parallel to the upper line of the eye. Eyebrows are wider than the eye, and arch up at the edge of the eye. Do not make the eyebrow into an Alpine mountain or Indian tepee by having a point in the middle.

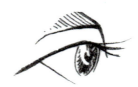

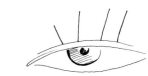

DO NOT DO:
Eyeballs in shock

8. The eyelid is the same shape as the eye and can be made higher to show a more deep set eye.

9. Draw in eyelashes subtly using a simple, dark tone. Eyelashes grow from the edge of the eye upwards and outwards with the last eyelashes dipping down for a flirtatious look.

DO NOT DO:
Steel eyelashes

10. Do not make the eyelashes straight or they will appear to injure the eyelid. Do not make the eyeball a full circle as it will appear to make the eye in shock.

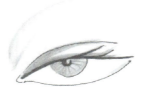

DO NOT DO:
Alpine eyebrows

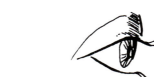

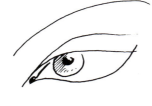

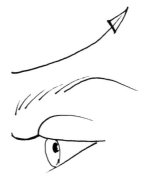

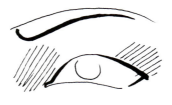

Lovely eyebrows

mouth

The mouth is the most sensuous and expressive part of the face. We use it as an accessory to the garment, telling mood and attitude. The corners of the mouth tell us all.

1. Begin with an oval as wide as the eye socket.
2. Draw a line through the center of the oval.
3. Indent the top of the lip to match the V at the bottom of the nose.
4. Curve the edges of the mouth up to express happiness.
5. Because the mouth is lush and round and full, make the center and the two bottom parts of the mouth darkest.
6. Leave a spot of light at the center of the bottom lip to express light and shine, a little dew drop.

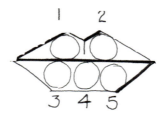

A mouth can be broken into five circles

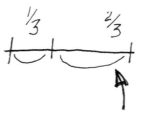

Soften lines

Shade

Three-quarter mouth

Shaded three-quarter mouth

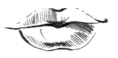

Setting three-quarter mouth with circles

Shaded three-quarter mouth

mouth
side view
three-quarter view

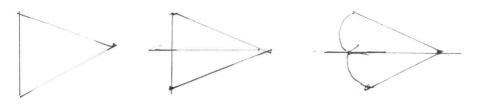

Take a triangle Cut in half Round tips like ice cream cones

Lips are like a heart

DO NOT outline the nose—
it looks like an elephant foot

DO NOT make the mouth pointed

nose

1. The nose is a delicate arrow. On a woman the nostrils angle at a slight V.
2. If you are a beginner, ignore the bridge of the nose. (Do not outline the nose—it looks like an elephant's foot).
3. The nose is the same length as the eye is wide. Be careful not to exaggerate the length. (We expect the nose to be longer than it is because it pokes out at us.)
4. The nose begins at ½ the head and ends at ¼ the head.
5. Add shadow at the base to give the nose an upward tilt.

Begin with tip of nose on axis line

Nose extends out from face

Add bridge

Base of nose turns up

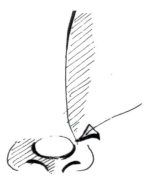

Shade up to bridge and erase opposite side

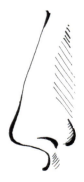

Shade

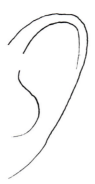

S defines simple ear

The ear fits in between the center of the eye and the bottom of the nose. It can be expressed as a half circle which is slimmer at its base. The top edge of the ear may need a second line. To express the complex structure of the ear draw an S. (Detail of the ear is not necessary in most fashion drawings). It is essential to move the ear with the axis of the head. As the head moves back, the ear appears lower. The head bending down changes the axis of the ear so it is placed higher.

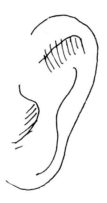

Simple ear with shading

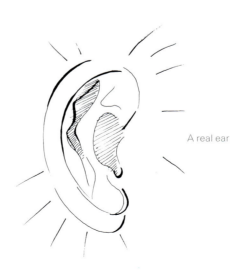

A real ear

hair

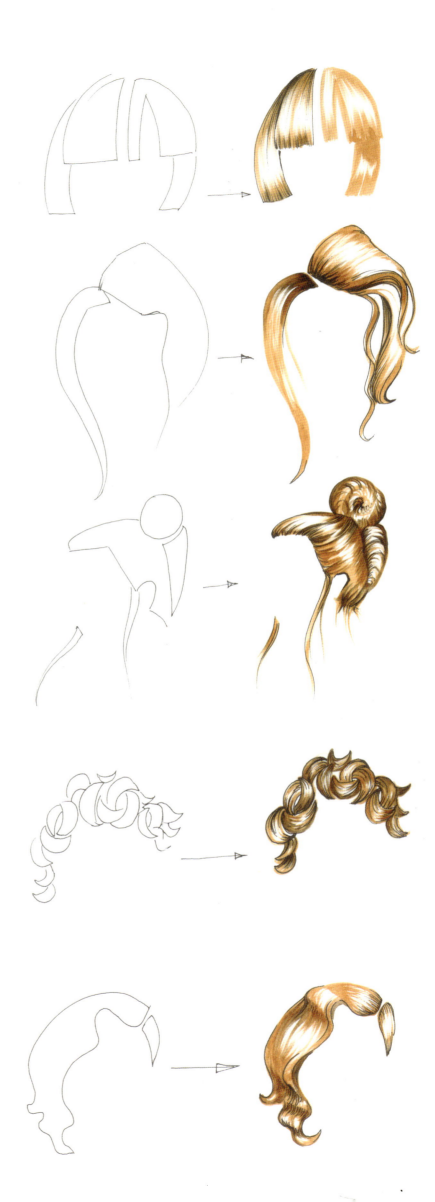

1. Hair must be drawn from simple shapes. The shape of the hair is determined from the inside hair line, which is one quarter of the distance down from the top of your head. The hair line extends across the distance of the eyes (an umbrella for the eyes) and falls to the ear.

2. Draw the shape of the hair starting from the inside line of the hair or from the top of the head, called the crown. Draw the shape close to the face until you reach the eye level.

3. Hair is darker close to the head.

4. It is easy to draw straight hair by breaking up the edge of the hair shape using straight lines. A technique for making straight hair is this: choose a small piece of paper with a straight edge and place on top of the piece you are drawing on. Line up the straight edge of the small piece of paper with the edge of the hair and draw parallel lines from the small piece to the drawing paper, so creating a nice even edge for the hair.

5. When drawing curls, fill in the basic shape of the hair. Do not draw lots of lines inside the basic silhouette of the hair, especially lines which overlap, for this makes the hair look like a bird's nest. Break up the outer edge of the shape with half circles of different sizes.

6. Do not let hair get too wide above the eye level.

7. Do not make parts larger than the head itself.

8. Draw braids as intersecting chains which are dark where the chains overlap.

9. Draw long hair by shading the skin and adding tone behind the silhouette of the hair. All hair, including blonde, has very dark and very light areas. The dark areas tend to be closer to the face. Looking at photographs of hair styles is extremely helpful when drawing hair.

10. Using the sharp edge of an eraser, make quick strokes to add highlights where you decide.

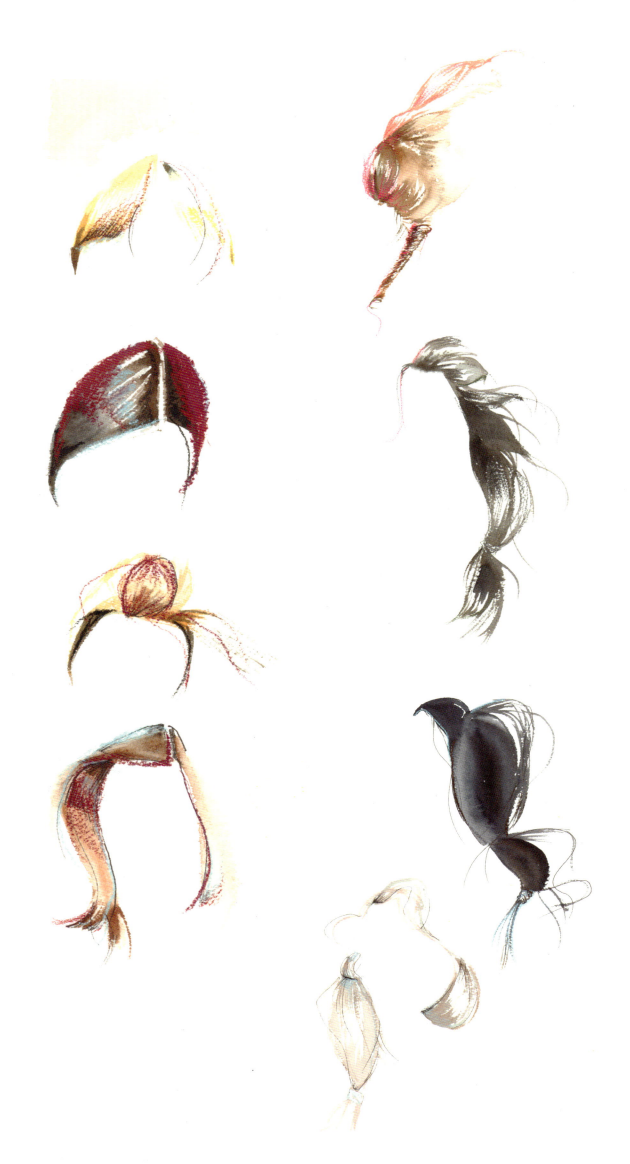

hair

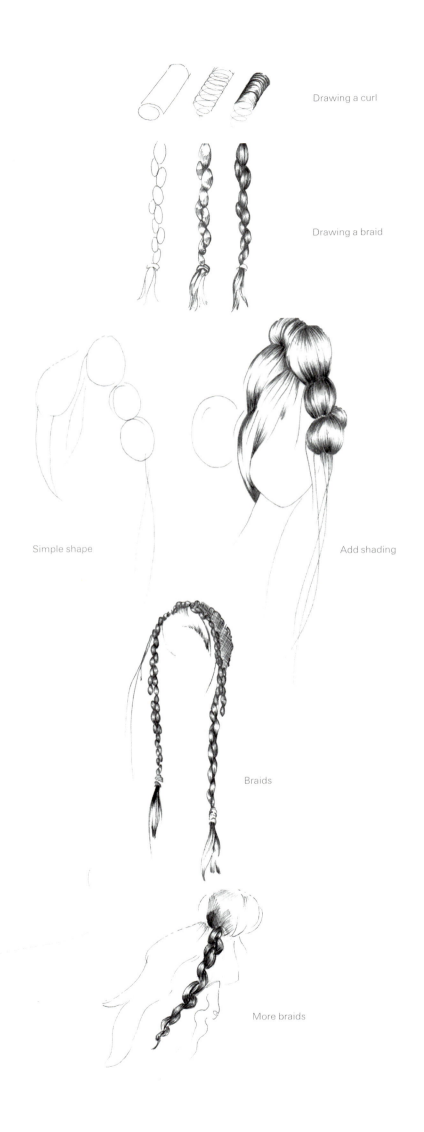

Drawing a curl

Drawing a braid

Simple shape

Add shading

Braids

More braids

EXERCISE

1. Look at fashion magazines to find hair-styles that you like and trace them. Fill in the silhouette with pencil as if it were flat.

2. Copy hairstyles, beginning with simple shapes, remembering that hair has to grow from the skull. Draw a part—a parting—in the hair, remembering that the part is on the head and cannot be drawn beyond the head. Now draw a few lines for the hair from the part to indicate the direction of the hairstyle.

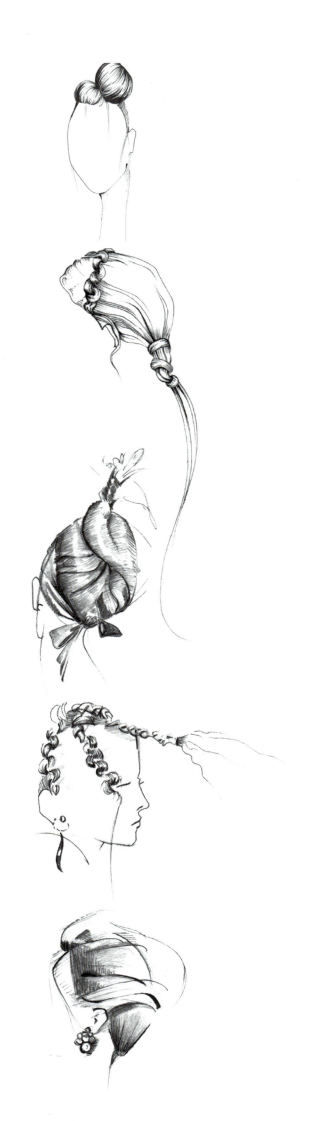

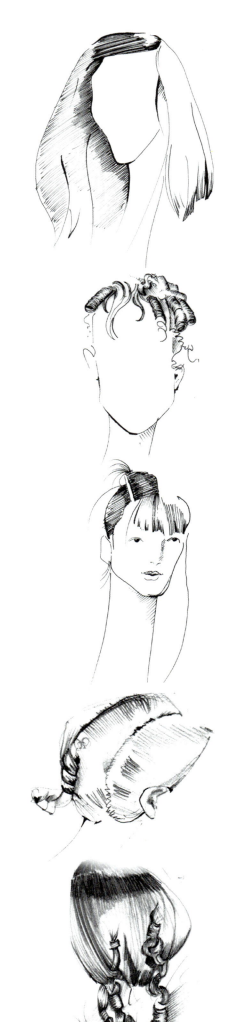

Twists and turns of the hair.
Look for simple shapes and highlights

hair

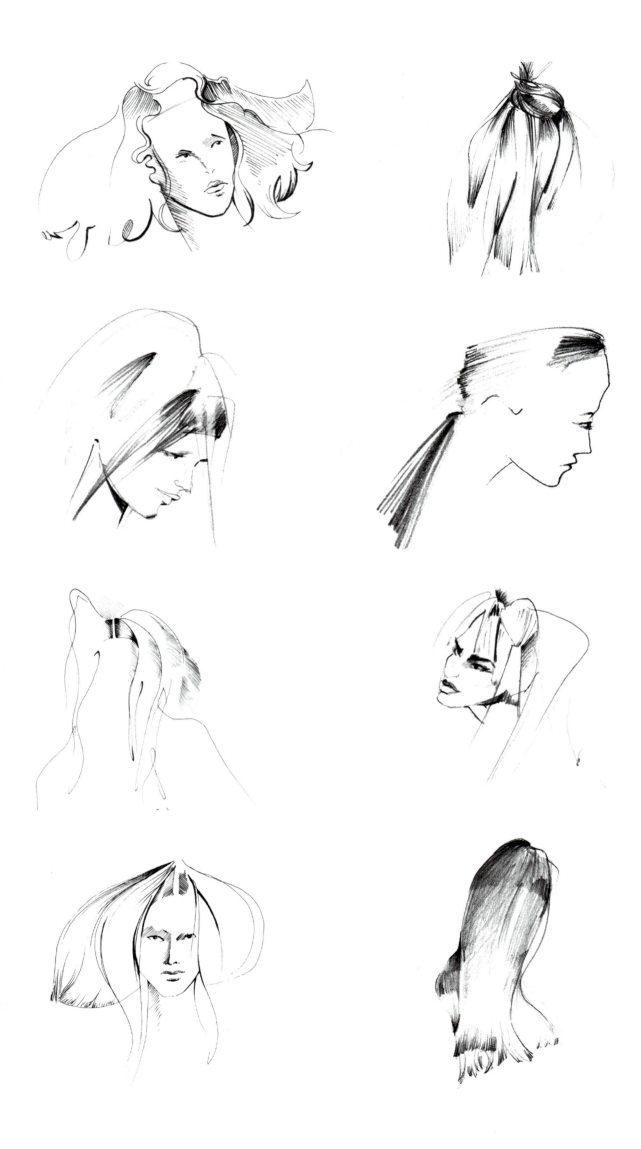

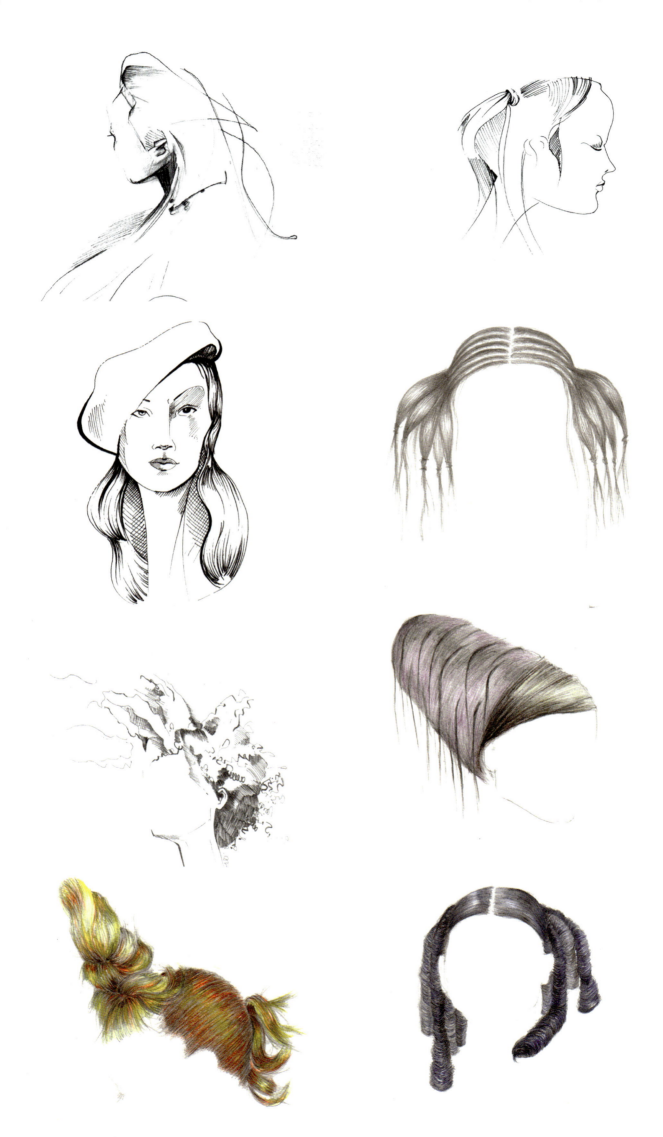

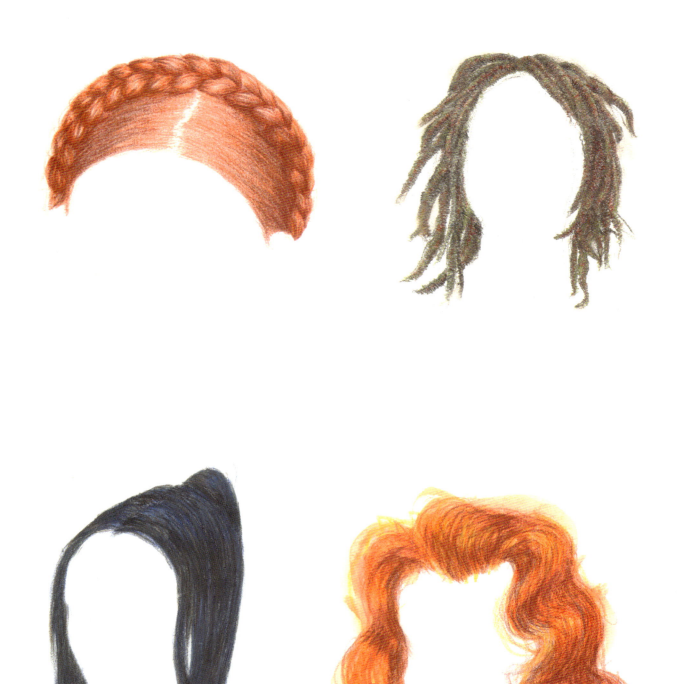

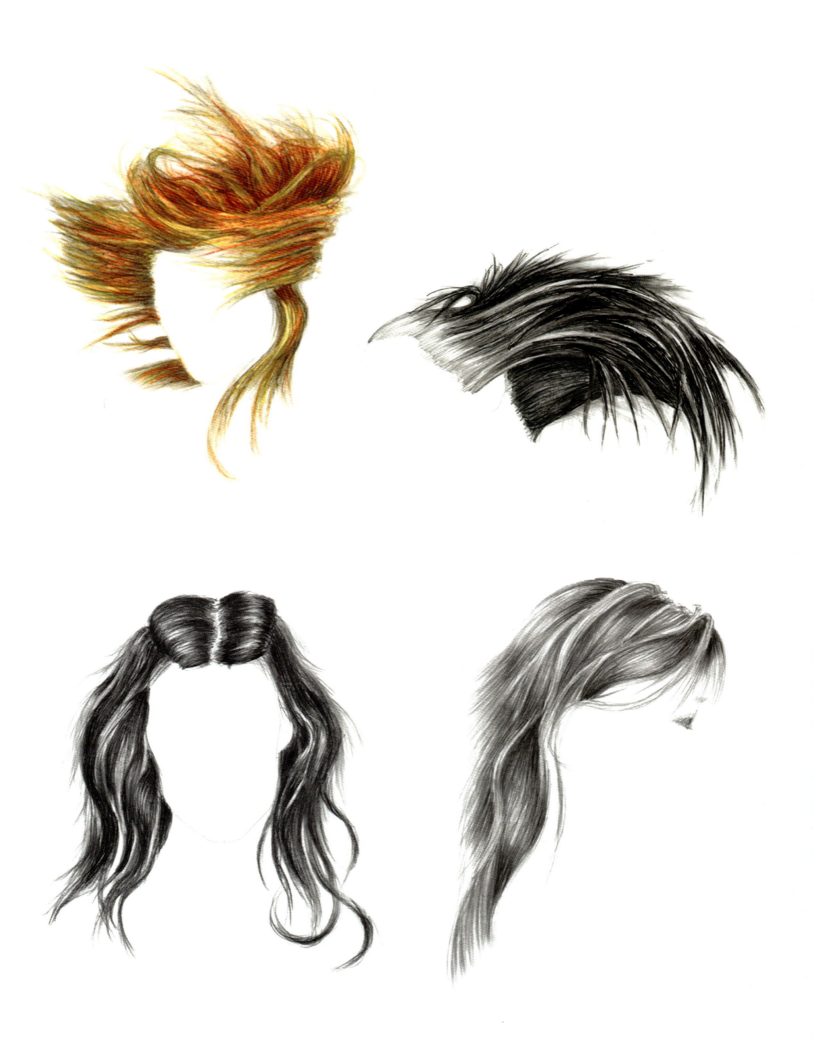

hands

The hand is equal in size to one head. It is much larger than we expect. (Do you remember when you were frightened as a child and covered your face with your hands?) The hand is a wonderful tool; don't hide it. It can point to the areas of the garment which you wish to emphasize—the collar, waist, an important pocket. Don't point the hand away from the figure as it will lead the eye to your neighbor's work or to a blank space. Don't point the hand to the ground as there is nothing there! The hand can be used also to express different attitudes. Spread your fingers and your figure will appear to have energy. Drop the hands to the sides of the body and your figure will appear to be at rest. The hand and fingers are long, tapered and elegant.

1. A good way to begin is to place your hand on the page and trace around it three times. It is nice to have a convenient model to observe. Notice that the wrist is much slimmer than the hand; by tapering the arms down to a slim wrist we can create an elegant form whether creating a full-bodied or skinny croquis.
2. Start with a palm as a rectangle measuring half a head. The finger area too, is a rectangle, also half a head.
3. Divide the edge of the palm into four equal areas. It's easy to begin by dividing the line in half and taking the remaining sections and dividing them in half. Each finger is very thin and is the same width. Finger number one is almost half a head. Finger number two is the longest finger and is half a head. Finger number three, the ring finger, is the same as number one, comparatively long. Finger number four is the baby, approximately two-thirds the length of finger number three.

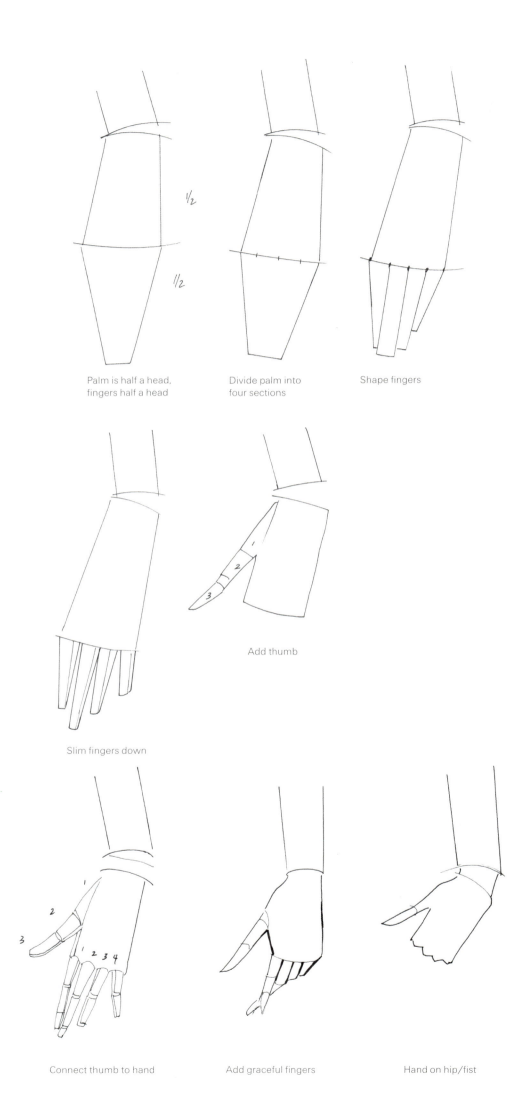

Palm is half a head, fingers half a head

Divide palm into four sections

Shape fingers

Slim fingers down

Add thumb

Connect thumb to hand

Add graceful fingers

Hand on hip/fist

hands

4. Each finger can be drawn with a
single line. Stop and check measure-
ments. Now flesh out the finger by
adding a second line, making sure that
the finger remains the same width from
top to bottom. If we wish to add a finger-
nail, be careful to place it directly on the
finger, not at the tip and not crooked as
it will look very painful. Please do not
draw nine-inch nails.

5. Each finger has three separate joints.

6. The thumb is made of two equal
bones. It can be a real troublemaker to
draw as it is so different from the rest of
the hand. The thumb fits into the hand
halfway up the palm. It is important to
include a wedge between the wrist and
the thumb so that all these areas fit
together.

7. The side view of the hand is made
from a triangle that is half a head. From
the thin point of the triangle, we can
draw finger number one, which is
almost one half a head. Finger number
two extends out from the same point, a
bit longer. Finger number three extends
from the same point, a bit shorter—think
of the extended blades of a Swiss Army
knife. To finish the drawing, add the
thumb by placing a wedge from the
wrist to half-way up the palm and fit the
thumb onto the wedge.

8. Be careful not to attach the thumb to
the wrist— a common problem.

EXERCISE
Draw your own hand. Draw your friend's
hand. Fill three pages with as many
hands as you can draw.

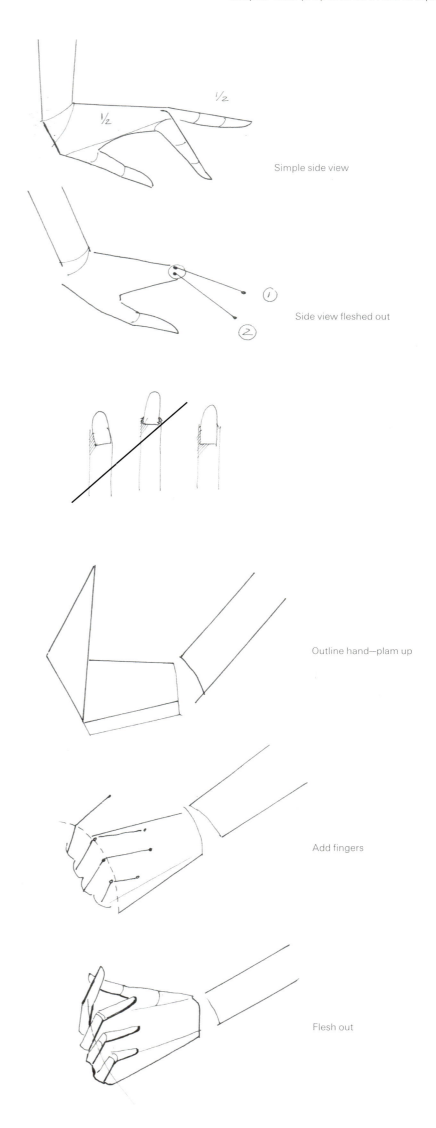

Simple side view

Side view fleshed out

Outline hand—plam up

Add fingers

Flesh out

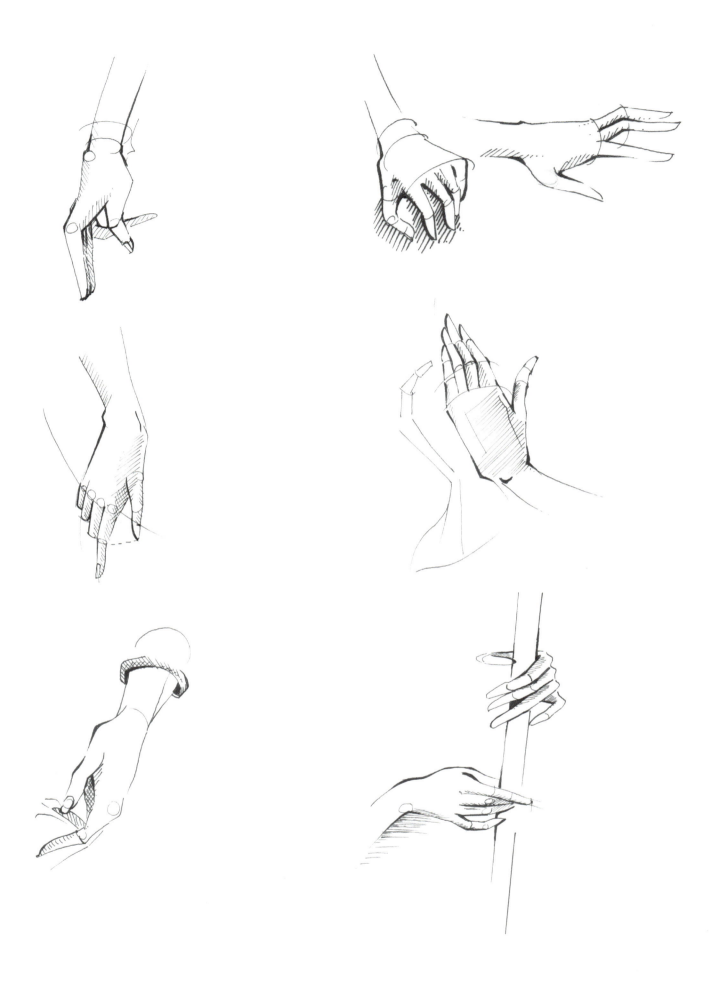

hands

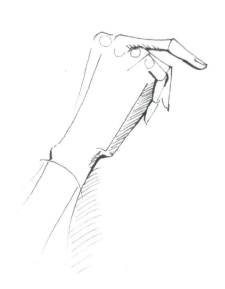

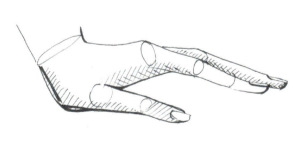

hands

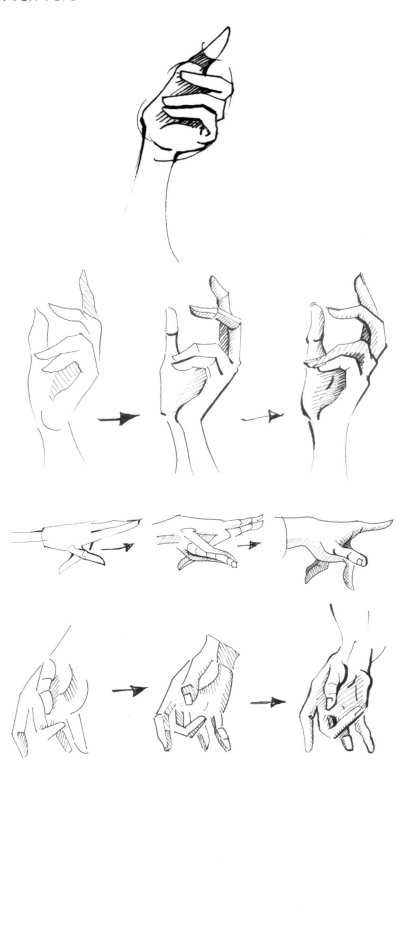

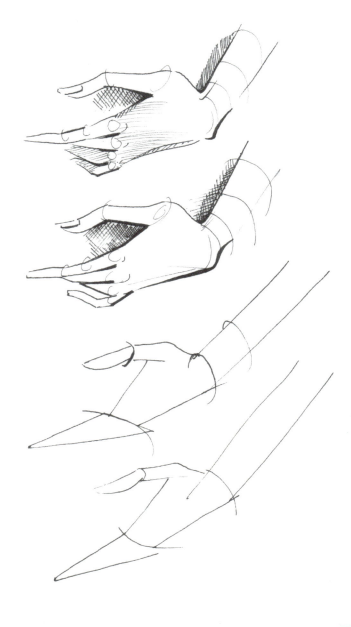

Advanced variations of the hand

hands

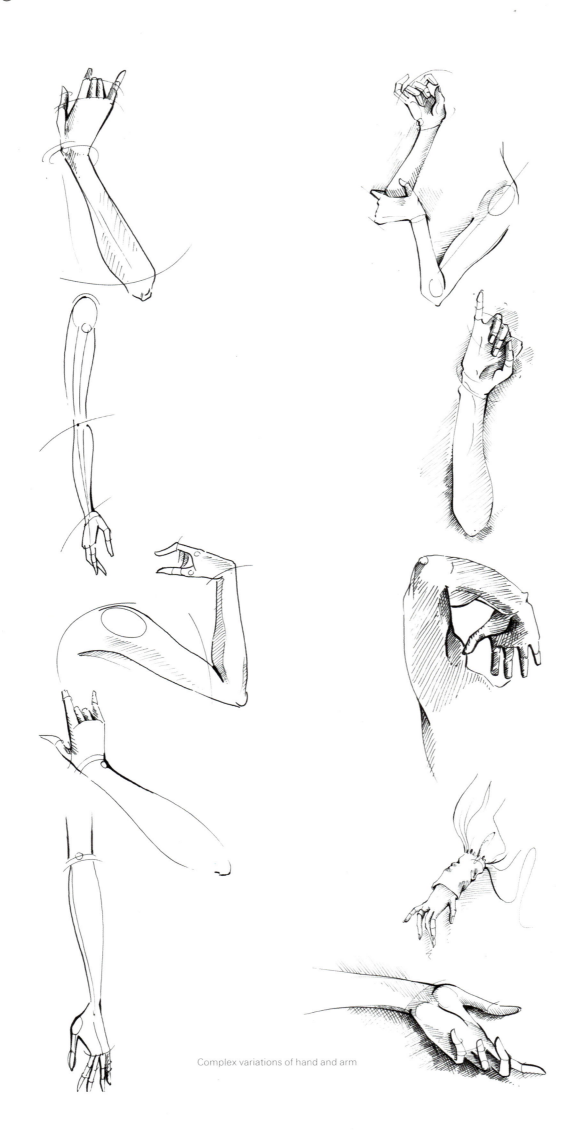

Complex variations of hand and arm

feet

The foot is equal to one head and is long and slim, just like the hand. It is made up of the ankle bone, which is higher on the inside and lower on the outside and is engineered to support the weight of our body: consider the construction of a bridge over water.

1. The foot is often drawn at an angle to express grace. It is slim, as we mentioned, and is made of a rectangle for two thirds of its length and a triangle for the remaining third. The ball of the foot is the widest point and tapers into the large toe. The toenail appears to rest on the top of the toe like a crescent moon. The remaining four toes are shorter and are drawn at an angle up from the inside of the foot.

2. The arch of the foot can be expressed by drawing a curve from the ankle to the ball of the foot.

3. When drawing a shoe on the foot, remember that all lines bend around the form.

4. The foot from the side is also one head and can be drawn as a triangle. Divide the foot into three equal parts placing a circle at the heal, a square at the arch and a triangle at the toe.

5. To draw the foot with a high heel, slant the middle—*the arch*— at an angle and draw the toe as a triangle which rests flat on the ground.

6. A three-quarter foot is also drawn as a triangle which slants at a 45-degree slope. The foot can also be broken into heel-circle, arch-square, toe-triangle.

7. The back of the foot can be drawn by tapering down from below the back of the knee to the ankle. At the ankle the leg becomes very thin and is made up of cord called the *tendon*. From the tendon one can draw the heel as a circle which measures one third of the foot. The arch is a square, one third of the foot. We cannot see the toe.

EXERCISE

Draw three pages of feet. These may include shoes.

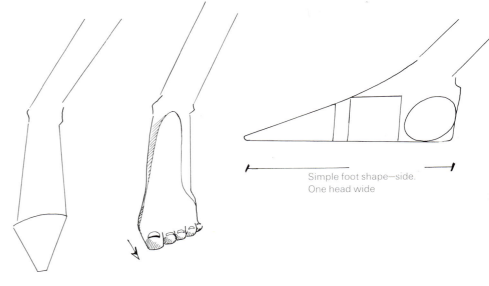

Simple foot shape—front Add toes

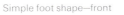

Simple foot shape—side.
One head wide

Add toes Foot shape for high heels

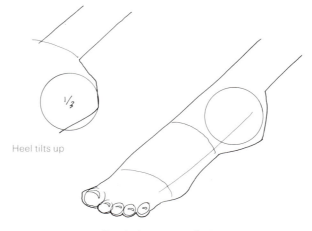

Heel tilts up Simple three-quarter foot

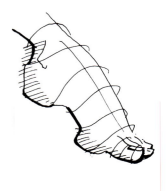

Shaping three-quarter foot

feet

Simple back view of foot

Fleshed out

DO NOT DO—
Too many toes, swollen ankles.

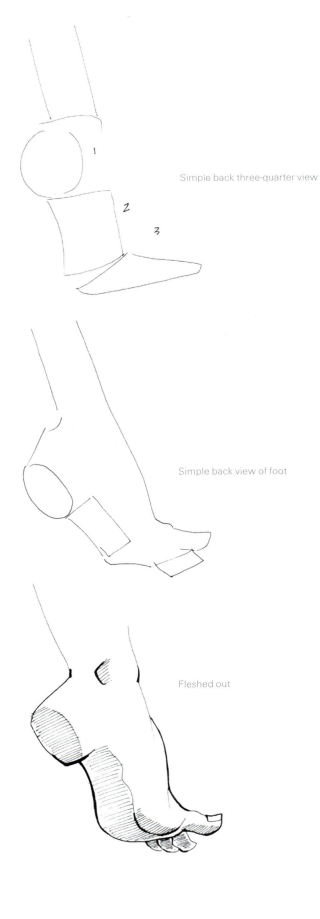

Simple back three-quarter view

Simple back view of foot

Fleshed out

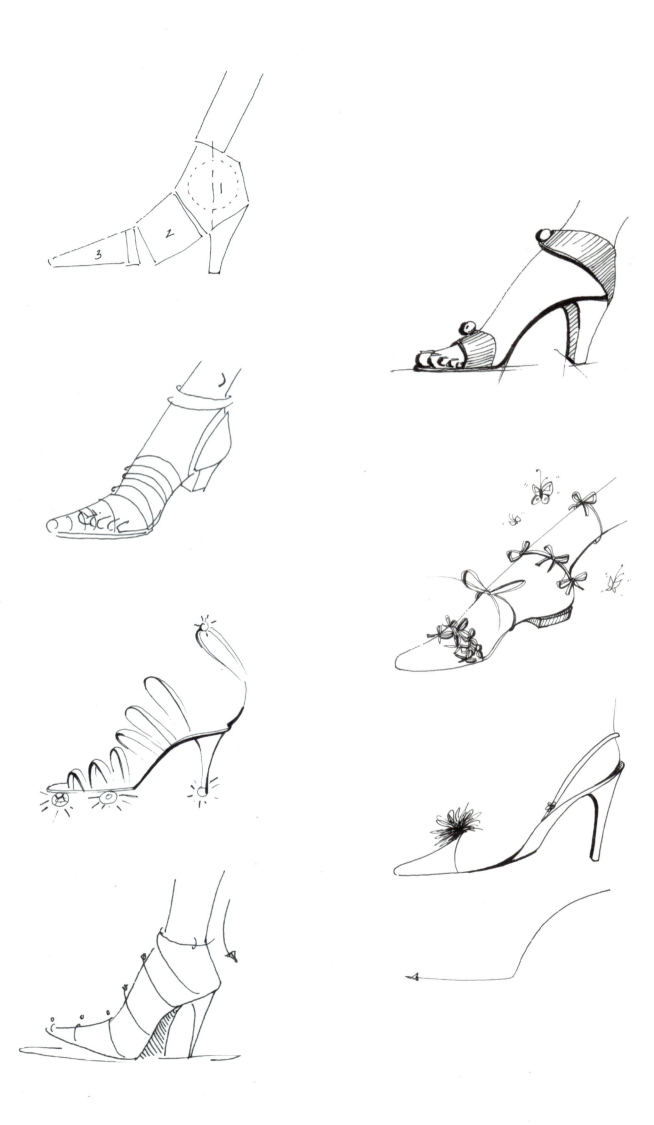

motion
the S curve

Using a diagonal axis instead of a
straight axis gives the figure energy.
Moving the hips will help us to show
folds when we drape our croquis.
Fashion illustrators use the term "S
Curve" when expressing motion in a fig-
ure.

1. Begin by standing. Place all your
weight on your right leg and make sure
your right leg is behind your left leg. You
will notice that this pushes your right hip
up. The hip is one large bone. The center
and the sides of the hip all shift to the
right. This is essential when drawing the
hip. Be careful to shift the axis line!

2. Now that the hip is up it needs to be
balanced so the leg returns to the center
axis under the neck. Look at your body in
a mirror. You will see it is forming the
shape of an 'S'.

3. To review, when we place our weight
on the right leg, the right hip pushes up
and the right leg returns to the axis line.
When we place our weight on the left
leg, the left hip pushes up and the left
leg returns to the axis line.

4. The weight of the body is usually on
the back leg except when walking or
running. Place your weight on your front
leg and you will feel like a hood orna-
ment on a car.

5. The other leg is now free to move in
front of your support leg or off to the
side. It can bend or stretch etc.

6. To measure both legs, we use the fol-
lowing method: a) start at the side of the
hip which is up and draw a line from
the outside of the hip to the center axis.
b) we know the hip is number 4, mark
number 5, now number 6 using the
head measurement. Number 6 is the
knee, continue down the line to number
9. c) by measuring carefully it is easier to
draw the leg at this new angle from hip
to center axis. d) to draw the other leg,
draw a line any direction you wish
(here you are in control). Mark out your
head measurements stopping at the
knee—number 6. You may wish to bend
the leg which is free of weight. Continue
to number 9.

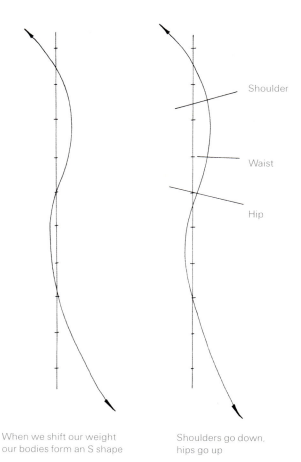

Shoulder

Waist

Hip

When we shift our weight
our bodies form an S shape

Shoulders go down,
hips go up

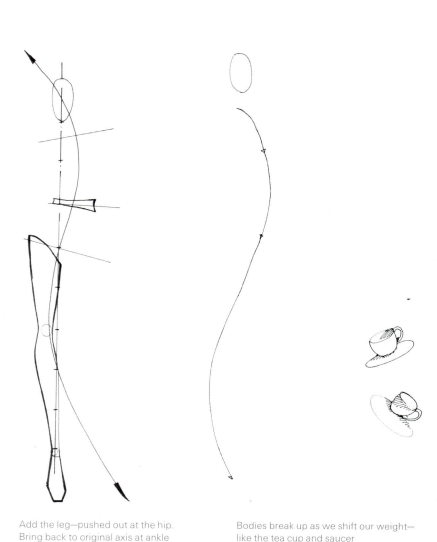

Add the leg—pushed out at the hip.
Bring back to original axis at ankle

Bodies break up as we shift our weight—
like the tea cup and saucer

motion
the S curve

7. Be careful to indicate the direction of the leg. A side view leg will have a straight line with a curve to indicate the muscle at the calf.

8. There are many variations on movement. Try a side view head with a straight body, try a three-quarter head, move your shoulders down and your hip up. The more angles the merrier.

9. When the arm moves, the structure of the body remains static when the arm is parallel to the shoulder. When the arm moves above this point, the armhole moves with the arm, close to the head (check in the mirror to observe that the armhole is next to the neck).

10. All of the poses in this book can have movement. Look at the following examples and experiment.

EXERCISE

Pick your favorite pictures and poses from your scrap file. Look for the center axis line by drawing a line through the center of the bust, waist and hip. If the line moves to the right the weight is on the right hip, if it moves to the left the weight is on the left hip. Create a croquis using the above rules that expresses this shift in weight. After drawing this croquis, add eyes, nose, mouth, hair, hands and feet. You are now at the intermediate stage of drawing. Congratulations.

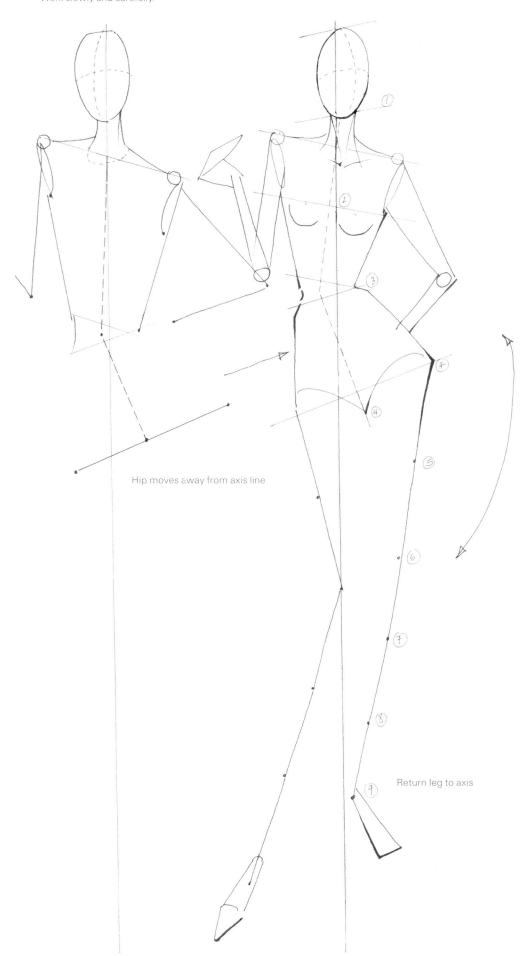

This figure is more advanced.
Work slowly and carefully.

Hip moves away from axis line

Return leg to axis

motion
the S curve

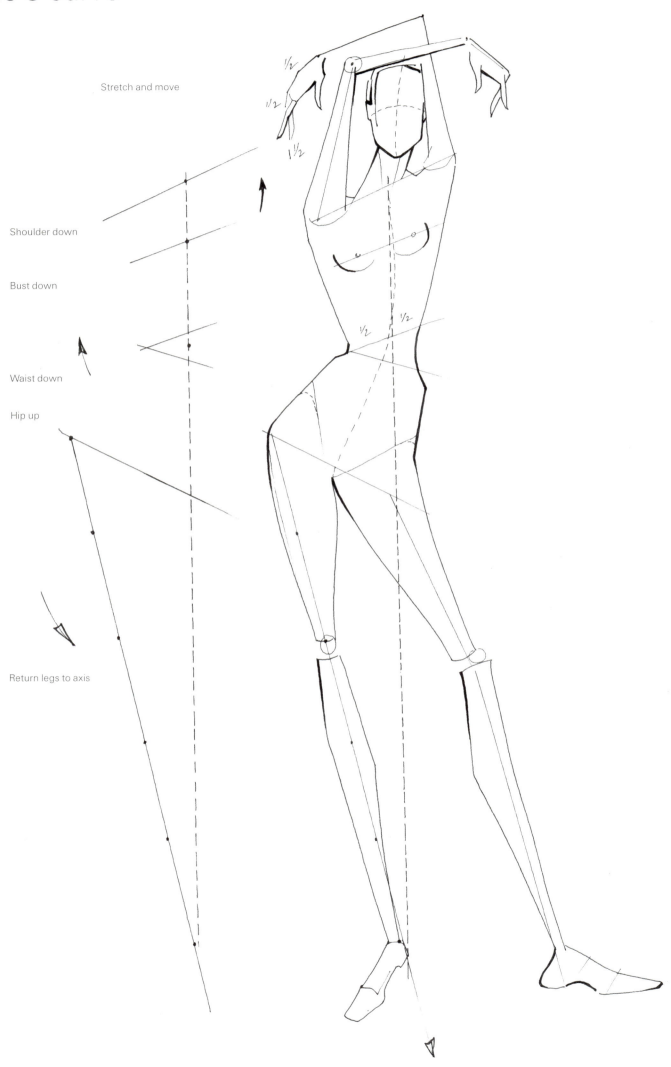

Stretch and move

Shoulder down

Bust down

Waist down

Hip up

Return legs to axis

motion
the S curve

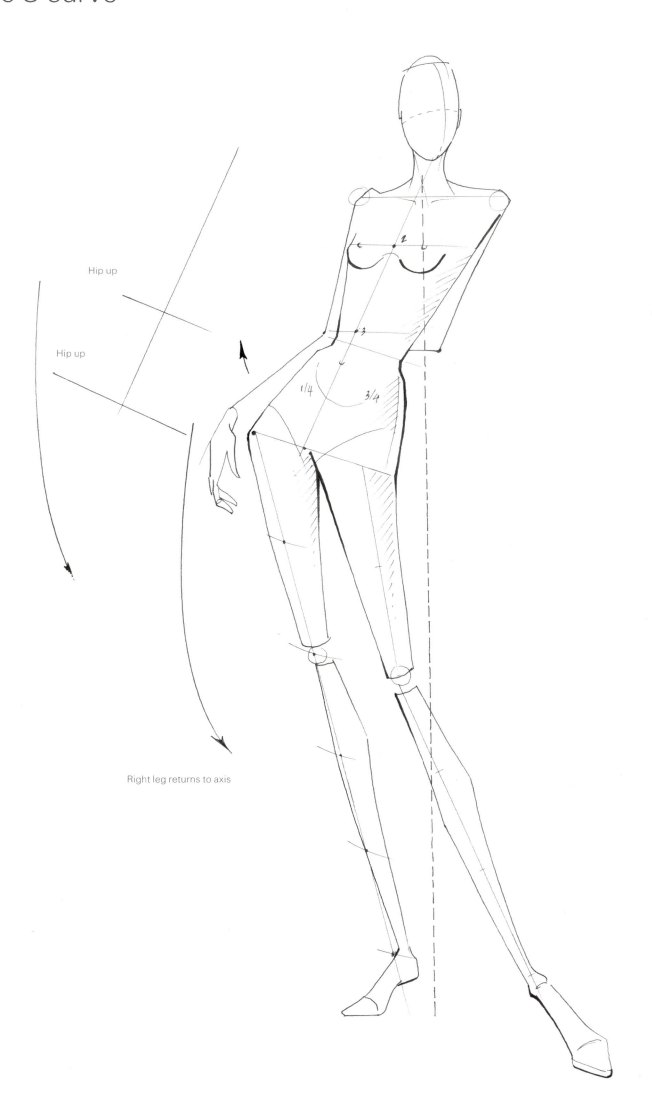

Hip up

Hip up

Right leg returns to axis

1

3

1/4 3/4

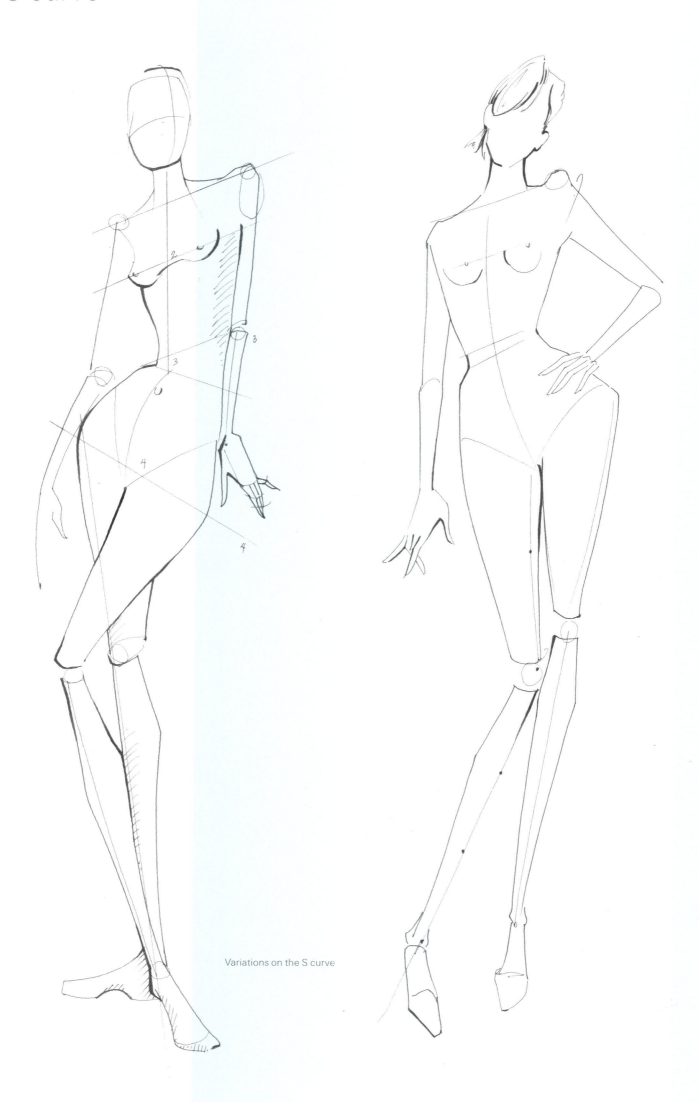

Variations on the S curve

motion
the S curve

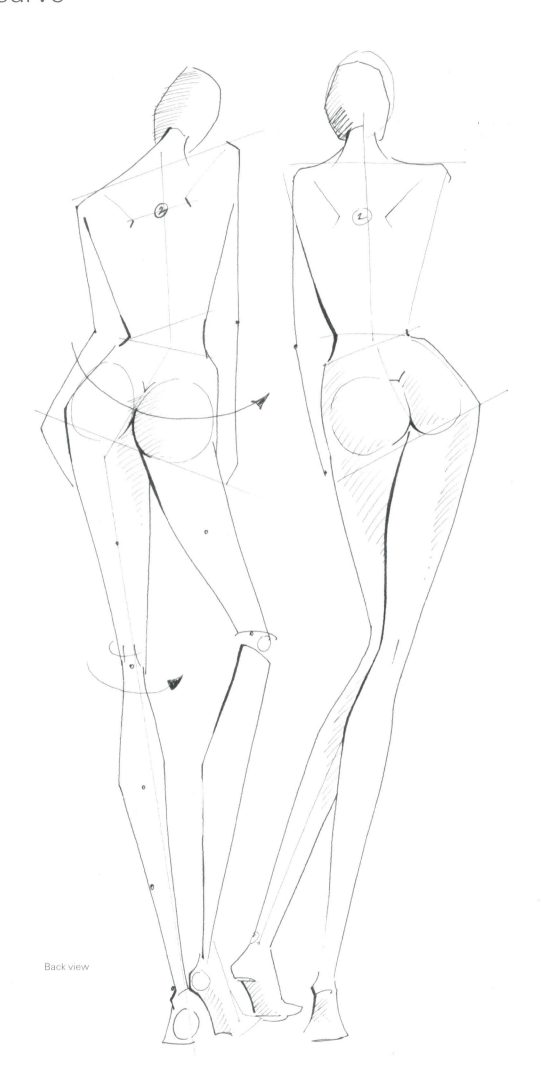

Back view

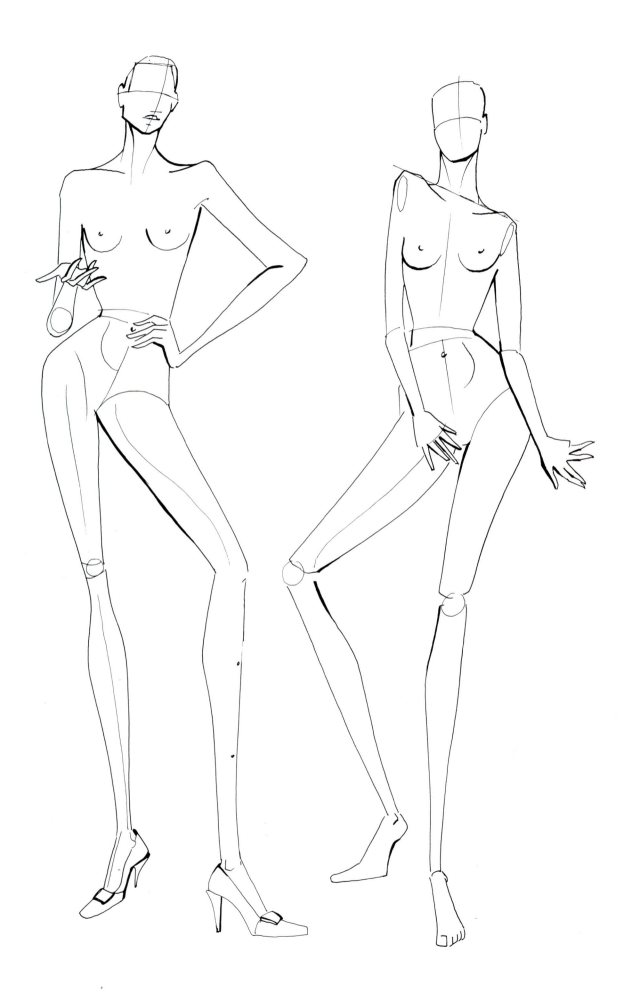

motion
the S curve

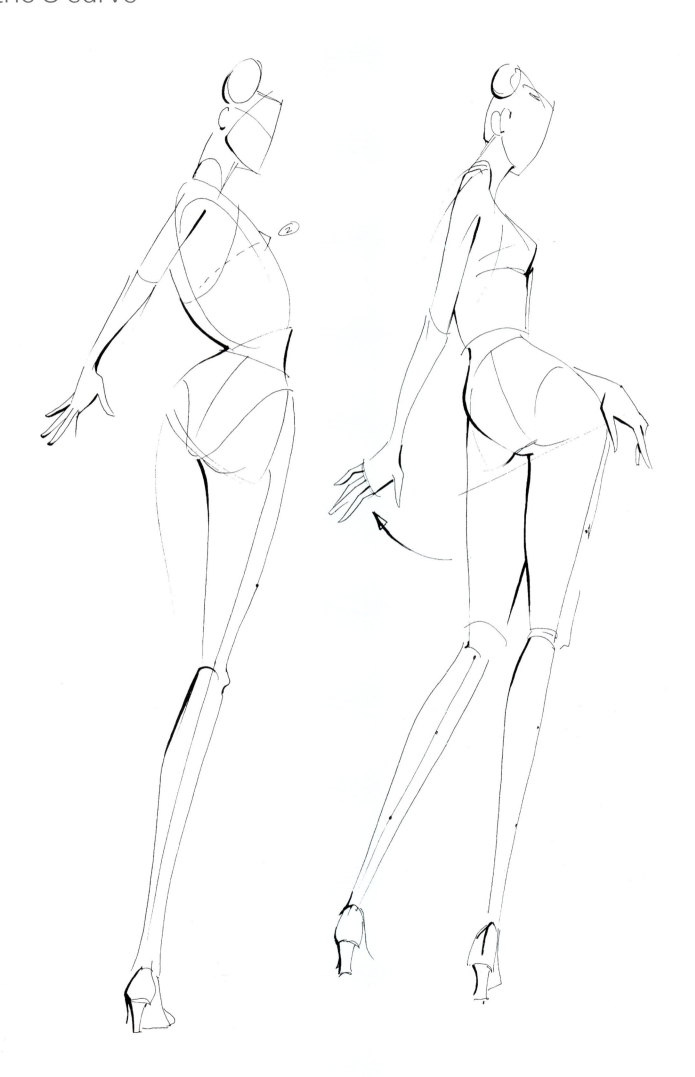

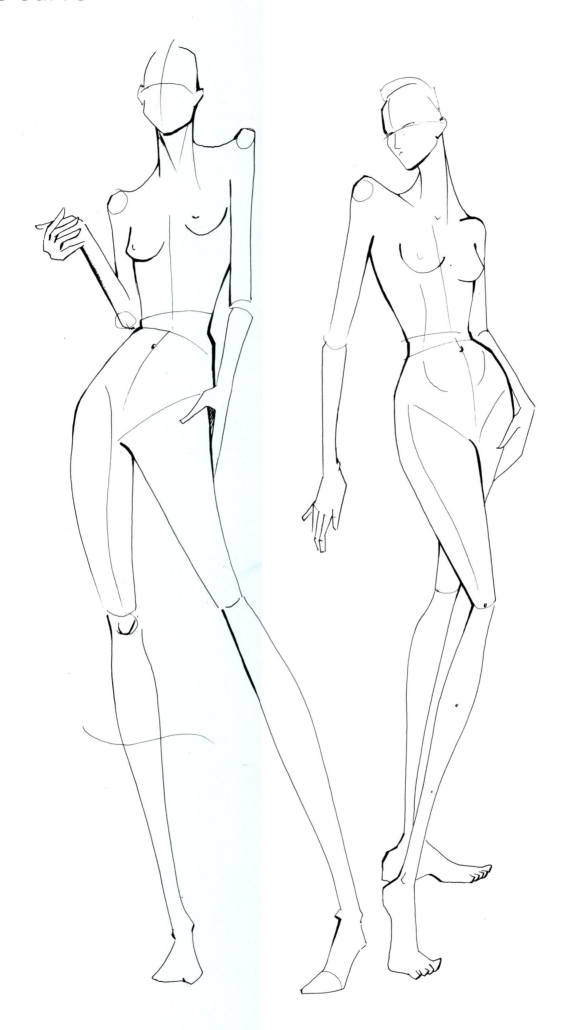

motion
the S curve

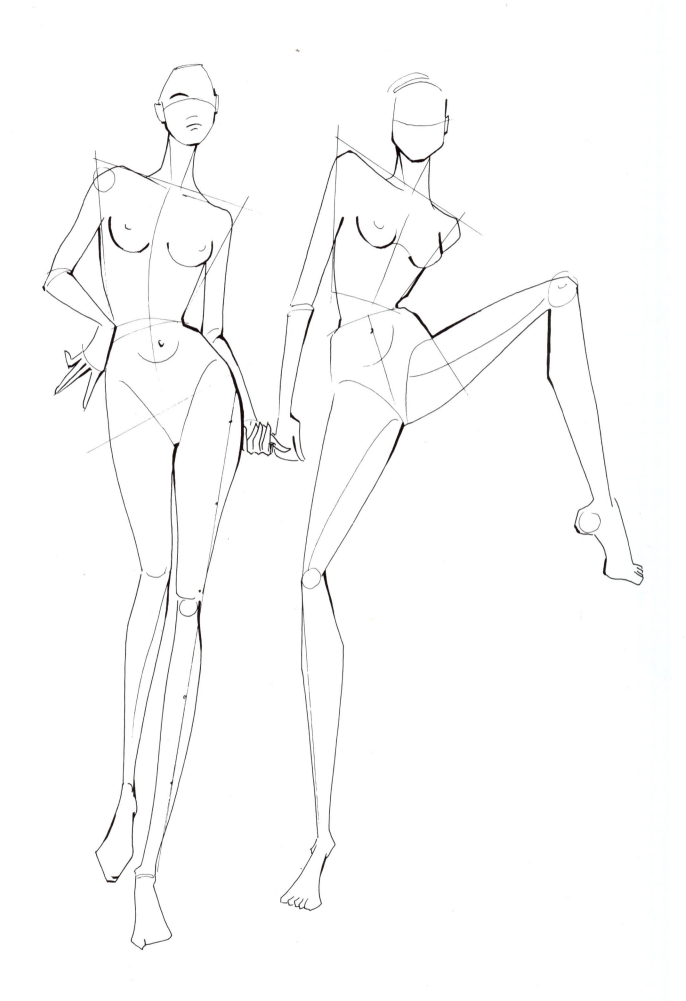

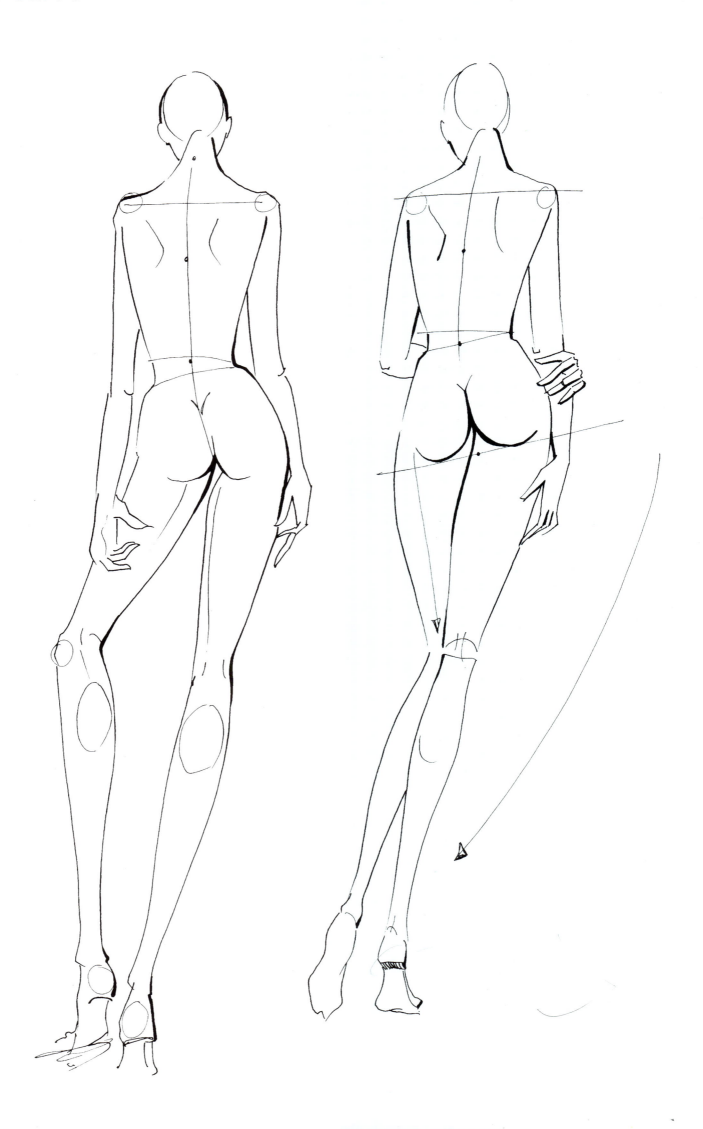

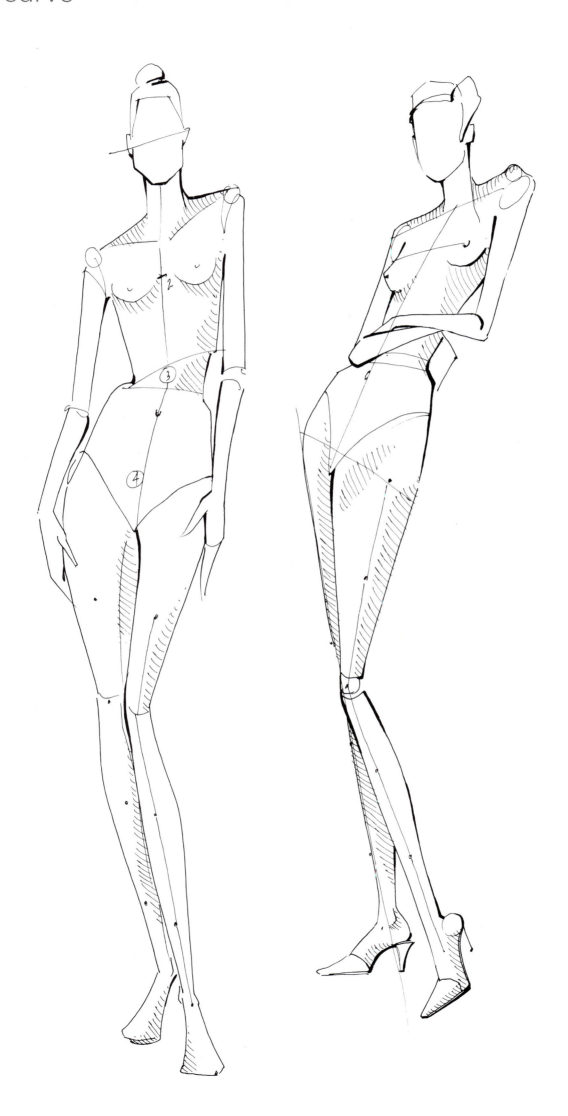

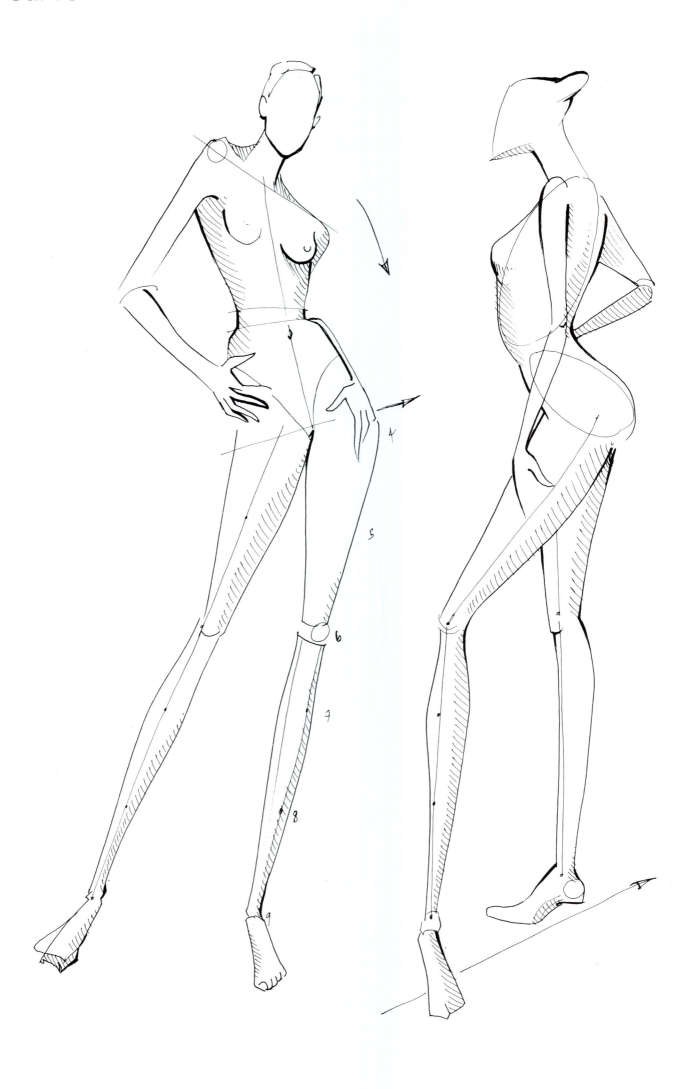

motion
the S curve

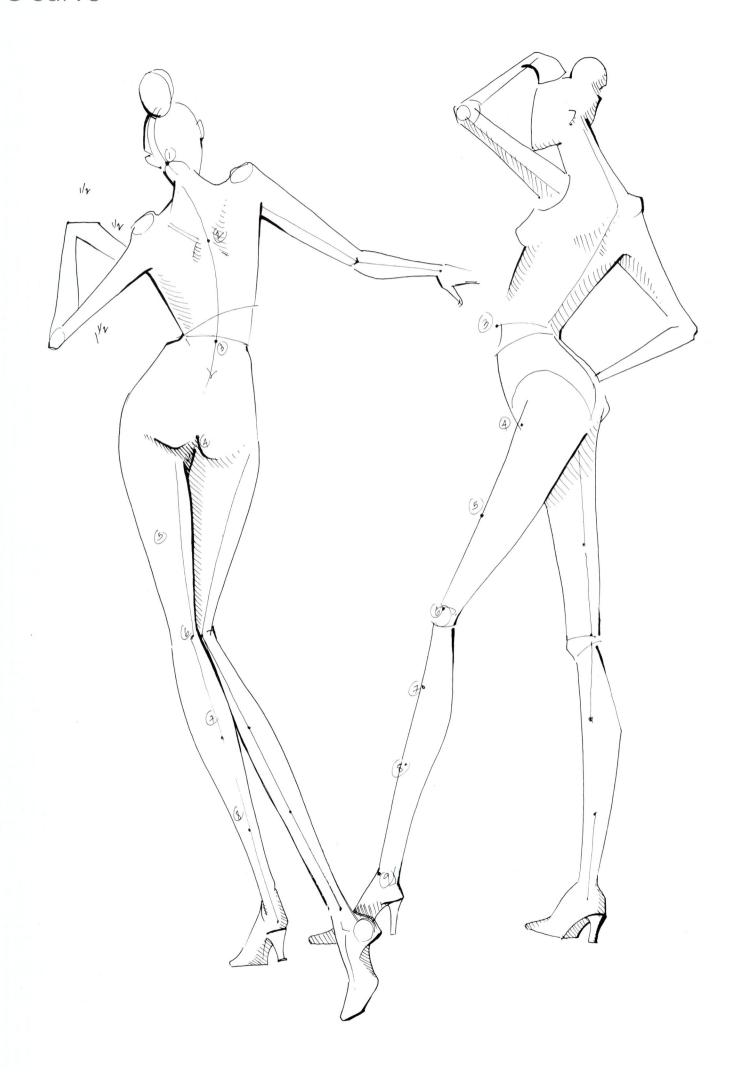

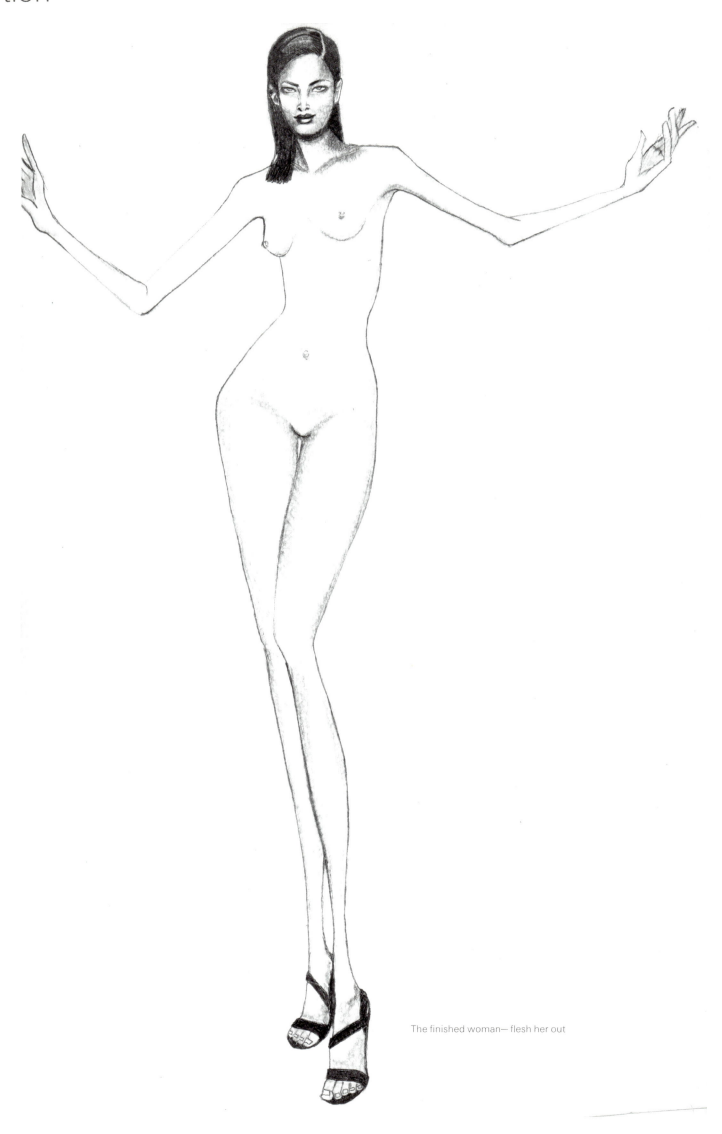

The finished woman— flesh her out

motion
with clothing

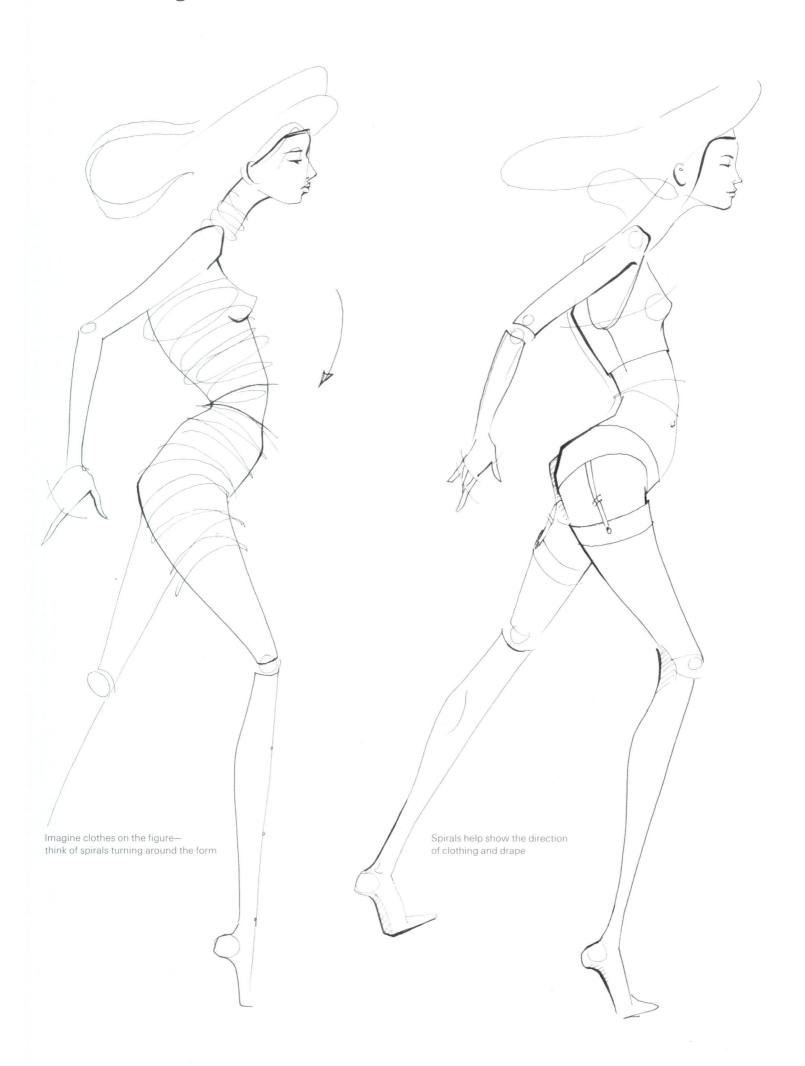

Imagine clothes on the figure—
think of spirals turning around the form

Spirals help show the direction
of clothing and drape

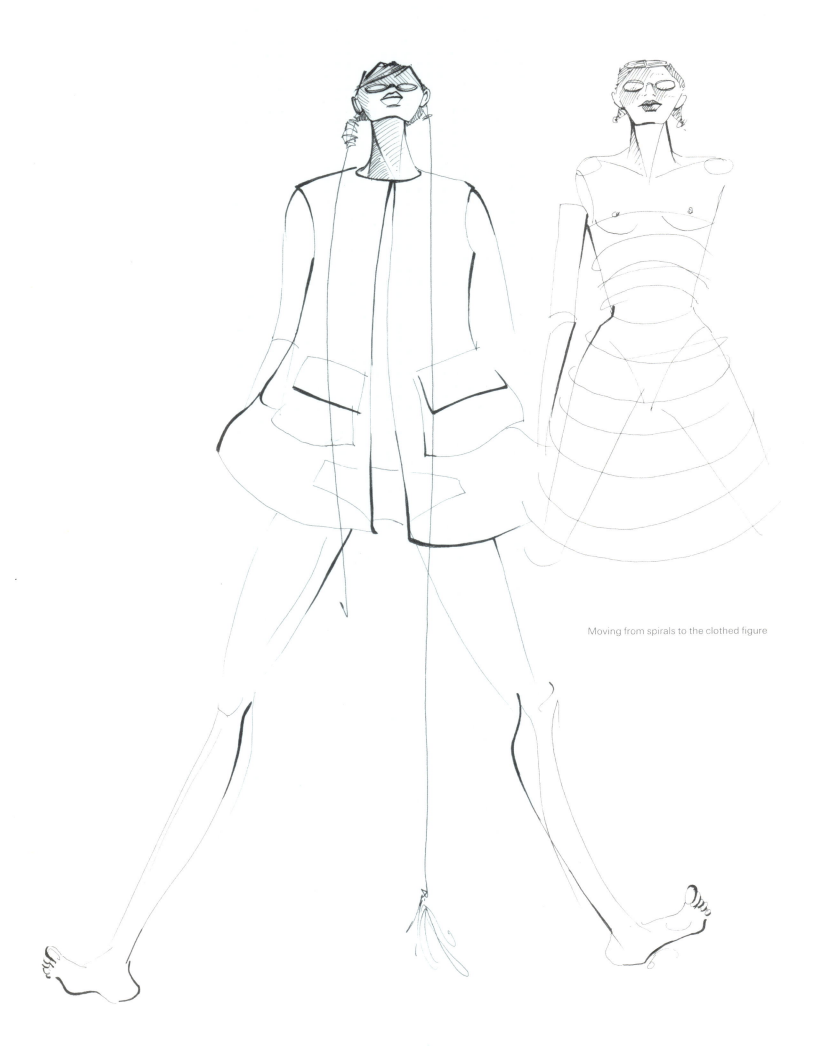

Moving from spirals to the clothed figure

motion
with clothing

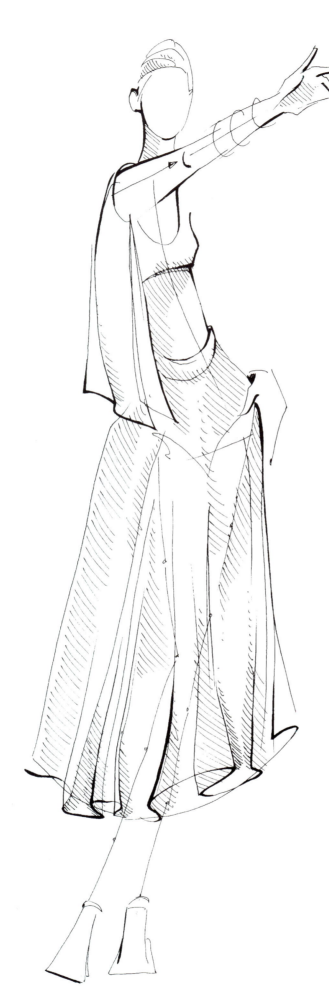

Simple skirt and leotard on figure

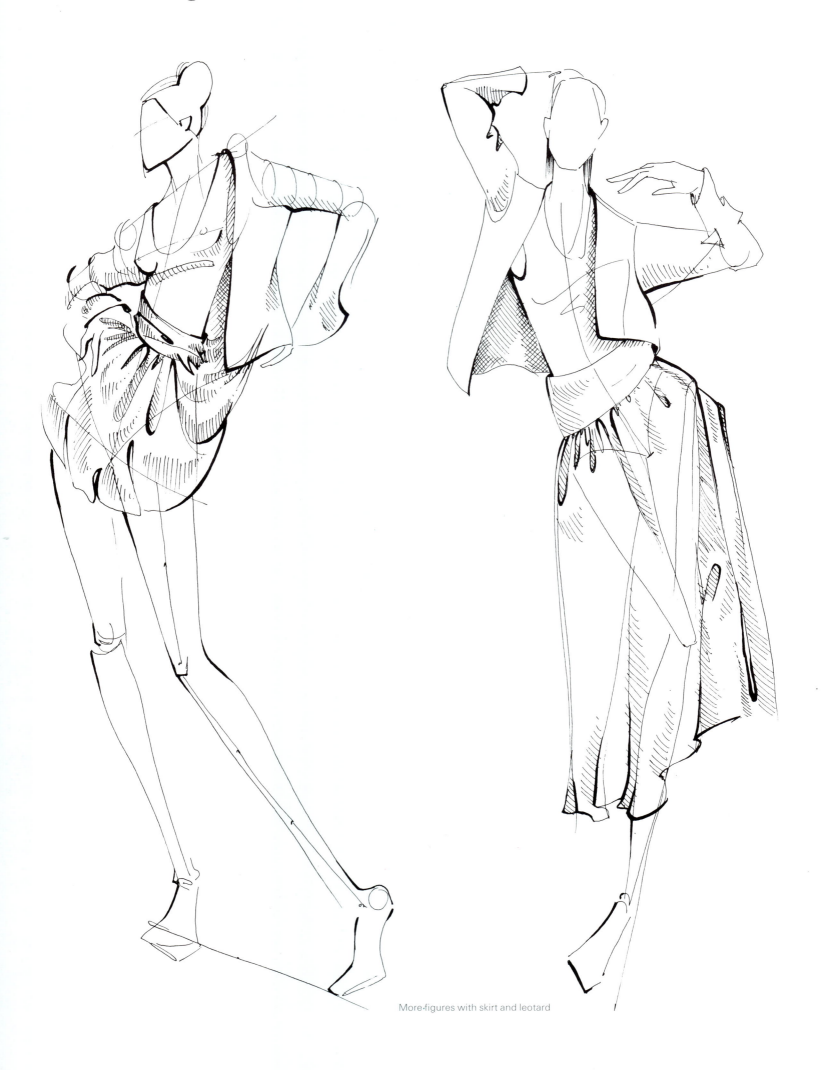

More figures with skirt and leotard

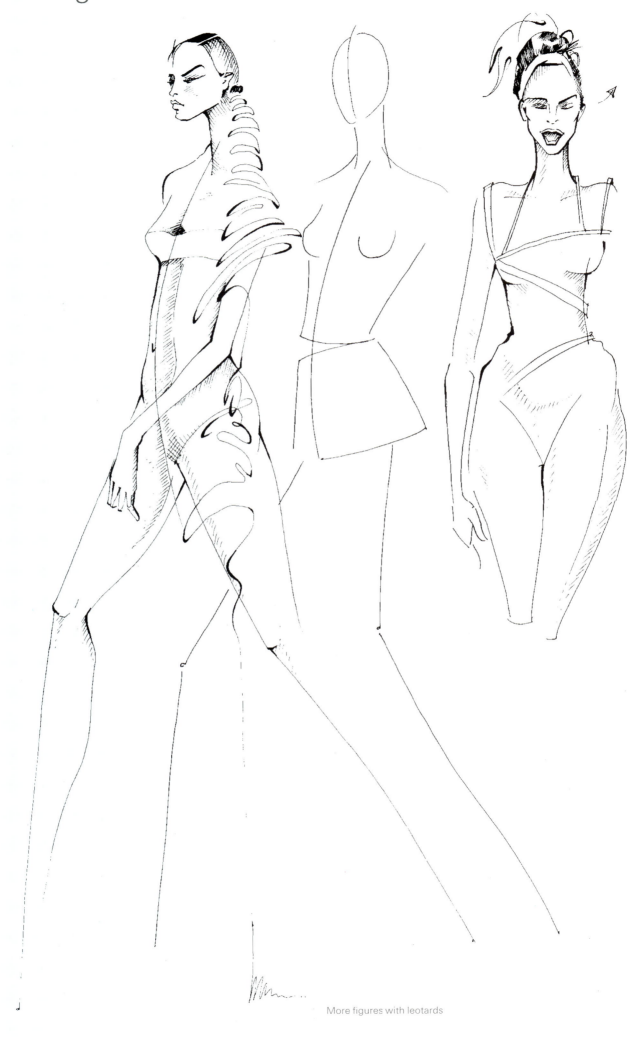

More figures with leotards

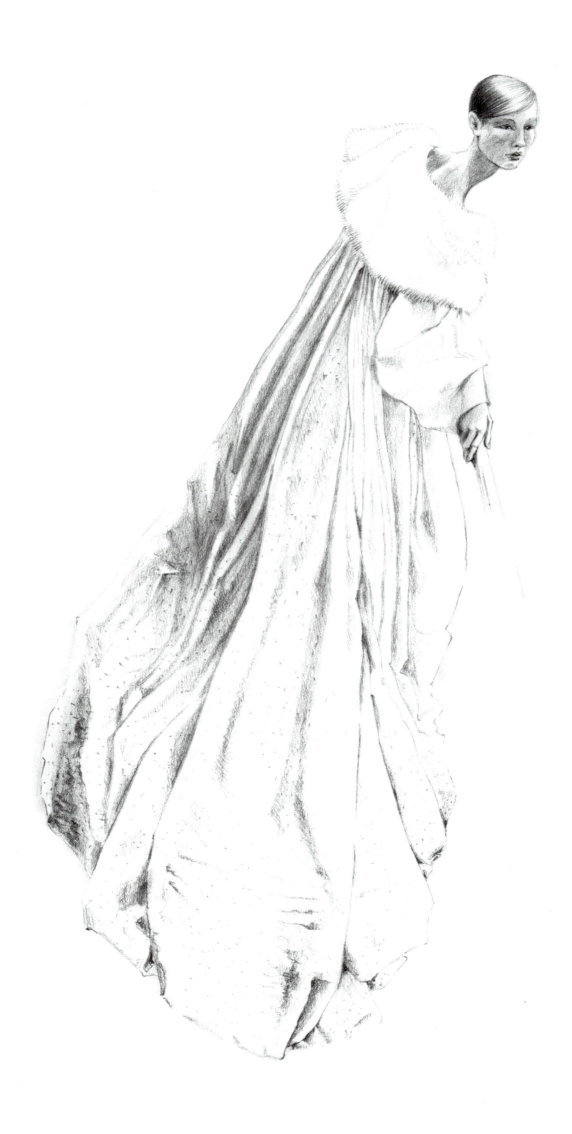

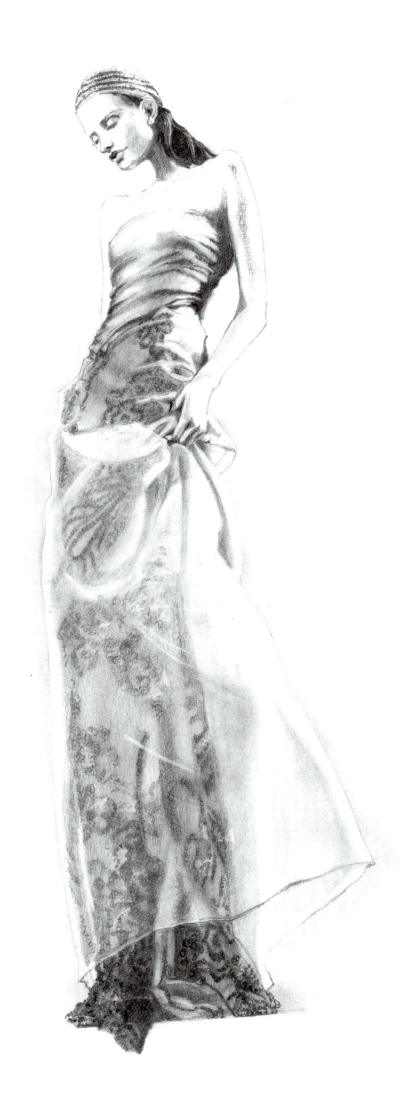

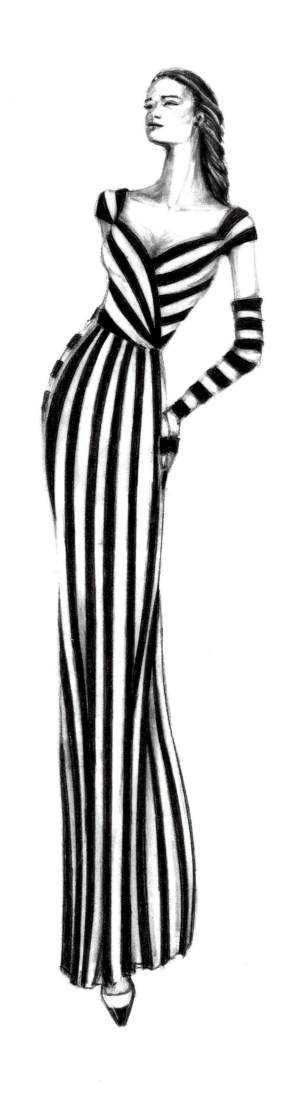

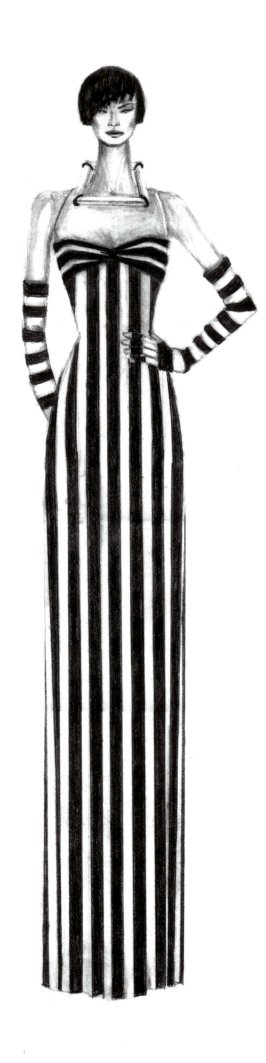

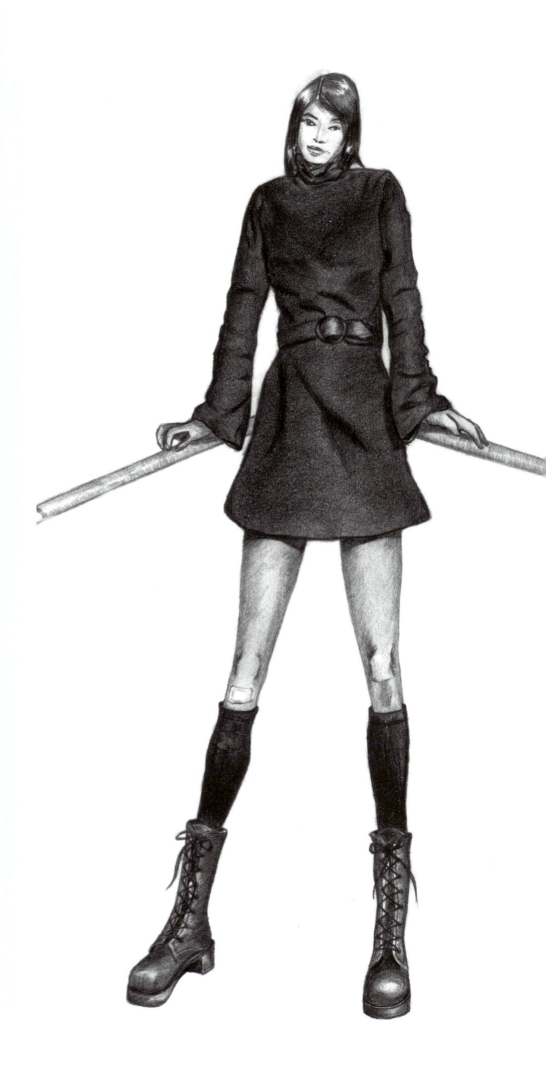

different racial/ethnic characteristics

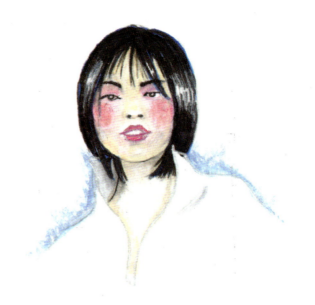

Every fashion figure tries to create expressions of beauty, health, energy, seduction, humor and the ideas of what is fashionable at the moment. Fortunately there are enormous variations from one race to another and each may be a wonderful variation on the theme of beauty. The Asian face is drawn with a higher eyebrow, slimmer eyes and less eyelid. Hair is dark and straight and the mouth is round and full. The Japanese face has pale skin and slim, delicate bones. The Korean face has fuller eyebrows, stronger bones and a stronger chin. The Chinese face is round with round dark eyes with limited shading at the eyelids, noses with straight bridges but full bases and a soft, round mouth. Hair is very black and very straight.

The black, or African woman has dramatic deep-set eyes and stronger eyelids which require more shading. Eyebrows are stronger and can be drawn with a full arch. The nose is drawn with a broader base, the mouth is round and wide and the lips are full. What is most fascinating about the black woman's face is the high cheek bones, high hairline and rounded forehead. There are many variations on skin tone depending on specific nationality and genes. Skin tone can range from aubergine to cinnamon.

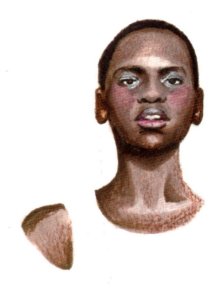

different
racial/ethnic
characteristics

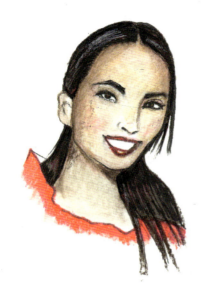

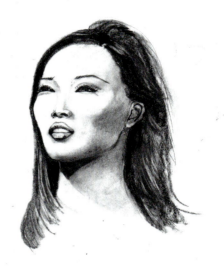

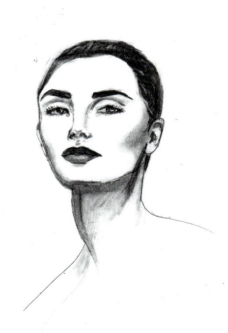

different racial/ethnic characteristics

Northern Europeans have strong bones, thin, strong noses and wide mouths and eyes. The eyes are set wide apart but do not require a great deal of shadow at the lid. The mouth is wide but can be drawn with a thinner lip or full. Skin tone is usually light. Hair is usually fair but there are many exceptions.

Southern Europeans are principally the Latin races. They have round deep set eyes and wide arched brows, full wide mouths, high cheek bones and strong chins. Hair is often blue-black, full and lush. The Latin eye tends to have a flirtatious down-curve at the end of the lash.

body types

Bodies of all sizes can be drawn beautifully and gracefully. Human curves are a sensual, beautiful gift of nature. To assure graceful drawings, bring those curves down to slim waists, ankles and wrists. The following are examples of different figure types:

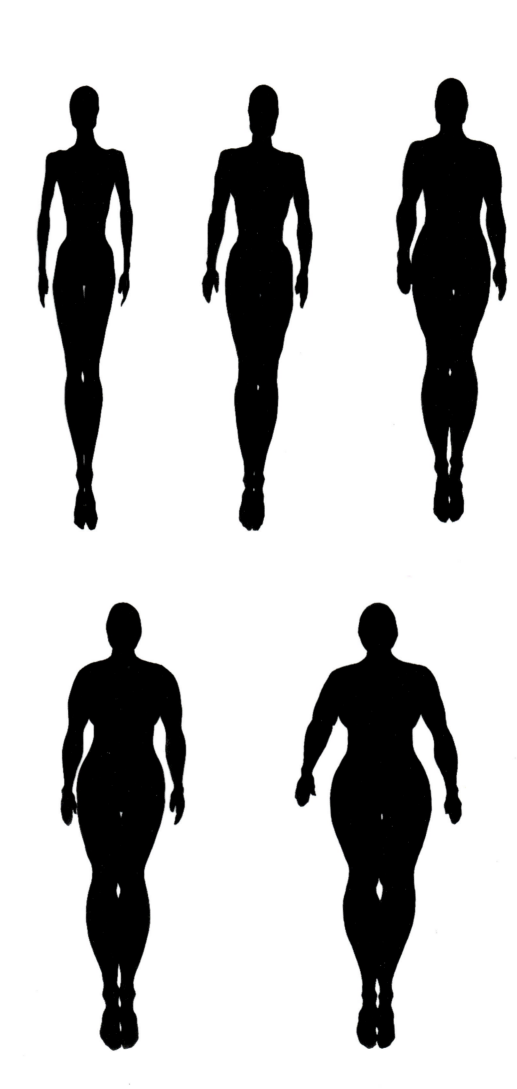

chapter two:
draping the figure

draping

Draping is the way in which a fabric folds and falls. Draping is like architecture: the body is the armature, the internal structure, and the fabric, like skin, glides over this frame. Fabric falls and twists, forms knots, bends and curves, like a river it ebbs and flows over the contours of the body. Draping is the ulitmate art of design.

All fabric drapes: nothing is so tight that it will not drape.

This section will start with simple, commonsense explanations of draping and will progress to more complex ideas.

THE FASHION SILHOUETTE
1. The silhouette is the key to understanding the garment. The silhouette is the edge of the garment: it will indicate which areas are draped. Look for drape at the collar, armhole to bust, waist, hips to crotch (especially in pants), at the knee, elbow and ankle. Drape will appear as a variation—a bulge or a bump— in the silhouette.
2. Thick fabric is depicted using bulges, thin fabric with small bumps.
3. Soft fabric is depicted with a soft 4B pencil. Crisp fabric is drawn using the point of the pencil with a sharp line.
4. In order to show whether the fabric is shiny or matt use shading. Shading is created in the valley of a fold. It is a wide area and is best drawn with a soft 4B pencil. Fill in the area carefully. Do your housework: neatness counts.
5. Folds are like cone-shaped mountains or volcanoes, with light on the mountain top of the cone and shadows, as we explained earlier, filling in the valleys, or folds.
6. Light areas tend to be thin and shadowy areas wide. Shiny fabric requires a contrast of very dark valleys and white areas which at the top, along the ridge or crest of the mountain, appear to be crisp white lines. The darkest part of the shadow appears next to the lightest area at the crest of the fold. Matt fabrics (not

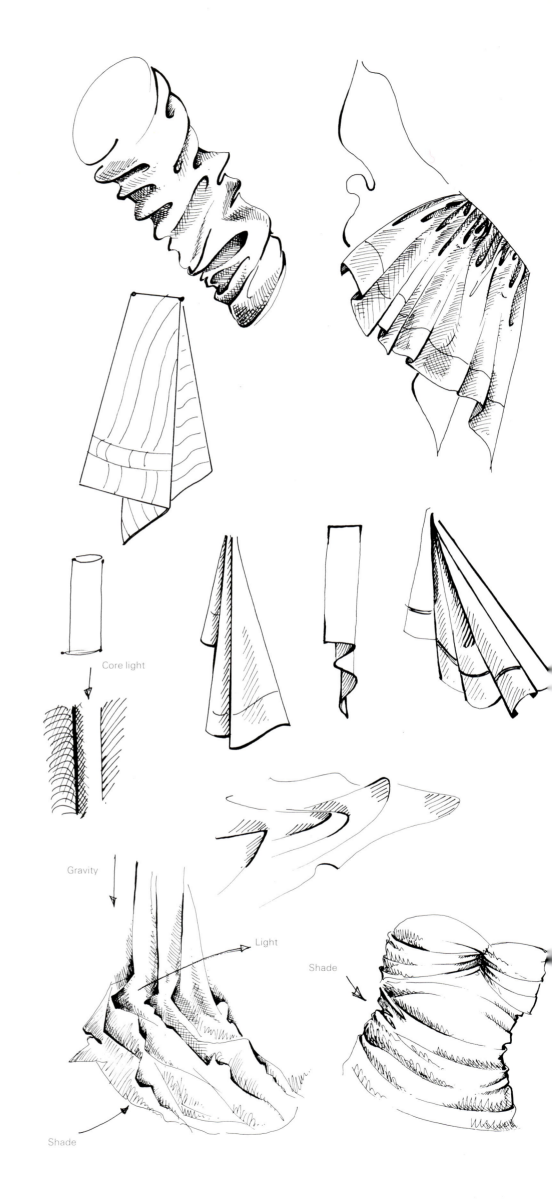

Core light

Gravity

Light

Shade

Shade

draping

shiny) follow the same rules, however there is little contrasting between dark and light.

7. When draping enormous, billowy garments, use shadows everywhere there is fabric which is not directly covering the figure underneath.

8. When drawing clothes on the body, Use Curves. Above the waist, curve your lines up, and below the waistline, down (you may break this rule from time to time). Curve belts, shoes, cuffs, collars, lapels, necklaces, rings, bracelets, and hems around the figure.

9. Decide on the direction of your fabric: is it draped horizontally, vertically or on the bias (diagonally)? This influences the way we will draw the folds.

10. Identify the center front of the figure. This can be observed by locating the axis which runs through the bust, waist and crotch. This is important. There is another style line which runs in between the outside seam and the center front and which travels over the bust to the waist and out to the hips. This line is called the princess line.

11. Identifying the center axis and princess lines offers an opportunity to draw clothes which fit correctly on the figure. It is essential to place buttons on the center axis when drawing a jacket or blouse. In the case of double-breasted jackets, buttons are placed symmetrically in relation to the center axis.

12. It is vital to look at the figure under the garment. Where does the figure bend? Does it bend at the elbow or at the knee? This will influence the draping of the garment.

13. Remember seams, zippers, buttons, snaps, elastic, velcro. Remember gravity.

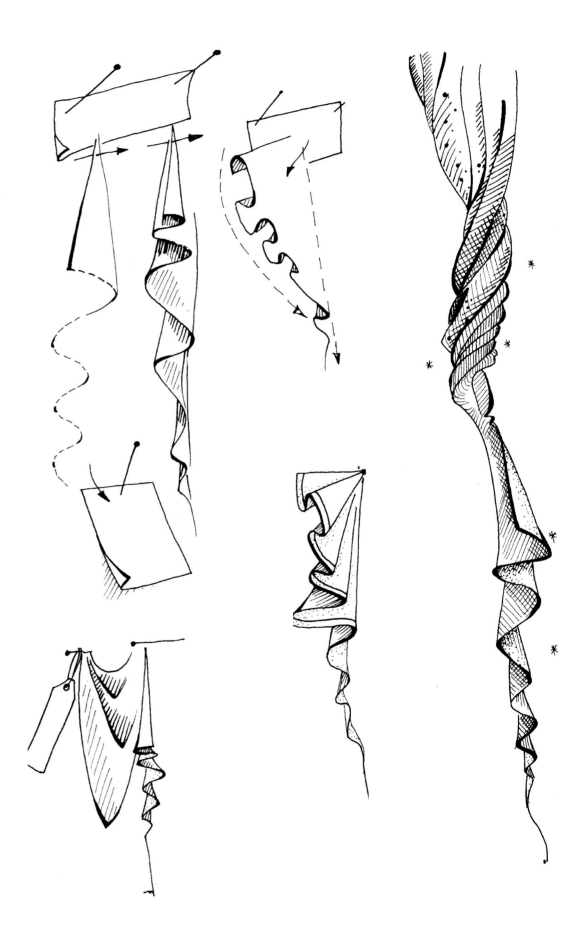

skirts

Let's move on. Let's draw skirts, the simplest of garments to draw.

1. A skirt can be thought of as a tube. A skirt circles around the waist, flows over the hip and covers the lower part of the body.

2. When skirts have more fabric, the excess fabric is draped. Designers use darts, pleats, ease and seams to fasten the fabric to the body.

3. Begin with the waistband, drawing around the waist either up or down. Apply belt loops and/or darts on the princess line. Follow down the line of the hip until you reach the widest point of the hip. After this point the figure becomes slimmer and the extra fabric which falls towards the knee will drape. Follow all the way to the end of the skirt whether it falls at the thigh, the knee, the calf or the ankle, and draw the hem by bending a line around the figure at this point.

4. When drawing the hem, never make a straight line. If the skirt is fitted, the hemline will bend down. If the skirt is fuller and has fabric which extends beyond the line of the figure, the extra fabric is drawn by bending the hemline upwards.

5. When drawing horizontal patterns on the skirt, follow the hemline and remember to break up patterns at folds. Vertical patterns can appear closer together at the sides of a garment.

6. Gathers are formed by sewing wide fabric into a smaller area and sewing the fabric into a seam. Gathers extend out from the seam like the petals of a flower. Remember: the more gathers, the wider the flair of the skirt. Gathers often break at the knee.

7. When drawing a full skirt at the hem, begin with a simple curved line and proceed to show gathers by drawing one cylinder representing a gather with its curved end up and the next cylinder with its curved end down. Avoid drawing gathers that appear the same size.

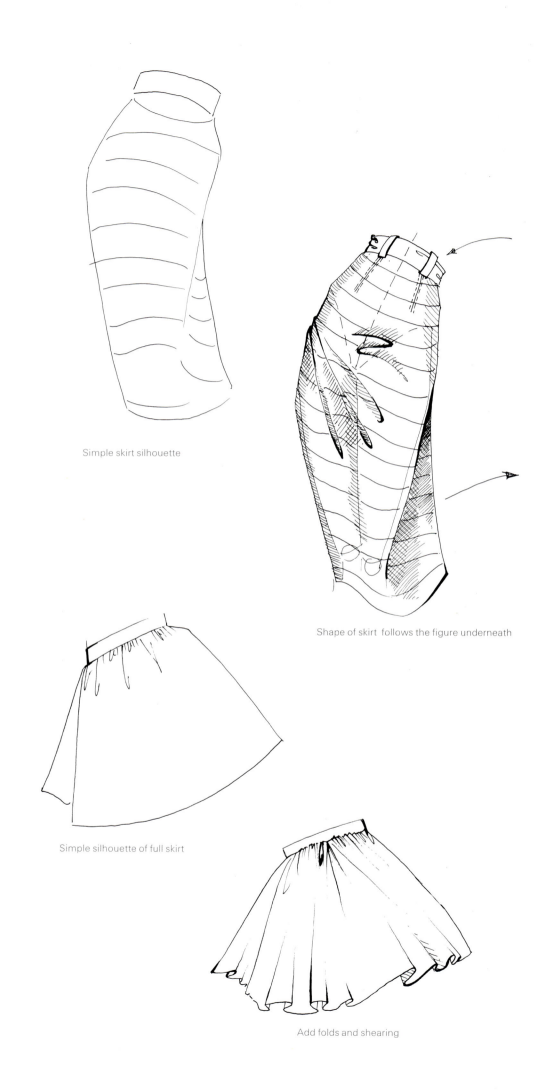

Simple skirt silhouette

Shape of skirt follows the figure underneath

Simple silhouette of full skirt

Add folds and shearing

Expressing the weight of a fabric requires gathers which are closer together at the center axis and wider apart as you move away from the center axis.

8. Tiers of fabric. Layers, or tiers of skirts are sewn to undergarments so that the skirts become progressively narrower: the top skirt is wider than the next skirt which is wider than the skirt after that.

9. A mitered skirt will create the illusion that patterns form "V"s.

10. Pleats are flat drapes. Pleats are folds of fabric stitched into a seam. There are many forms or types of pleats. The knife pleat is flat and is used in tennis or cheerleader skirts. Fan pleats are made of panels which resemble a fan. Box pleats are inset into a seam and are used in jackets and shirts. Pleats can be drawn with a straight line when the fabric is crisp, like crepe or gabardine, or with a soft line such as in pleated chiffon. Pleats have been developed into accordion pleats, elegant crystal pleats, mushroom pleats and cluster pleats. Shade every other panel of a pleated garment.

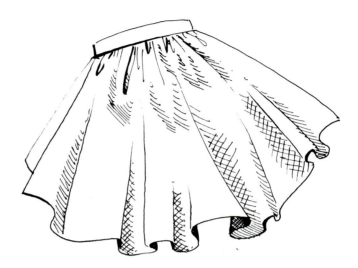

Shade next to drape line and shearing

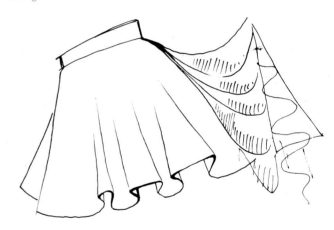

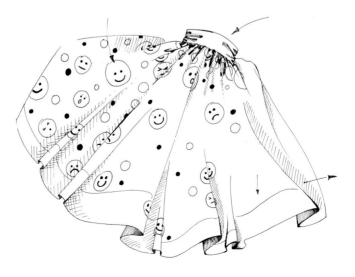

Add pattern (here we have schizophrenic happy faces)

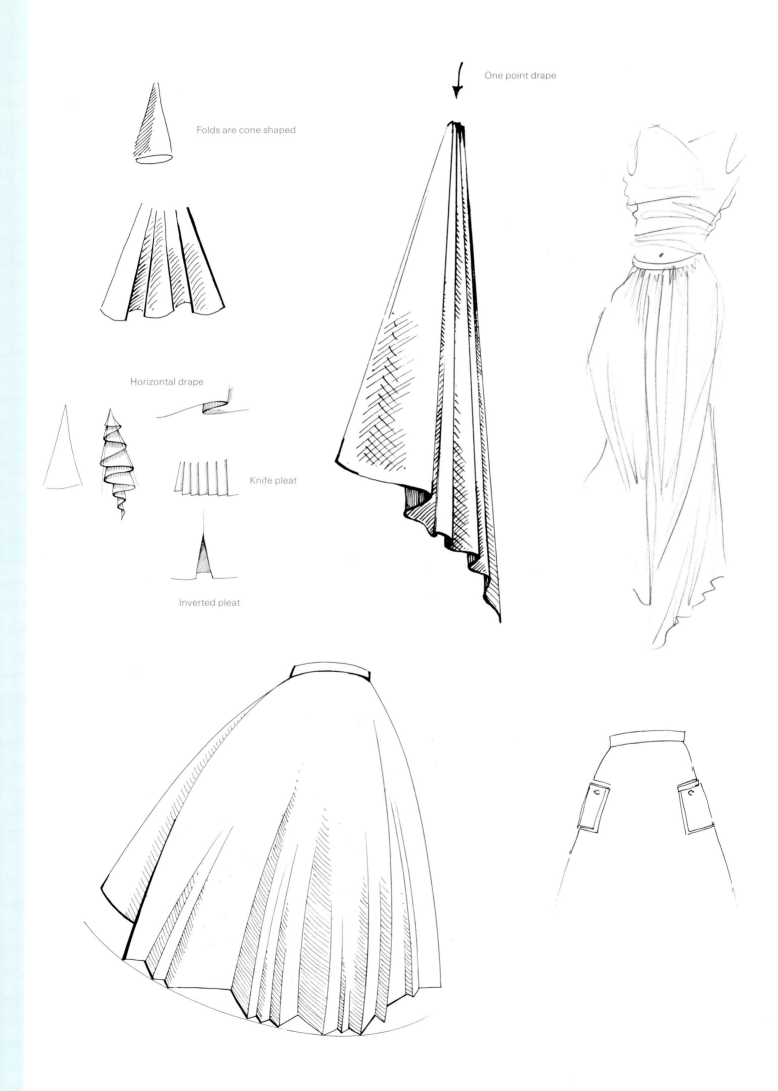

Folds are cone shaped

One point drape

Horizontal drape

Knife pleat

Inverted pleat

sleeves

1. Sleeves cover the arm. They can be tailored or soft and magnificent, following the curve of the elbow with billowing folds. The sleeve may be constructed from a drop shoulder and appear more relaxed, or a pad may be used and give a sleeve a more architectural appearance.

2. A tailored sleeve should be attached to the armhole so the appearance of the fall of the sleeve is knife edge straight (it takes a rare and sophisticated skill to achieve the precise shape of a tailored sleeve).

3. For coats and jackets sleeves can be cut in two pieces.

4. Raglan sleeves are attached to a diagonal seam which extends from the neck. A two piece raglan sleeve appears to be more tailored.

5. Drawing the sleeve requires special attention to how gravity affects the fabric. Begin by following the "cap" of the sleeve at the armhole (this is the section where the sleeve is sewn into the armhole). Break your line to show a gentle fold at the elbow.

6. There is a small drape at the back of the sleeve near the shoulder when one is drawing a set-in sleeve.

7. Fabric falls away from the lower part of the arm.

8. Soft sleeves drape more at the elbow and often have deeper armholes.

9. Look for the amount of excess fabric draping from the arm and shade this area.

10. The tailored sleeve ends at a hem which curves slightly away from the hand.

11. Sleeves can be gathered at the hemline into a cuff. Different fabrics create different folds at the cuff. When gathering excess fabric from the cuff make sure your fold lines are drawn directly from the seam.

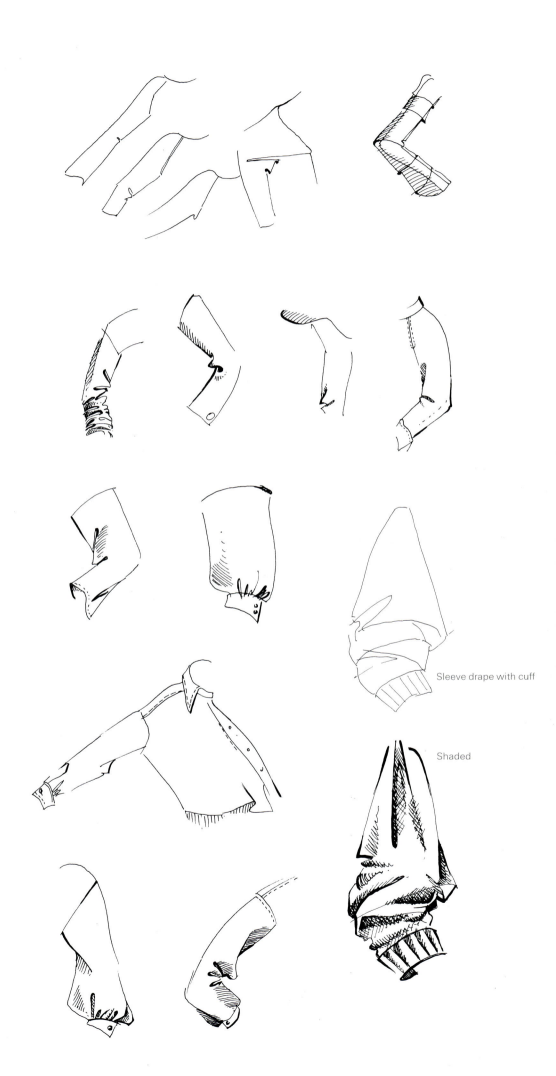

Sleeve drape with cuff

Shaded

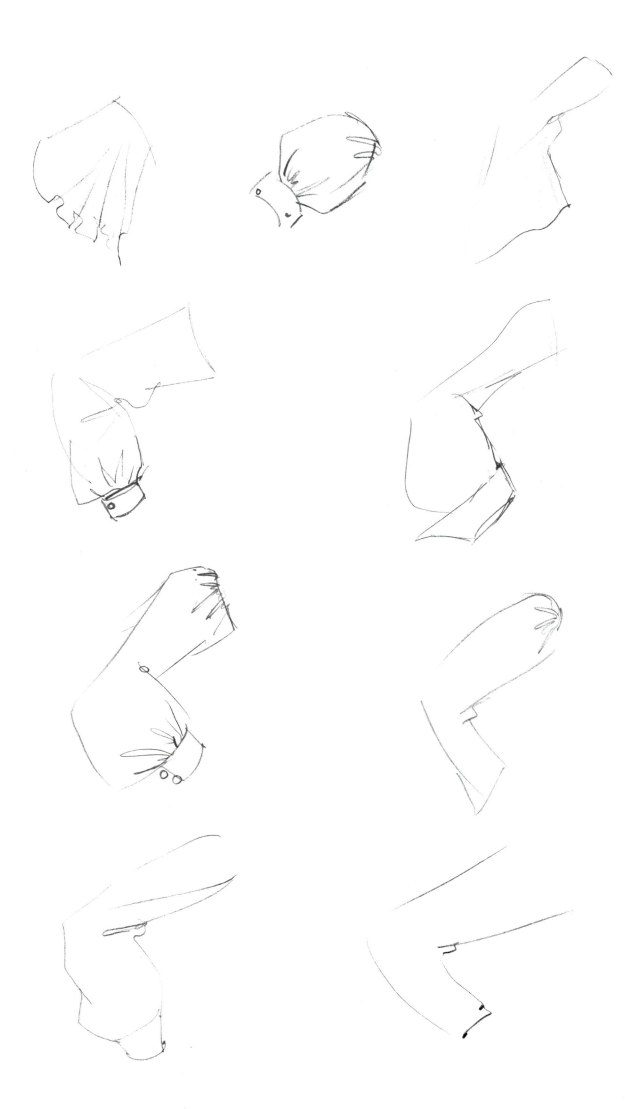

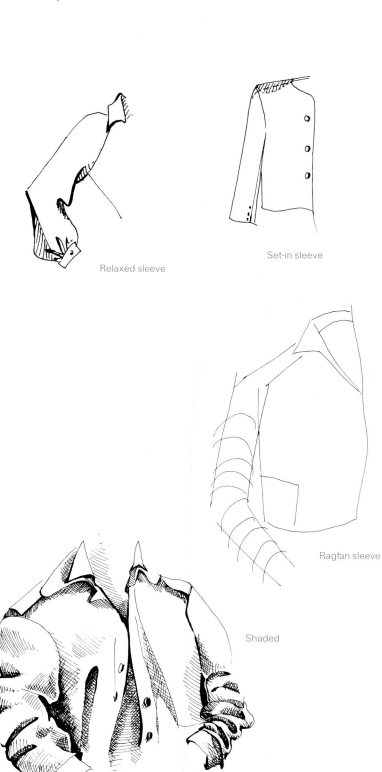

Relaxed sleeve

Set-in sleeve

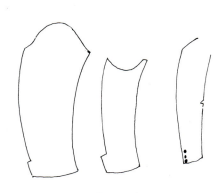

Pattern pieces

Raglan sleeve

Shaded

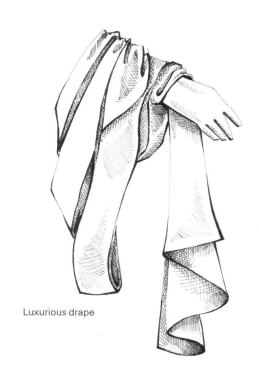

Luxurious drape

Soft folds

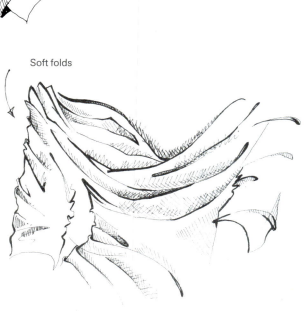

Soft folds

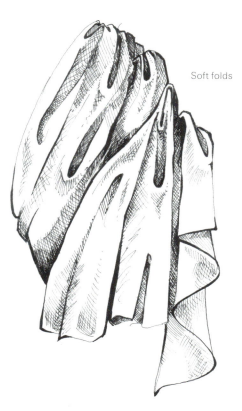

Soft folds

pants

Pants showed up on women in the mid-19th century. Women wore pants because they offered freedom of movement, an idea borrowed from men (and we know men had all the freedoms before the 20th century).

1. To draw pants look for lots of cylinders. Cylinders at the waist, hip to crotch, crotch to knee, with the final cylinder at the hem. Also pay attention to inseams, creases, zippers, pockets and tucks.

2. Establish a support leg (the leg carrying the weight of the body). The pant drapes from the hip to the knee. The pant often rests on the inside of the support leg and flairs out from the leg. If the leg is stretched away from the center axis, fabric falls on the outside of the leg.

3. The hem of the pants curves around the leg but will form a slight V shape when there is a crease. To indicate the point at which the pant leg attaches to the hip, draw a simple horizontal line which marks the crotch. There is a great opportunity for imaginative design by raising or lowering the crotch line.

4. A zipper is drawn on female pants on the left side of the center seam. Be careful. It is a common error to place it on the wrong side. Danger—Do *not* draw zippers which are attached to the crotch. This would be very painful.

5. Side pockets are indicated by drawing a vertical line parallel to the outside hip line from the waist to the hip.

6. For full length pants, the hem of the pant leg must be drawn so that it gracefully falls over the shoes.

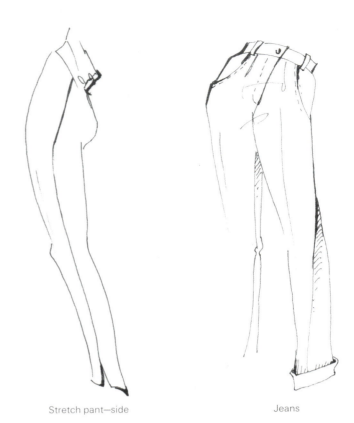

Stretch pant—side

Jeans

Shorts with yoke

Do not attach zipper to crotch. Ouch!

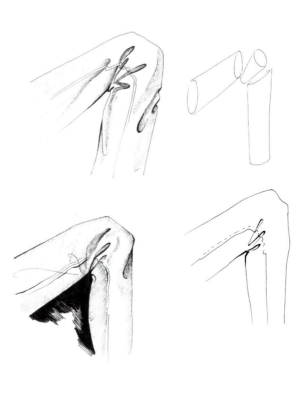

Gaucho pants

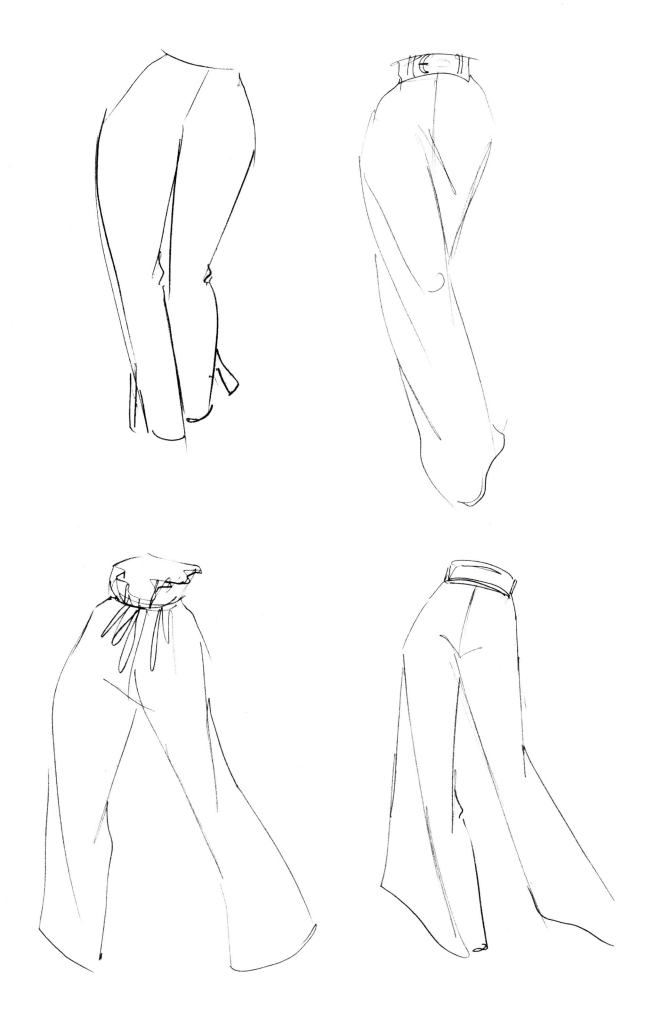

pants

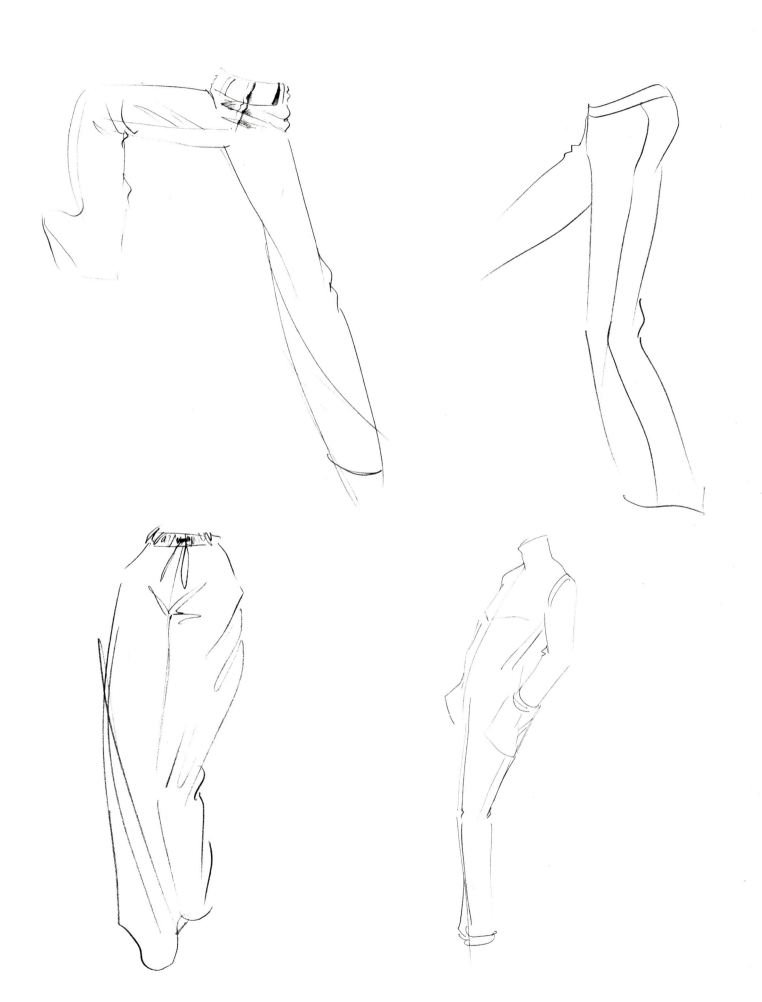

blouses/shirts/top

Blouses, shirts and tops cover the upper body, sometimes like a caress, sometimes like a protective skin. Blouses and shirts are constructed so that there is an opening or band on the center axis. The band is used for the placement of buttons.

1. Blouses and shirts have collars which circle around the neck and are connected to facings which allow the collar to stand up.

2. Shirts are often constructed with flat-seams with top stitching.

3. Sleeves are attached to the main bodice and often include plackets or openings at the bottom which allow a space for the hand. Don't forget to draw sleeves wide enough for the hand and arm to exit and enter.

4. Cuffs are fabric pieces which are attached at the base of the sleeve to give a tailored finish. French cuffs are turned back and fastened with a cuff-link —a very elegant detail.

5. Shirt bands are attached from the collar to the hem. The bottom band normally has buttons attached, and the top, buttonholes.

6. Shirts are constructed using formal guidelines. Blouses are constructed with more style variation. Blouses can evoke innocence, casual charm, ethnicity, decadence—very provocative garments.

7. Tops are skins for the body, often designed with stretch, showing the muscles of the shoulders and back and the contours of the bust. Tops include T-shirts, tank tops, halter tops and often sport lively graphics and designs.

8. Vests are tailored tops used to even out the lines of the torso. They provide warmth and give a boyish charm to women's fashion.

9. Hoods are separate pieces attached to tops to enclose the head.

10. Turtle necks are added to tops and circle the neck up to the chin.

11. Drape and shade blouses, shirts and tops with soft tones around the bustline to identify the body underneath the garment.

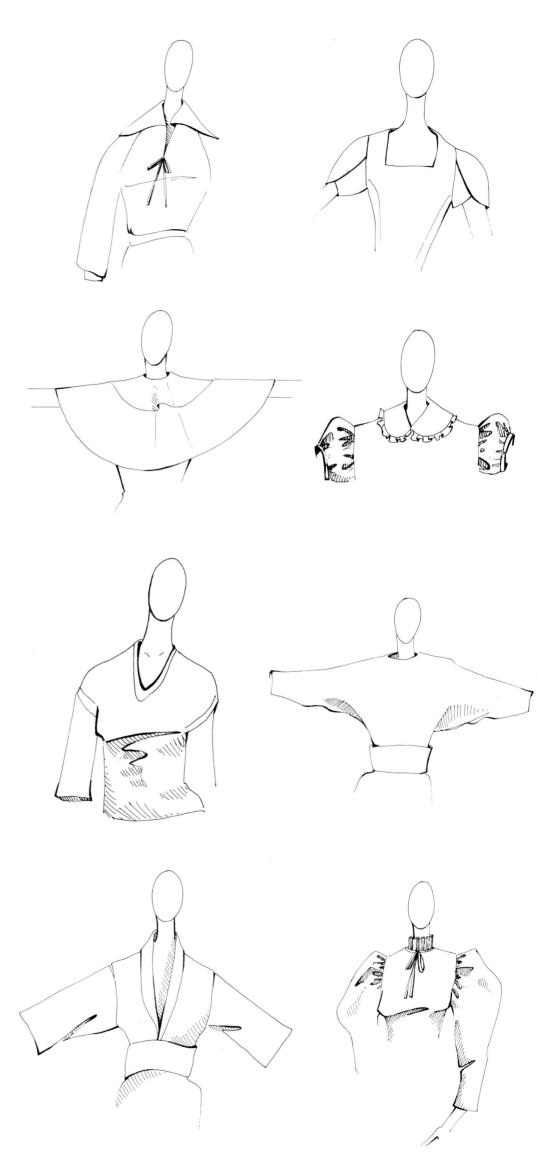

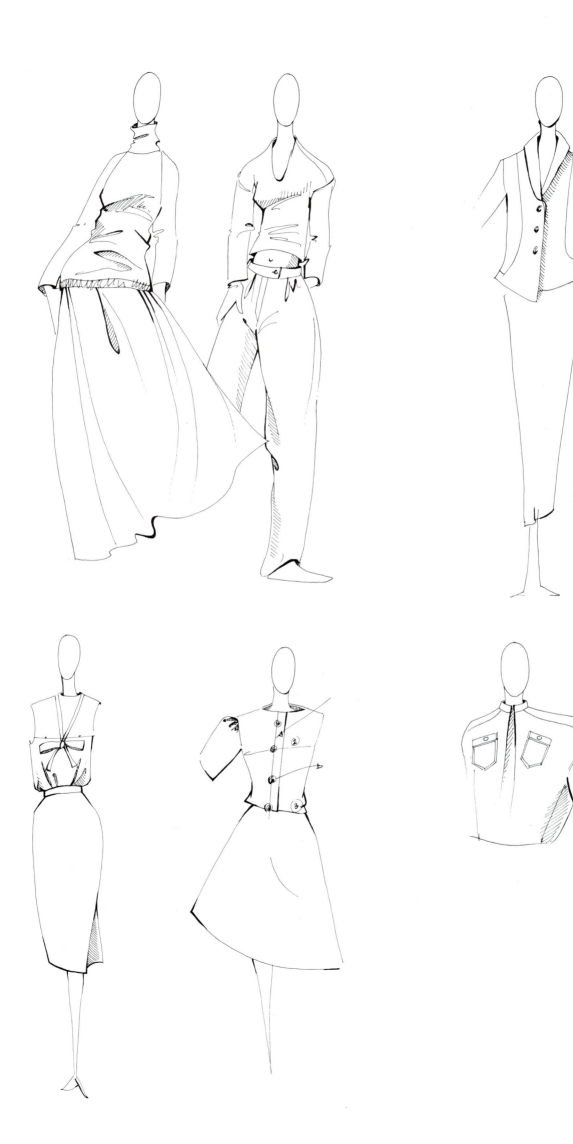

blouses/shirts/tops

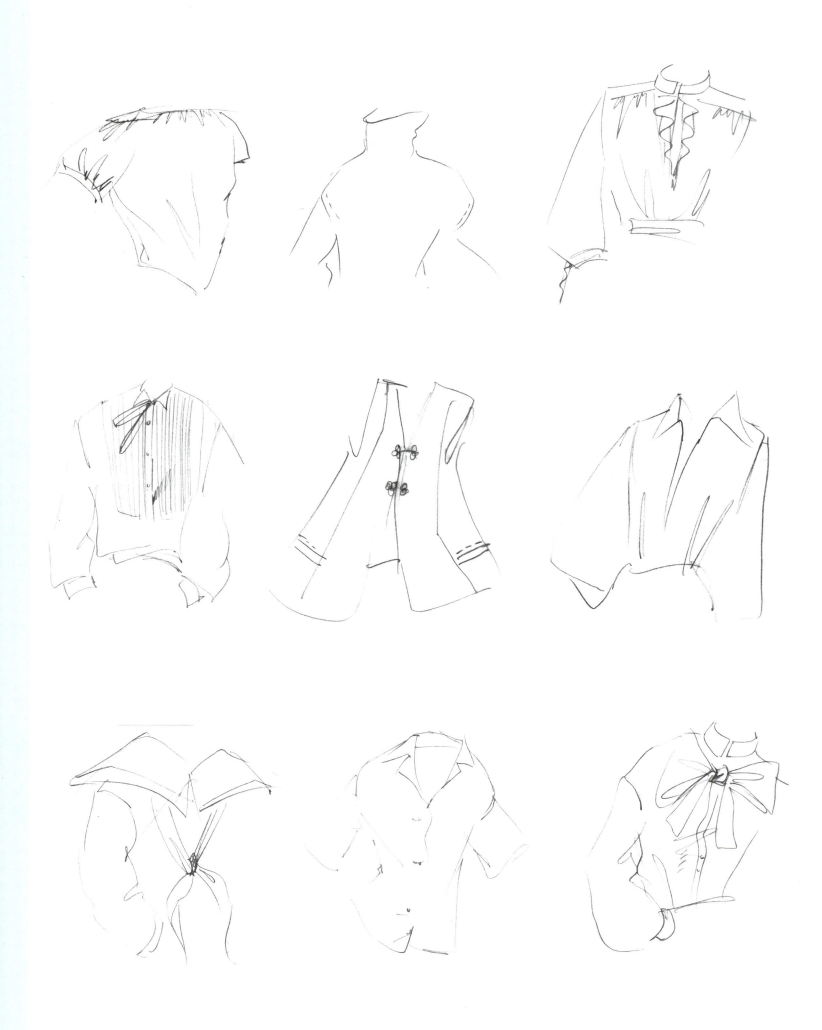

118

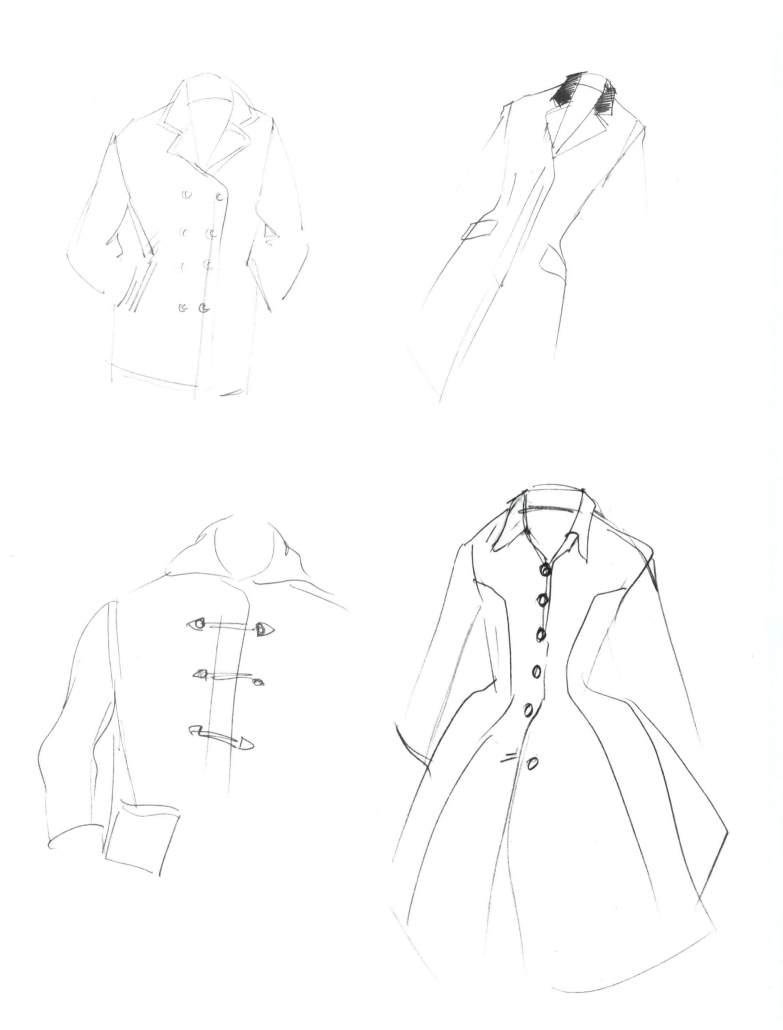

dresses

Let's move right on to Dresses. Dresses
require large amounts of fabric. The
drape falls like a waterfall over the shoul-
ders to the waist, slides over the hip to
the knee, curves, twists and bends. If the
fabric is snug under the bust, a subtle
horizontal drape line is used. If the dress
is designed using shirring from a side
seam over the body, use a jagged line at
the side edge with horizontal folds and
drape.

1. When drawing dresses be attentive to
scale and silhouette. Belts often create a
slim area close to the body and when
pulled tight at the waist create a soft sil-
houette in the upper torso.

2. All parts of a dress have to be drawn as
curving around the figure underneath.
Draw the neckline around the neck, the
armholes around the arms and the hem
around the legs like a bee buzzing around
a flower.

3. Drawing the layers of a dress requires
making the top layer fuller, with slimmer
layers as we travel to the feet. Pay close
attention to the edge of each layer so
that it appears to bend around the layer
below. This can be accomplished by
drawing shadows at the edges and under
each layer.

4. All hems bend.

5. Wedding dresses and evening clothes
require a full sweep and curve of the hem
which can dip down at the back of the fig-
ure, in the front of the figure or perhaps
off to the side.

6. No matter how long we wish to draw
the hem it is graceful and instructive to
draw the toe of the shoe.

7. Tailored dresses are drawn with crisp
sharp lines and straight folds.

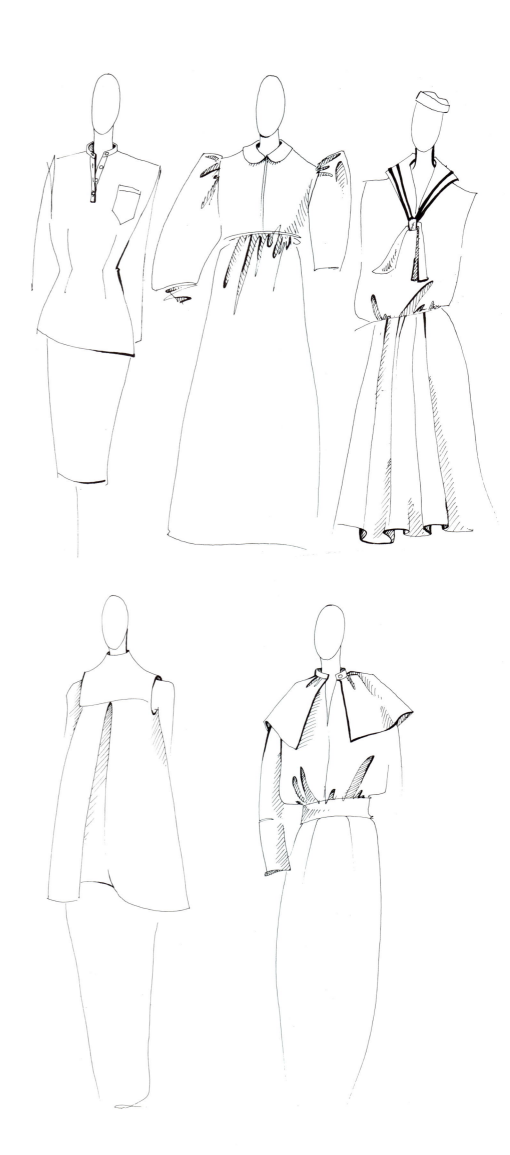

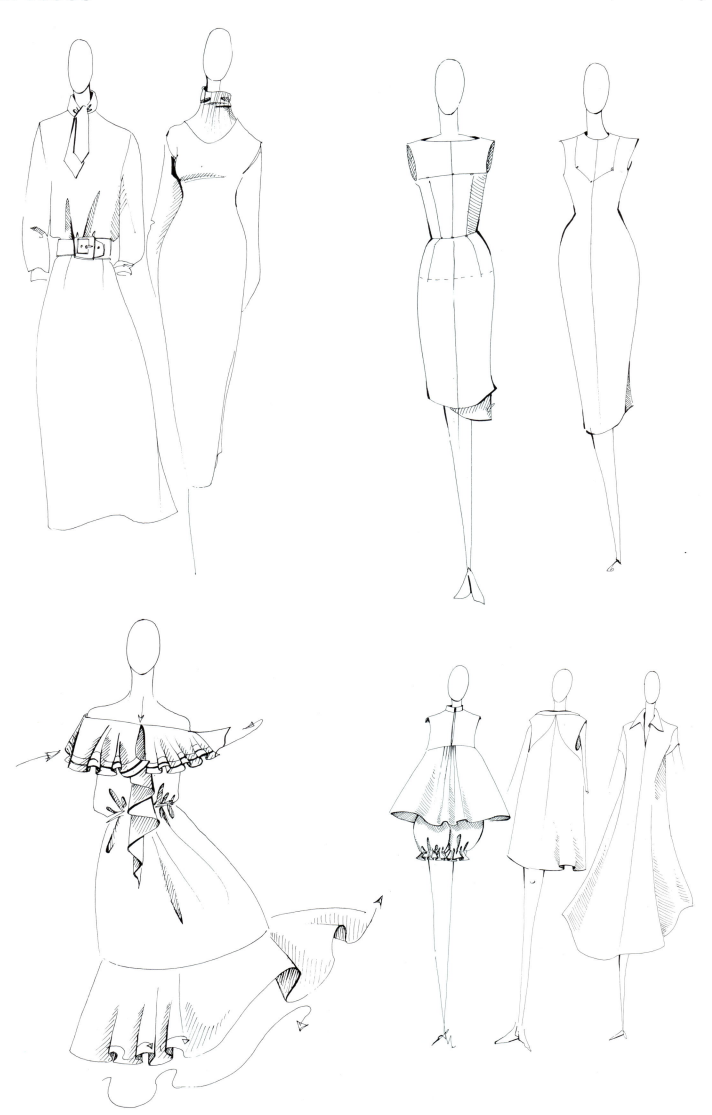

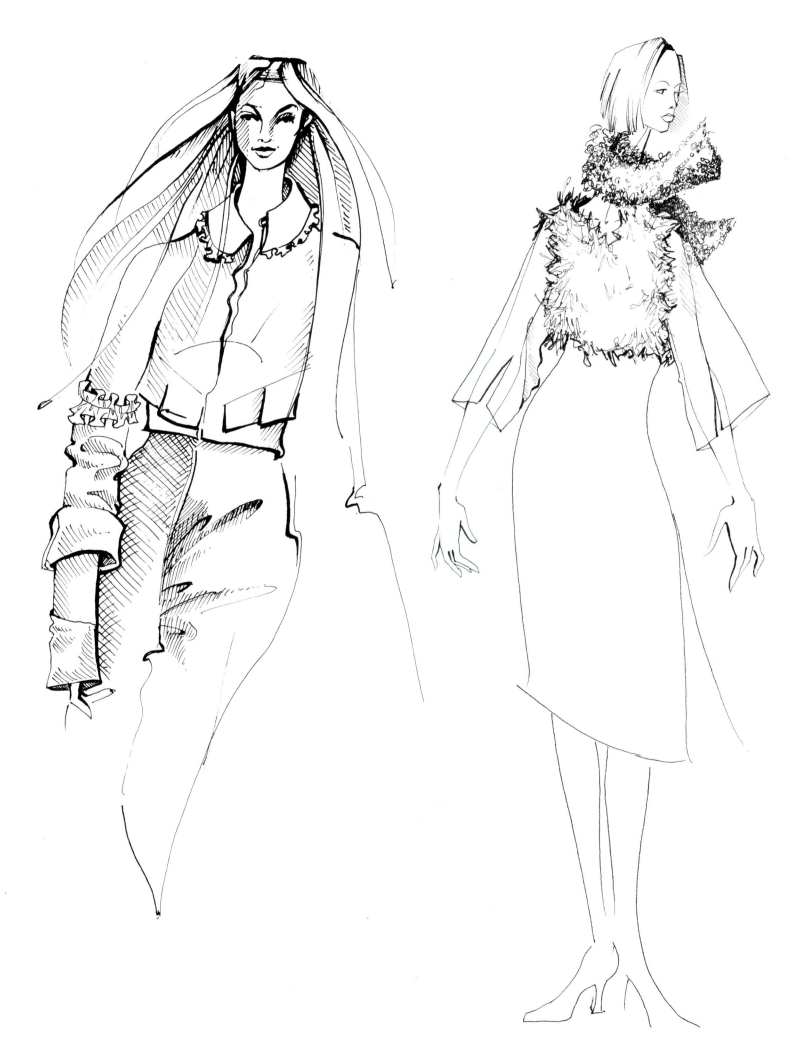

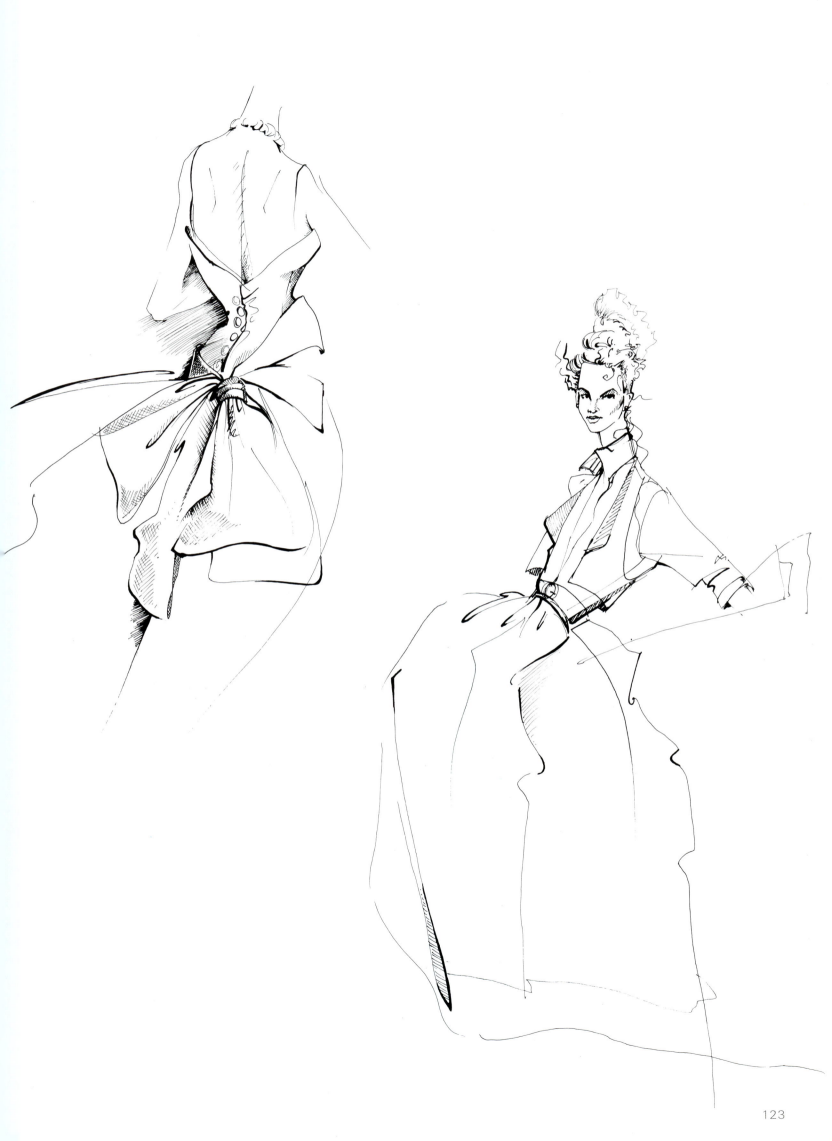

dresses

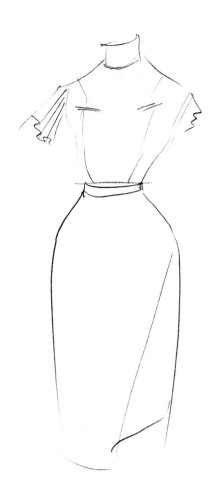

Practice with a pencil to achieve a different line weight. A looser style of drawing has an ethereal quality—the fabric appears to float.

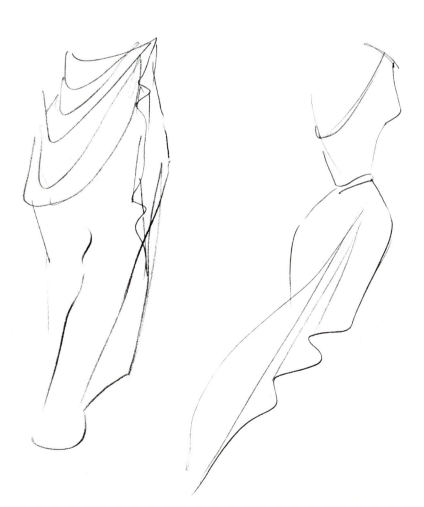

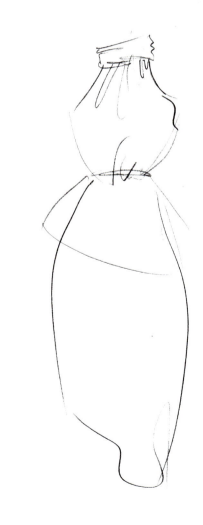

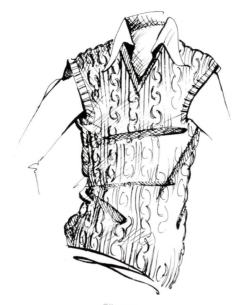

Slipover

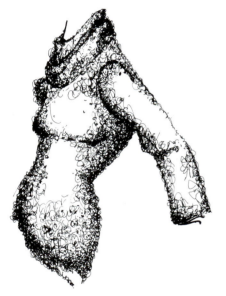

Cowl-neck

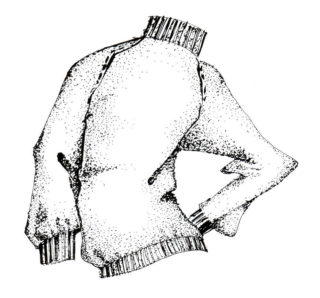

Mock turtleneck

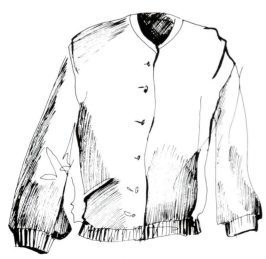

Cardigan

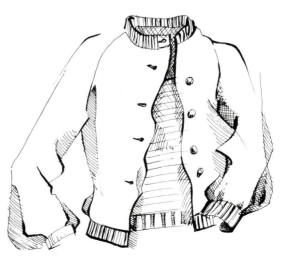

Twin sweater set

tailored garments

The tailored jacket is a designer's greatest challenge—and can be his biggest triumph, his pièce de résistance. As the silhouette of the jacket is independent of the body and can be used to enhance the female form, tailoring is the pure art of design.

1. The jacket is precisely fitted with the fabric moulded over interfacing.

2. The jacket has a facing in the center front which opens into a deep or shallow V. A *facing* is a stiff piece of fabric which is sewn under the garment to give it strength. The V is elegant if it successfully frames the neck and head.

3. Attached to this V is the collar. The collar is made up of several areas. A *roll line* divides the upward slope from the facing to the downward slope of the end points. The traditional collar is called a Revere.

4. The line of the opening V at the center front is anchored by a button. The placement of the button is essential in creating the fit of the jacket; a tiny difference in the placement will radically change the fit and style.

5. There are many variations in the design of collars. The flat collar is traditional, a shawl collar is softer and rounder. The Peter Pan collar is a flat, round shape with a boyish look.
A Puritan collar is larger and round.
A Sailor collar, (yes, just like the man's uniform) is called a Middy.

6. Detailing is masterful in jackets. Buttonholes are finished, princess lines are applied or fisheye darts (pinched seams which extend vertically upwards and down from the waist, and which resemble the squinty eyes of nifty fish) are used to create shape.

7. When drawing the lapel of the jacket and outside silhouette, keep in mind that hours of handwork may be required in good tailoring.

8. A jacket is symmetrical (balanced).

9. A jacket is not a box but a softly constructed frame. Lines should be carefully drawn so as to avoid the appearance of the fabric pulling.

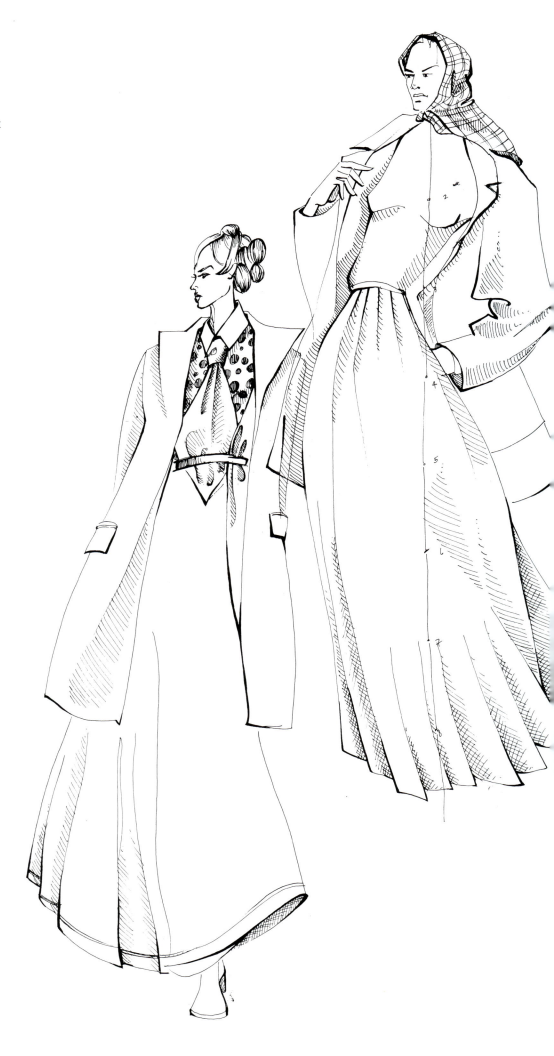

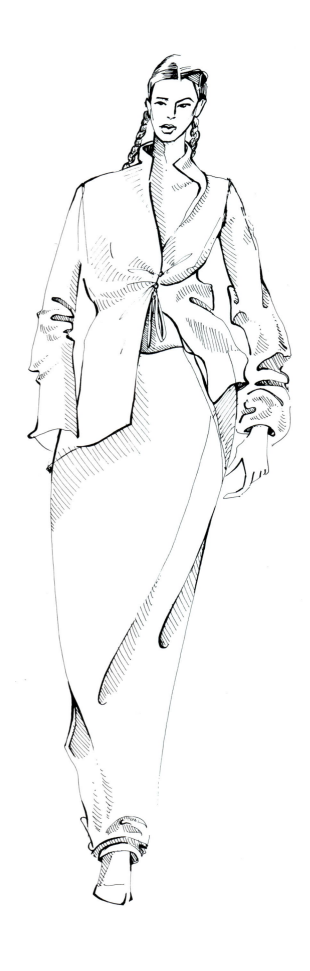

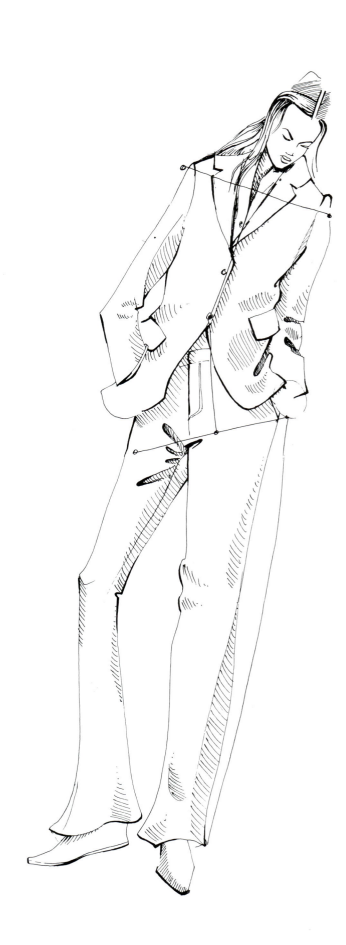

tailored garments/buttons/belts

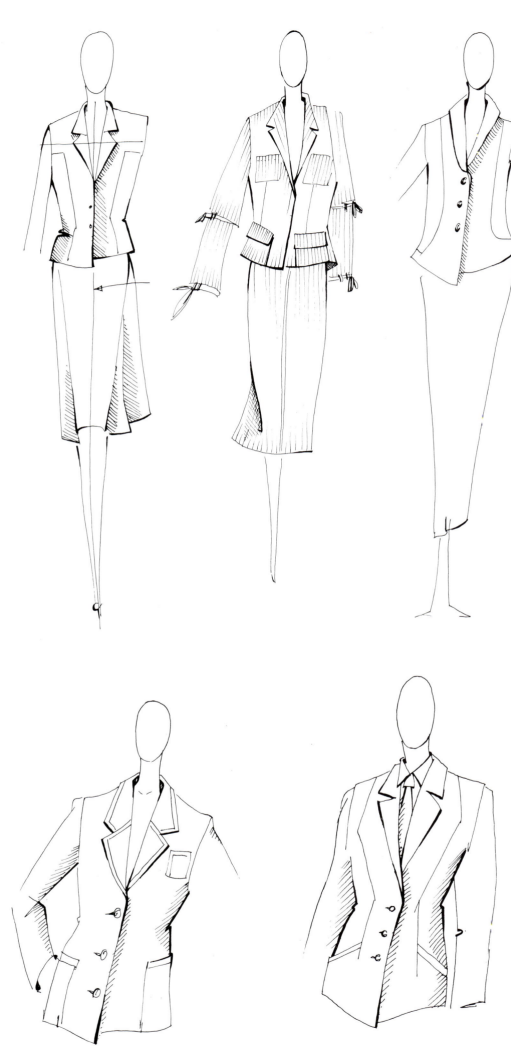

10. Check to see that the hem of the jacket is balanced with the sleeve (a great designer will make adjustments in this area for many hours).

11. Draw the lapel symmetrically, measuring out from the center axis.

12. Stop the outside line of the lapel just before it hits the first button. Now add shadows under the lapel and button to create dimension so that the lapel appears above the main body of the jacket.

13. The collar is drawn higher than the shoulder. An extra line can be drawn to indicate top-stitching.

14. Do not draw a line around the bust as the body is softened by a jacket or vest.

BUTTONS

1. Buttons are evenly spaced on the opening of the garment, especially where there is stress at the bust line, waist and hip. Extra buttons are evenly spaced between these points and must be carefully chosen for visual balance with the garment.

2. Buttons are often made out of plastic, however, jewels, sea-shell, mother-of-pearl, wood, bone and a variety of other materials have been employed. Buttons are labelled and measured by line (see example).

3. Buttonholes can be machine-stitched or hand-stitched. Buttonholes may be bound or corded in better garments. Shirt buttonholes are placed vertically on the placket as a design detail. Loop buttonholes are made from cord and are stitched into the center-front seam. Buttons and buttonholes may disappear in the next century as life becomes fast and zippers and velcro take their place.

BELTS

1 Belts are used to accentuate the silhouette (and also so the fit of the garment can be tightened and loosened before and after a meal).

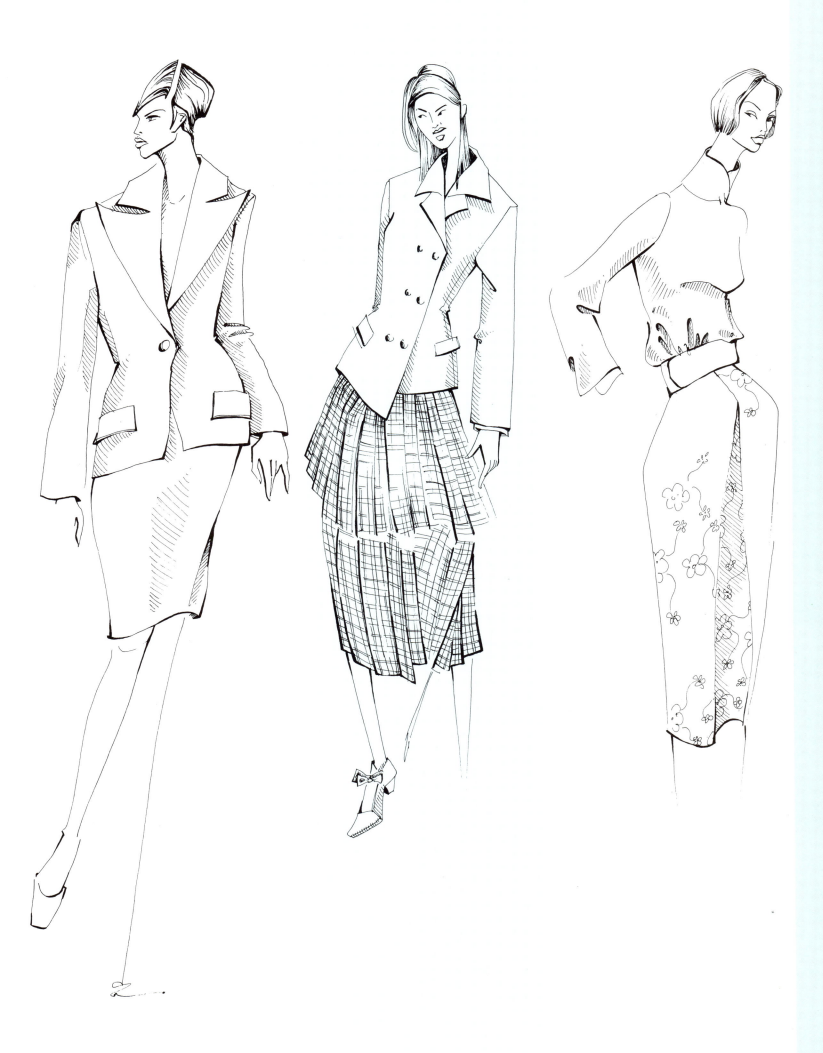

active sportswear

1. Active sportswear is clothing worn for sport, or outdoor leisure pursuits. Over the last twenty or thirty years sport has become a part of most people's lives and a large number of new sports have come into existence. Fashion has moved aggressively into this area and American active sportswear has influenced fashion ideas around the world.

2. Active sportswear can be divided into two categories—for the professional sportsman and the amateur. Clothes for professional sportsmen have to focus first on function, second on fashion. On the whole, seams are stronger, more padding is employed and layering is used to keep the body warm when the body begins to cool down. For amateurs, the emphasis is on making the body look good for those who miss the occasional workout.

3. Active sportswear is drawn with many seams. Top stitching is often used to indicate extra strength. Snaps, elastic and velcro are often used in addition to buttons and laces. Accesories are commonly drawn as an important part of the outfit for function, protection and style.

4. Because the materials are often man-made, the silhouettes of active sportswear are usually clear and crisp. Use a clean, clear, sharp line that bends around the body. Use a young, active fashion pose which represents a moment in the sport or a relaxed pose.

5. Accessories can be witty, functional or very sexy.

6. Active sportswear can be garments for swimming, golf, skiing, wind-surfing, surfing, mountain climbing, running, mountain biking, snowboarding, in-line skating, dance/aerobics, weightlifting, bodybuilding, tennis, ice skating and others.

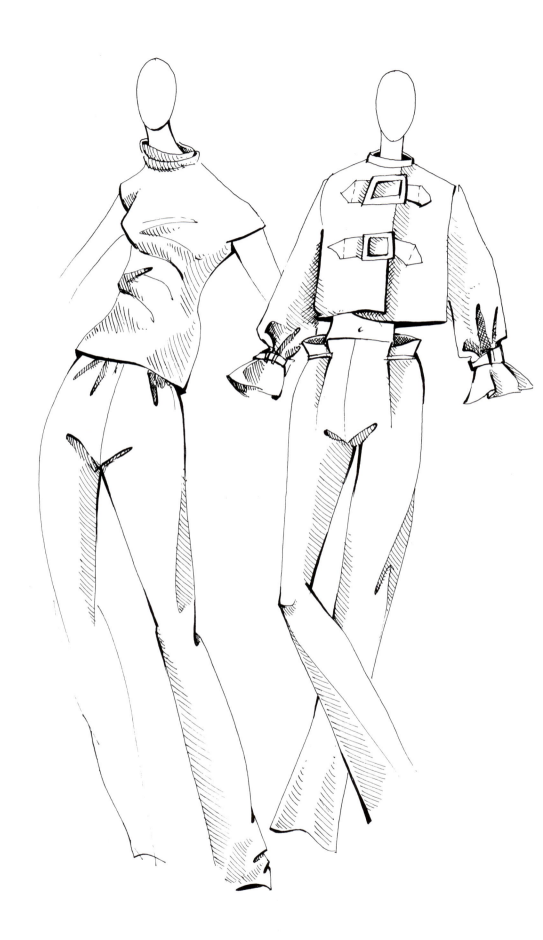

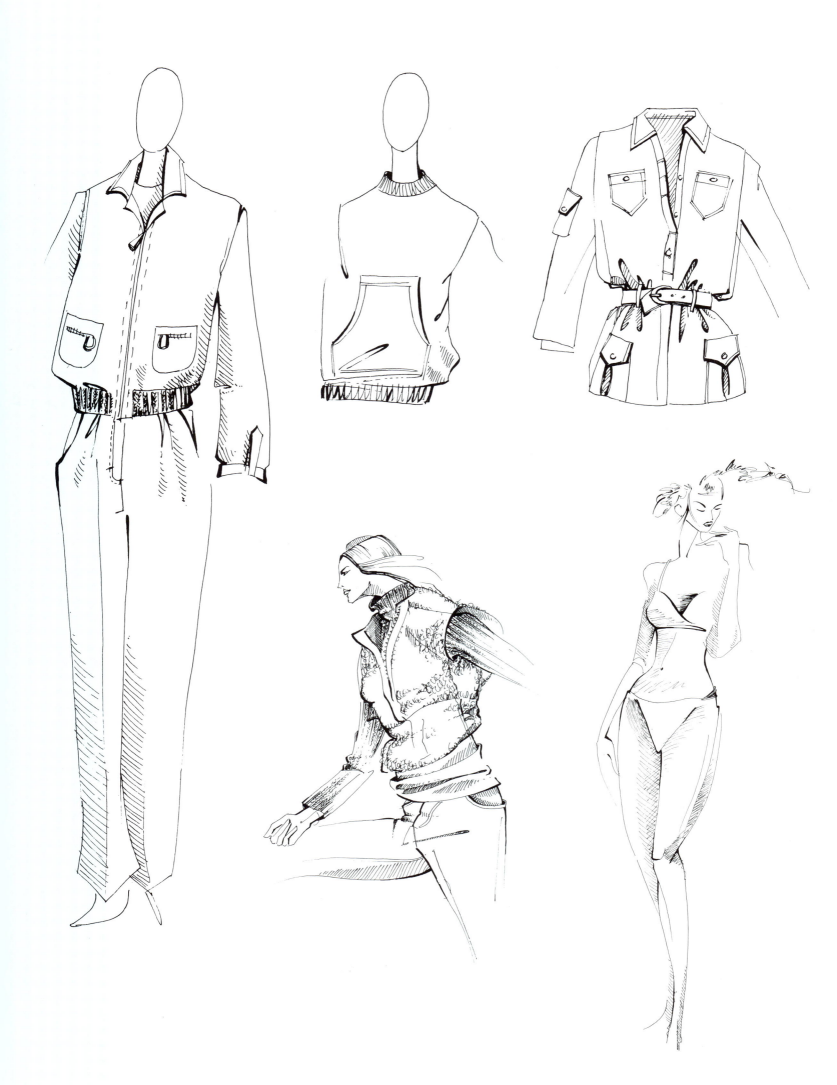

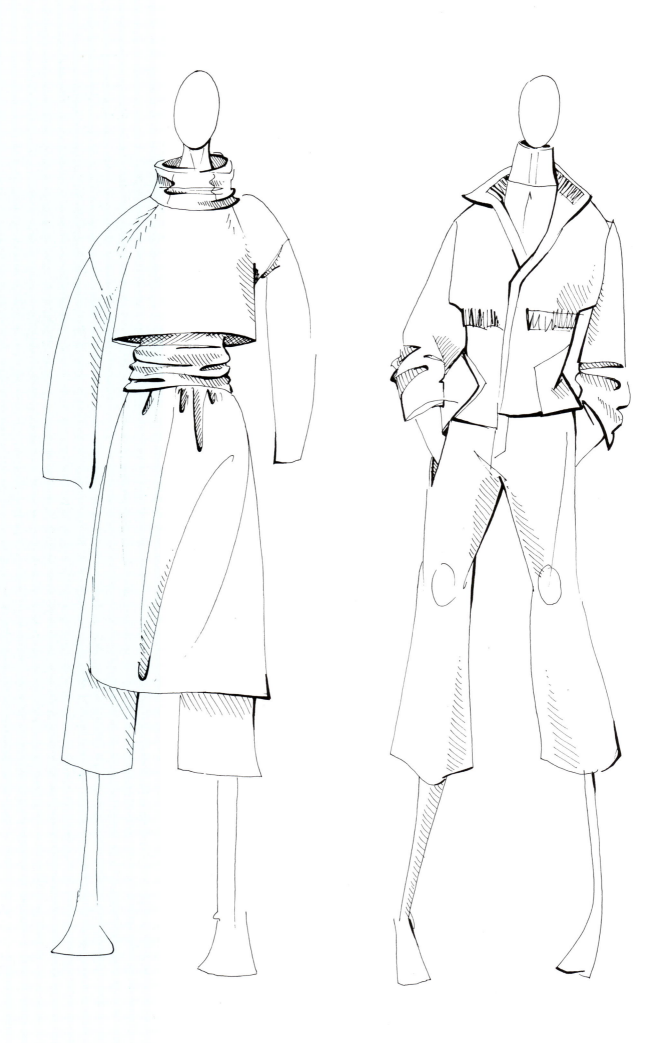

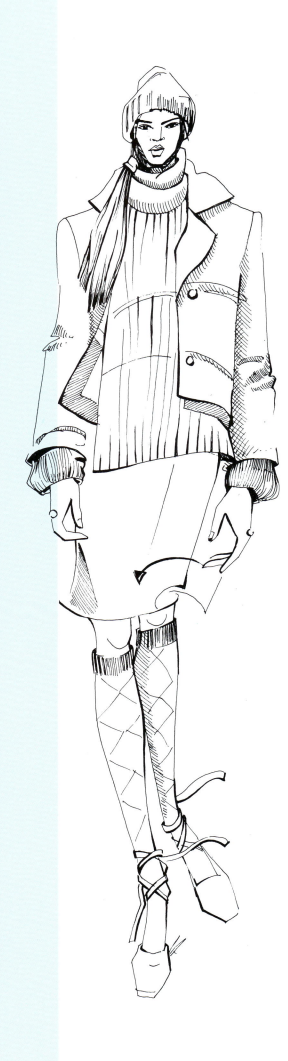

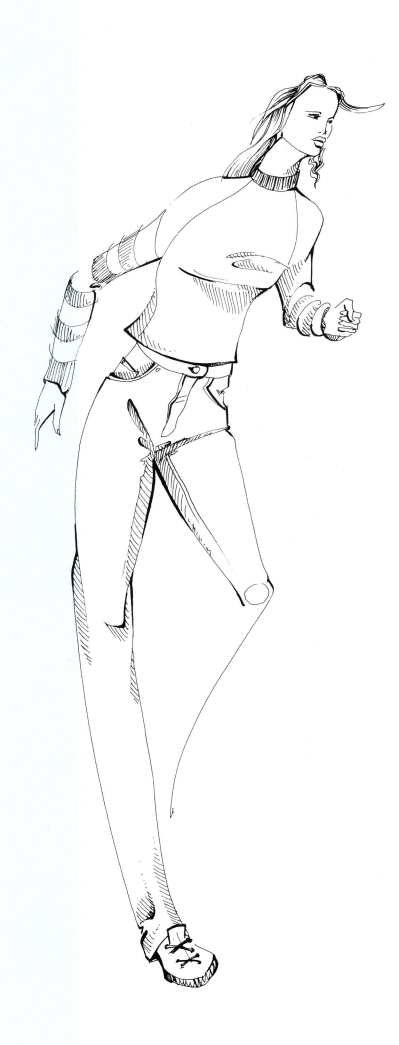

collars

1. A collar is a frame for the neck. It can be functional, keeping us protected from cold and wind, or luxurious, chic or pert. Almost all collars share design elements.

2. Collars are usually constructed from three pieces of fabric. The upper collar is what we see from the outside. Interfacing is the next layer, used to stiffen the collar. The undercollar is the final layer, cut on the bias and joined to the neckline.

3. The portion of the collar which is folded over from the neck is called the roll line. The roll takes on a different shape depending on the thickness of the fabrics. Thin fabrics such as lightweight cotton create a thin roll and are drawn as such; very thick fabric, such as fur, is drawn with a full roll.

4. The collar travels up from the neckline, over the roll and down to the shoulder again like a roller-coaster. The distance between the neckline and the top of the roll is called the stand. Very high collars have a very high stand.

5. There is an important relationship between the collar and the neckline. The more the collar is constructed close to the neck, like a Peter Pan or Mandarin collar, the less shadows are used between the neckline and the collar. The more structured the collar and the more it stands away from the neck, such as a stand-up collar, the more shadows are used between the neck and the collar.

6. Collars can be attached to the neckline with the straight of the fabric or on the bias. They can also be mitred, which means the fabric is cut, at the center back seam.

7. All collars go completely around the neck and often meet at the center front axis.

8. Drawing collars takes precision. Draw one side of the collar first from the back of the neck to the center front and measure this distance before drawing the other side.

9. Three-quarter collars are smaller on the side turned away from us.

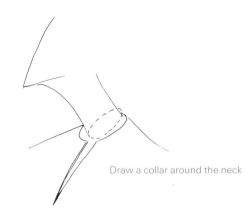

Draw a collar around the neck

Wing basic

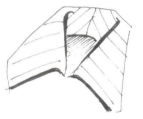

Wing basic with mitered seam

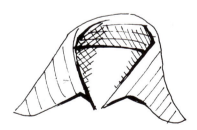

Wing basic with horizontal stripes

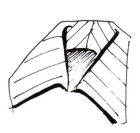

Shirt basic

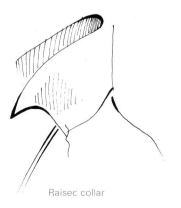

Raised collar

collars/seams/yokes

NECKLINES

1. Necklines are opening for the head. Be careful to make an opening wide enough for the head. We must be able to get in and out!
2. The most common neckline is a jewel or V-neck. To keep the neckline flat we use a facing or a flat piece of stiffened fabric which is sewn into the hem of the neckline.
3. Necklines can be constructed with elastic bands or be decorated with a variety of trims.

SEAMS AND GORES

1. A seam can run through any section of the garment, helping to create its shape and architecture. A seam is drawn with a thin line. Remember to put seams at the armhole and waist if they are required.
2. Gores are pieces of fabric which are attached vertically to create fullness in the garment. A gore line runs the full distance of the pattern piece.

YOKES

1. A yoke is a mis-spelt joke and is a horizontal pattern piece. It is used to control ease or fullness. Yokes are used at the shoulder and at the hip line.

Stand away collar

Chinese collar

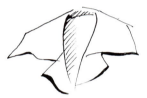
Convertible

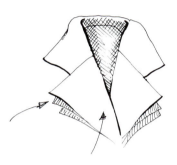
Shadow under collar

Wing—Chelsea style

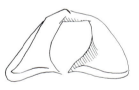
Shirt edged

Bouclé

Fur

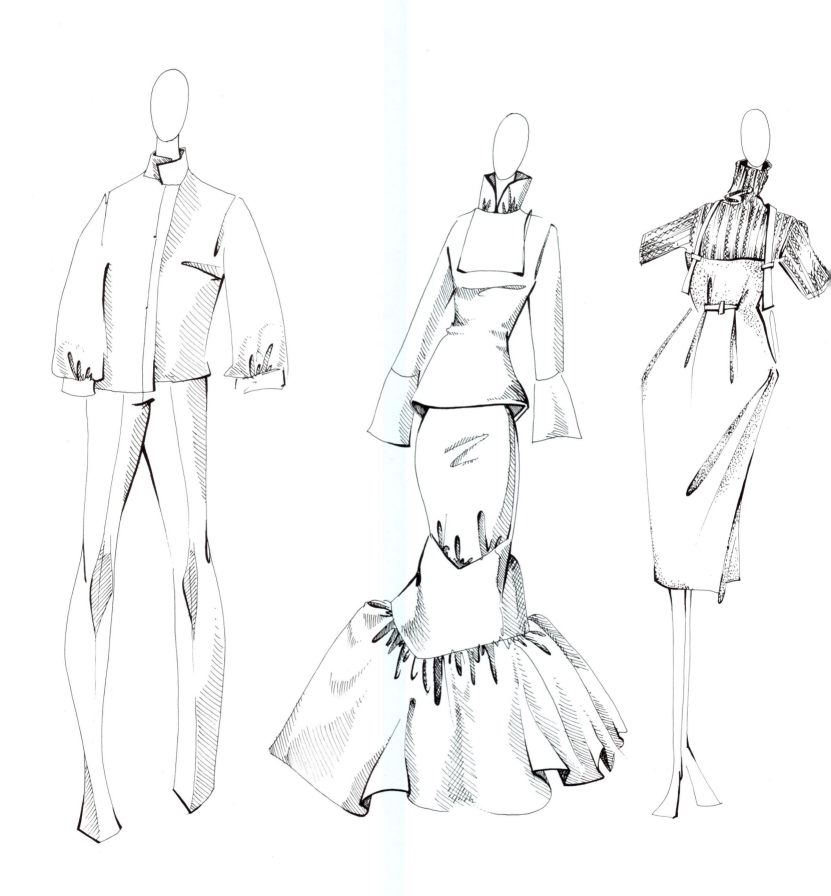

modern
silhouettes

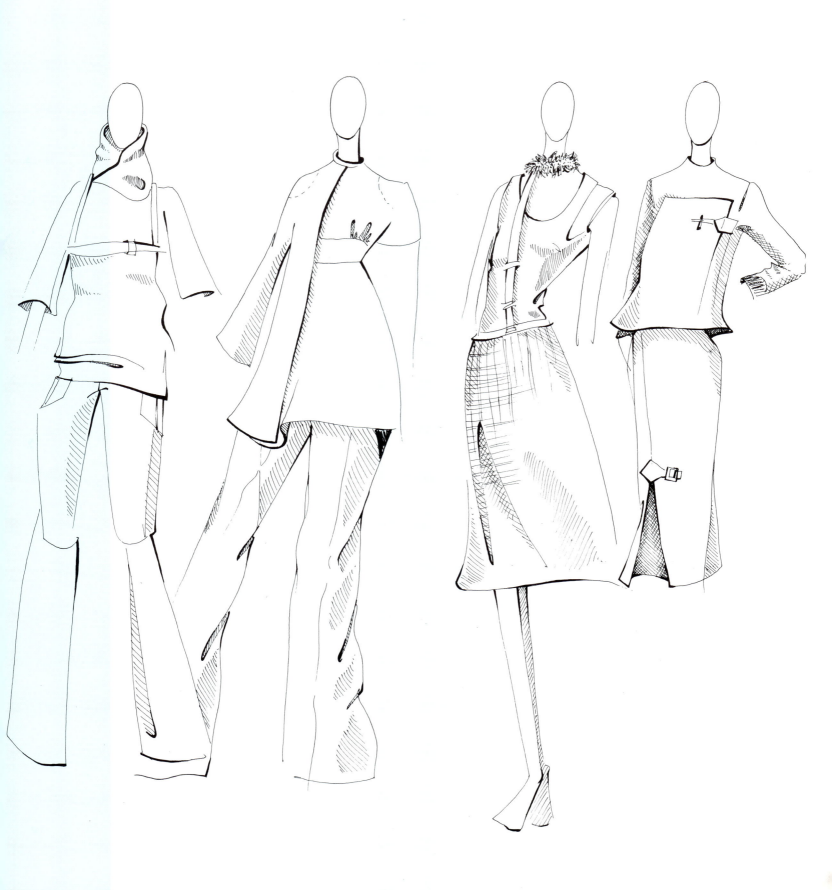

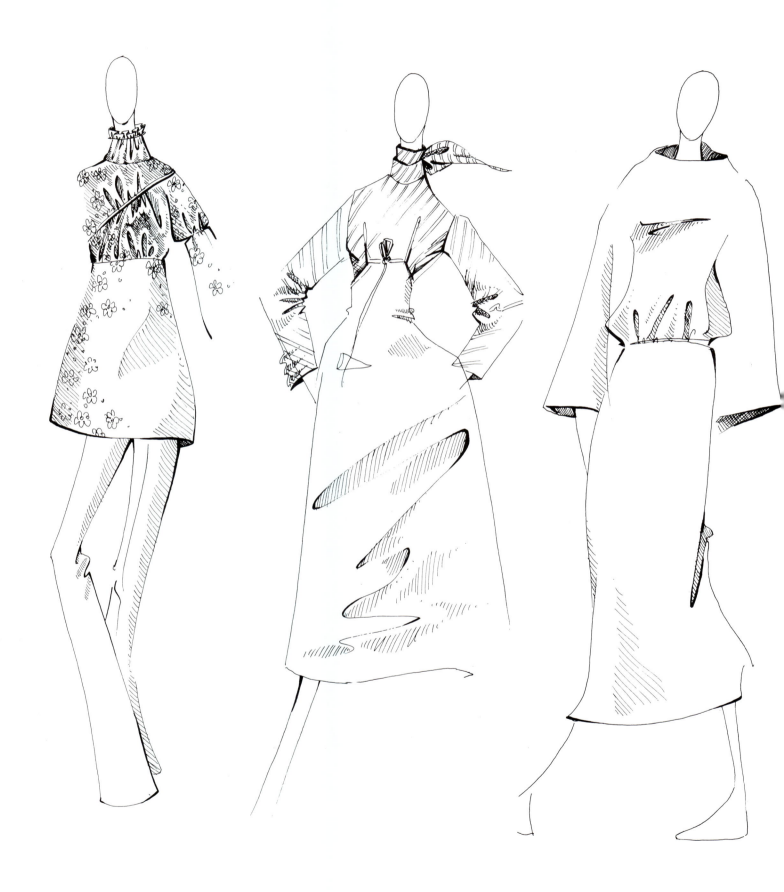

modern
silhouettes

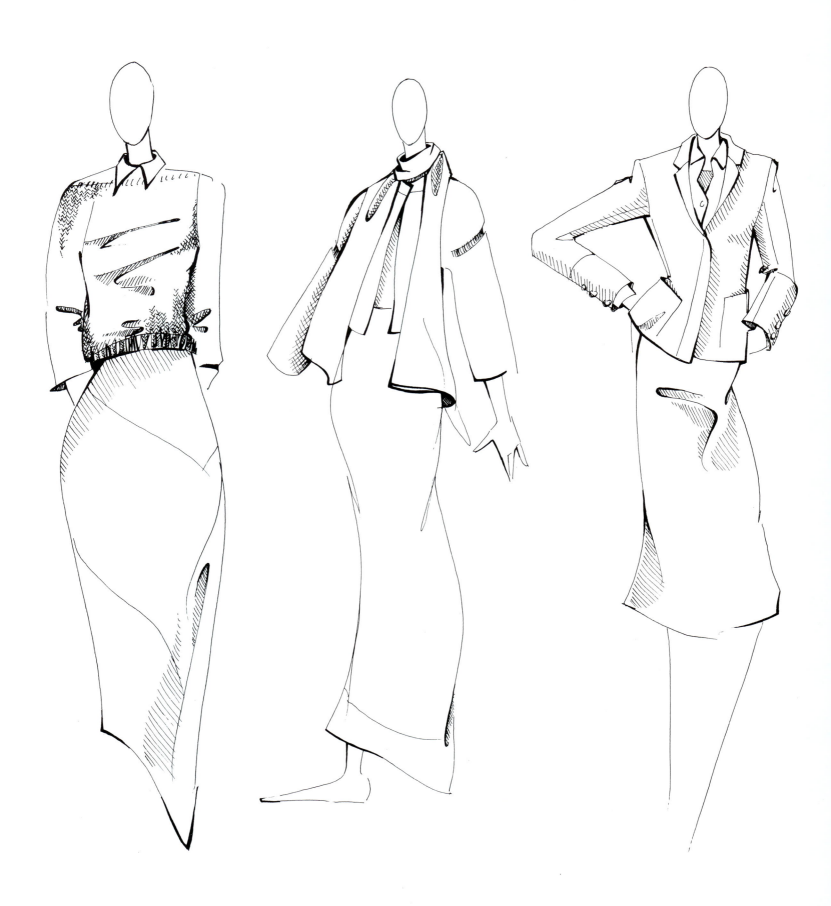

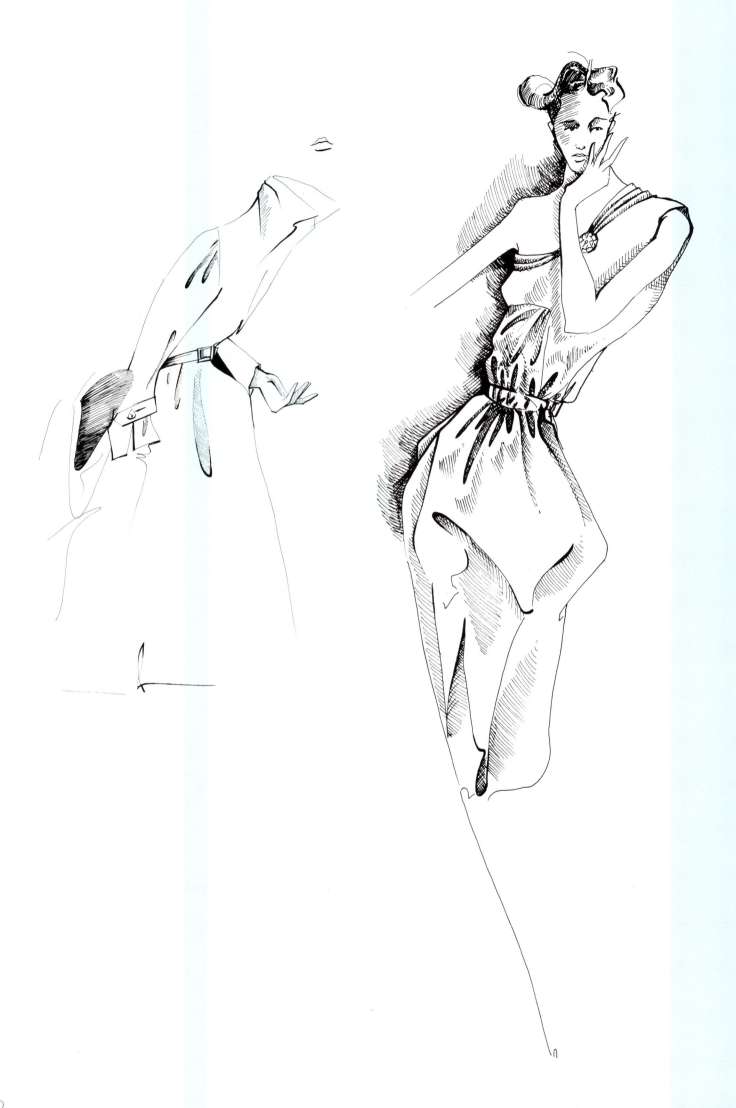

modern
silhouettes

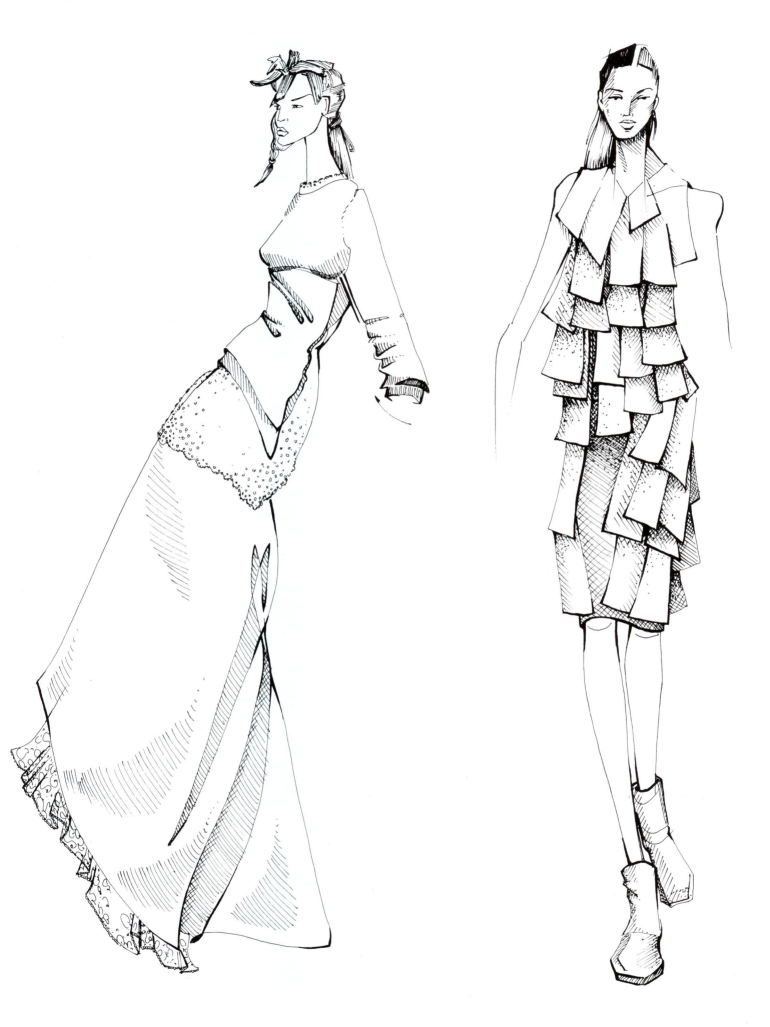

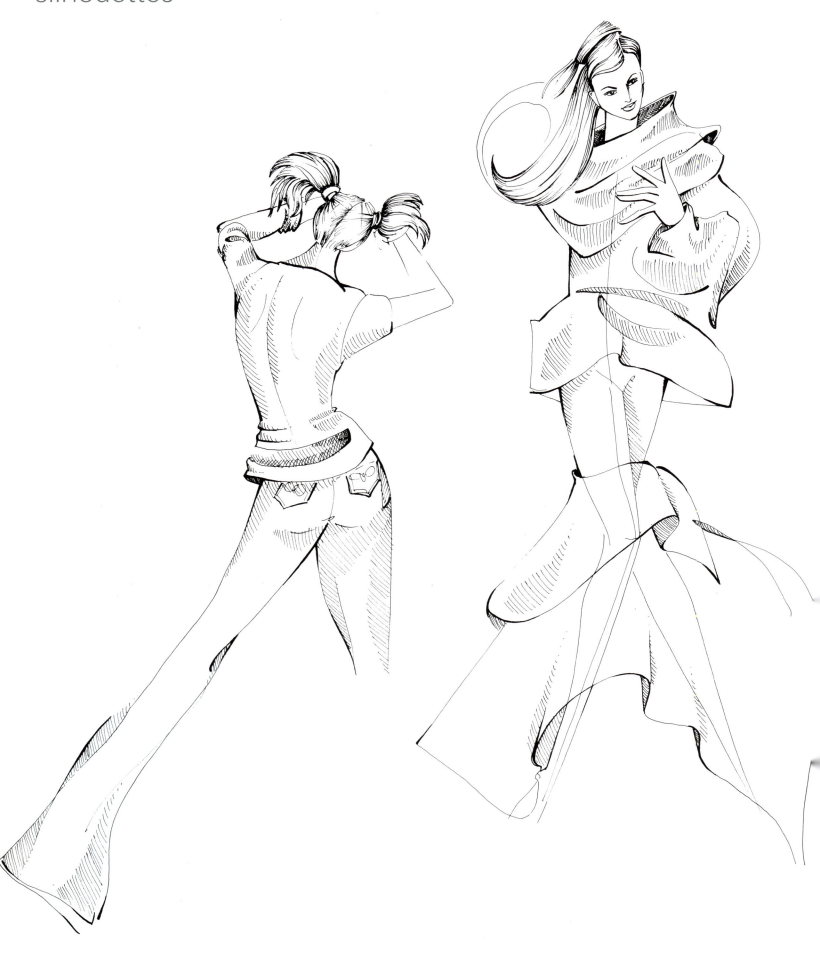

modern
silhouettes

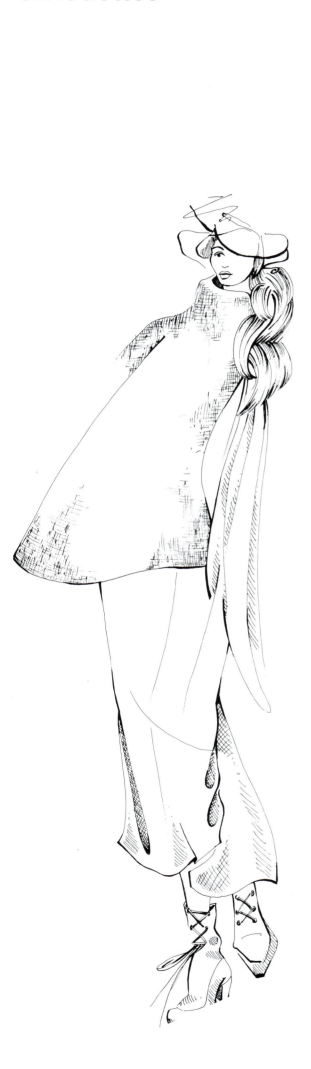

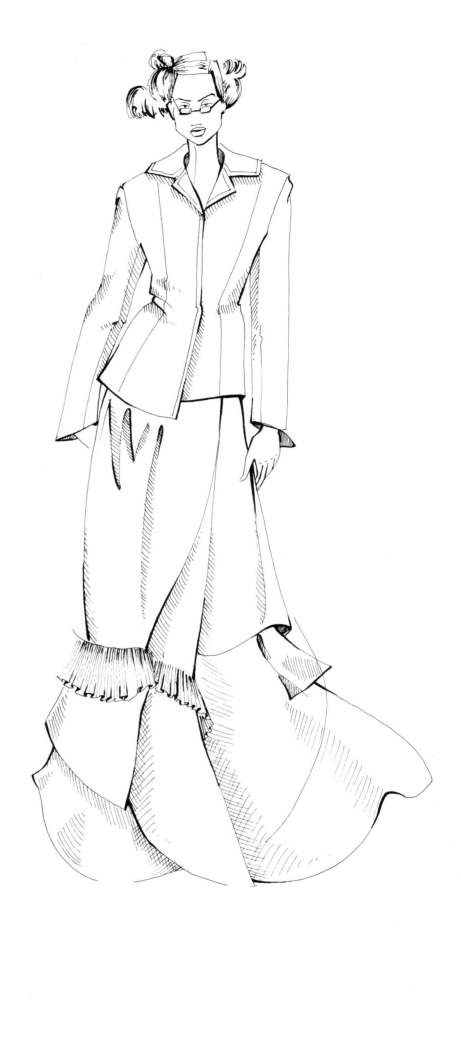

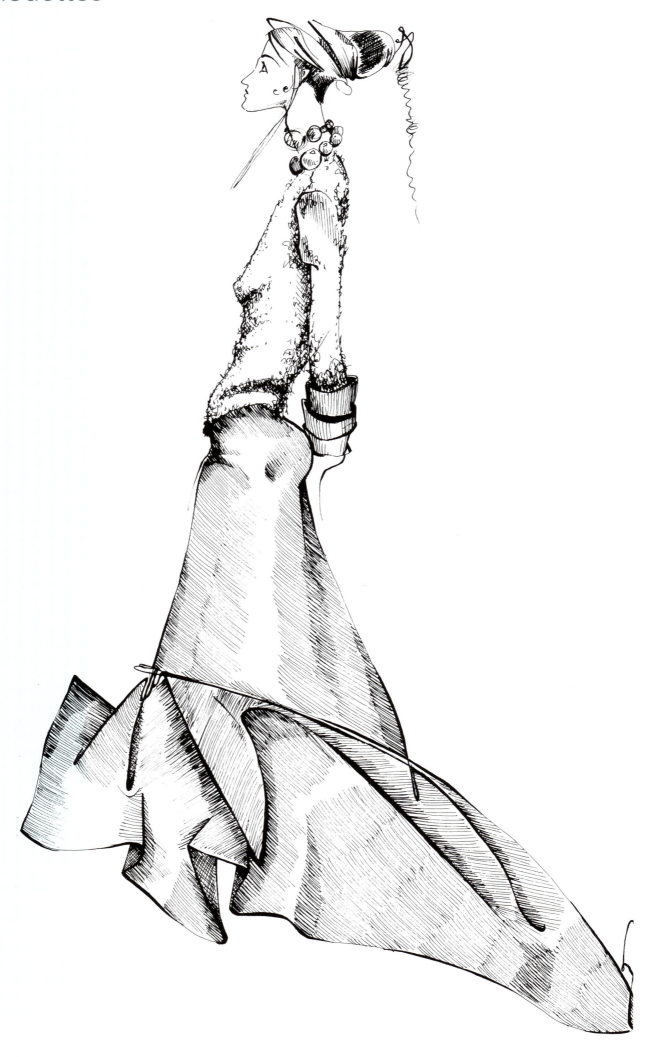

modern
silhouettes

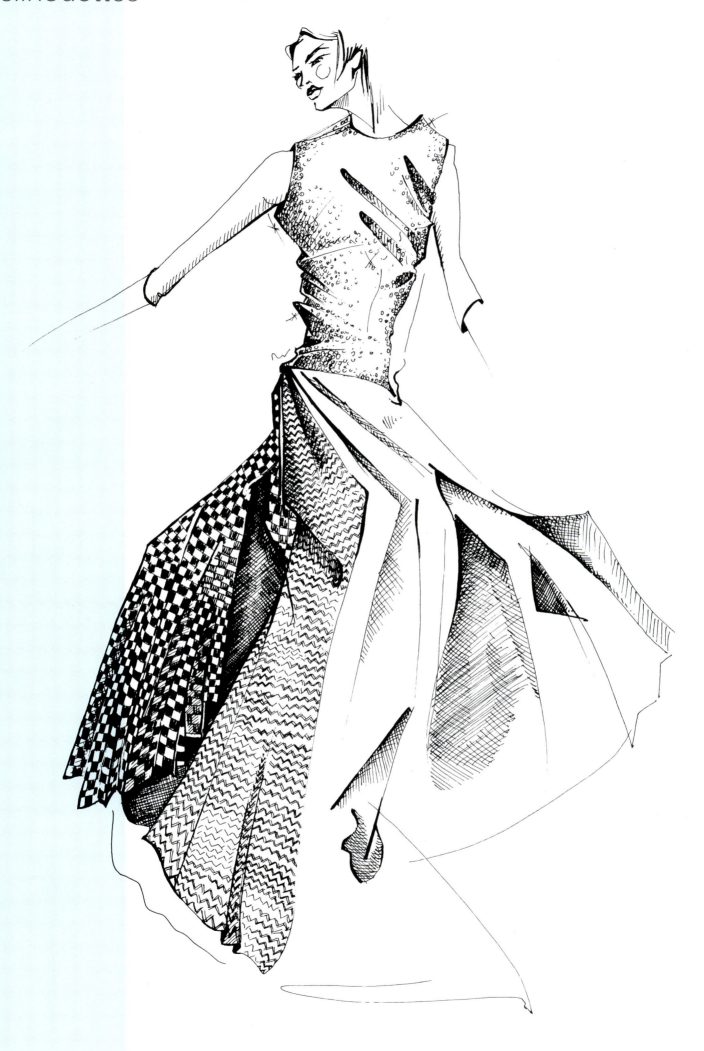

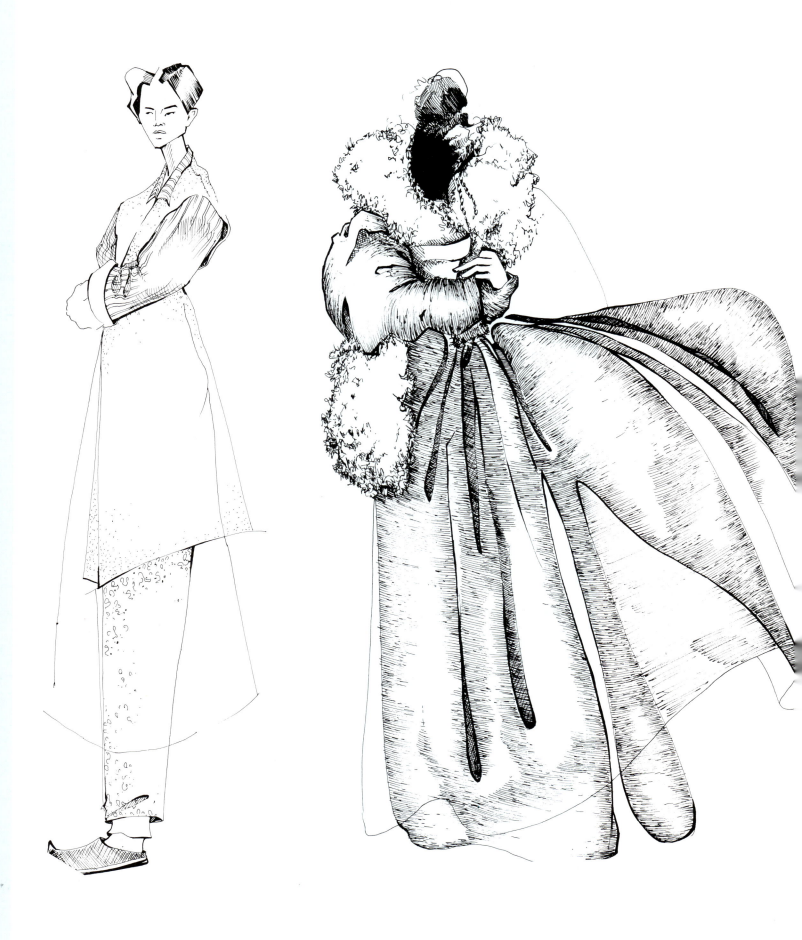

modern
silhouettes

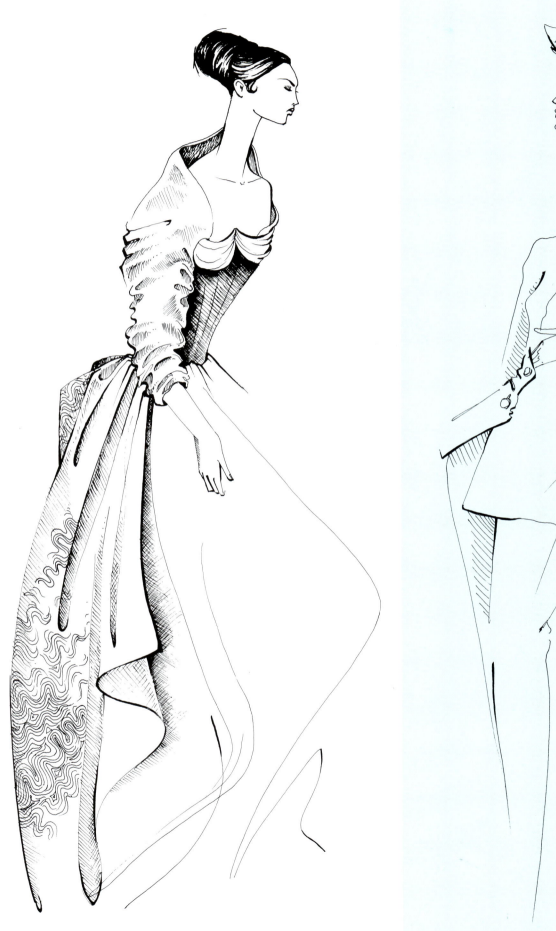

modern
silhouettes

EXERCISE

1. Draw five dresses as flats, referring to
chapter 3 as a guide. Remember flats
are eight heads. Draw a simple figure
croquis using the measurements from
the first chapter. Remember the croquis
will be nine heads long, making the legs
appear longer. Draw spiralling ovals
around the croquis from top to bottom.
This will allow you to see the directions
in which the fabric will bend and fall
around the figure. The next step is to
draw a simple blouse and skirt or a
dress, paying special attention to col-
lars, armholes and hems. Draw these
garments on the croquis, aligning your
seams, looking for drape at the shoul-
ders, the elbow, the waist, the hip and
the hem.

2. Collect photos of skirts. Twelve is a
nice number. Copy these photos exact-
ly, using shading. Begin by drawing the
simplest silhouette of the outside edge
of your garment. Add details of silhou-
ette of drape. Look at the section of this
book on rendering and add shadows.

3. Form an imaginary active sportswear
company (swimming, tennis, mountain
climbing, golf). You can do it alone or
with a friend, in which case you will
have a partnership, with two friends, a
corporation. Give yourself a small busi-
ness loan. You are ready to begin. Give
your company a name, decide on a par-
ticular sport and the type of client you
are designing for—is she a professional
or an amateur? Consider the overall
look of the clothes you are going to
produce i.e. are the clothes very simple,
will you use graphic images, do they
have transparent areas etc.? After you
have made these decisions draw twen-
ty flats starting with very simple shapes.
You could draw one part of the outfit
(a swimsuit for instance) and your
friend could draw accessories. At the
end of this exercise choose your most
successful ideas and draw them on
a croquis.

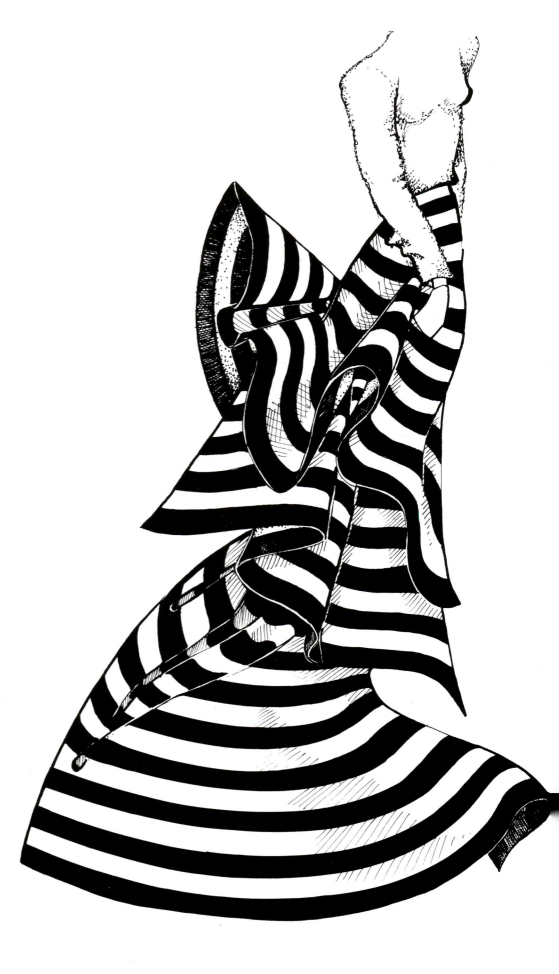

modern
silhouettes

4. Choose a favorite photo from a fashion magazine. Turn the photograph upside down and look carefully at the spaces around and between the areas of the figure. This is called negative space. Turn the figure right side up and draw over the silhouette of the figure and the garment. Trace this outline onto a separate piece of paper. This process will train your eye to see detail and proportion in the garment and will help you to draw better, more convincing figures.

Inspired by Jean-Paul Gaultier

chapter three: accessories

hats

Accessories are items of fashion worn or carried in addition to the primary articles of clothing. They include such items as hats, gloves, jewelry, bags, umbrellas, shoes, scarves and bows, belts, watches, socks, nylons, eyeglasses. Today the range of accessories is wider than ever because of the numerous gadgets of the modern age -cell phones, pagers, sophisticated watches, laptop computers, hand-held electronic devices, cameras, binoculars, videocams, tape recorders, roller skates, skateboards. Accessories used to be made from a limited choice of materials. Today they are made from a far greater range, both naturally occurring and man-made, including plastics, nylon, rubber, metals, papers, leathers and animal skins.

When drawing accessories first pay attention to the material they are made from. If the accessory is made from a solid material, e.g. metal, plastic, glass, wood or gemstone, it should be drawn with a crisp, clean outline. Use a very sharp pencil point or thin ink line. When drawing cut gems (diamonds, sapphires, rubies, emeralds) be sure to leave a tiny separation at the corners where the different facets meet. This gives the illusion of reflection and shine. Draw pearls with a tiny highlight and a dark area where each individual pearl is connected to its neighbor. Be sure that all jewelry appears to go around the body.

HATS

Hats come in many shapes and forms and have many different functions; they can be decorative, protective or form part of a uniform. Hats are also made from a large variety of materials. The hat must fit around the head, with the rim usually extending down the forehead, often as far as the eyebrows. Since hats actually change the scale of our heads, they are a significant and important accessory. Don't let hats levitate, they cannot float in space.

Hat with veil

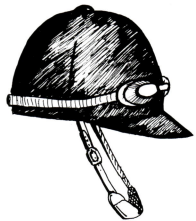

Jockey/horseriding

Feather

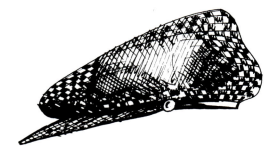

Newsboy/casquette

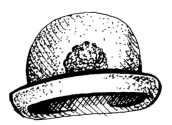

Cloche

Crochet/knit hat

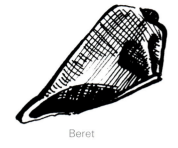

Beret

Fedora

Cossack

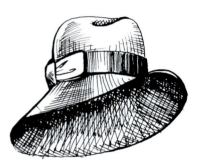

"Garbo" hat/ capeline

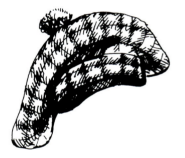

Tam-O'-Shanter

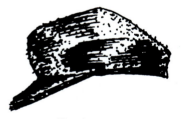

Hunting cap

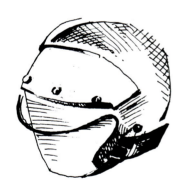

Motorcycle helmet

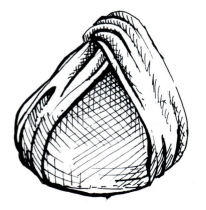

Turban

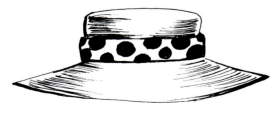

Straw hat

gloves
bows and shawls

GLOVES

Gloves are often made of plastic, fur, fabric, leather or are knitted. They add volume to the hand so must be drawn with care and an elegant line to avoid a bulky sausage-like shape. You can taper the fingers and wrist to enhance the beauty of the drawing. Remember to add stitching, especially round the thumb.

BOWS AND SHAWLS

Begin with a simple butterfly shape consisting of two triangles touching in the center (refer to Encyclopedia of Details). Add the knot , which bends around the center of the two triangles and often has a little fold. Bring the ties or streamers out of the sides of the knot. Remember the streamers cannot come out of the center of the knot. This is a do-not do! Shade with a soft pencil or ink wash. Drawing the streamers in a soft scarf or bow requires more curves and fluid lines as if the wind has softly whisked the scarf into the air. .

Shawls require a large amount of fabric and are often drawn framing the head and shoulders. To show the luxury and fullness of the drape, use sweeping, voluminous lines. Shade with wide, soft tones. Add fringe and pattern as desired.

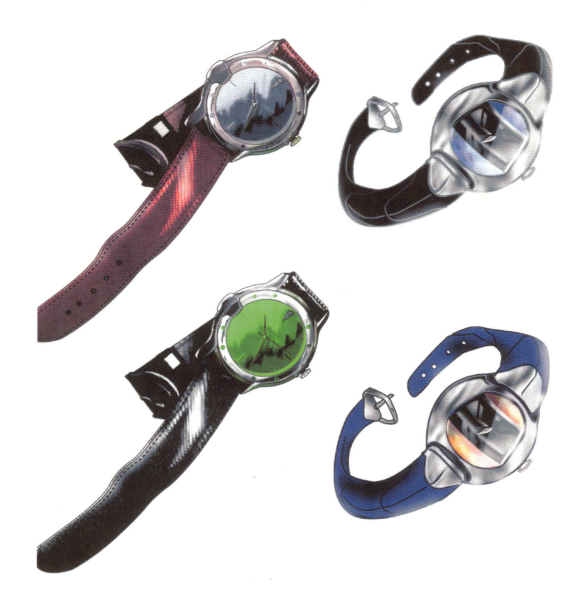

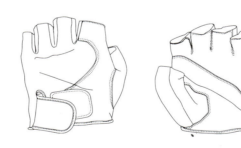

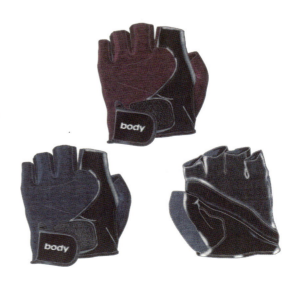

bags and jewelry

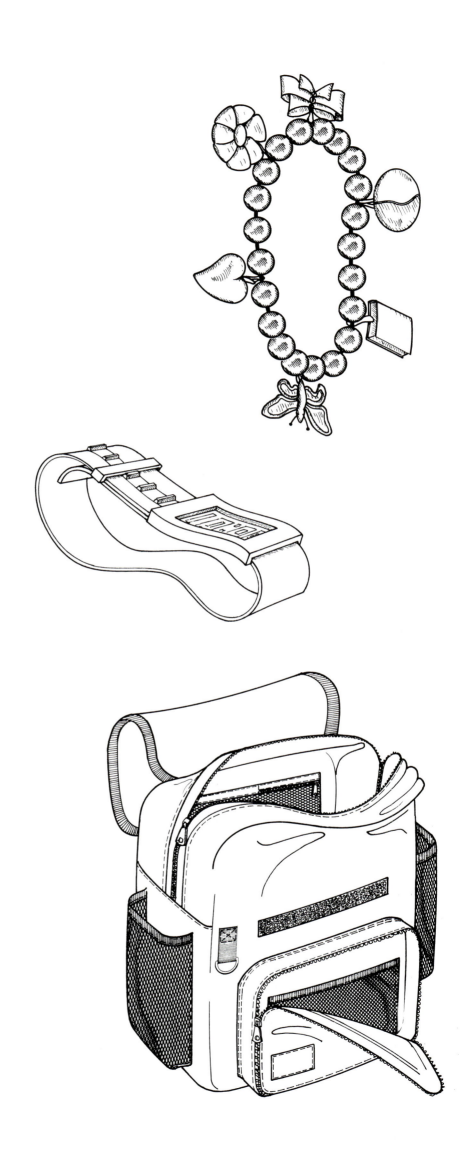

BAGS
The best angle from which to draw a bag to show its design details to the best effect is the three-quarter view. Start with a cube (refer to chapter one); add shading and design details.

JEWELRY, BRACELETS AND WATCHES
When drawing these items, think about simple ovals. A bracelet may be drawn using two parallel ovals, connected at the ends. Shading is darker in the interior of the bracelet. Add additional elements such as beads or indentations using a dark tone. Watches must be drawn with care so that the face and the frame of the watch remain distinct. Surface reflections may be drawn by adding an even tone of pencil. To add the appearance of a reflection on the face of a watch, use a sharp eraser, such as a "Pink Pearl", quickly make a streak across the drawing. This gives the illusion of reflected light.

Notice that a variety of drawing techniques are used in this book: pencil, pen and ink and computer-generated drawings. This is to show the reader how ideas about accessories can be expressed in a number of different ways. Certain techniques lend themselves more to drawing some accessories than to drawing others. Accessories made out of plastic or man-made materials can often be best expressed using a computer-generated drawing; fine, hand-made accessories, like Hermes bags or Tiffany jewelry are usually best drawn by hand.

EXERCISE
Begin by drawing twenty ovals. Divide a piece of paper into four sections. Choose your four favorite accessories from your wardrobe. Look for shadows and light and the materials they are made from. Copy with great care each one of these accessories. If you work slowly and with great precision you will have a piece for your portfolio.

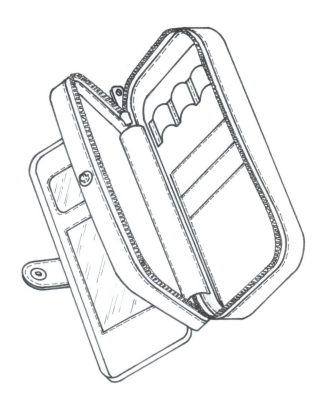

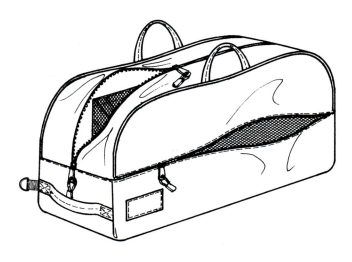

gloves

Mitten with fur cuff

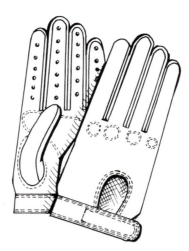

Walking glove/golf glove

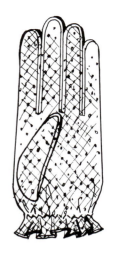

Lace glove with elastic wrist

Arm long with embroidery

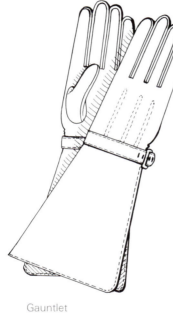

Gauntlet

Shortie

Opera glove with trim

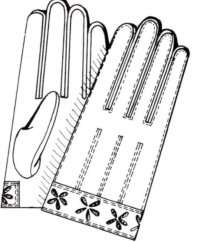

Slip-on with burn out
flower design

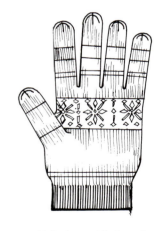

Knit glove with rib cuff and
jacquard inset

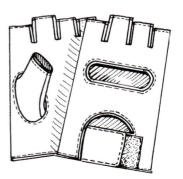

Sports glove/workout glove/half-glove

shoes

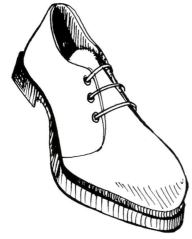

Oxfords

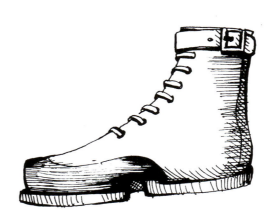

Work boots

Backless/slip-on pump

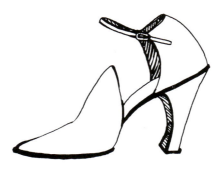

Ankle strap/ D'Orsay

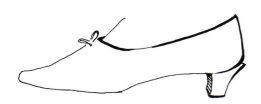

1950s Roland Jourdan
pump (elongated toe)

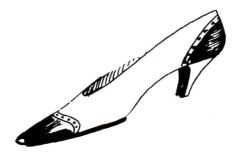

Spectator pump

Delicate woman's pump

Jester

shoes

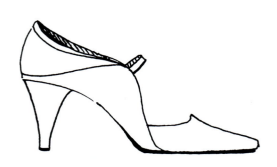

Mary Jane pump

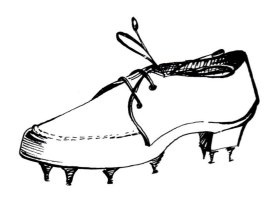

Golf shoe

Saddle shoe

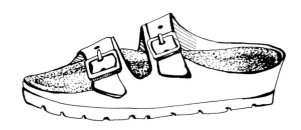

Birkenstock sandals

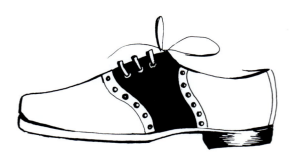

Chopines (17th c.
Venetian lady's shoe)

Ballet shoe

Clog

Sports shoe

shoes

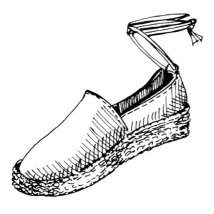

Espadrille with ankle tie

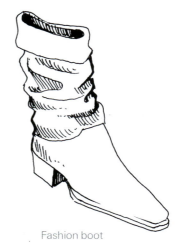

Fashion boot

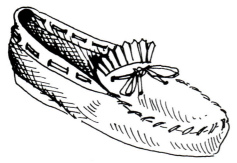

Moccasin

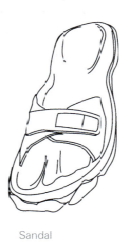

Sandal

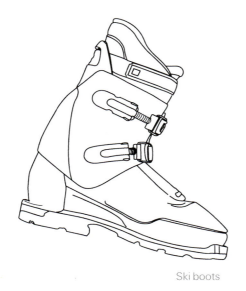

Flip-flop sandal

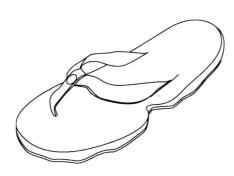

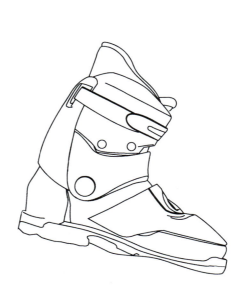

Ski boots

shoes

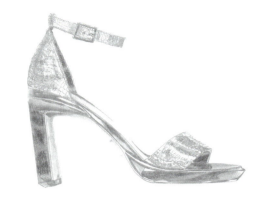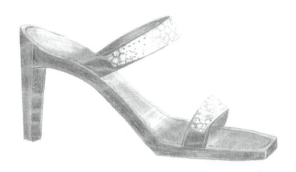

High heels

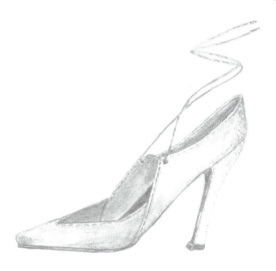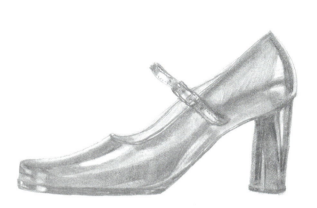

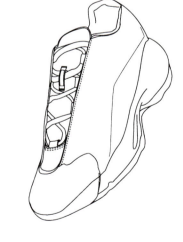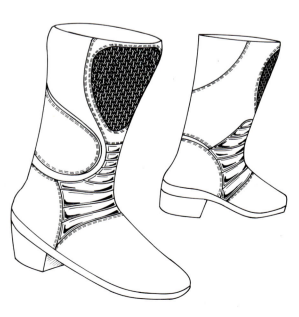

Sneakers

Cowboy boots

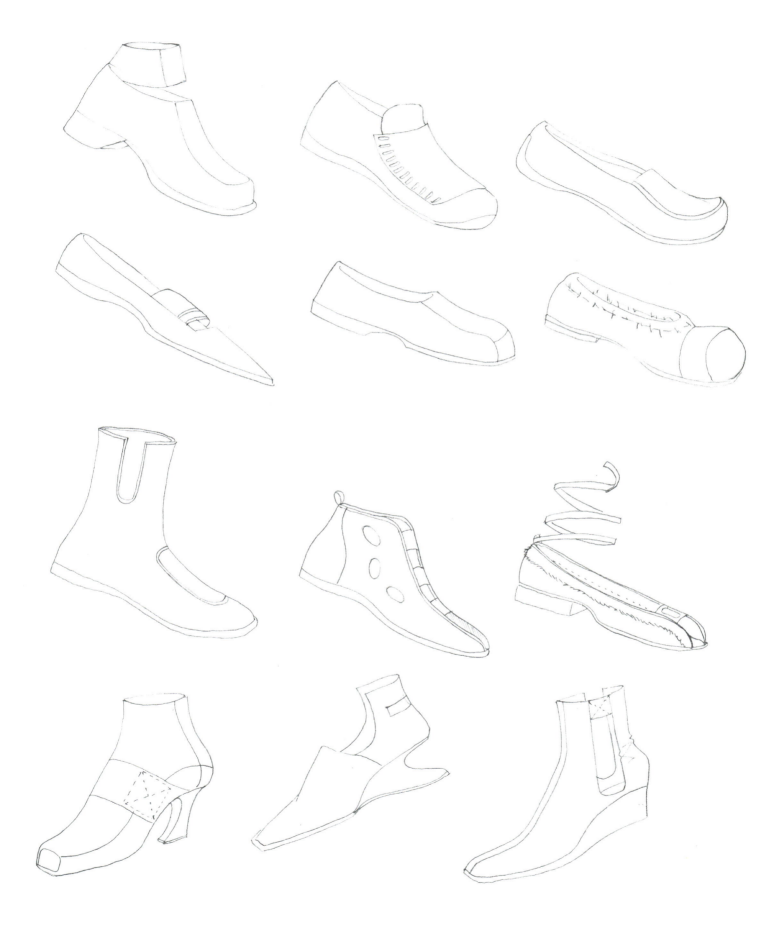

shoes

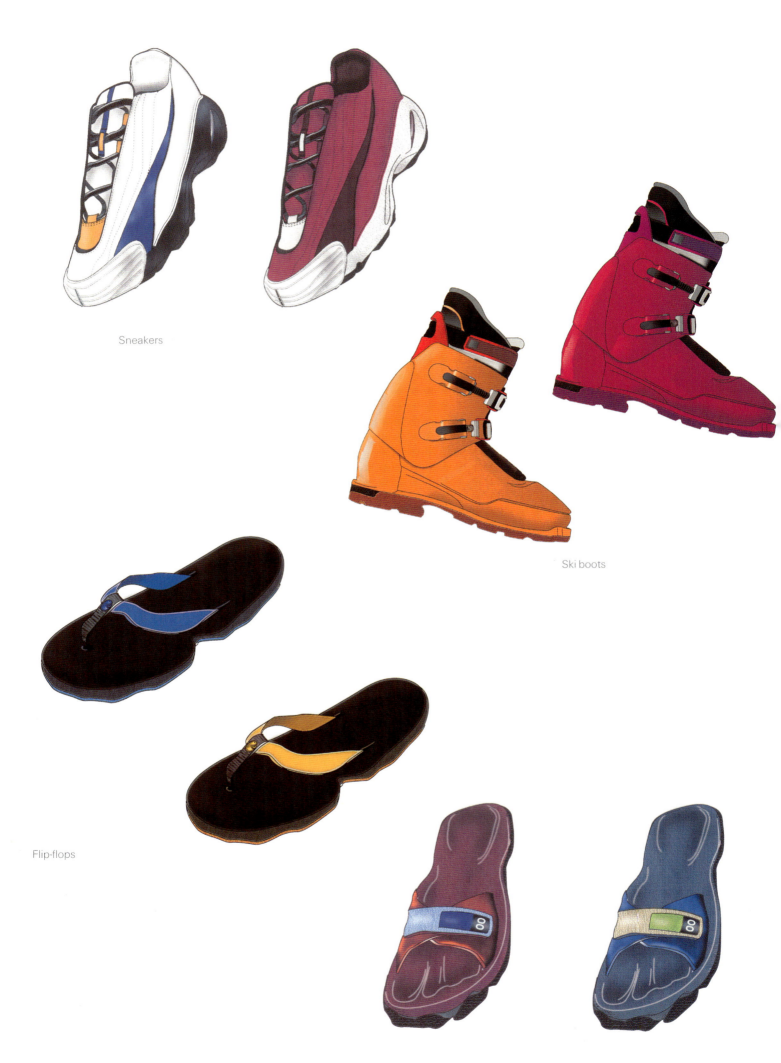

Sneakers

Ski boots

Flip-flops

Sandals

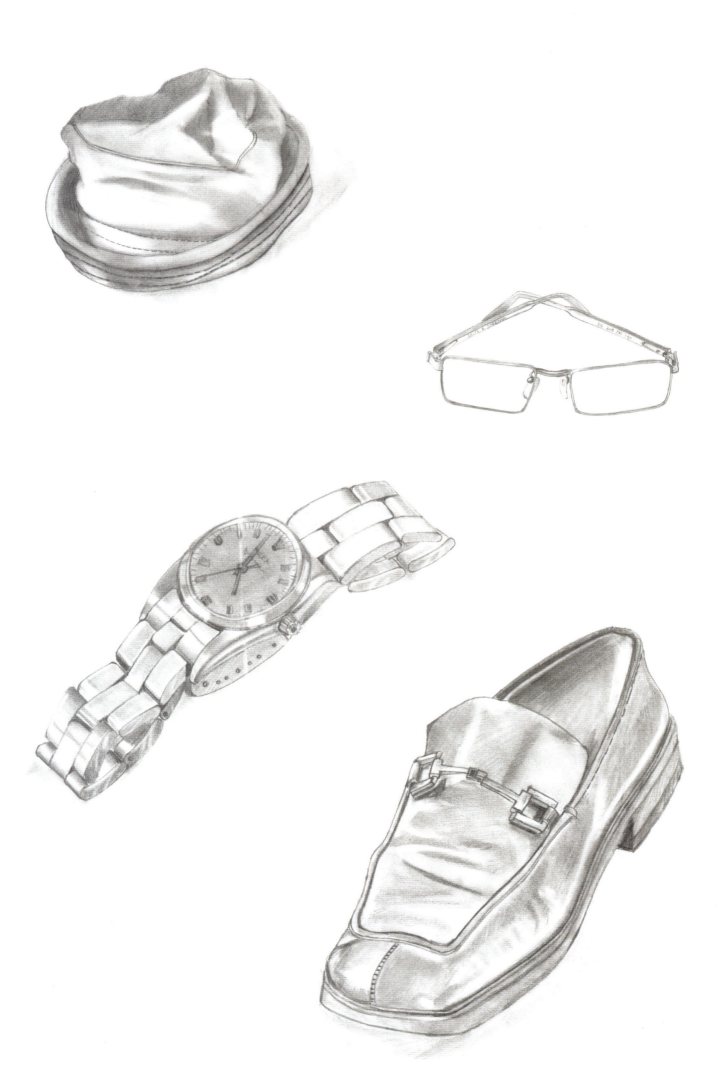

chapter four:
flats

flats

Flats are the essential tool for communi-
cating the specifications—shape, size,
color, fabric, details and style lines—nec-
essary to be able to create a pattern and
construct the garment. To the question:
"How is this garment constructed?" the
flat gives the answer.

1. Flats are drawn symmetrically.
2. Flats are eight heads, reflecting real
proportions. All proportions are the
same as the nine-head figure but the
legs are shortened by one head.
3. Flats must be drawn with a ruler or
French curve.
4. Flats include all seams and construc-
tion details drawn to the scale of the
garment.
5. Flats will appear slightly wider and
larger than garments drawn on a nine-
head figure.
6. Flats are tedious at first. With practice
they become a challenge and can be
entertaining, as the reality of making the
garment becomes clear: should I make a
seam here, or a tuck there?
7. There are several styles of drawing
flats. A common method is to use a cro-
quis and draw the flat over this croquis.
Use the front view of the figure, but
don't forget to double check that all
measurements are symmetrical to the
axis line. Draw with a very sharp pencil.
With a tracing paper over the croquis,
follow the proportions using number 2
as the bust, number 3 the waist, number
4 the hip. The shoulders remain one and
one-half heads wide. To finish the draw-
ing re-draw with a .005 micron pen on
top of the pencil drawing.
8. To create lovely lines, practice draw-
ing the figure from point to point. Try not
to stop the line in mid-stream. Drawing
flats takes practice, not talent. You will
need a 6" or 12" ruler, a french curve,
tracing paper, white-out (for correc-
tions), a cool grey marker (for shading)
and a black .005 micron Pigma pen.

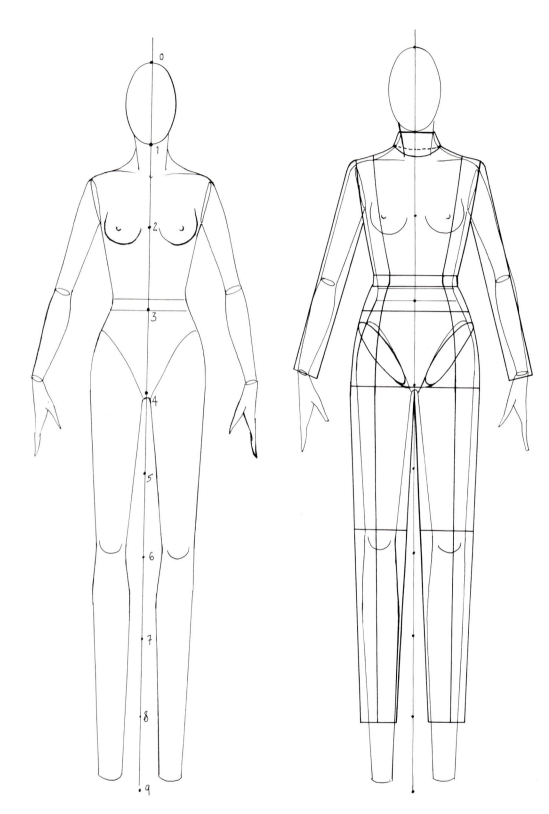

The original nine heads croquis

Template for flats based on eight
heads figure— appears fuller

Skirt/pant flat

1— Establish axis
2— Where does waist sit?
 —high waist
 —on waist
 —natural (just below)
 —high hip (hipsters)
 —low hip (low riders)
3— How long is it?
4— How full is it
 The fuller the shirt the more curves at the hem
5— Where does the fullness come from?

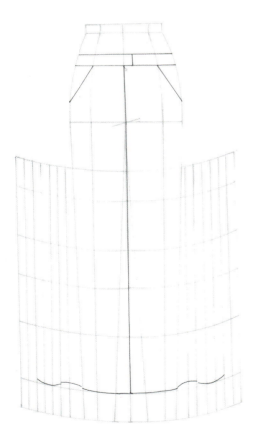

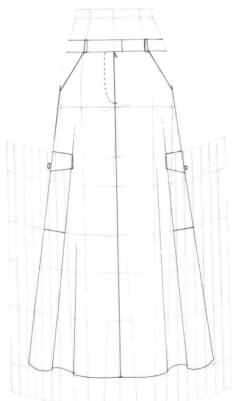

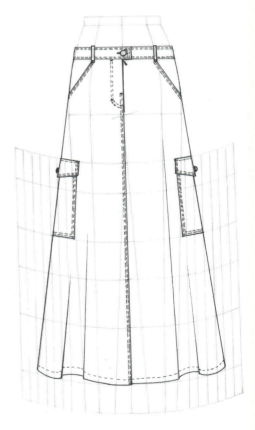

—Flesh in waistband styling
—Draw in pockets
—Draw in center seam & princess seams
if necessary

—Flesh in side seams on "shell" of garment
and any other details

—Add details, ie:
 — double needle
 — zipper
 — shadowing
 — hem
 — belt loops
 — button/buttonhole

templates
body suit/knitwear/tailored

9. A second method for creating flats is to use an axis line, eight heads long, as a guide, with number 1 being the base of the head, number 2 the bust, number 3 the waist, number 4 the hips, number 6 the knee, number 8 the ankle. To make your flats large enough to be easily read, it is best to leave a gap of 1 ¼ " – 1 ½ " between each consecutive number. Use the croquis measurements as a guide and measure from the axis to the right and the axis to the left at each important section of your drawing. Bend the arms at a forty-five degree angle to indicate details in the lower part of the sleeve as in jackets, coats and blouses. Loosely fitting clothes, such as coats and sweat shirts can be drawn on top of a slimmer flat to check proportions. Place all buttons at the center front axis when drawing a jacket or blouse or vest and overlap the fabric from left to right.

Follow this checklist to create professional flats:

1. Make the openings for armholes and necklines one half a head wide (beginners often make these too skinny).

2. Draw the top and the bottom lines of the facing of the collar parallel to each other (beginners often draw bending into each other).

3. Always draw buttons on the cuff on the outside of the arm, facing away from the body.

4. When drawing a double-breasted jacket place your buttons at equal vertical intervals and at equal distances from the center axis line.

5. When drawing fabric with shearing or gathering lines, be careful to draw directly from a seam with more shearing or gathering lines. More shearing or gathering indicates a fuller garment. Make sure this is reflected in your silhouette!

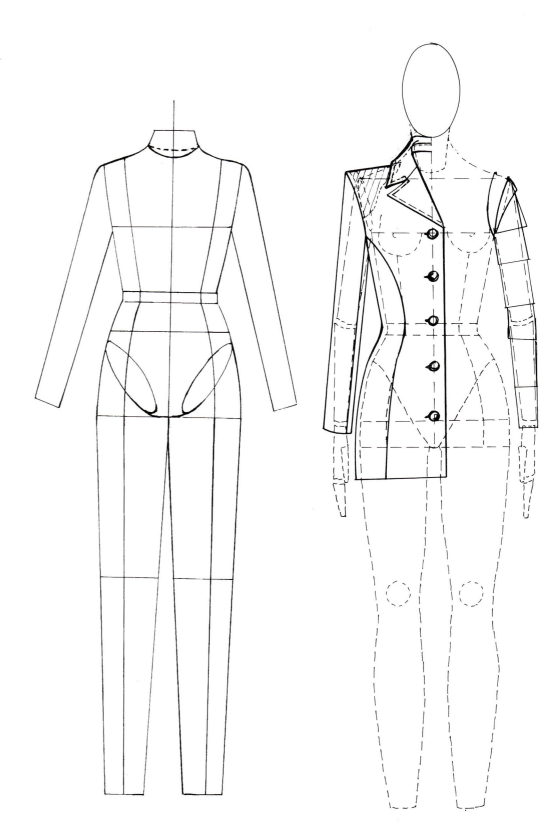

Body suit/knitwear template

Tailored template

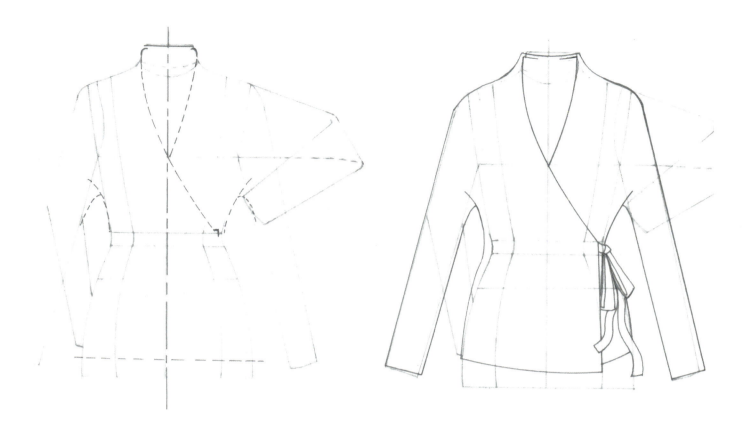

1— Axis
2— Collar opening to wrap point
3— Length
4— Armhole/sleeve adjustment

Flesh in "shell" of body and ties

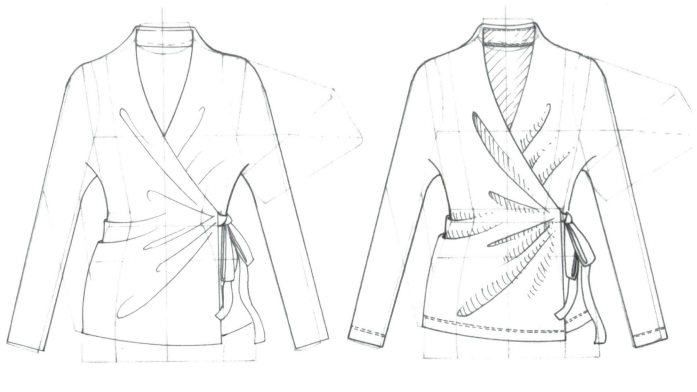

Add drape

— Fill in with shading
— Add stitching details
— How is back neck constructed

templates
body suit/close fitting

6. When drawing zippers don't forget to draw in a seam.

7. Button, snaps, velcro and other closures can be shown clearly by making a separate drawing which enlarges the detail.

8. Draw tucks symmetrically and don't forget to put a seam where the sleeve is sewn to the body of the garment.

The beauty of flats lies in the details. To make everyone's job easy, make yourself a heroine (or hero) by indicating zippers, seams, buttons and other details clearly. Take special care when drawing active sportswear and intimate apparel, both of which have many construction lines. In intimate apparel, a zig-zag line indicates that a seam is sewn twice. Thicker lines may be used under collars and pockets to show a separation of this piece of the garment.

Using flats to design garments allows us to try a number of variations in order to work our way towards the final design. Always begin with the simple silhouette and repeat it horizontally across the page adding a variety of detail until you are satisfied. Precise measurement is essential.

When showing layers of fabric in a flat, use a darker line to indicate shadow and depth. This technique can be used in such areas as lapels, cuffs, overlapping fabric (as in a jacket), slits in skirts, pleats and zippers.

Patterns and graphic images may be drawn on a small area of the flat. This saves time and effort.

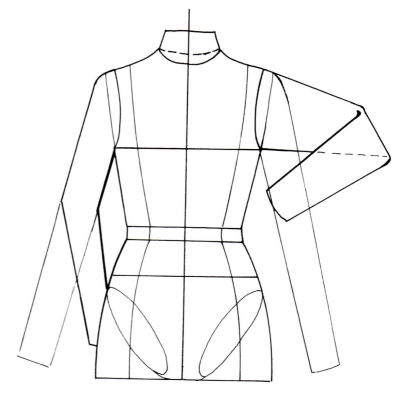

Body suit/close fitting template

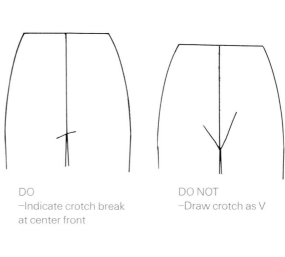

DO
–Indicate crotch break at center front

DO NOT
–Draw crotch as V

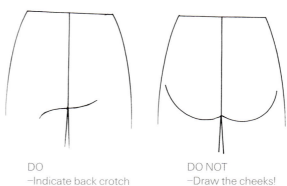

DO
–Indicate back crotch with more elongated line

DO NOT
–Draw the cheeks!

DO
–Curve the hem on shaped hemlines for shirts, skirts and pants.
–Remember, when you make a pattern you *square* your seams. Same principle applies.

DO NOT
–Show A-lines as triangles

1— Establish center front and position of buttons. If single breasted, buttons will be on center. Space evenly by marking center of each button.

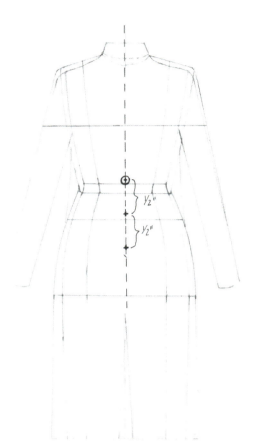

2— Establish extension from center front and thereby the breakpoint of the collar.
— Add buttons
— Add collar roll by hugging neck and drawing slightly curved line from neck to break point.
— Repeat other side. Note: this line will be to the imaginary break point on the other side of the jacket. If this is done correctly the ends of the collar rolls will be at center front.
— Establish finished length of coat.
—Make allowance for the thickness of shoulder pads (incorporate into the croquis)

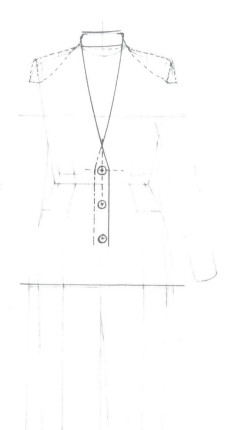

3— Establish lower lapel first. Then add top collar shape.

4— Pencil in internal details of the jacket ie.welts, princess seams etc.

5— Establish hem line shape at front and pencil in. Again measure from center front to check symmetry.

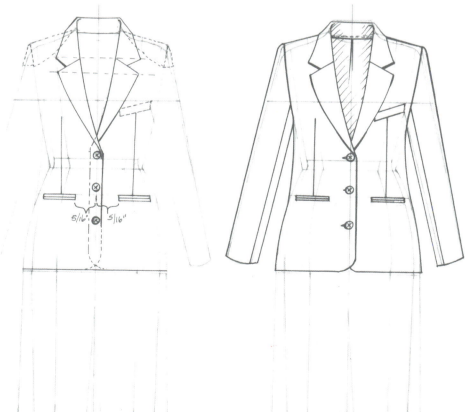

6— Add in "shell" of jacket.
— Ink in details & add buttonholes (usually keyhole on tailored jackets).
—Top stitching (if any)
— Lining details (if any)
— Shading to give depth under collar, lapel & back (preference)

Note: Tailored jackets generally have two-piece sleeves. Do not forget!

templates
fitted dress/square jacket

Questions to ask when sketching flats

— Is it knit or woven?
— If woven and fitted—how? (princess seams, darts)
— Shoulder pads?
— Buttonholes: which direction— are they at the stress points— bust, waist, hips; evenly spaced; extension at placket relates to size of button?
— Pockets; functional or decorative?
— How do I get into this garment?
— Do style lines match up?
— How loose is the garment?
— Stitching details?
— Buttons; What type?
— Does the croquis match the market i.e. juniors, missy, contemporary, designer, toddler, infant? Proportions change!

EXERCISE

Copy and trace one hundred flats. Use this book or professional patterns as a guide. Draw your favorite outfit as a flat. Draw a simple silhouette, e.g. a T-shirt. Add a pocket (refer to Dictionary of Details) then add a collar. Observe the difference between flats for knits, tailored garments and lingerie. Knitted flats fit the form, tailored flats tend to be boxier and lingerie flats tend to be drawn using complicated stitching and details.

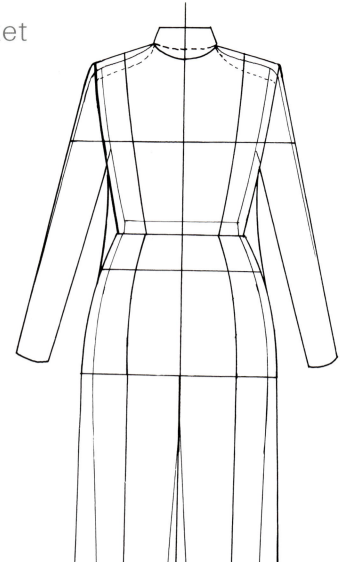

Fitted dress/jacket template

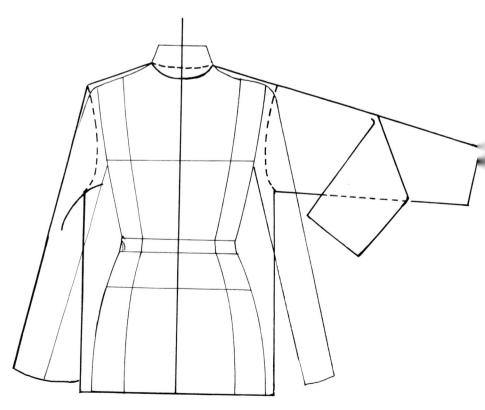

Square jacket template

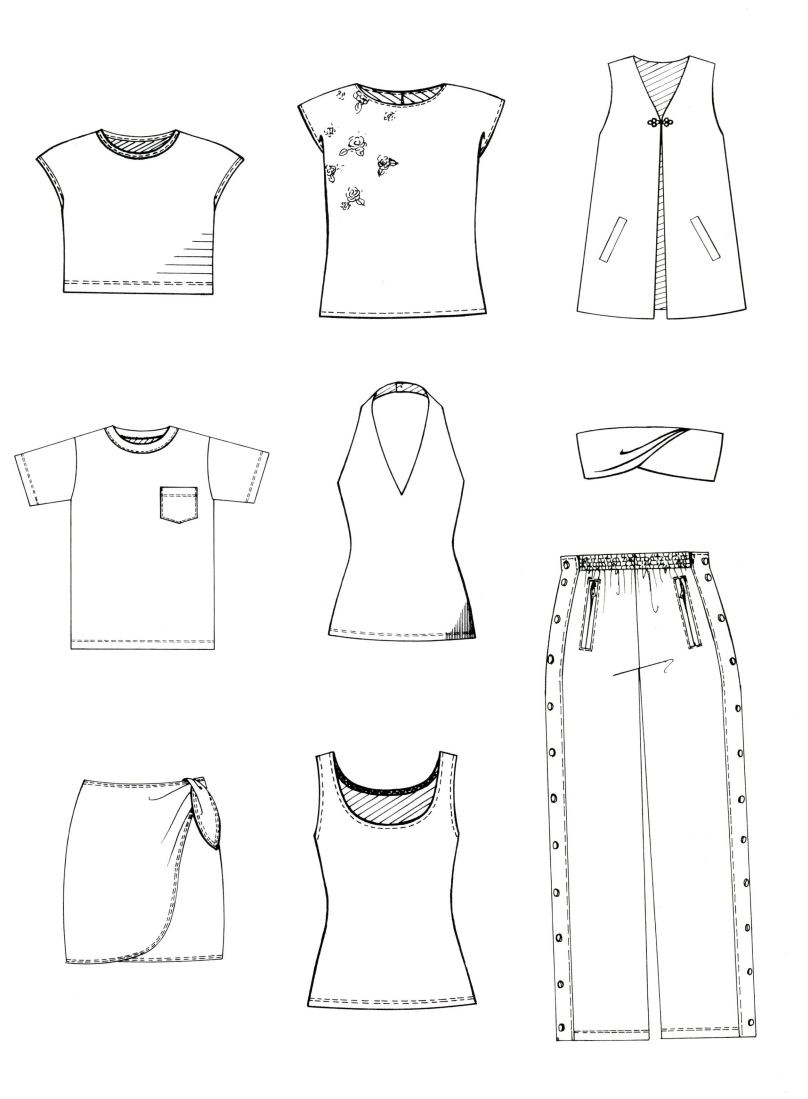

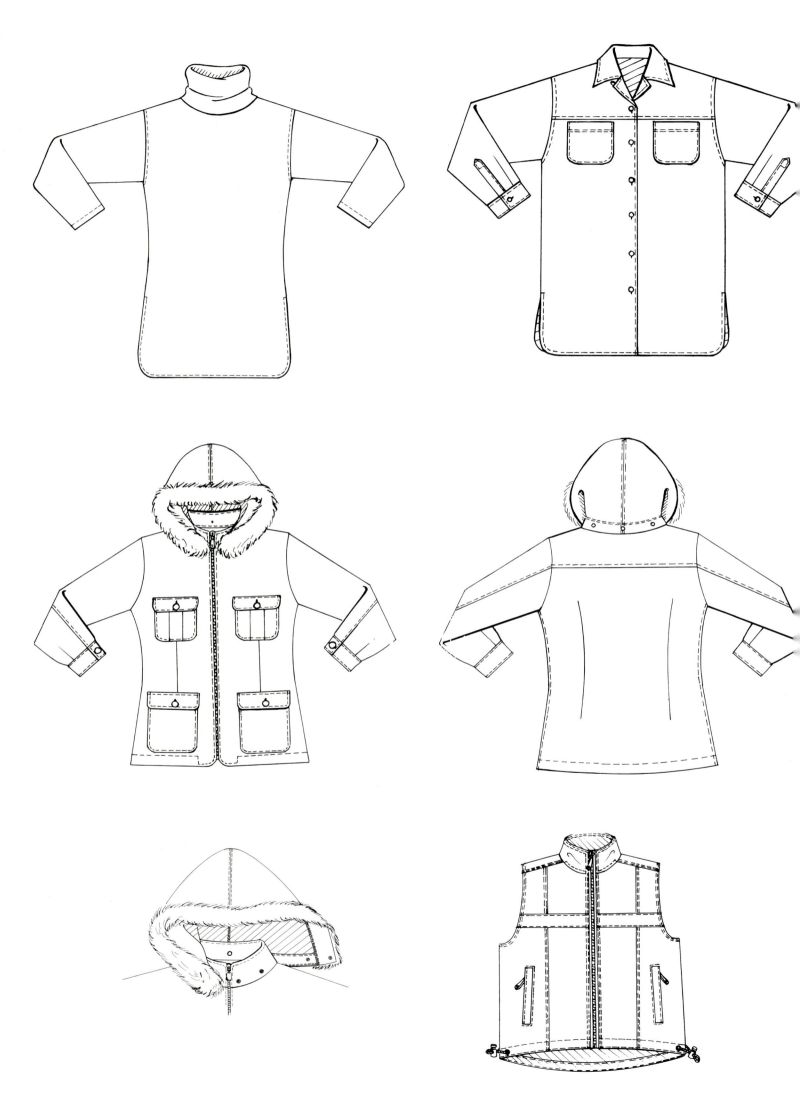

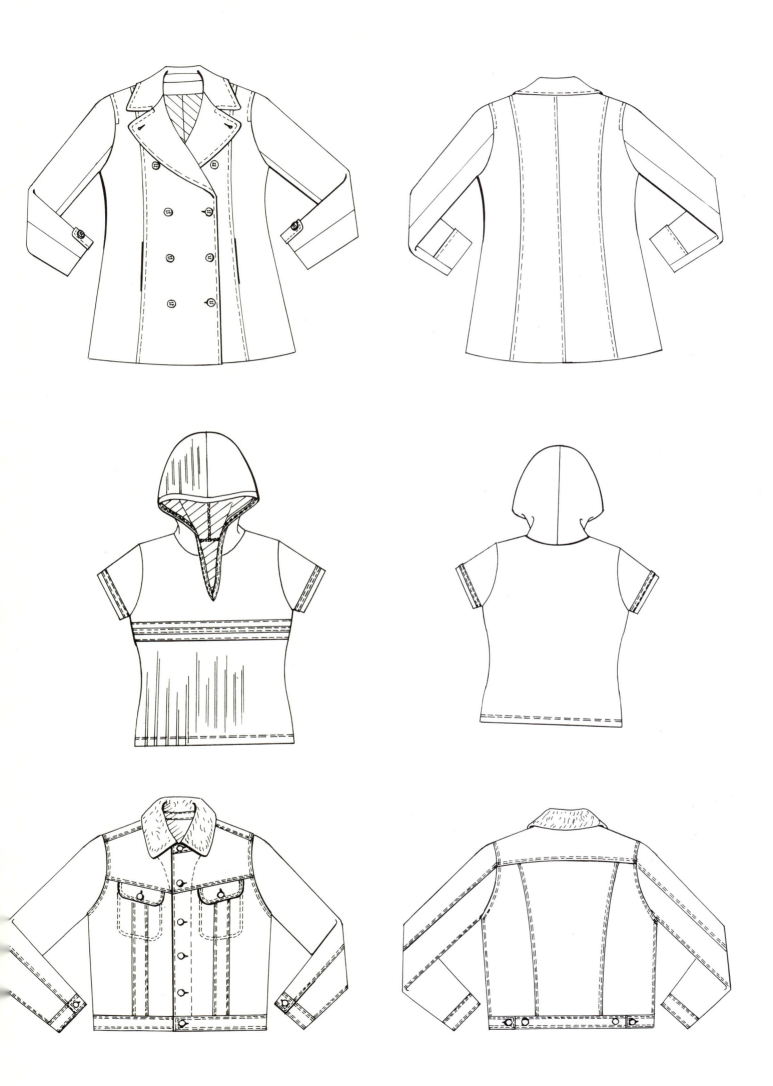

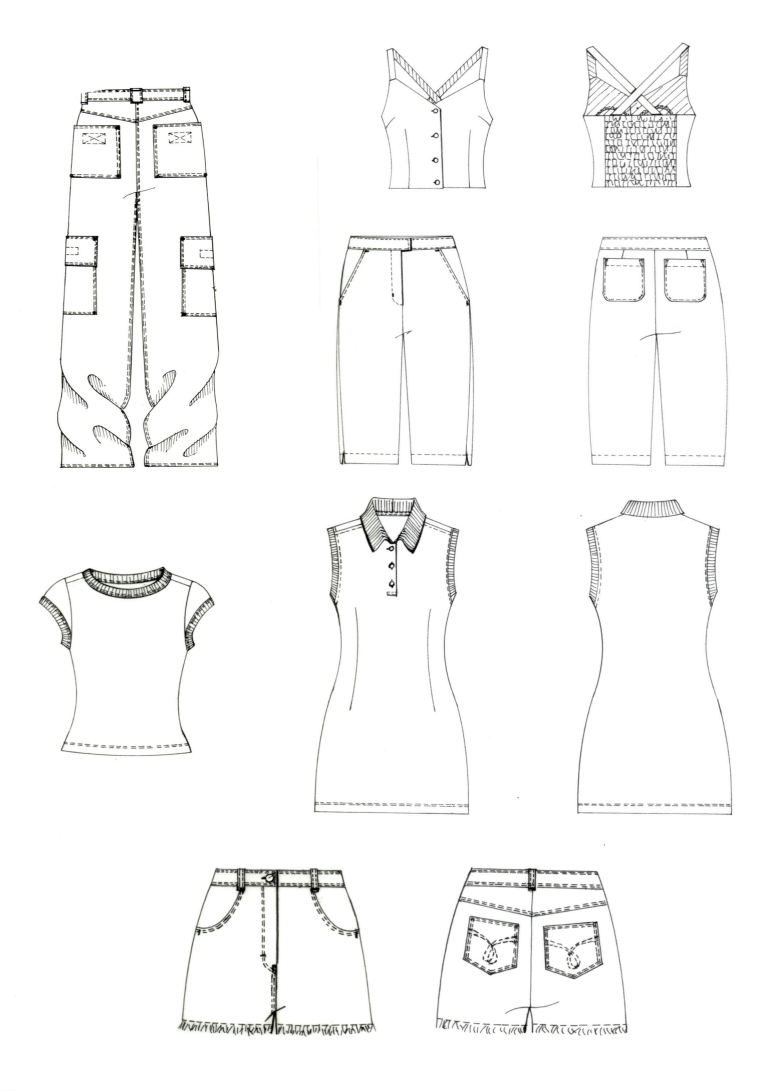

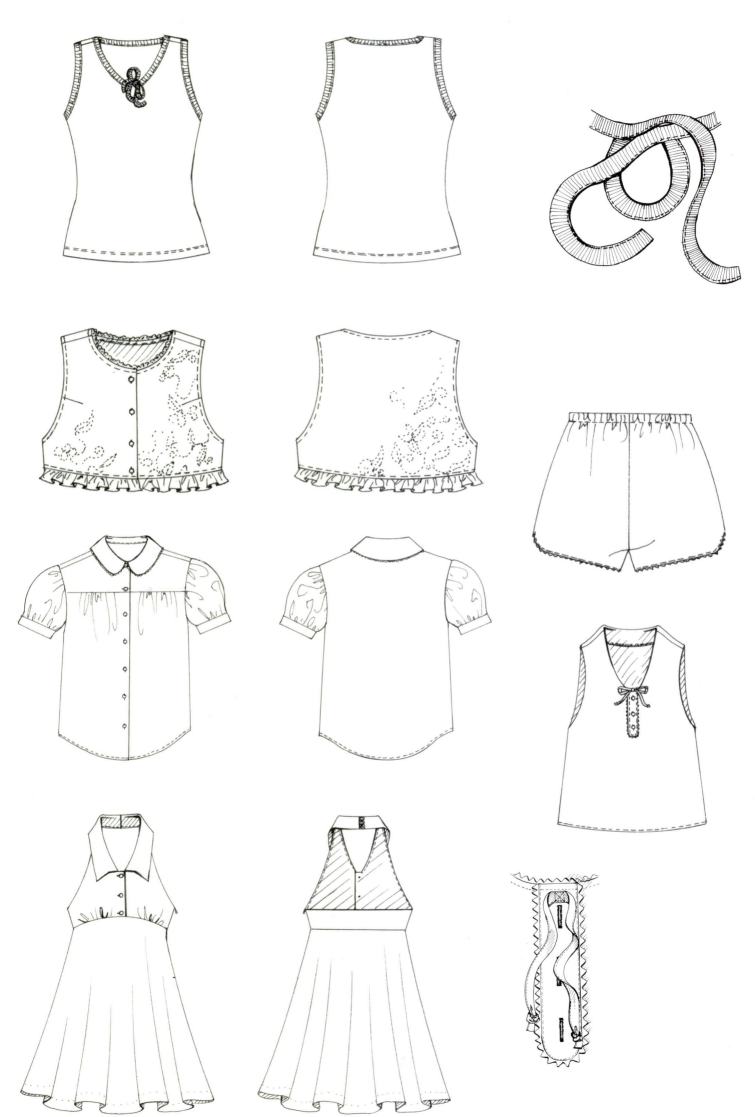

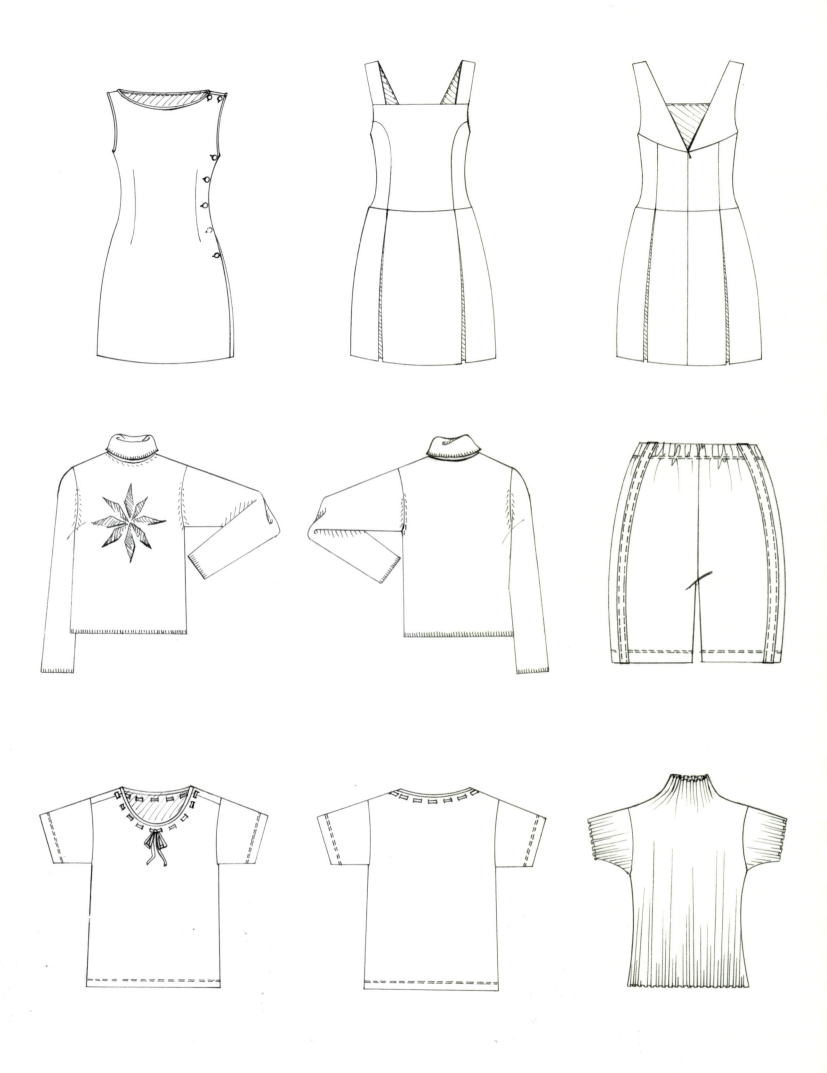

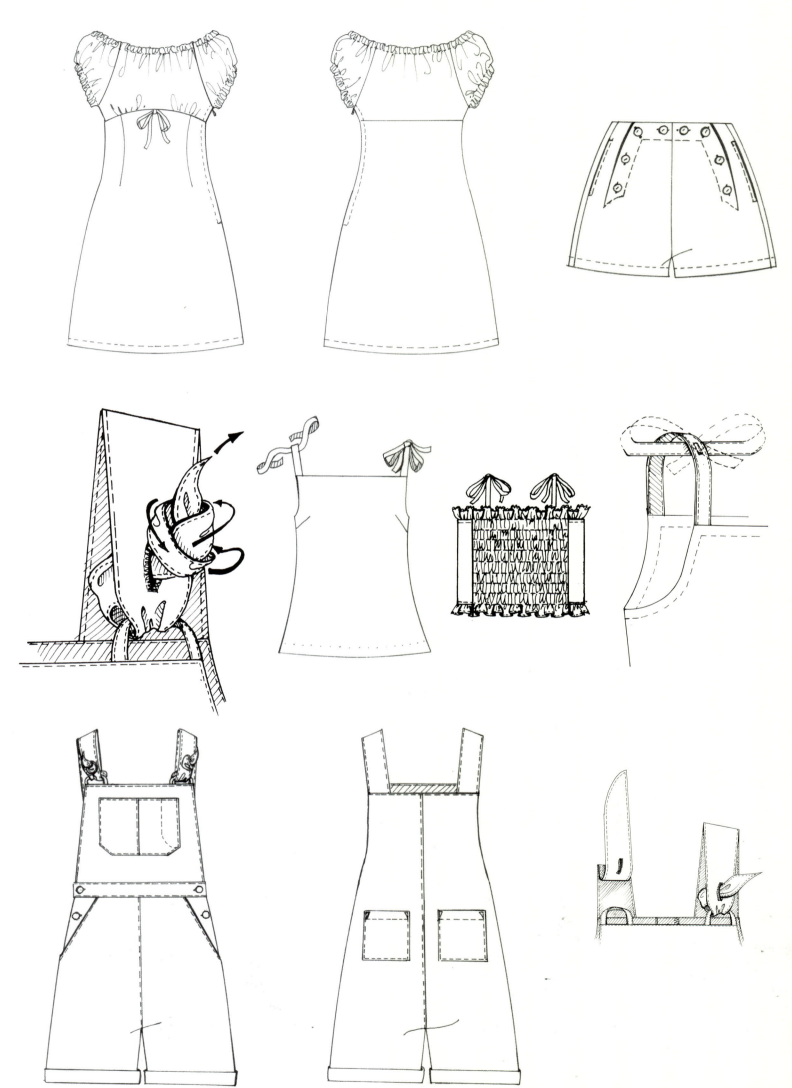

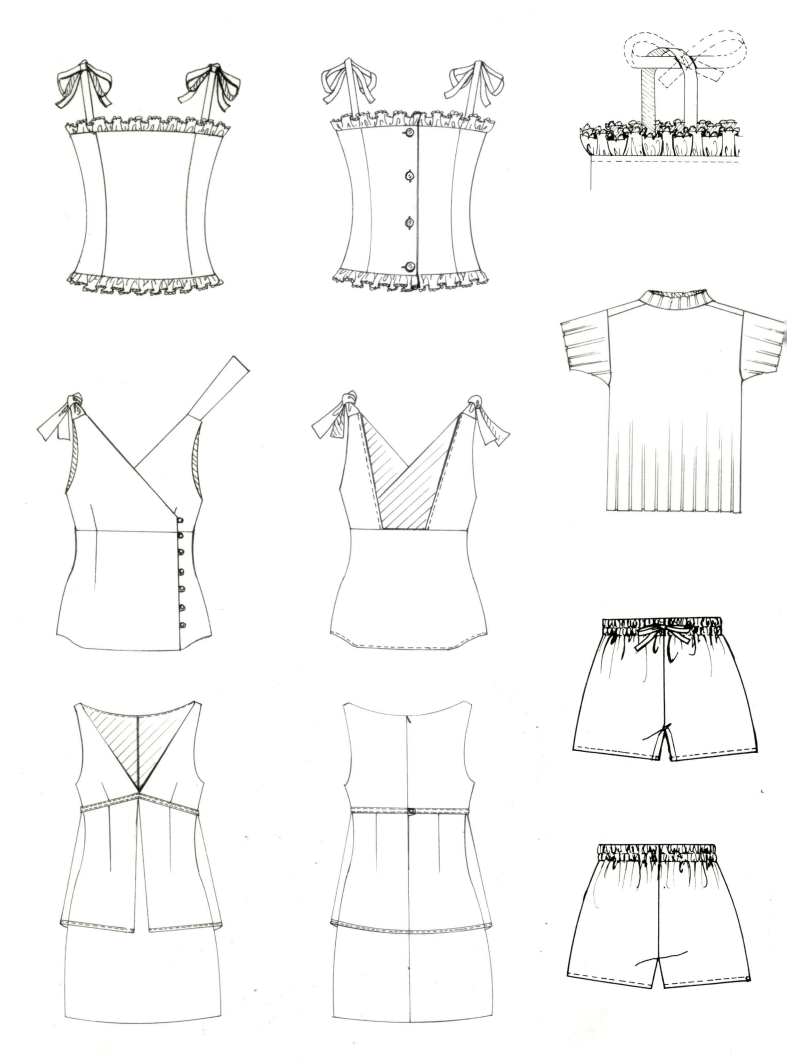

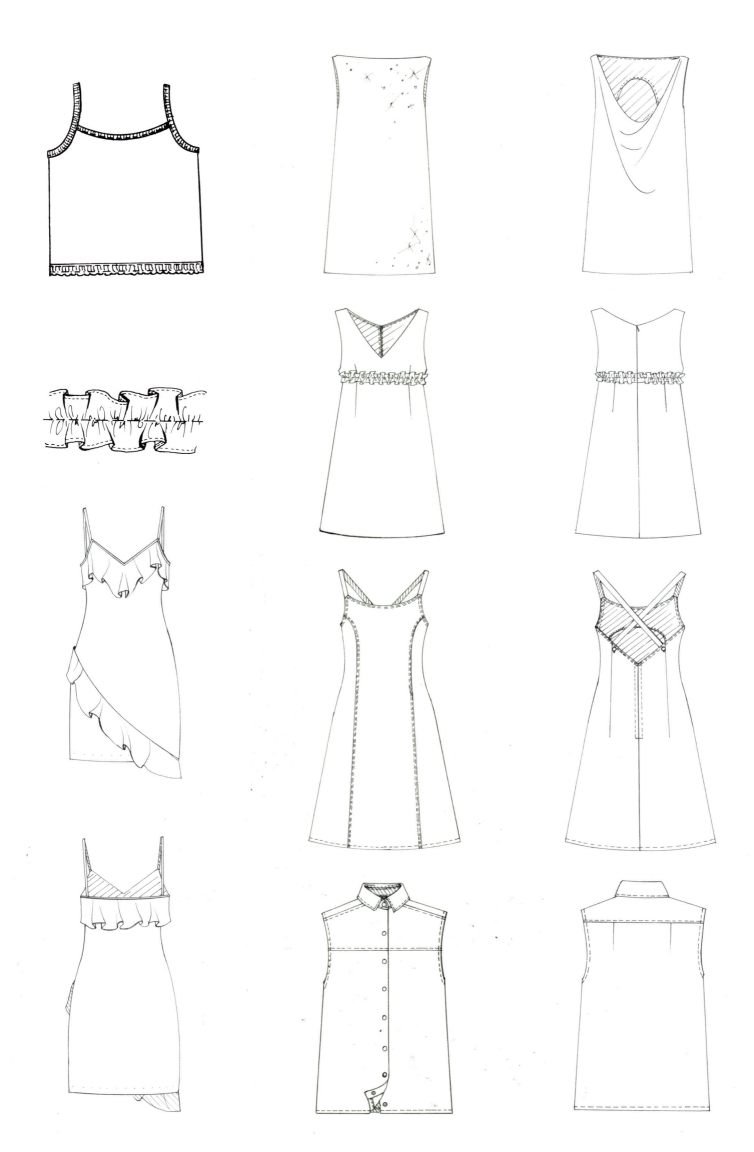

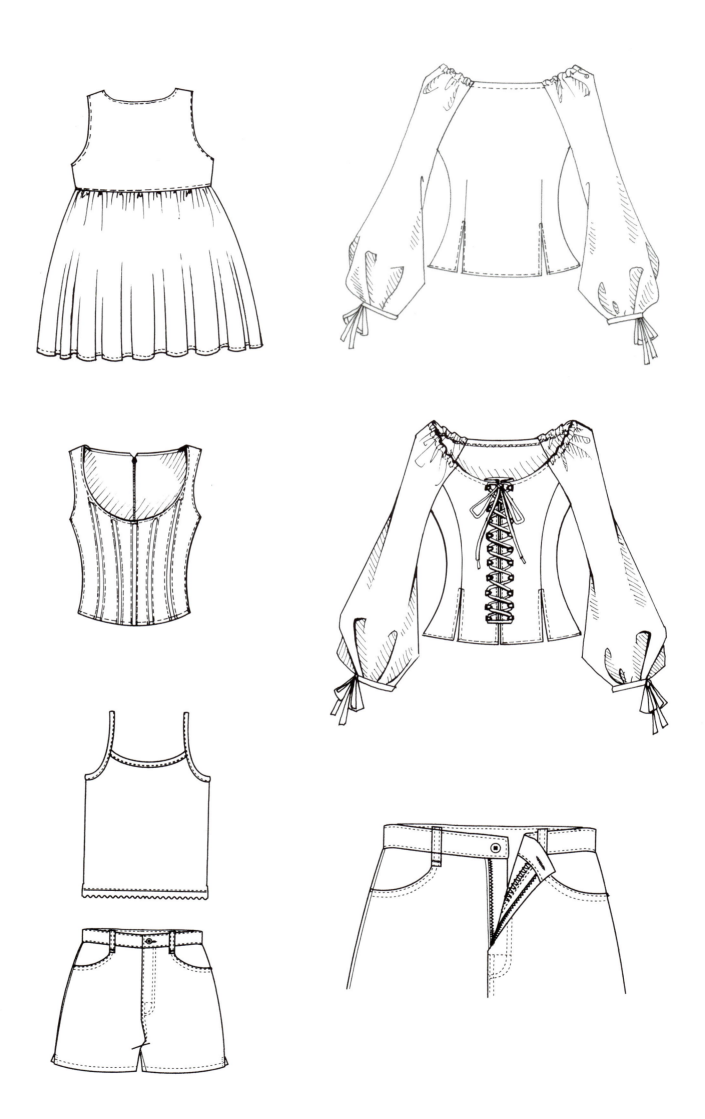

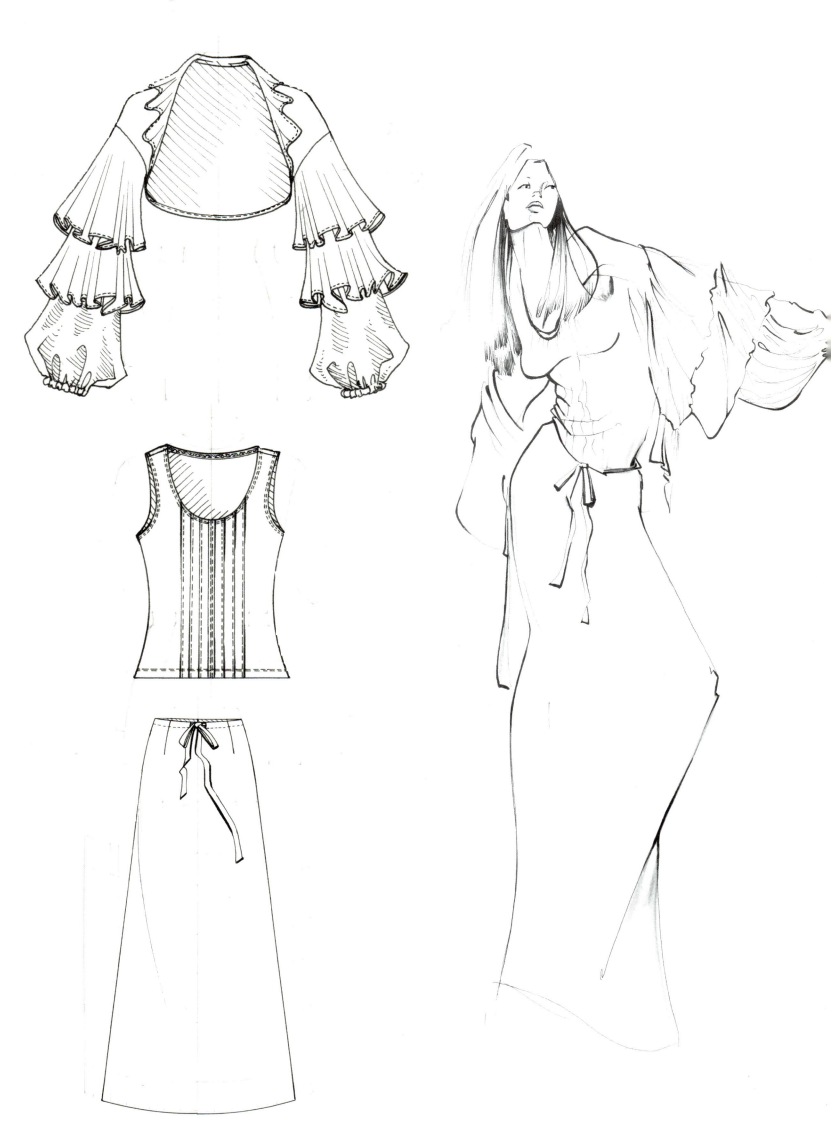

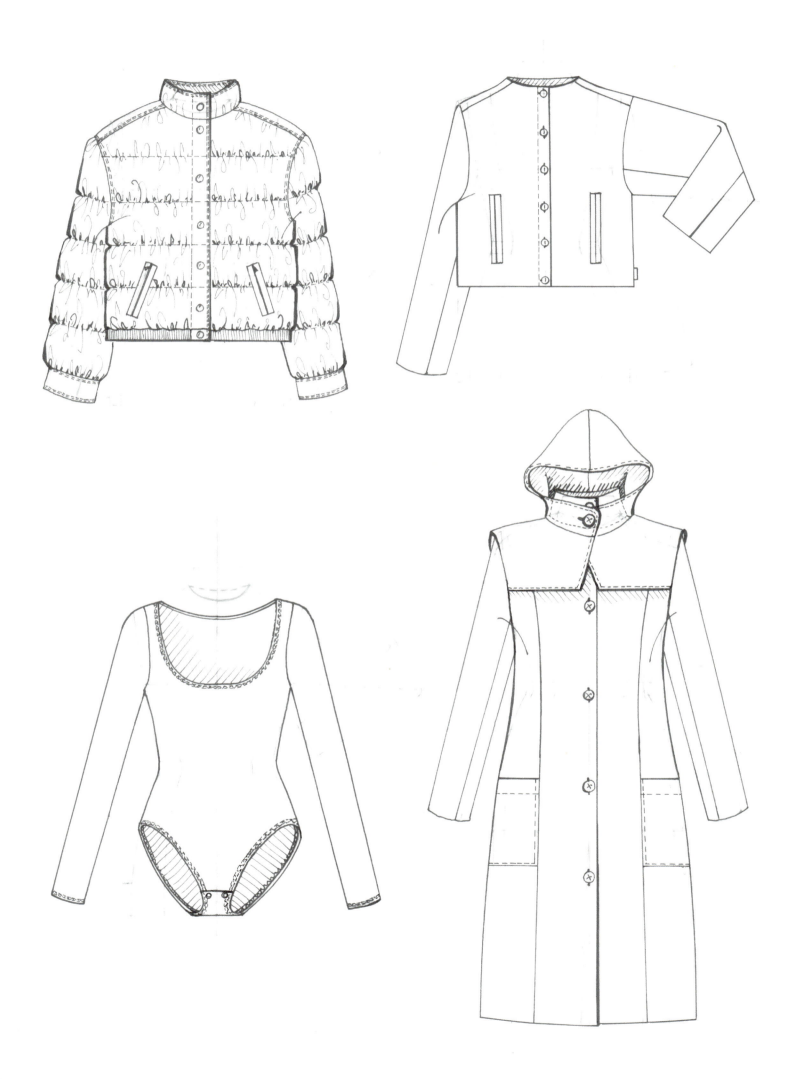

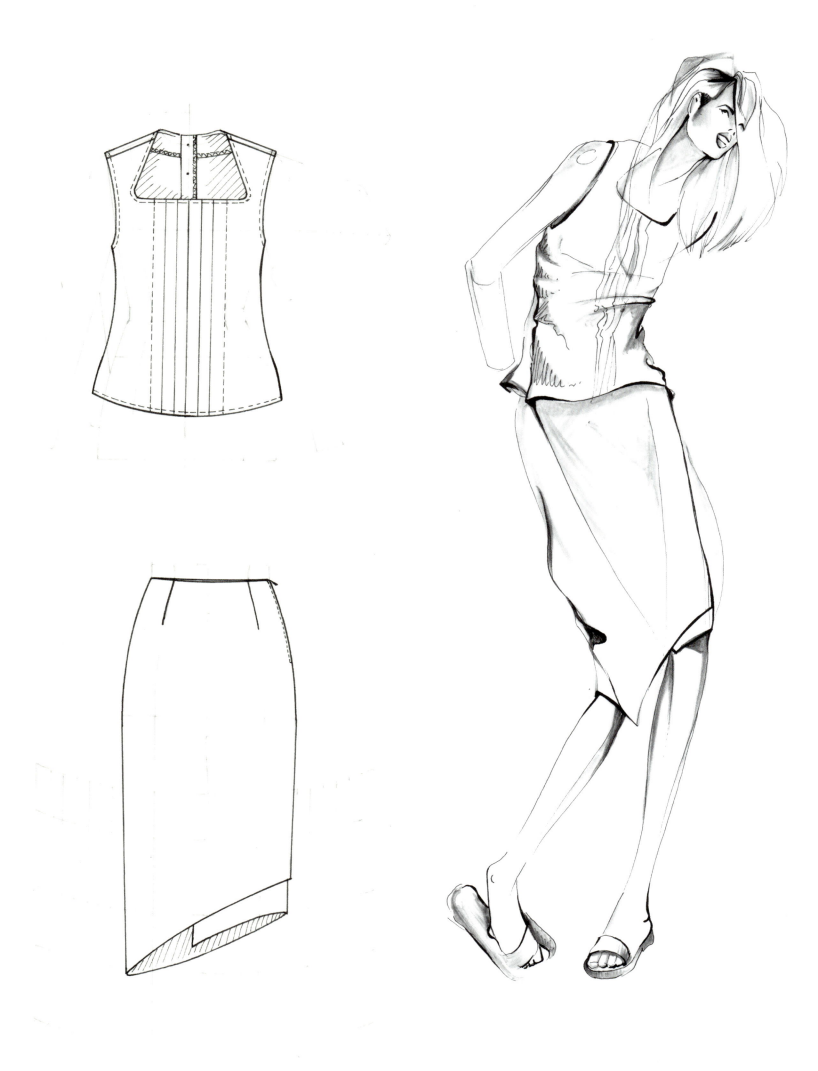

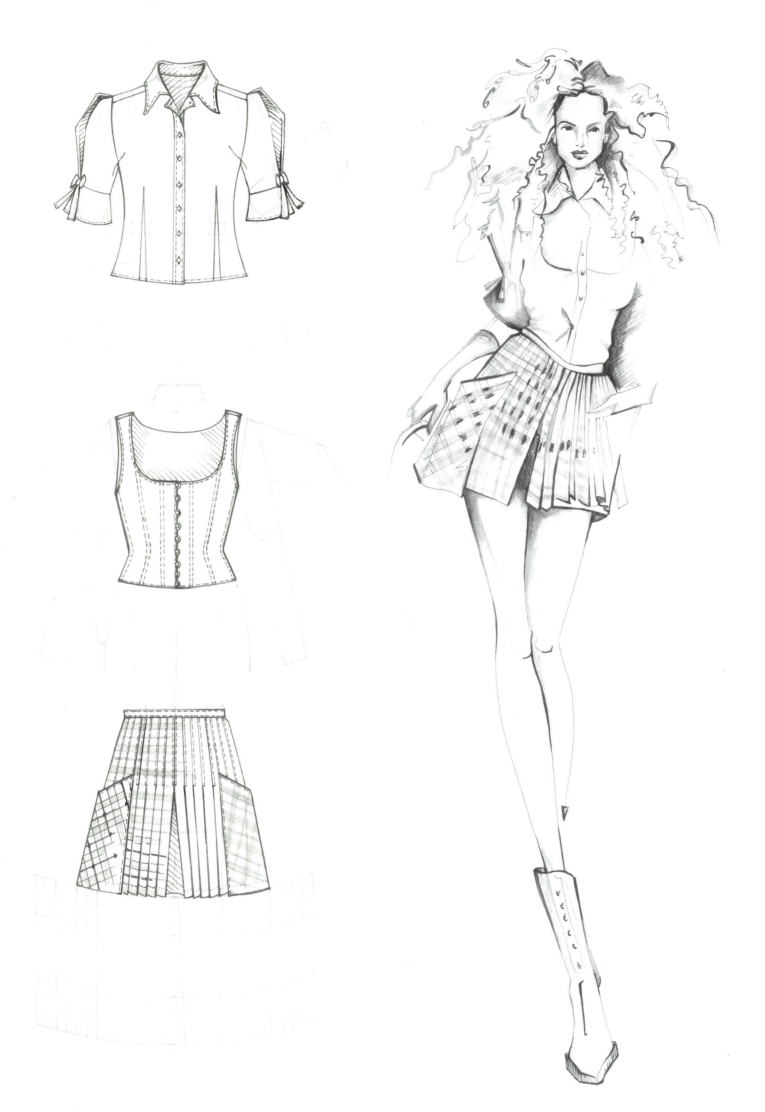

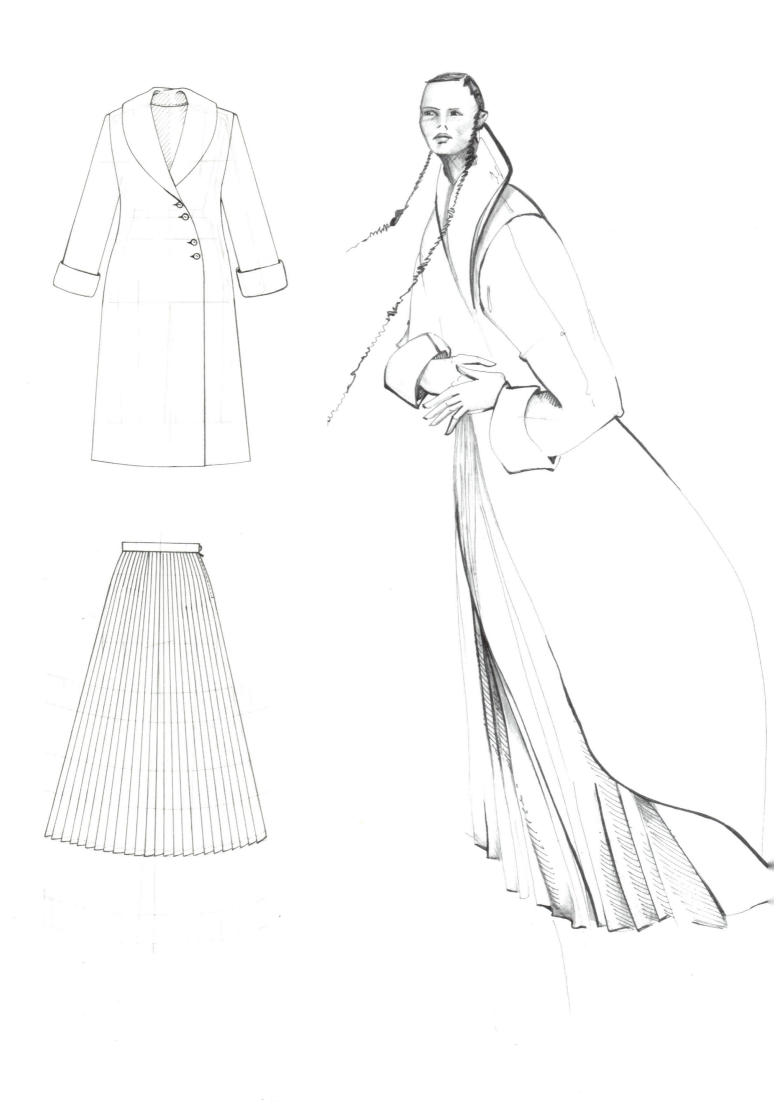

flats with figure

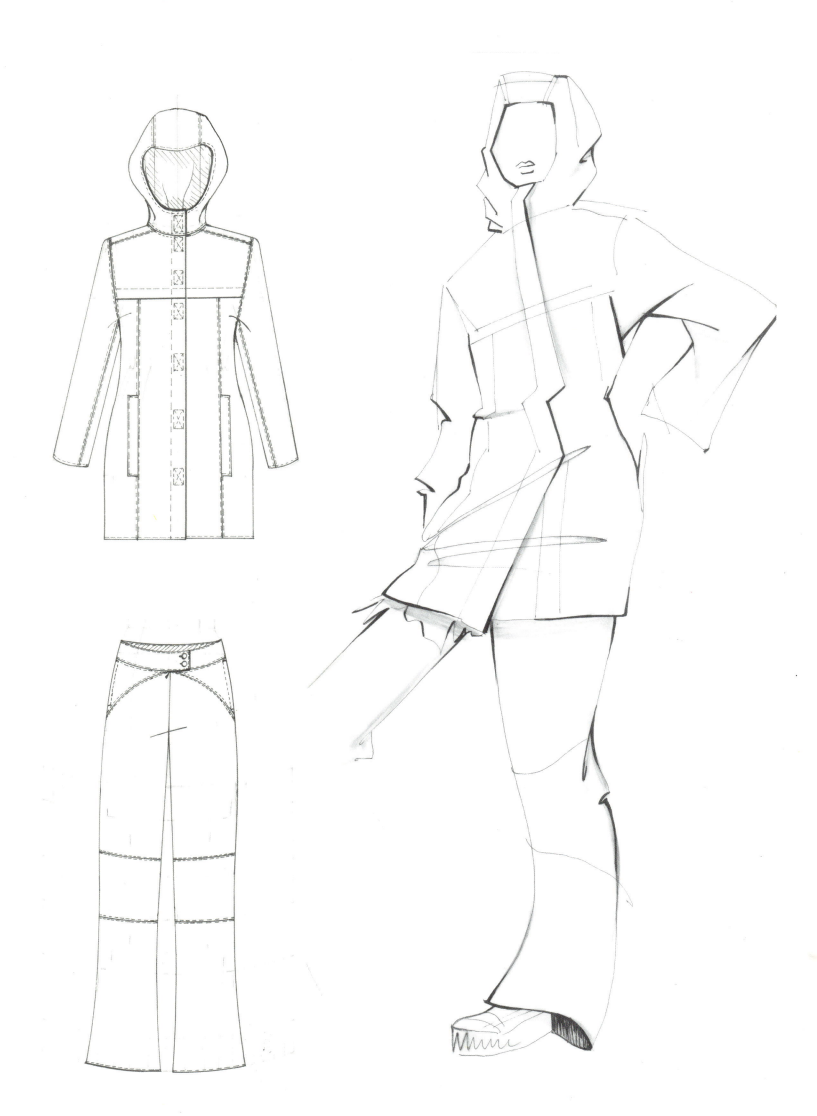

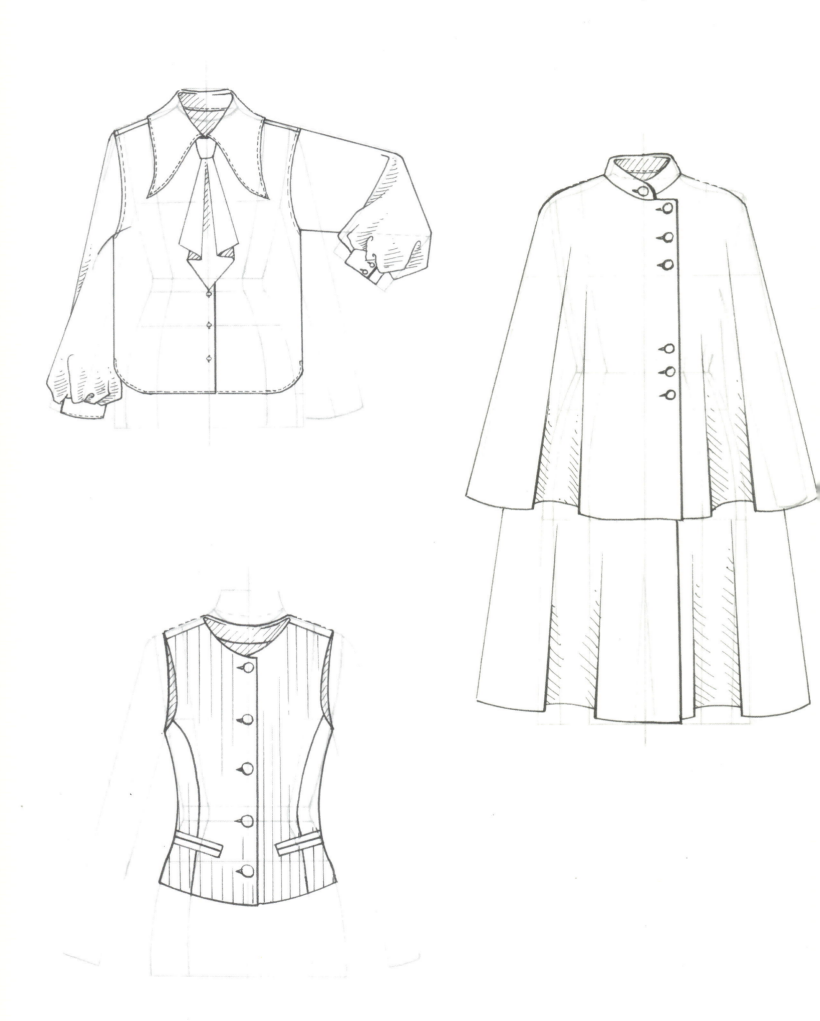

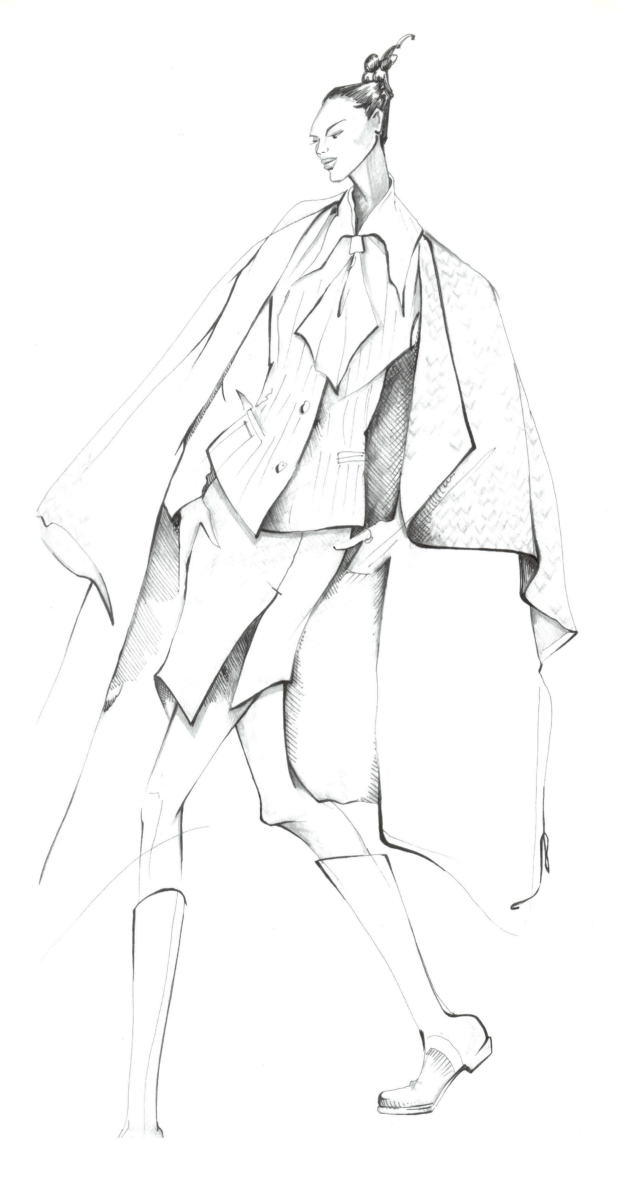

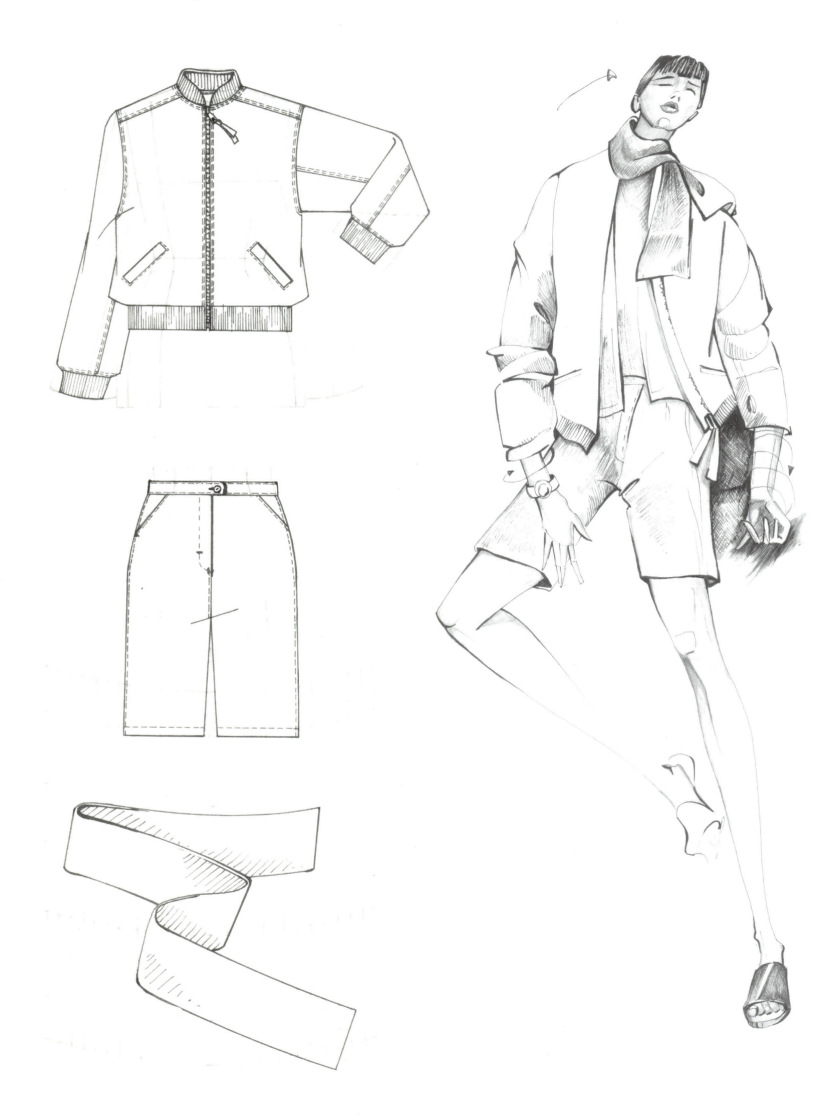

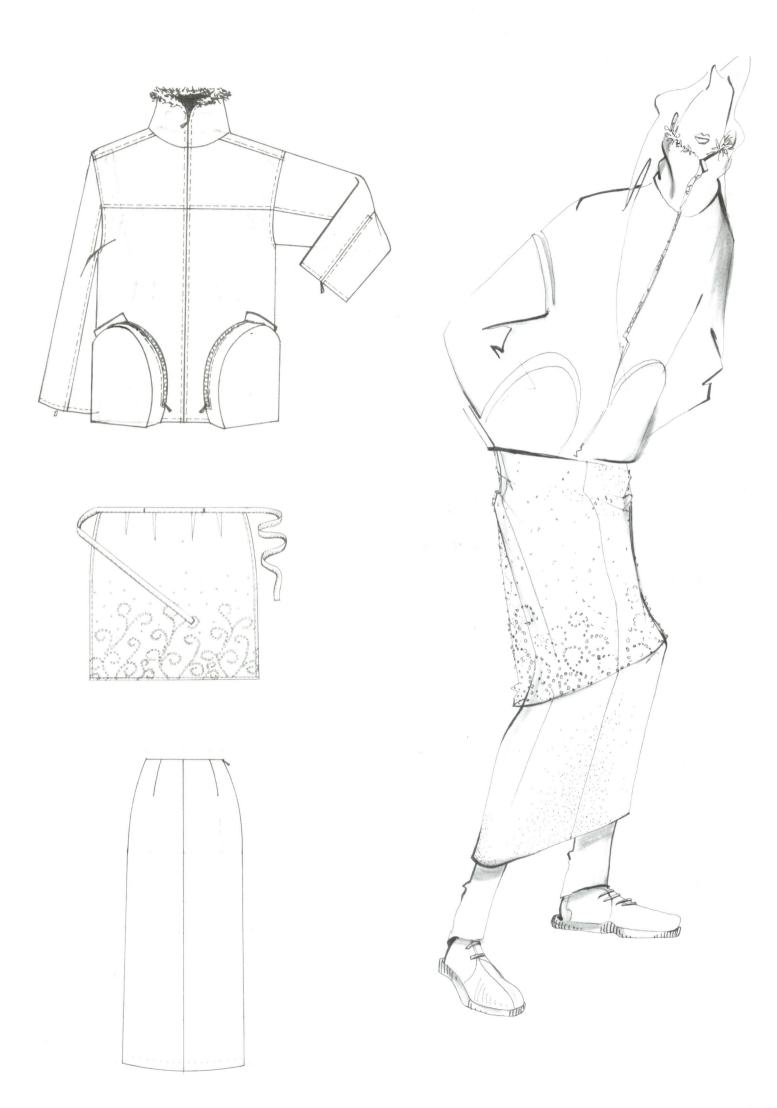

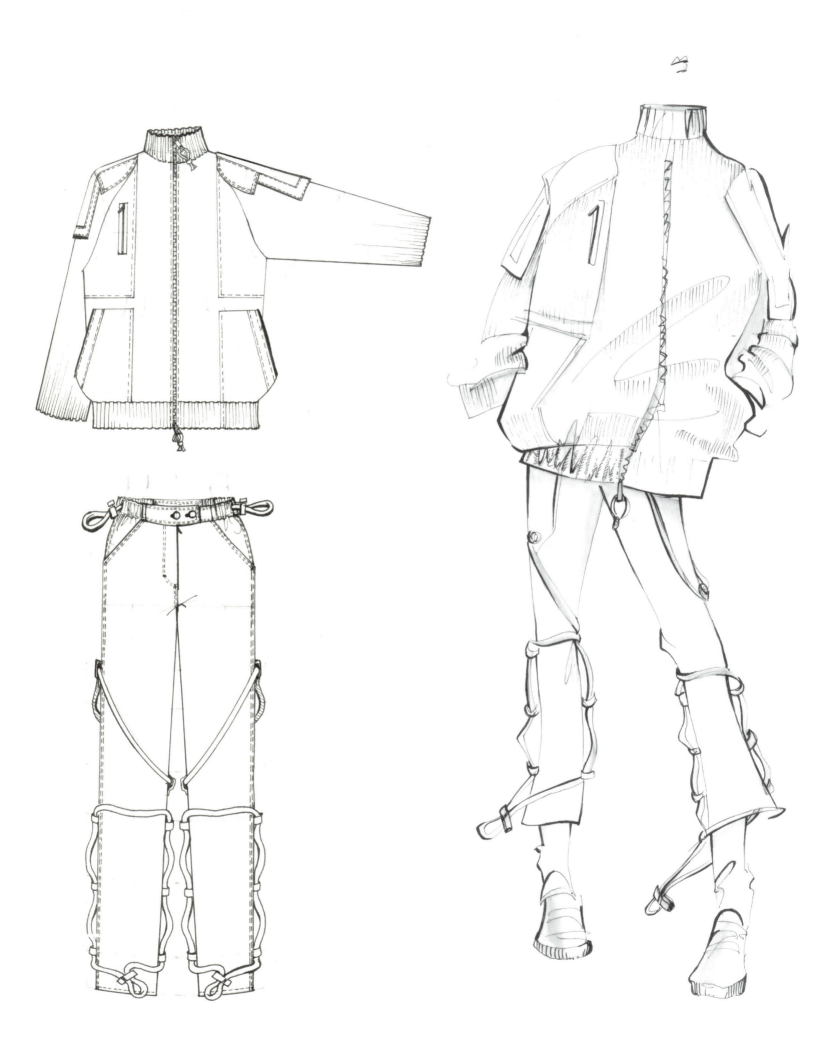

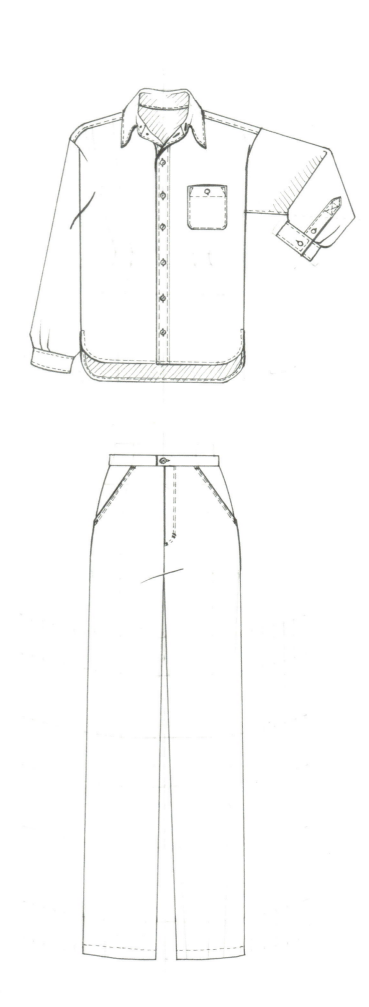

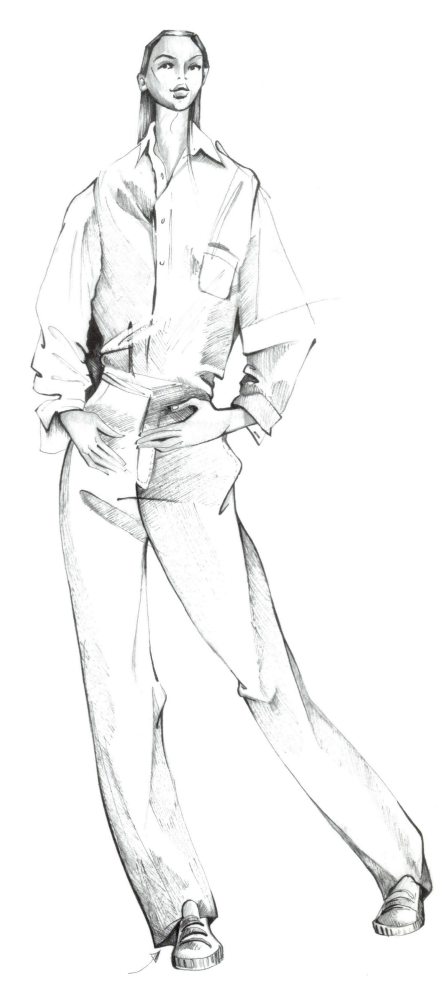

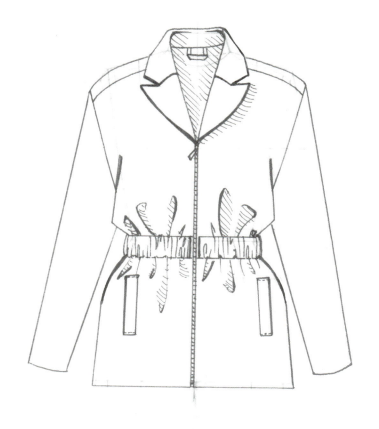

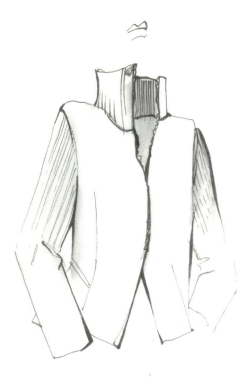

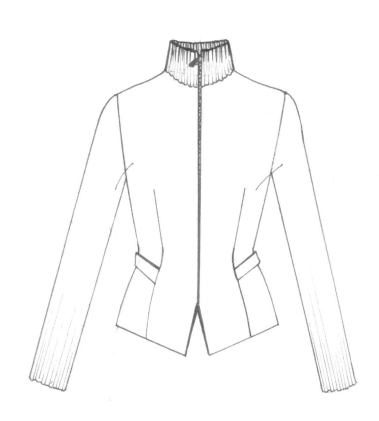

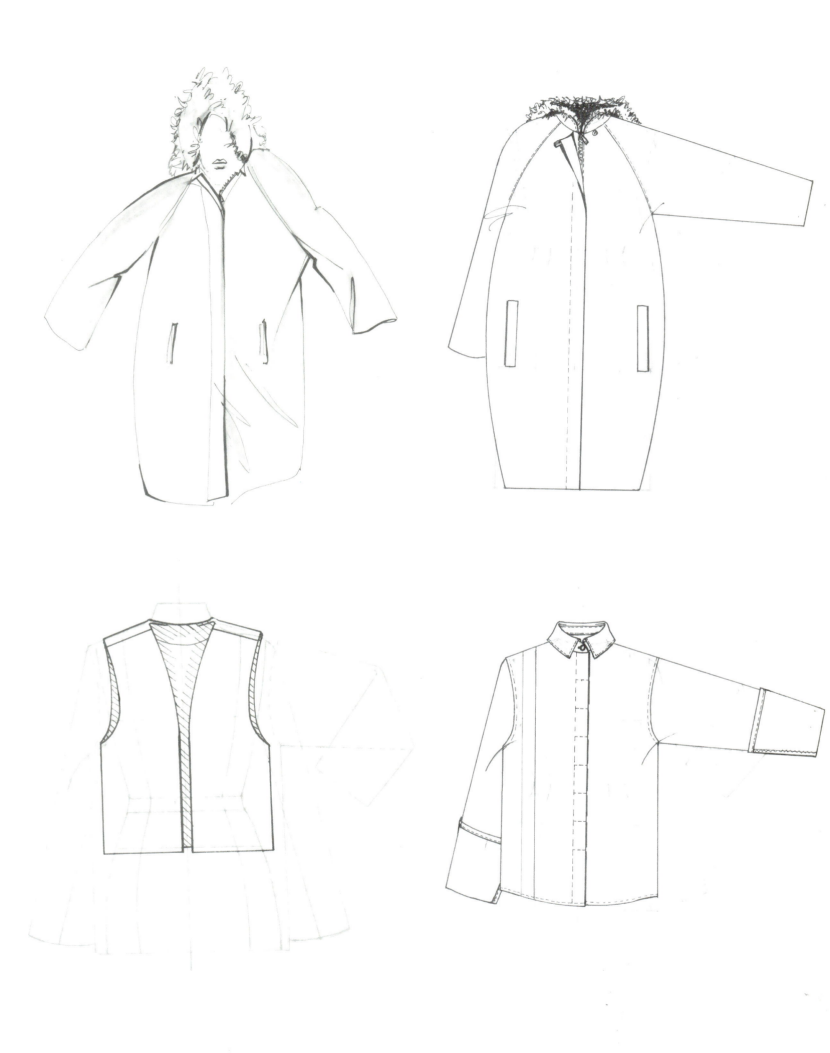

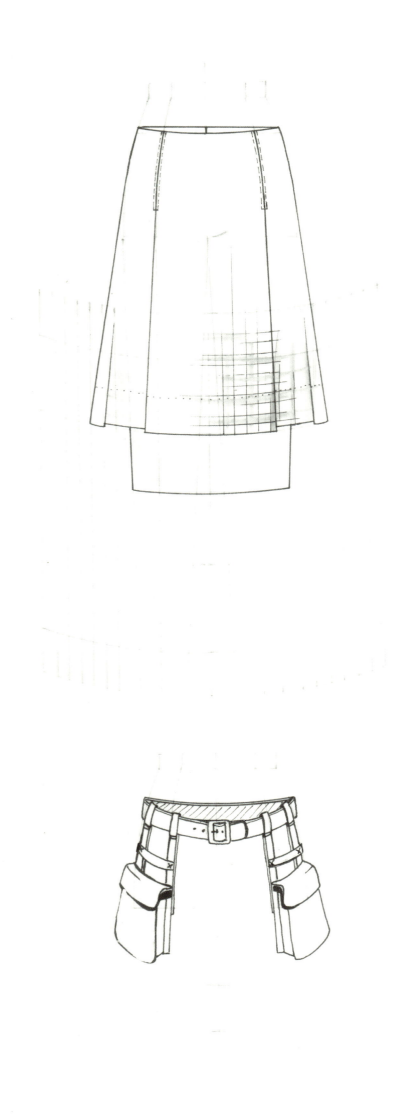

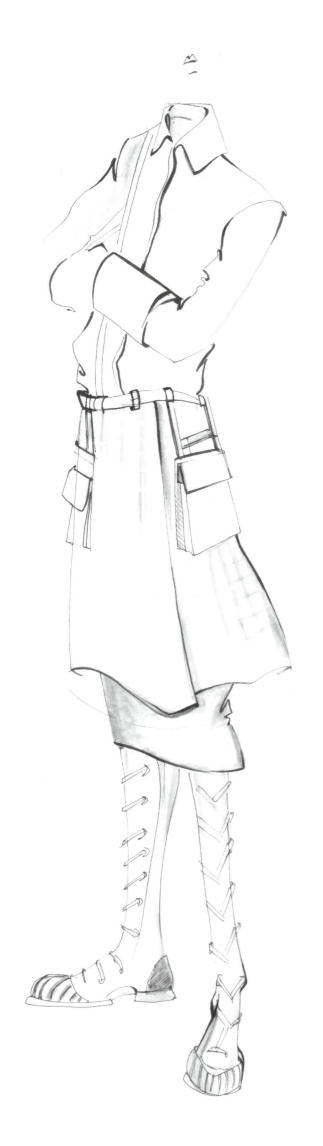

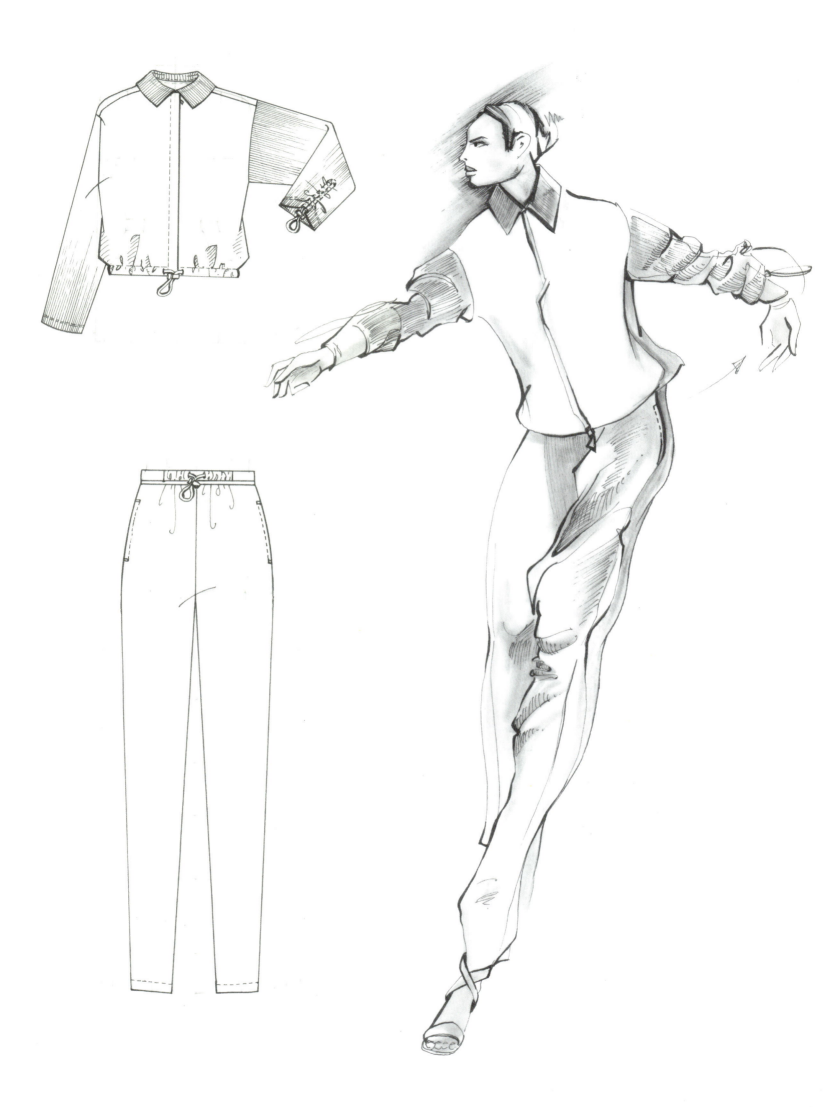

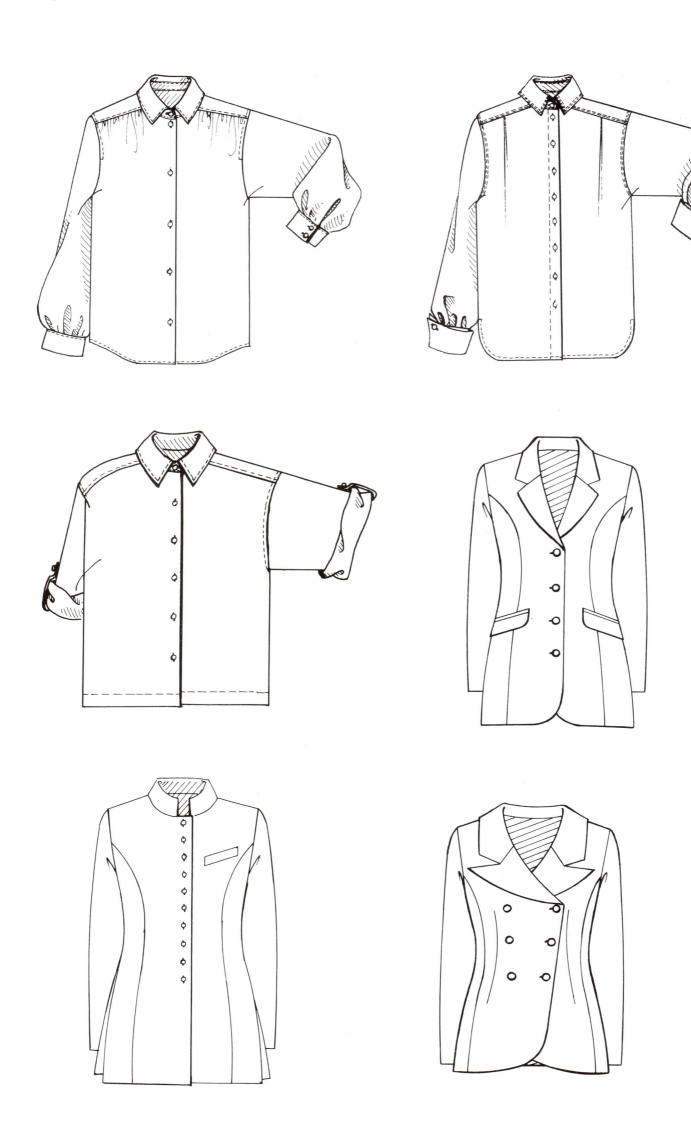

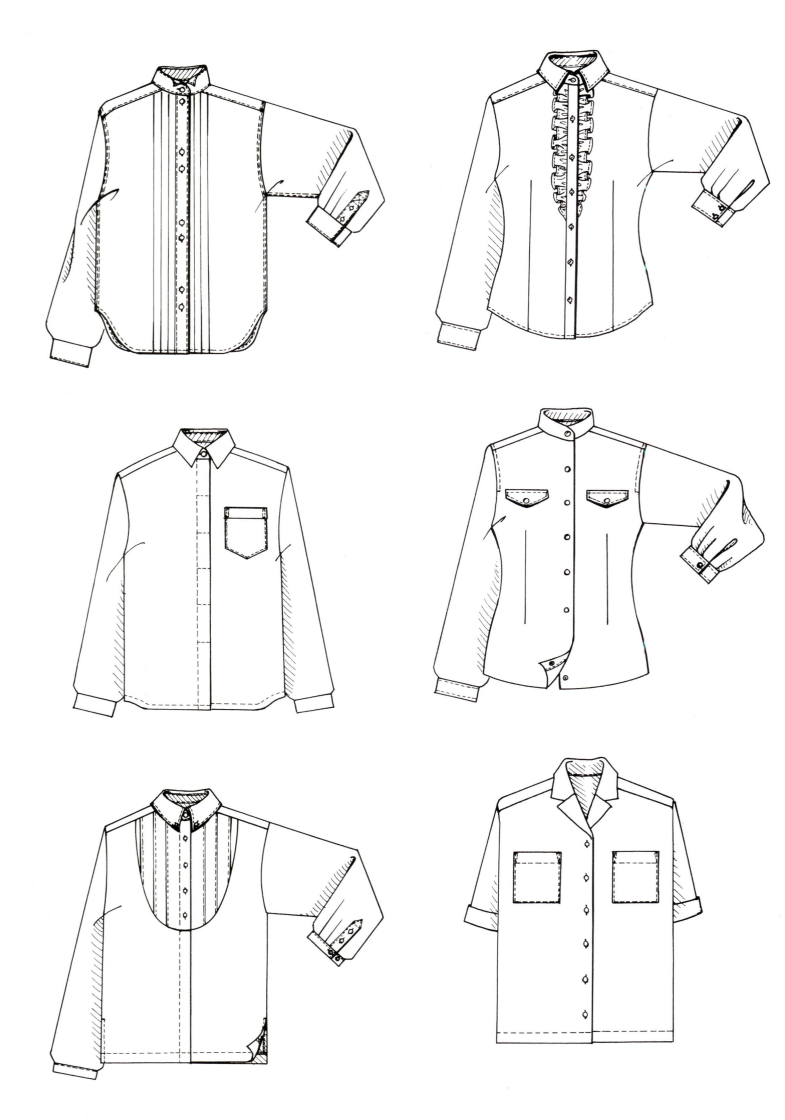

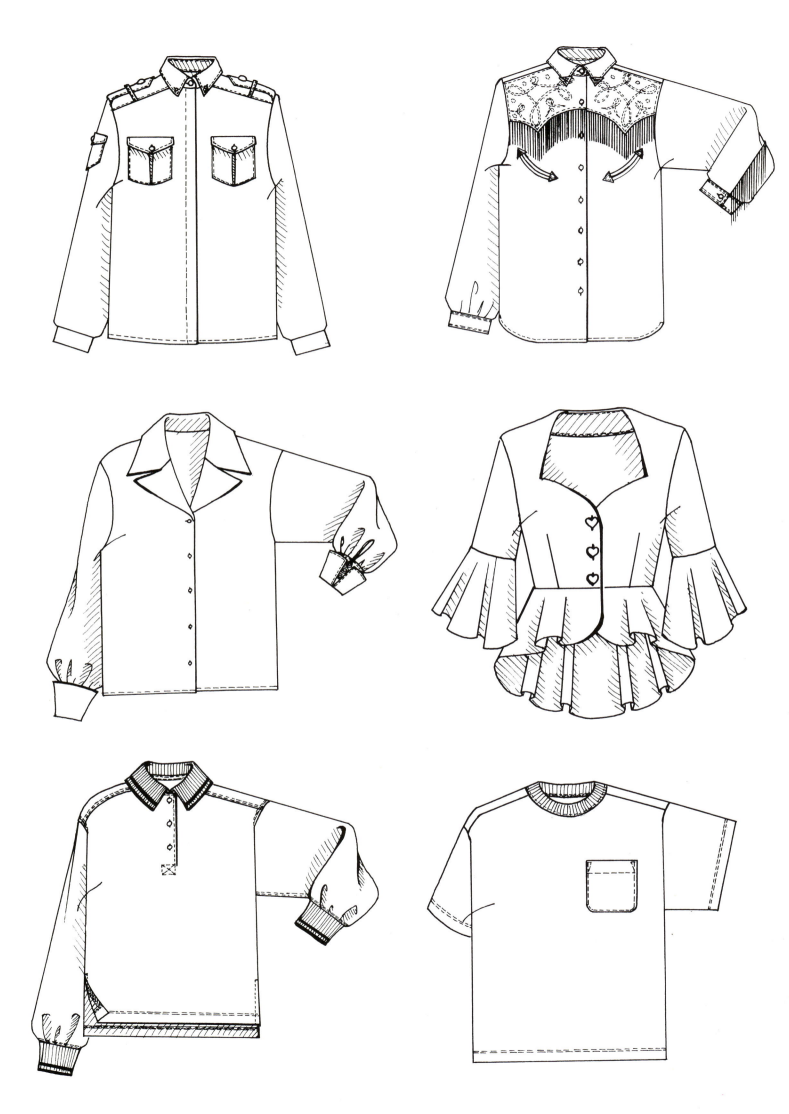

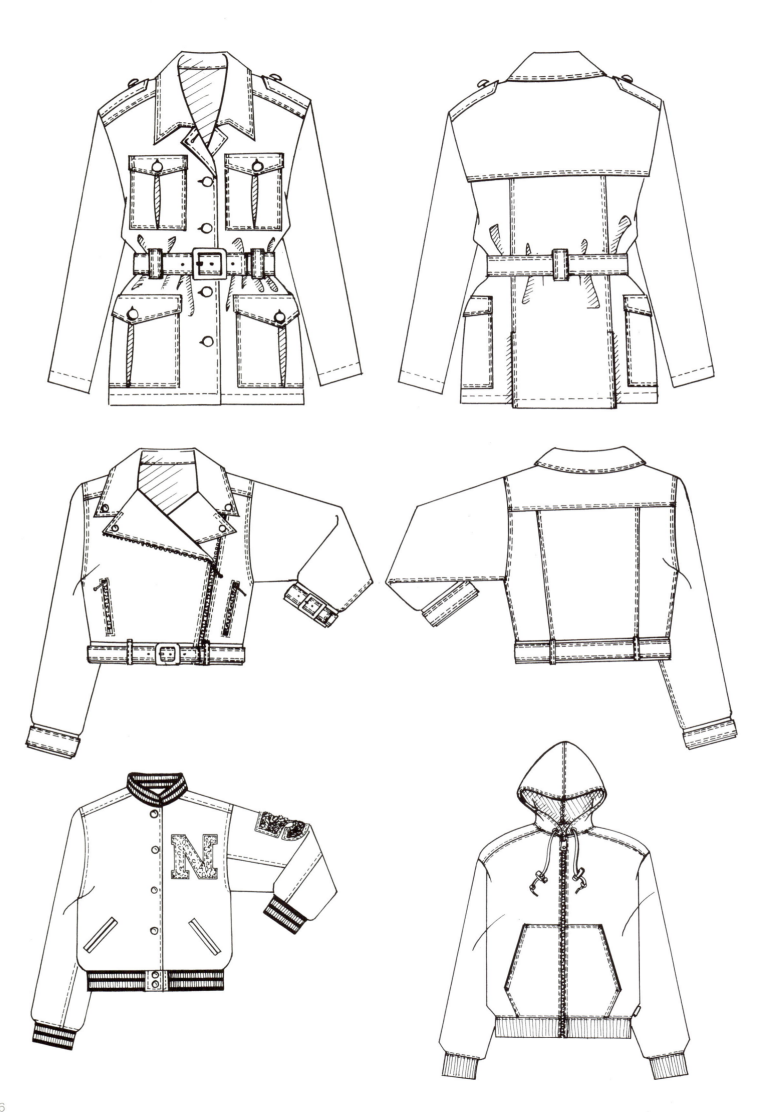

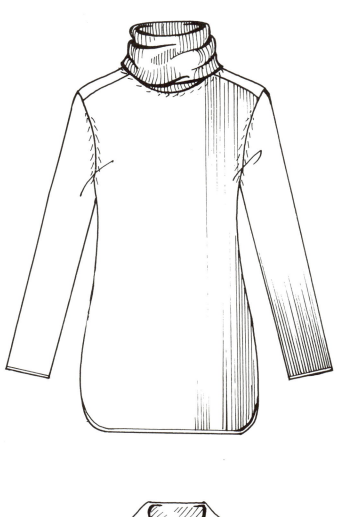

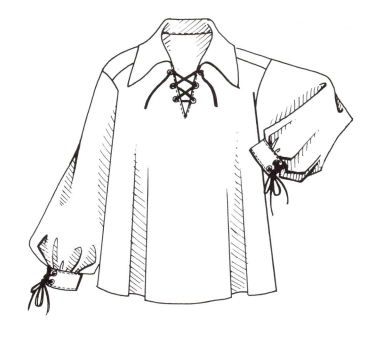

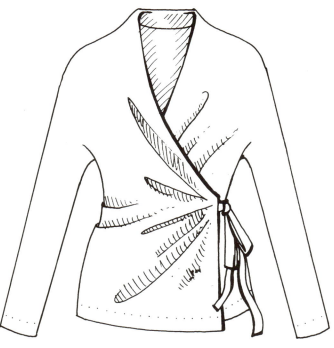

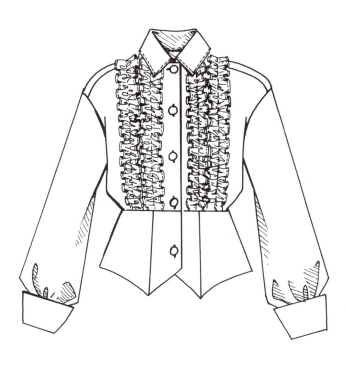

chapter five:
encyclopedia
of details

collars

This chapter includes visual information to be observed in detail and studied. If you are careful to add details to your clothing then, with high standards and care you will be more successful in communicating your ideas. Details can be added to both flats and figure drawings.

Included in this chapter are findings, buttons, collars, tucks, darts, folds, fabric renderings, stitches, knitting details, knots, bows, sequins, pearls, belts and more. Look at them carefully and refer to this chapter whenever necessary to check a detail for your drawing.

Funnel

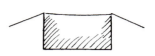

Square

Shirt—basic

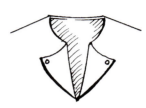

Round-roll back & buttoned

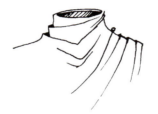

Cowl—stand style— high

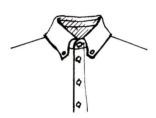

Button-down collar

Draped neck

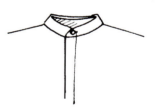

Stand-up/banded collar

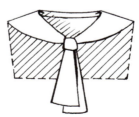

Fichu-tie front

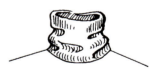

Turtle neck

One shoulder

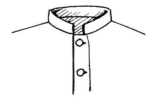

Mandarin

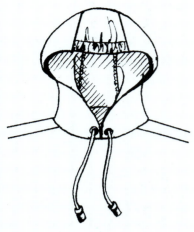

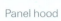

Panel hood

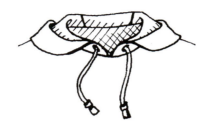

Hooded—drawstring

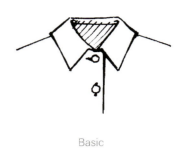

Basic

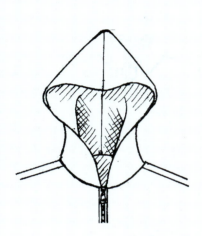

Panel hood/zipper

Hooded—zipper

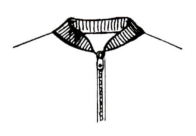

Round zipper/bobber

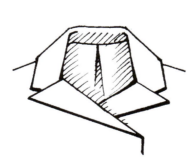

Hooded—drawstring &
zipper

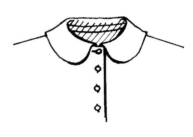

Peter Pan

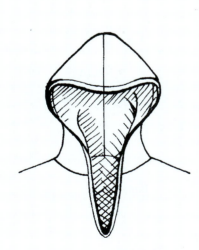

Panel hood/neck opening

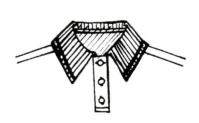

Double-breasted notch

Polo

collars

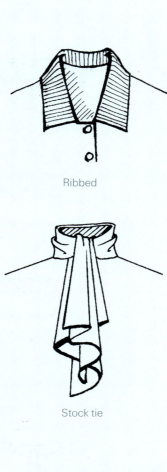

Ribbed

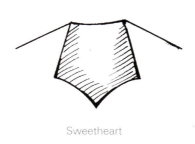

Sweetheart

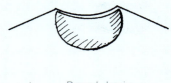

Round—basic

Stock tie

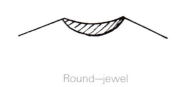

Round—jewel

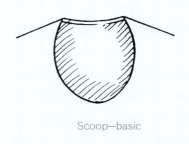

Scoop—basic

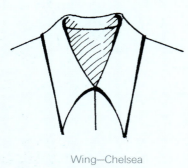

Wing—Chelsea

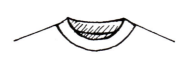

Round—bound/banded

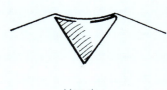

V-neck

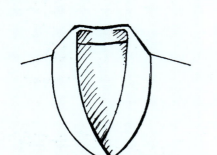

Shawl

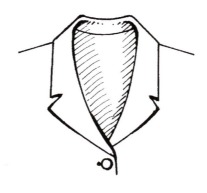

Notched

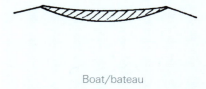

Boat/bateau

collars

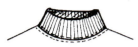

High rib with
railroad stitch

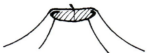

Funnel with
invisible zip

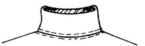

Offneck

Polo with tipped collar
& back neck taping

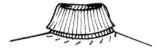

Turtle with knit neck

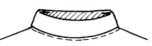

Mock turtle with
railroad zip cover

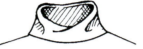

French turtle—clean

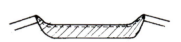

Boat neck—faced

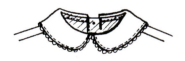

Peter Pan with
picot trim

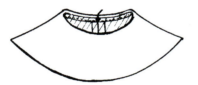

Bertha with zip back

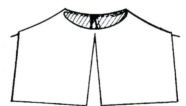

Pilgrim with button loop

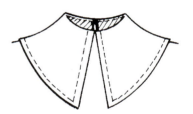

Puritan with button loop

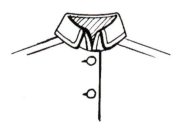

Convertible collar/high stand

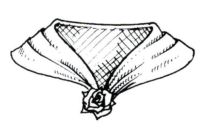

Fichu with rosette

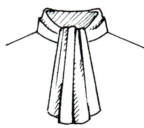

Scarf/ascot

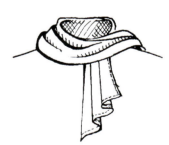

Stole collar

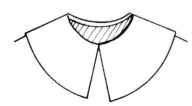

Notched Bertha

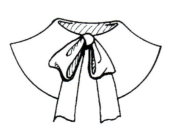

Buster brown (Bertha)

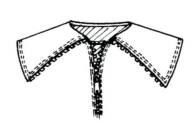

Zip-up Bertha

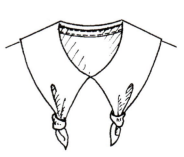

Bertha with knotted end

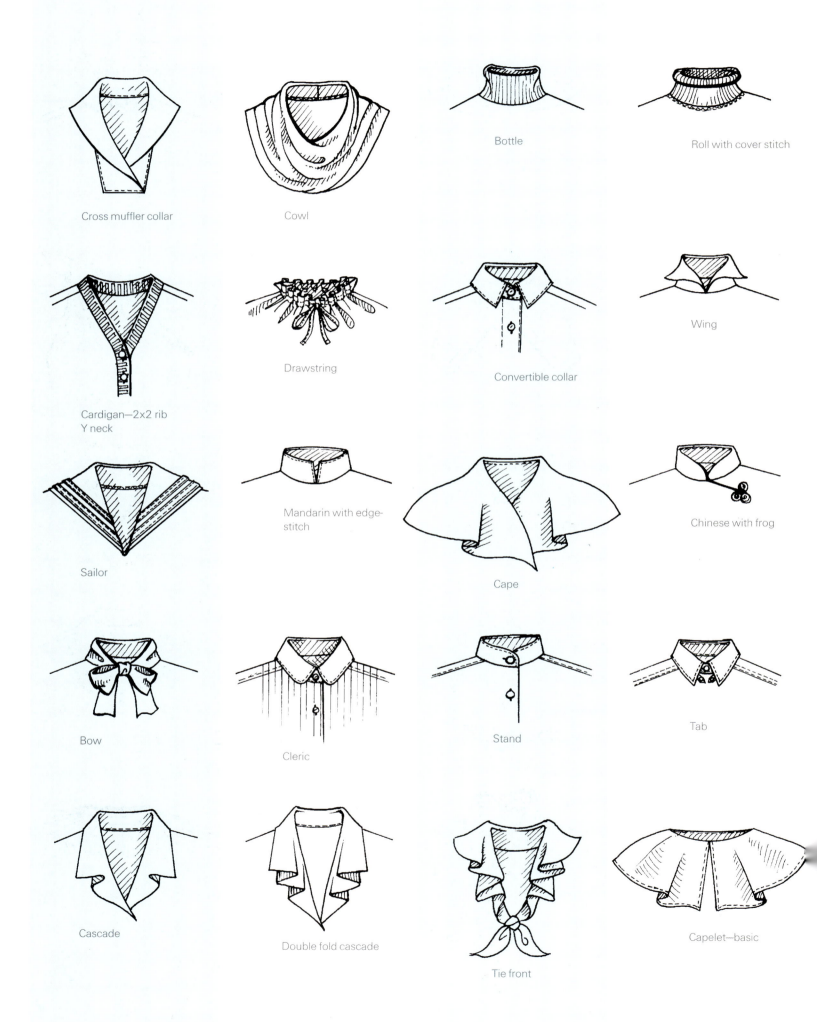

Cross muffler collar

Cowl

Bottle

Roll with cover stitch

Cardigan—2x2 rib
Y neck

Drawstring

Convertible collar

Wing

Sailor

Mandarin with edge-
stitch

Cape

Chinese with frog

Bow

Cleric

Stand

Tab

Cascade

Double fold cascade

Tie front

Capelet—basic

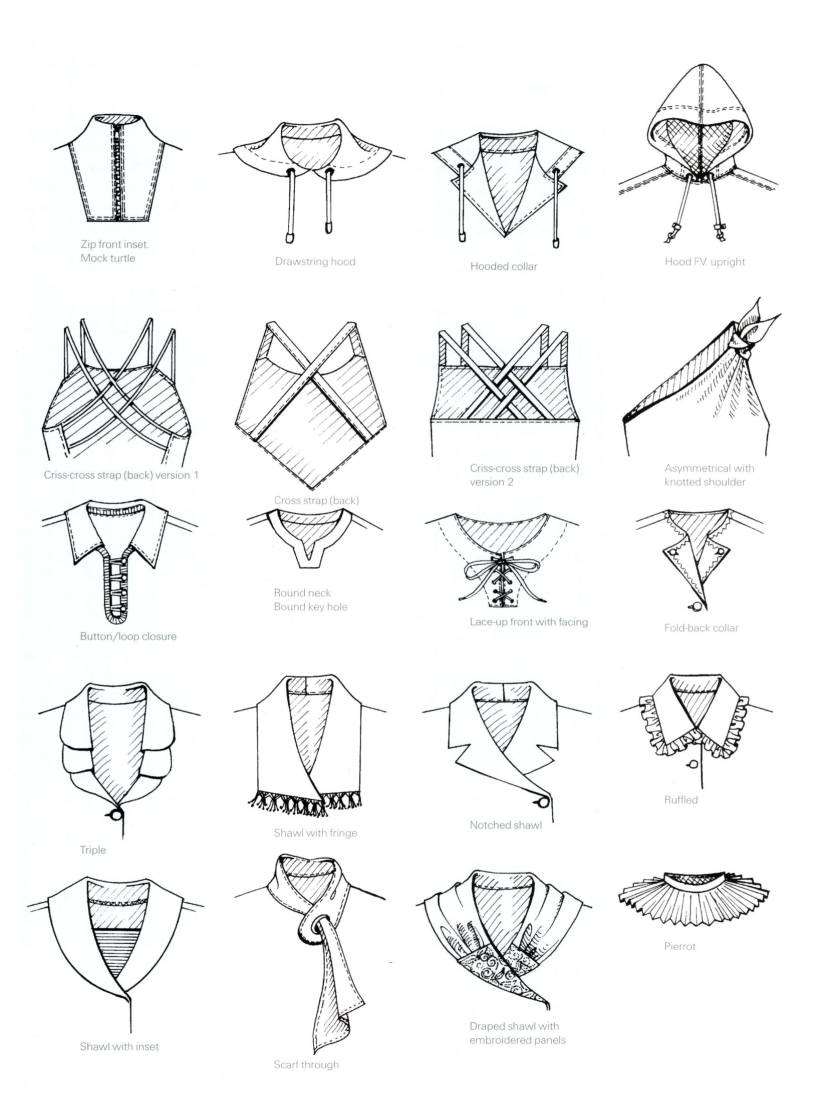

Zip front inset.
Mock turtle

Drawstring hood

Hooded collar

Hood F.V. upright

Criss-cross strap (back) version 1

Cross strap (back)

Criss-cross strap (back)
version 2

Asymmetrical with
knotted shoulder

Button/loop closure

Round neck
Bound key hole

Lace-up front with facing

Fold-back collar

Triple

Shawl with fringe

Notched shawl

Ruffled

Shawl with inset

Scarf through

Draped shawl with
embroidered panels

Pierrot

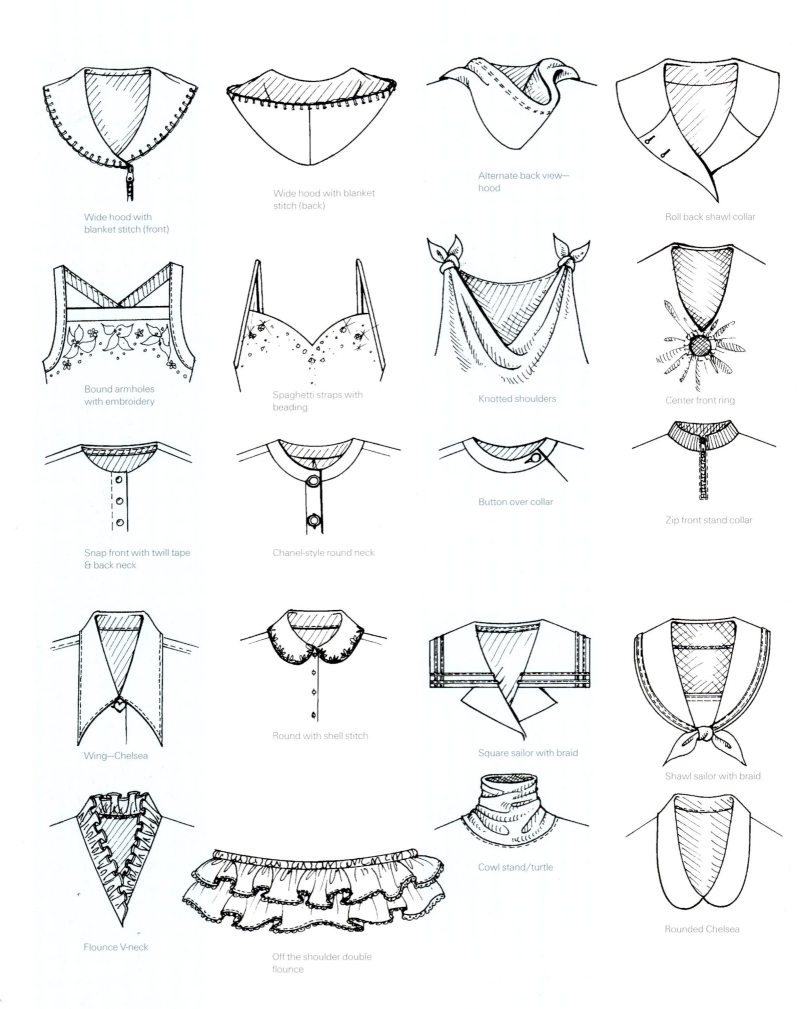

Wide hood with
blanket stitch (front)

Wide hood with blanket
stitch (back)

Alternate back view—
hood

Roll back shawl collar

Bound armholes
with embroidery

Spaghetti straps with
beading

Knotted shoulders

Center front ring

Snap front with twill tape
& back neck

Chanel-style round neck

Button over collar

Zip front stand collar

Wing—Chelsea

Round with shell stitch

Square sailor with braid

Shawl sailor with braid

Flounce V-neck

Off the shoulder double
flounce

Cowl stand/turtle

Rounded Chelsea

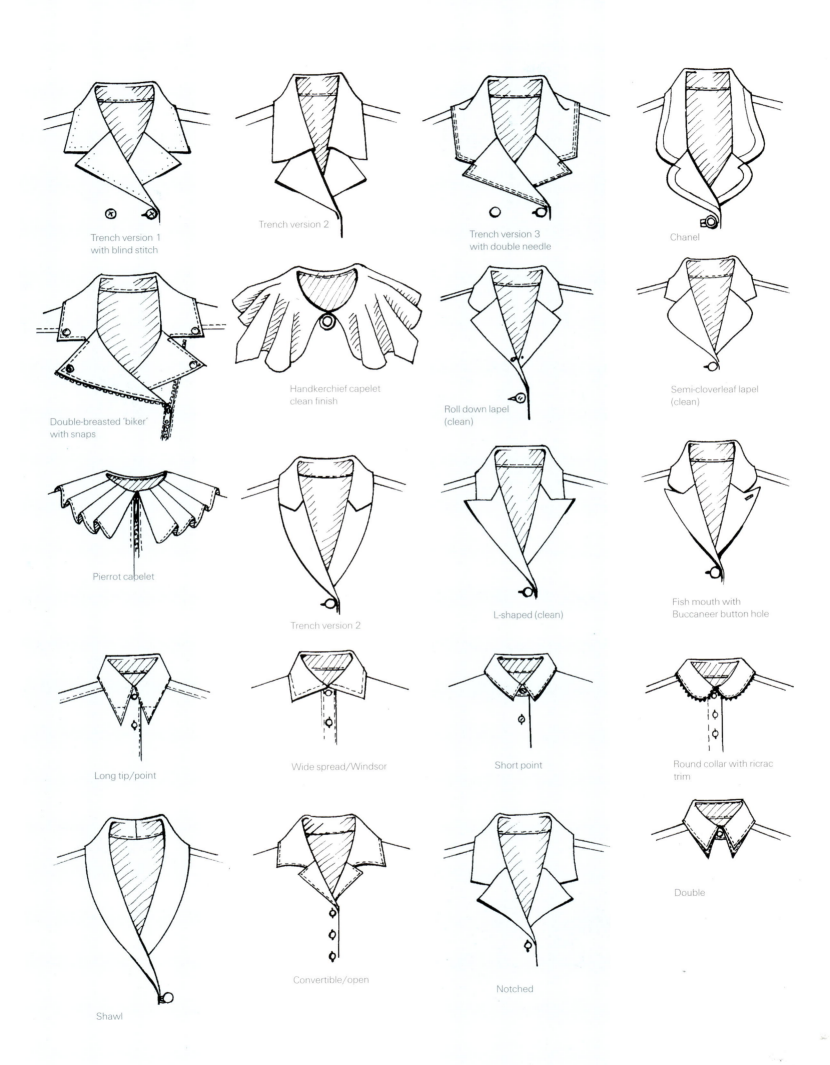

Trench version 1
with blind stitch

Trench version 2

Trench version 3
with double needle

Chanel

Double-breasted 'biker'
with snaps

Handkerchief capelet
clean finish

Roll down lapel
(clean)

Semi-cloverleaf lapel
(clean)

Pierrot capelet

Trench version 2

L-shaped (clean)

Fish mouth with
Buccaneer button hole

Long tip/point

Wide spread/Windsor

Short point

Round collar with ricrac
trim

Shawl

Convertible/open

Notched

Double

collars

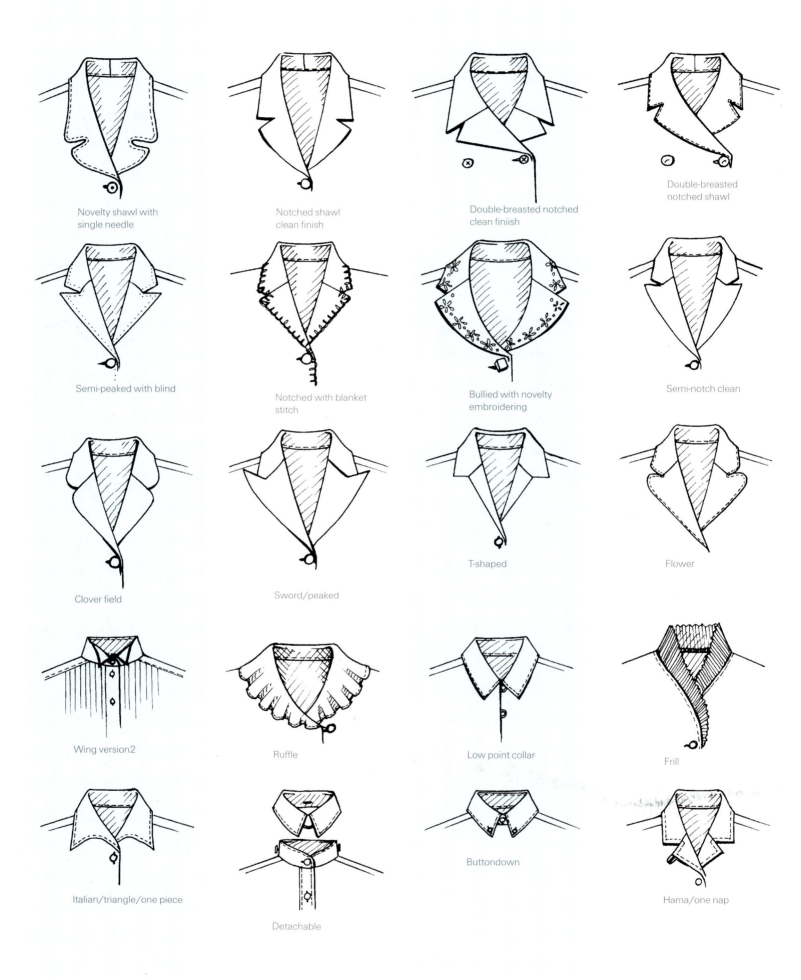

Novelty shawl with
single needle

Notched shawl
clean finish

Double-breasted notched
clean finiish

Double-breasted
notched shawl

Semi-peaked with blind

Notched with blanket
stitch

Bullied with novelty
embroidering

Semi-notch clean

Clover field

Sword/peaked

T-shaped

Flower

Wing version2

Ruffle

Low point collar

Frill

Italian/triangle/one piece

Detachable

Buttondown

Hama/one nap

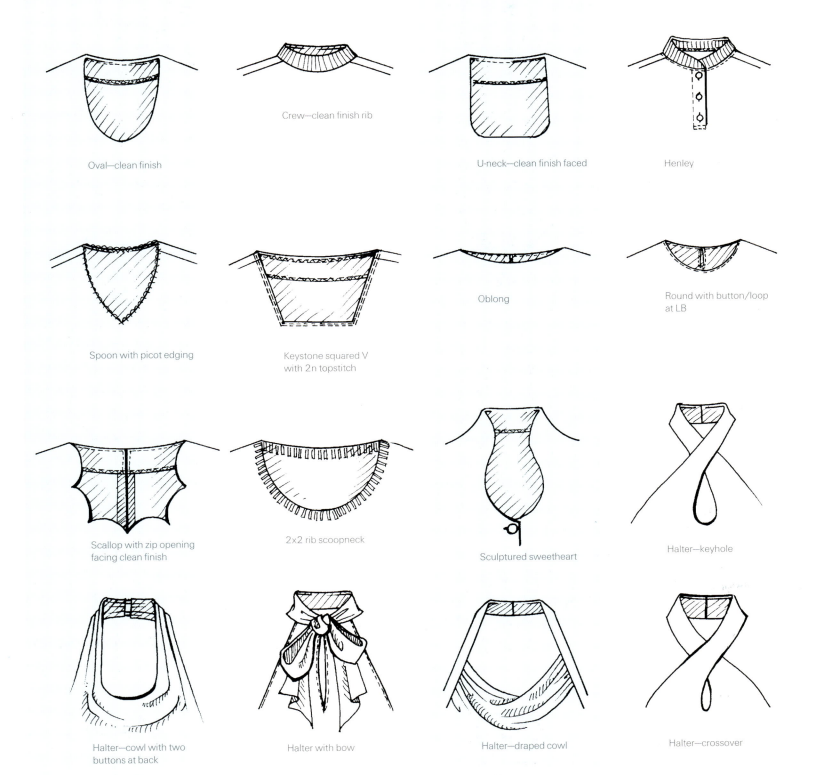

Oval—clean finish

Crew—clean finish rib

U-neck—clean finish faced

Henley

Spoon with picot edging

Keystone squared V
with 2n topstitch

Oblong

Round with button/loop
at LB

Scallop with zip opening
facing clean finish

2x2 rib scoopneck

Sculptured sweetheart

Halter—keyhole

Halter—cowl with two
buttons at back

Halter with bow

Halter—draped cowl

Halter—crossover

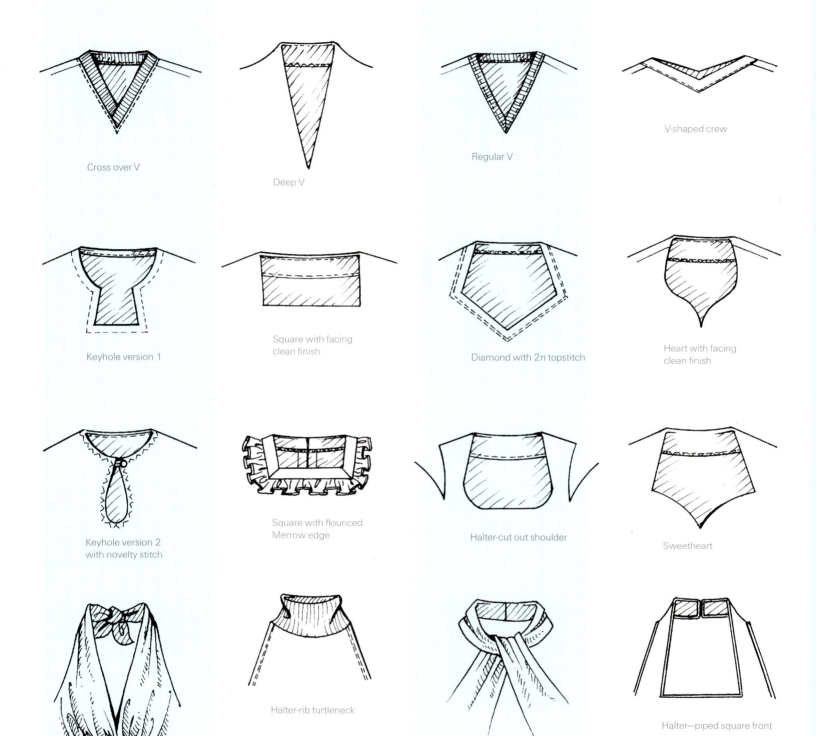

Cross over V

Deep V

Regular V

V-shaped crew

Keyhole version 1

Square with facing
clean finish

Diamond with 2n topstitch

Heart with facing
clean finish

Keyhole version 2
with novelty stitch

Square with flounced
Merrow edge

Halter-cut out shoulder

Sweetheart

Halter with tie at back

Halter-rib turtleneck

Halter—twisted

Halter—piped square front

Asymmetrical

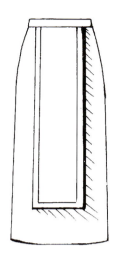

Flying panel

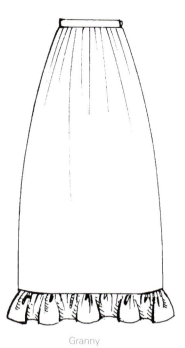

Granny

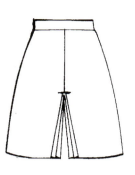

Culottes

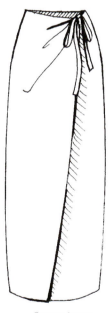

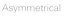

Sarong/wrap

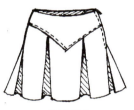

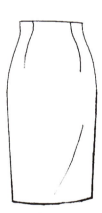

Yoke skirt

High-waisted

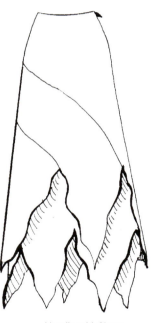

Handkerchief hem

underwear

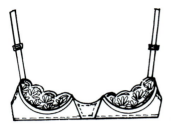

Half underwire bra

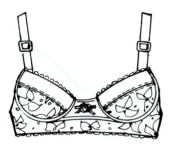

Full underwire bra

French cinch guppiere

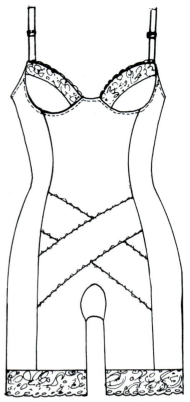

Full body summer

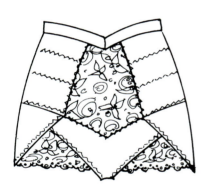

Panty girdle

Knee length panty girdle

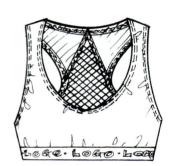

Sports bra with racer back

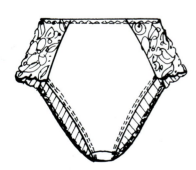

High cut control brief

'Seamless' bra

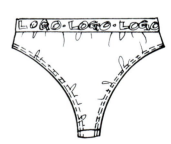

Sport thong front view

High cut brief

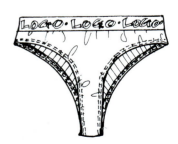

Sport thong back view

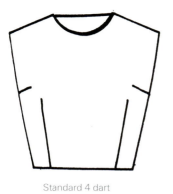

Standard 4 dart

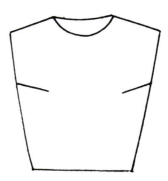

French dart

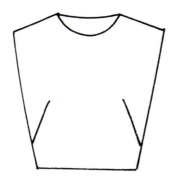

Armseye darts

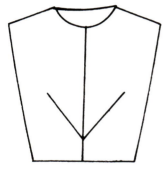

Center front seam parts

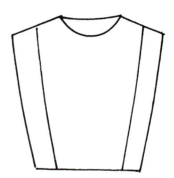

H dart princess

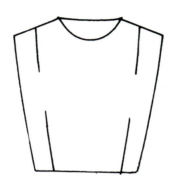

Princess seams

Armseye princess seams

Princess seams

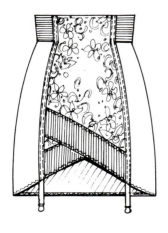

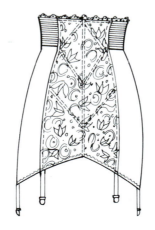

Panty girdle

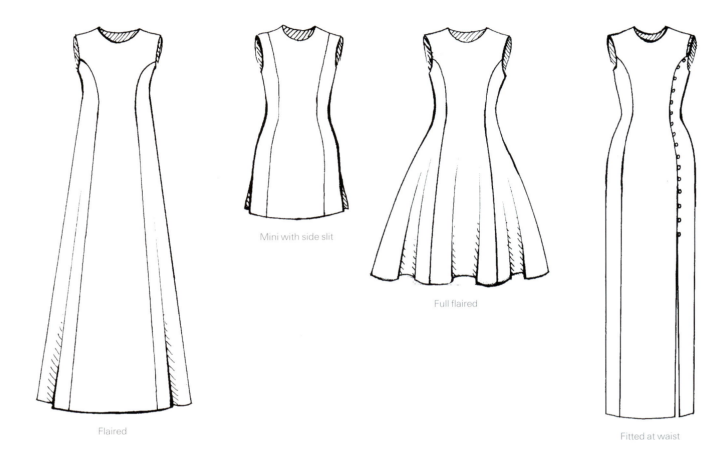

Flaired

Mini with side slit

Full flaired

Fitted at waist

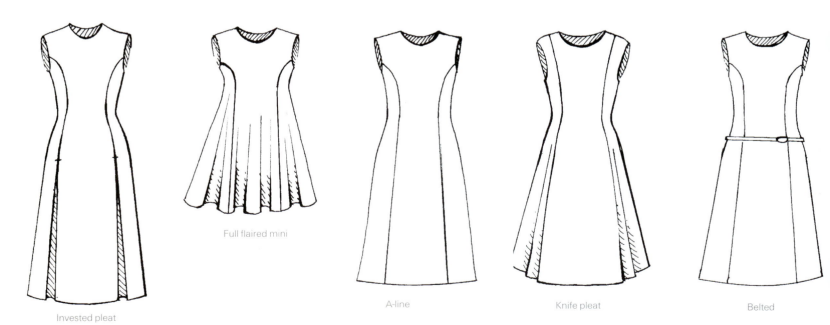

Invested pleat

Full flaired mini

A-line

Knife pleat

Belted

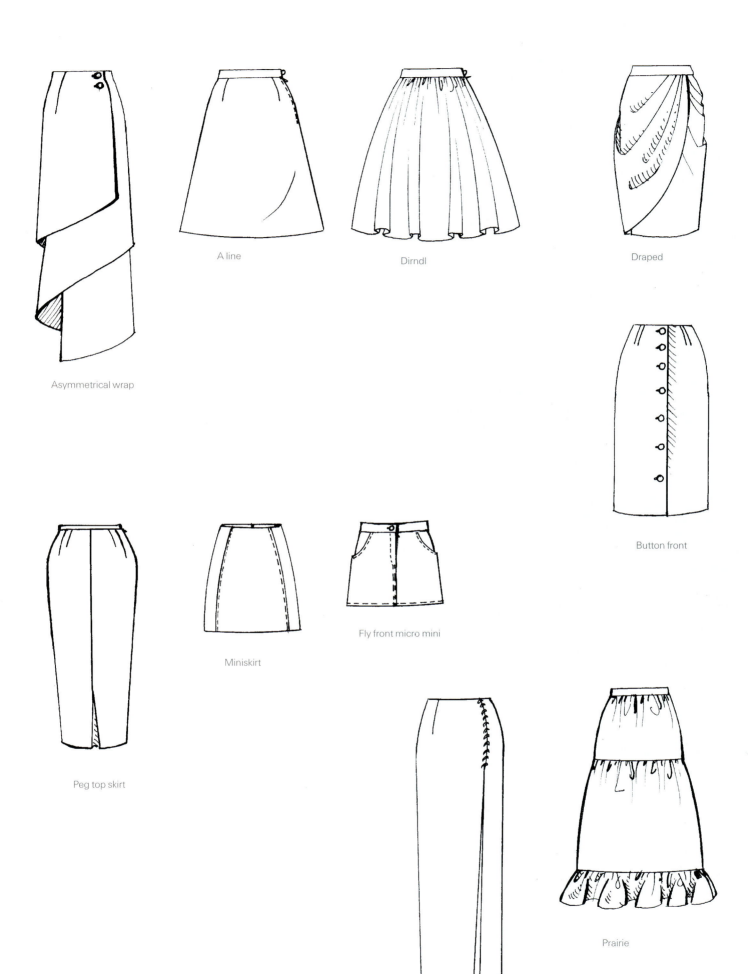

Asymmetrical wrap

A line

Dirndl

Draped

Button front

Peg top skirt

Miniskirt

Fly front micro mini

Slit skirt

Prairie

pants

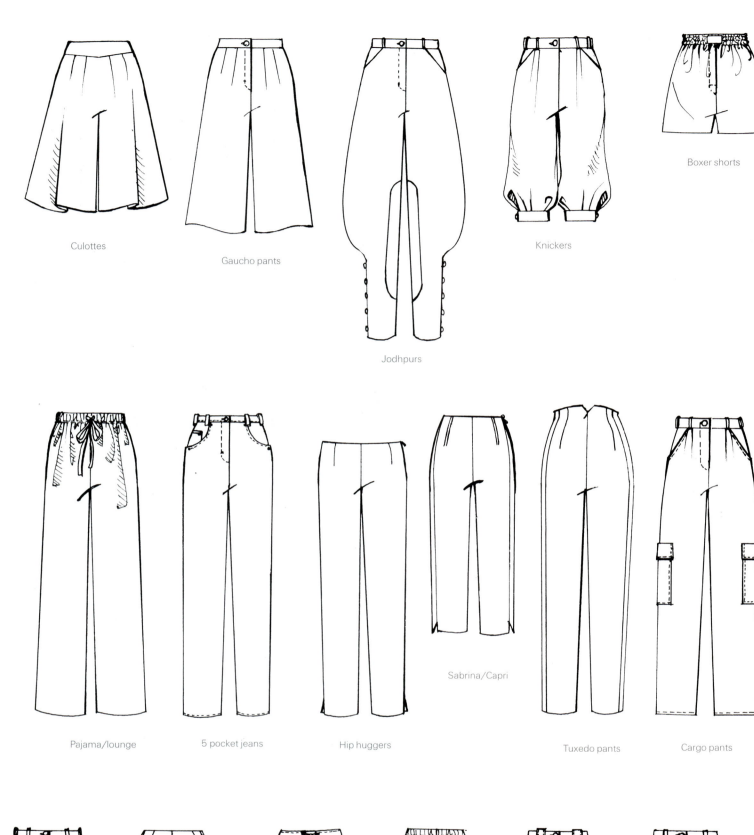

Culottes

Gaucho pants

Jodhpurs

Knickers

Boxer shorts

Pajama/lounge

5 pocket jeans

Hip huggers

Sabrina/Capri

Tuxedo pants

Cargo pants

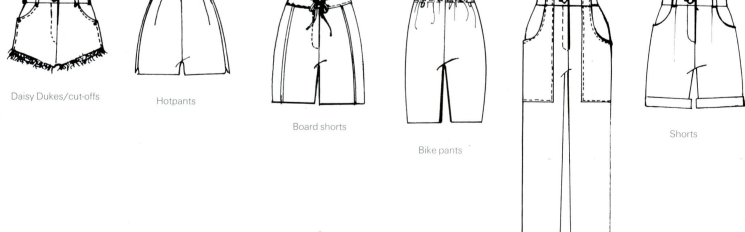

Daisy Dukes/cut-offs

Hotpants

Board shorts

Bike pants

Bush pants

Shorts

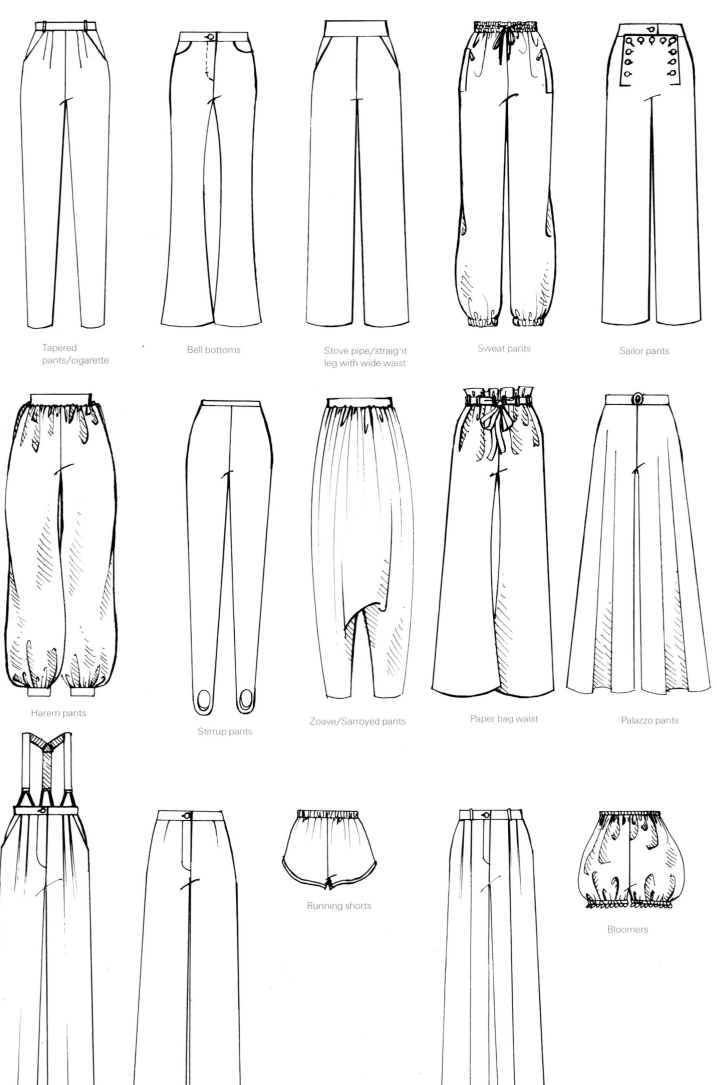

Tapered
pants/cigarette

Bell bottoms

Stove pipe/straight
leg with wide waist

Sweat pants

Sailor pants

Harem pants

Stirrup pants

Zoave/Sarroyed pants

Paper bag waist

Palazzo pants

Suspender trousers

Wide leg

Running shorts

Pantaloons

Bloomers

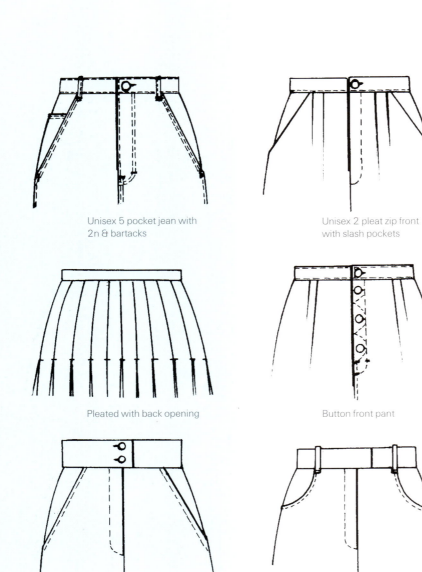

Unisex 5 pocket jean with
2n & bartacks

Unisex 2 pleat zip front
with slash pockets

Pleated with set on waist
band—side seam zip/ button
opening

Pleated with back opening

Button front pant

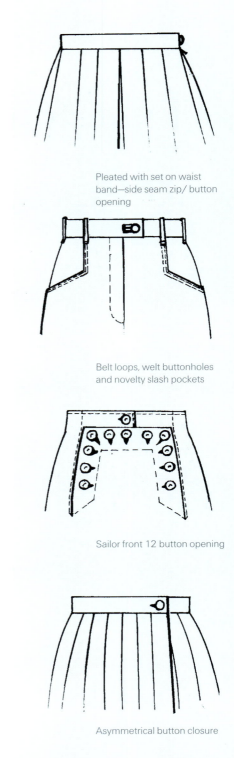

Belt loops, welt buttonholes
and novelty slash pockets

Wide waistband with 2-button
closure and slash pockets

Wide waistband with belt
loops and bar/hook closure
and rounded pockets

Sailor front 12 button opening

Elastic waist surge set
with "tearaway" side seam
snap closure

Faced waist with bow knot
at front

Asymmetrical button closure

Faced natural waistline with
railroad side zipper

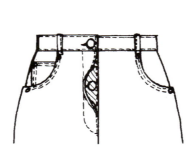

Womens 5 pocket jean with
button fly and rivet details

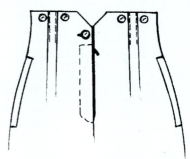

High-waisted 2 pleat pant with
single on seam welt pockets

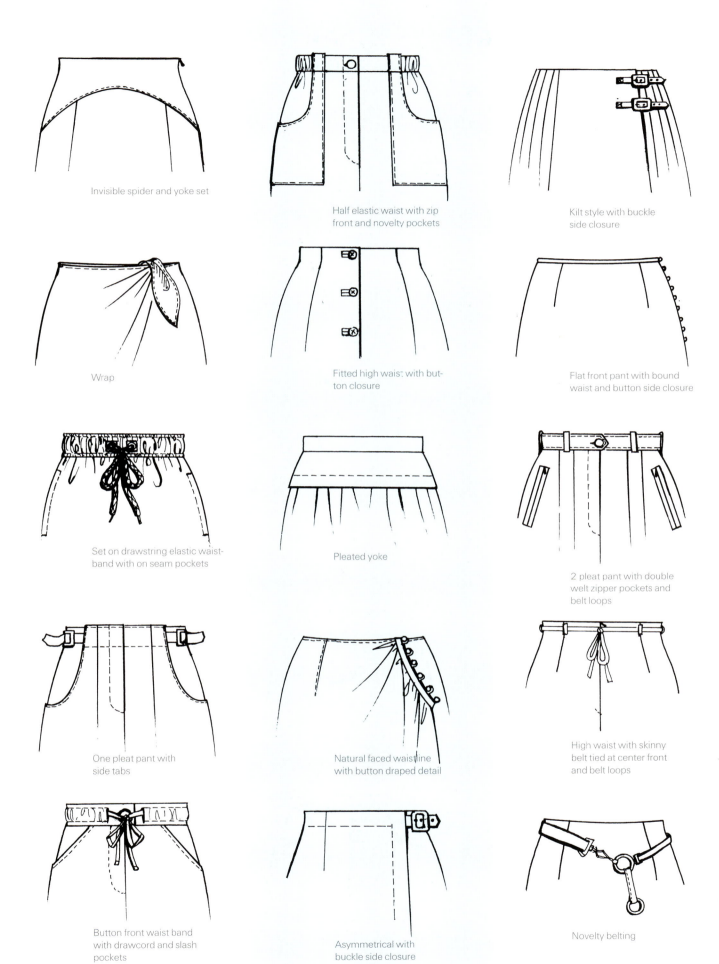

Invisible spider and yoke set

Half elastic waist with zip front and novelty pockets

Kilt style with buckle side closure

Wrap

Fitted high waist with button closure

Flat front pant with bound waist and button side closure

Set on drawstring elastic waistband with on seam pockets

Pleated yoke

2 pleat pant with double welt zipper pockets and belt loops

One pleat pant with side tabs

Natural faced waistline with button draped detail

High waist with skinny belt tied at center front and belt loops

Button front waist band with drawcord and slash pockets

Asymmetrical with buckle side closure

Novelty belting

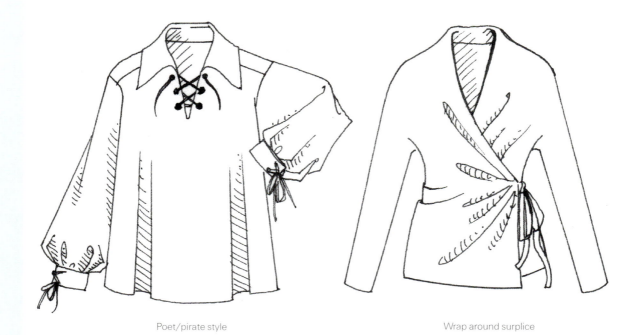

Poet/pirate style

Wrap around surplice

Straight vest

Boned bustier

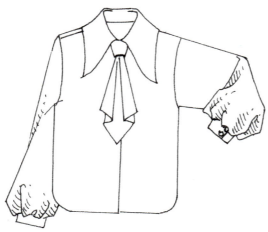

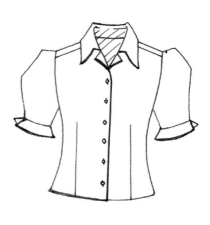

Tie front

Fitted with puff

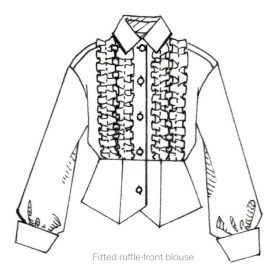

Fitted ruffle-front blouse

Fitted princess vest

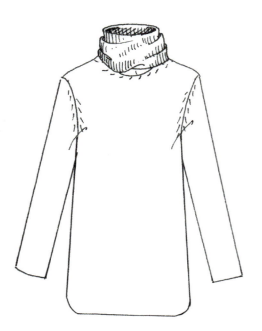

L/S tunic with cowl neck and
fully fashioned arm well

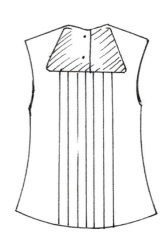

Sleeveless with front tuck
detail

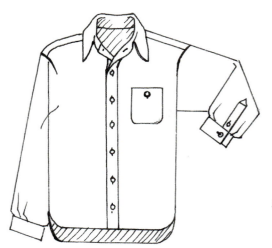

Basic unisex 1 pocket shirt

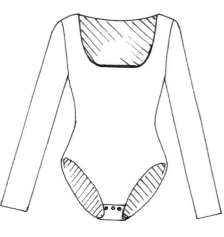

L/S bodysuit with open neckline

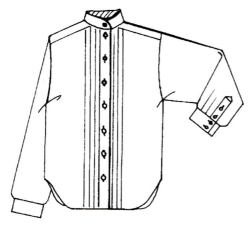

Dress shirt with pleated front

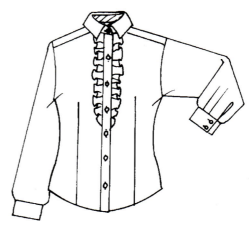

Fitted ruffle front

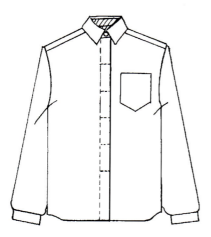

Shirt with hidden placket

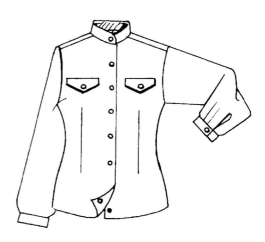

With snap front

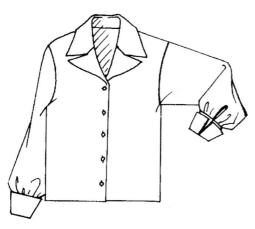

Bishop's sleeves and fold
backcuffs

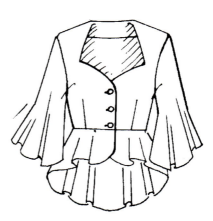

Peplum and bell sleeves

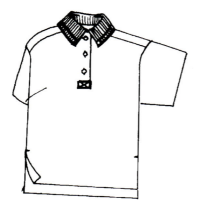

Basic short-sleeved polo

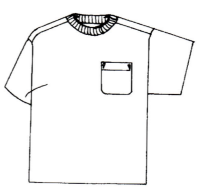

Basic short-sleeved
pocket tee

tops

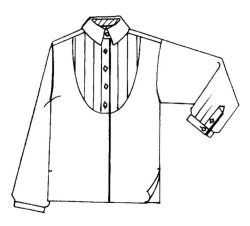

With pin tuck front

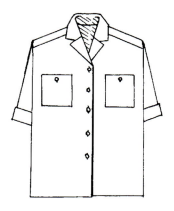

Camp shirt

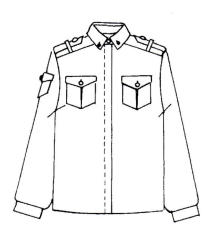

Military style

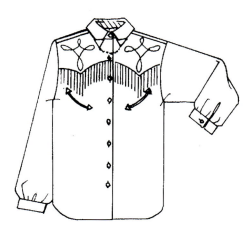

Western style

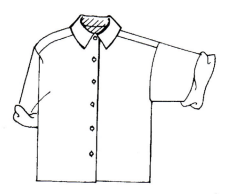

Short sleeve—basic button down

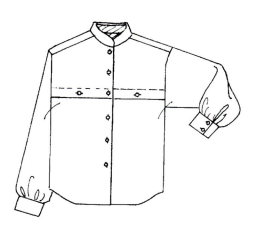

Hidden placket

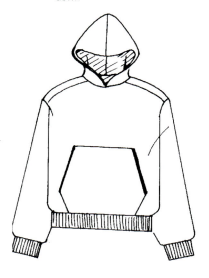

Hooded sweatshirt with kangaroo pocket

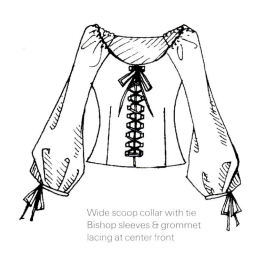

Wide scoop collar with tie
Bishop sleeves & grommet
lacing at center front

jacket styles

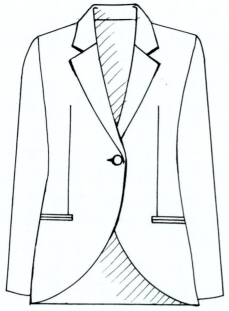

Single-breasted cutaway. Single button.

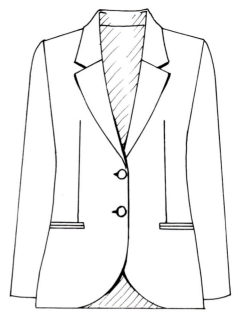

2 button single-breasted. Round hem.

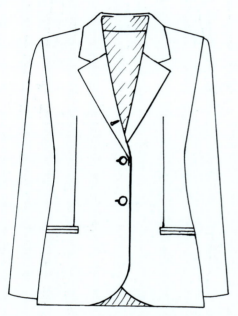

2 button roll-down single-breasted with regular front hem.

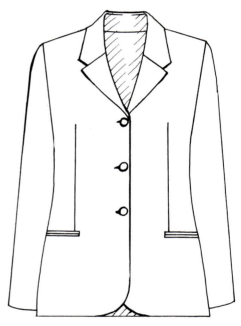

3 button single-breasted with regular front hem.

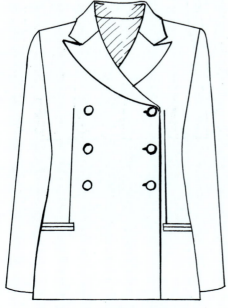

6 button double-breasted with square hem

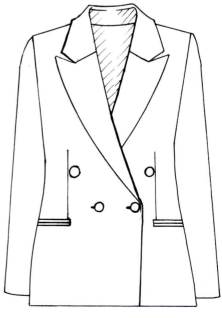

4 button double-breasted

jacket styles

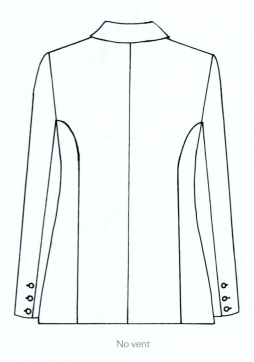

No vent

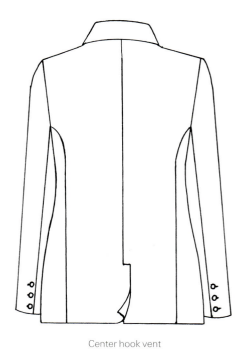

Center hook vent

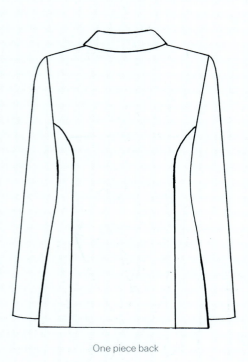

One piece back

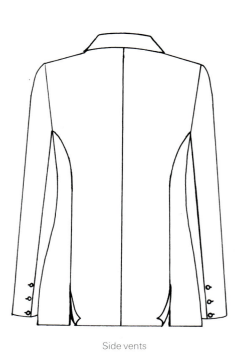

Side vents

jackets

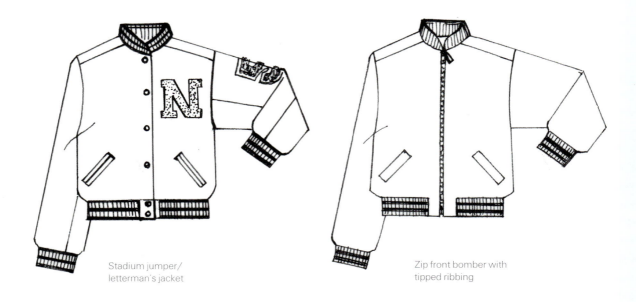

Stadium jumper/
letterman's jacket

Zip front bomber with
tipped ribbing

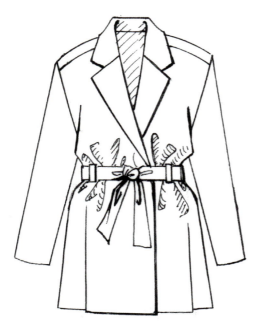

Tie locken or wrap around

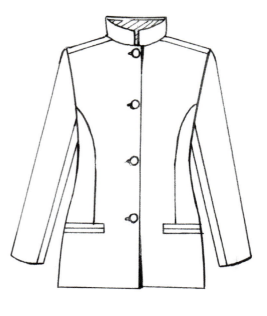

Nehru

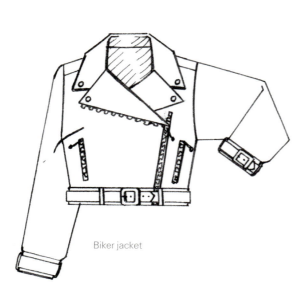

Biker jacket

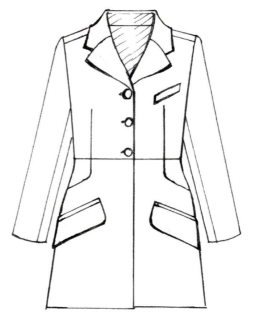

Riding jacket

jackets

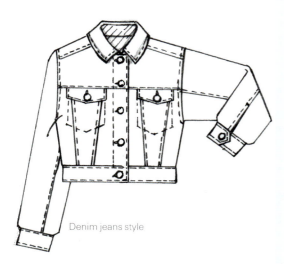

Denim jeans style

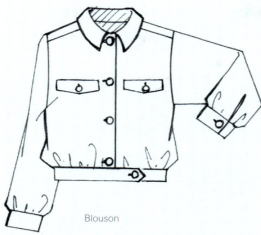

Blouson

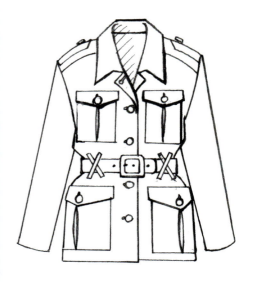

Safari

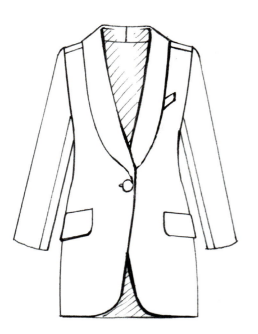

Tuxedo/smoking jacket

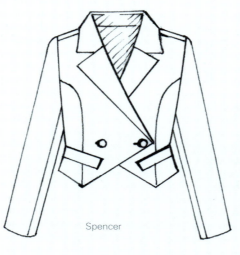

Spencer

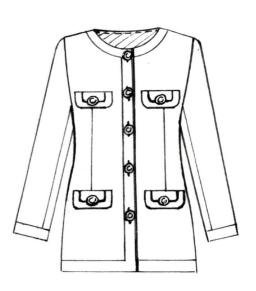

Chanel style

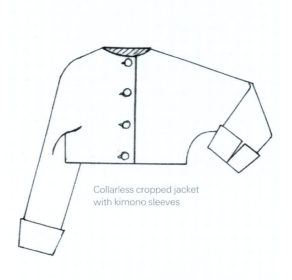

Collarless cropped jacket
with kimono sleeves

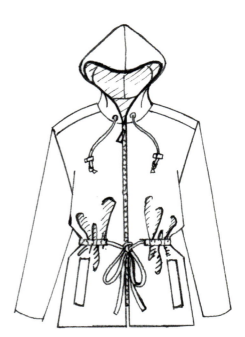

Hooded anorak

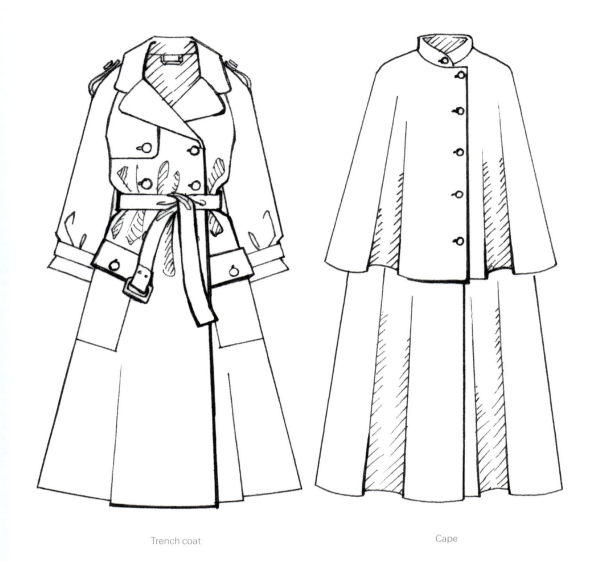

Trench coat

Cape

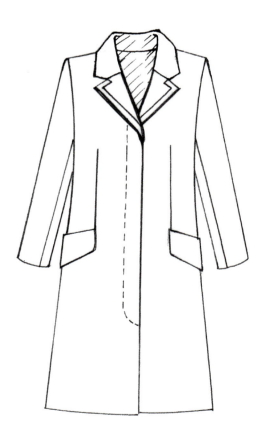

Chesterfield

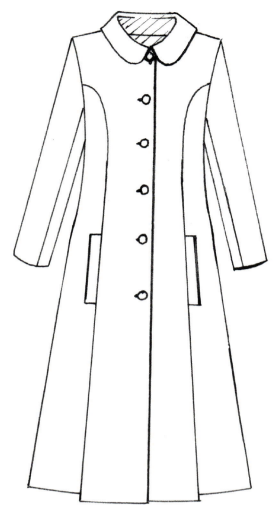

Princess

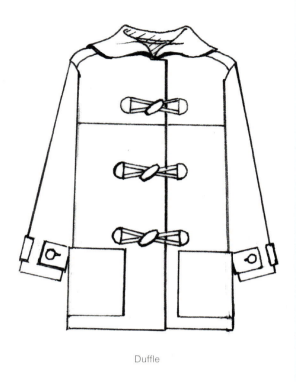

Duffle

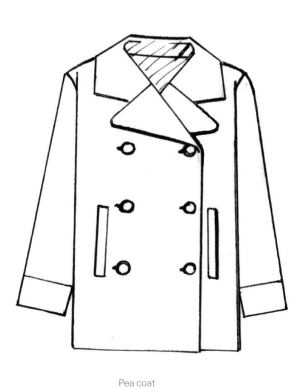

Pea coat

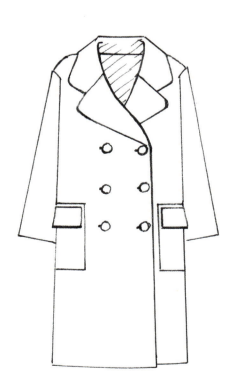

Polo

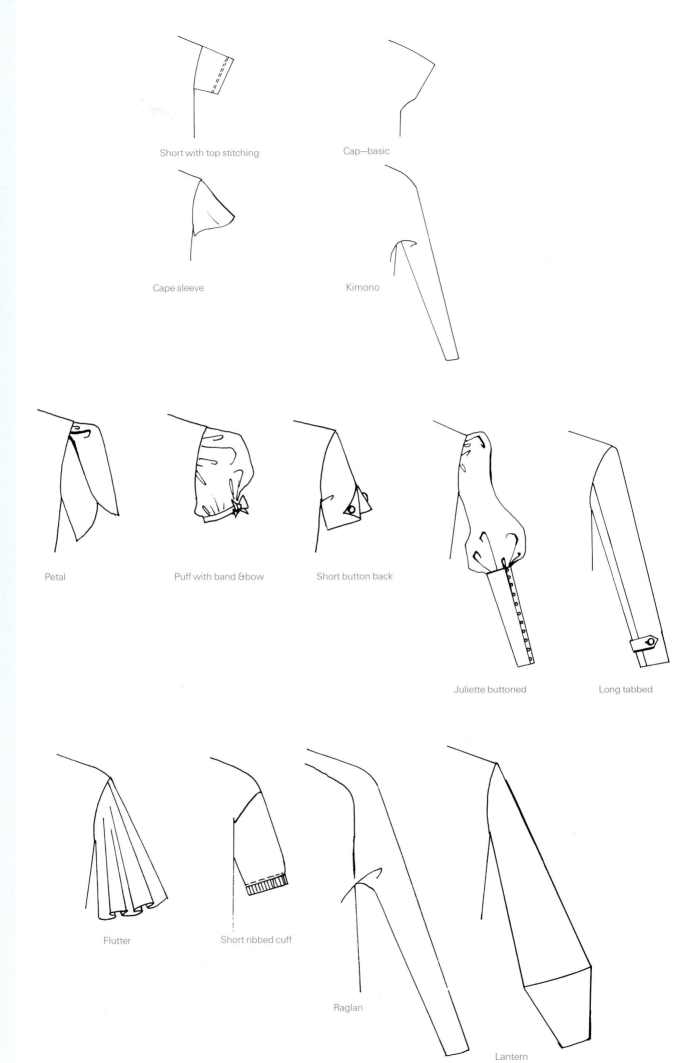

Short with top stitching

Cap—basic

Cape sleeve

Kimono

Petal

Puff with band &bow

Short button back

Juliette buttoned

Long tabbed

Flutter

Short ribbed cuff

Raglan

Lantern

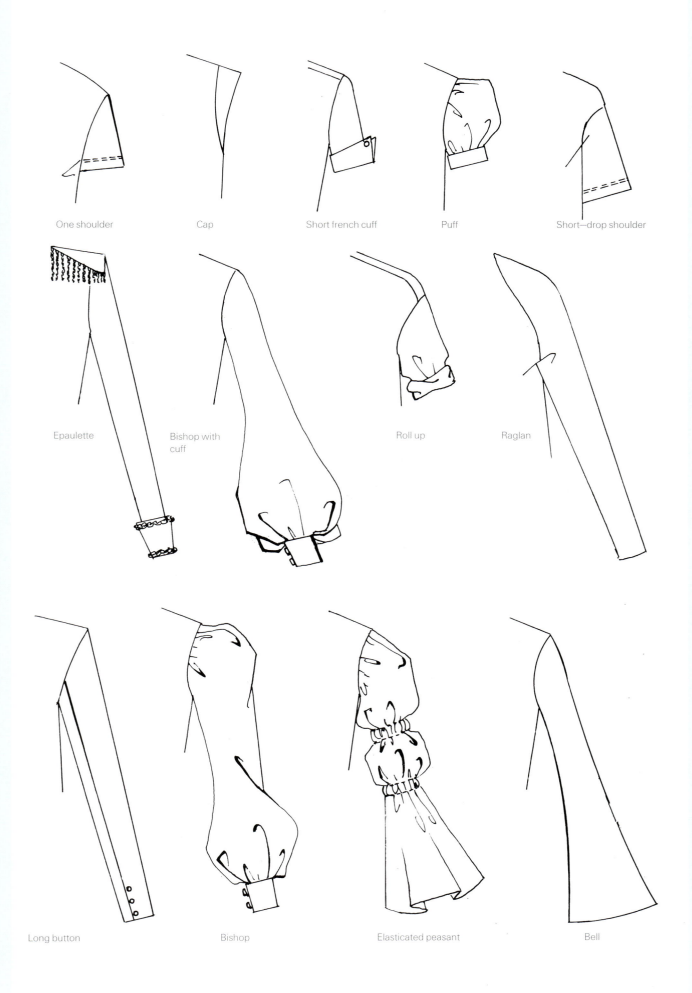

One shoulder

Cap

Short french cuff

Puff

Short—drop shoulder

Epaulette

Bishop with cuff

Roll up

Raglan

Long button

Bishop

Elasticated peasant

Bell

shoes

Gladiator sandal

Thong sandal

Galosh/arctic boot

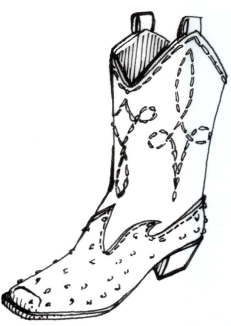

Cowboy boot

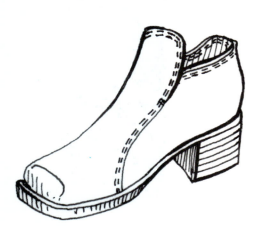

Pants boot

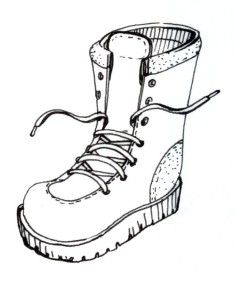

Pacboot

shoes

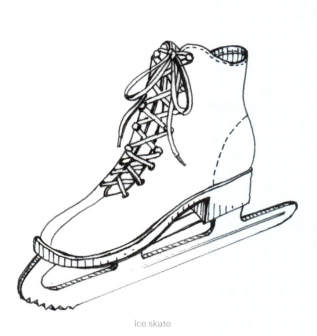

Ice skate

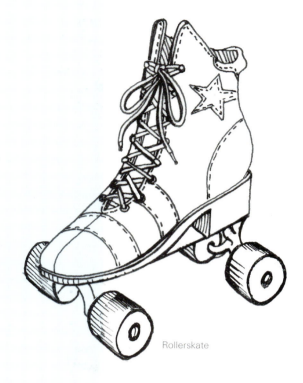

Rollerskate

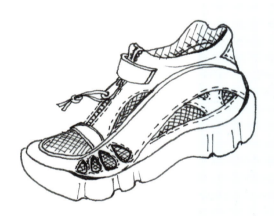

Water moccasin

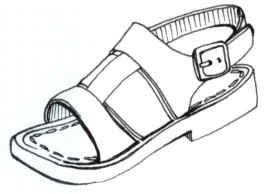

Dress sandal

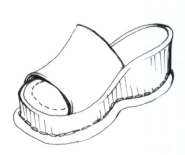

Platform mule

Roller skate

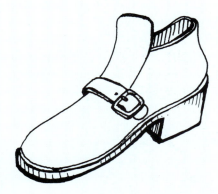

George boot

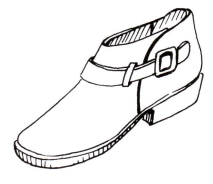

Jodhpur boot

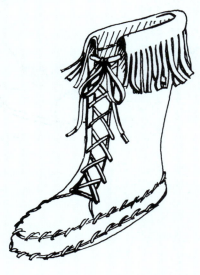

Squaw boot

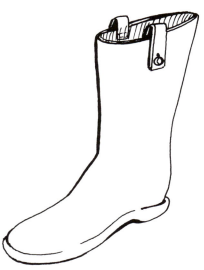

Wellington boot

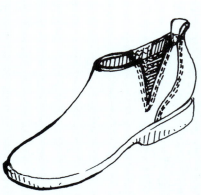

Half boot

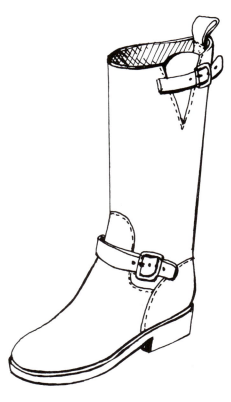

Engineer's boot

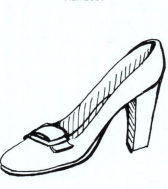

Clark pumps

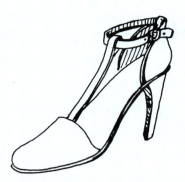

Ankle strap pump
closed toe

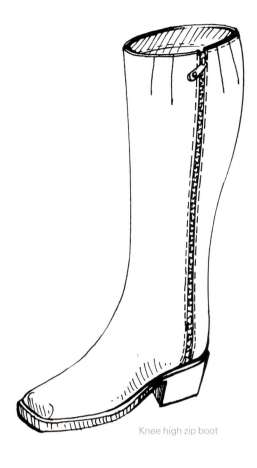

Knee high zip boot

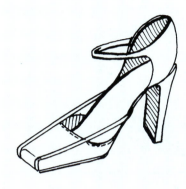

Charles David pump

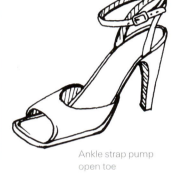

Ankle strap pump
open toe

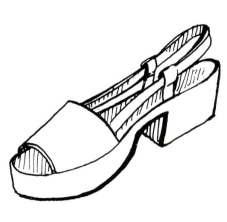

Slingback platform sandal

Raised sandal

Mule

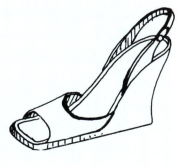

Wedge

eyeglasses

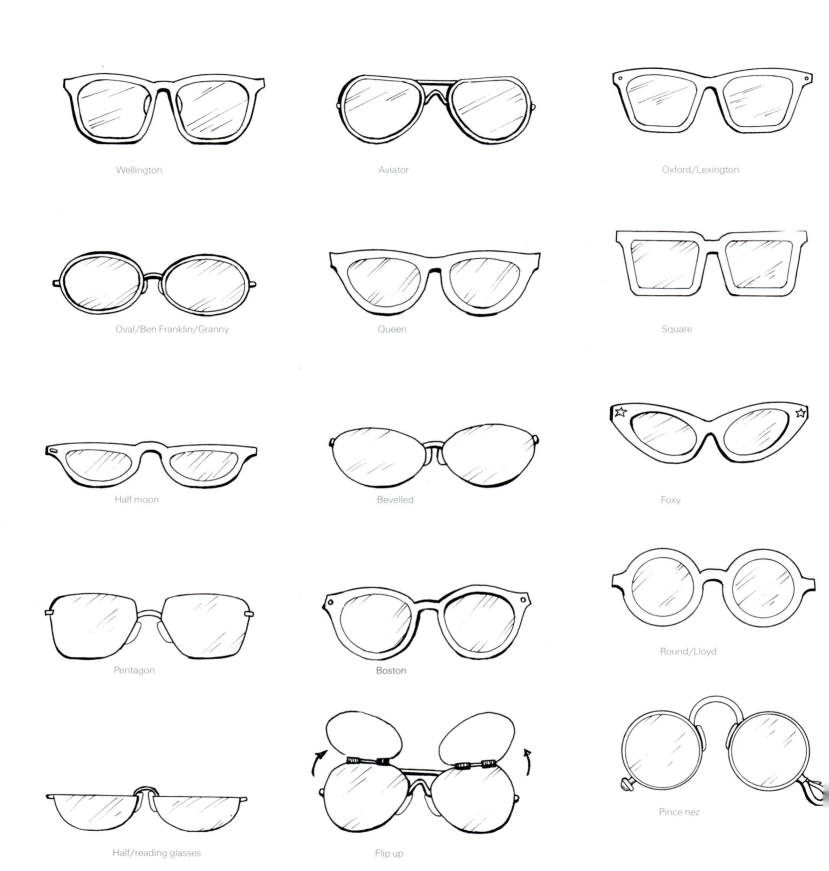

Wellington

Aviator

Oxford/Lexington

Oval/Ben Franklin/Granny

Queen

Square

Half moon

Bevelled

Foxy

Pentagon

Boston

Round/Lloyd

Half/reading glasses

Flip up

Pince nez

Octagon

Harlequin

Tear Drop

Wrap

Flat top

Lounge

John Lennon

Lorgnette

Monacle

Two wings one knot

Roll knot

Ascot

Single Windsor

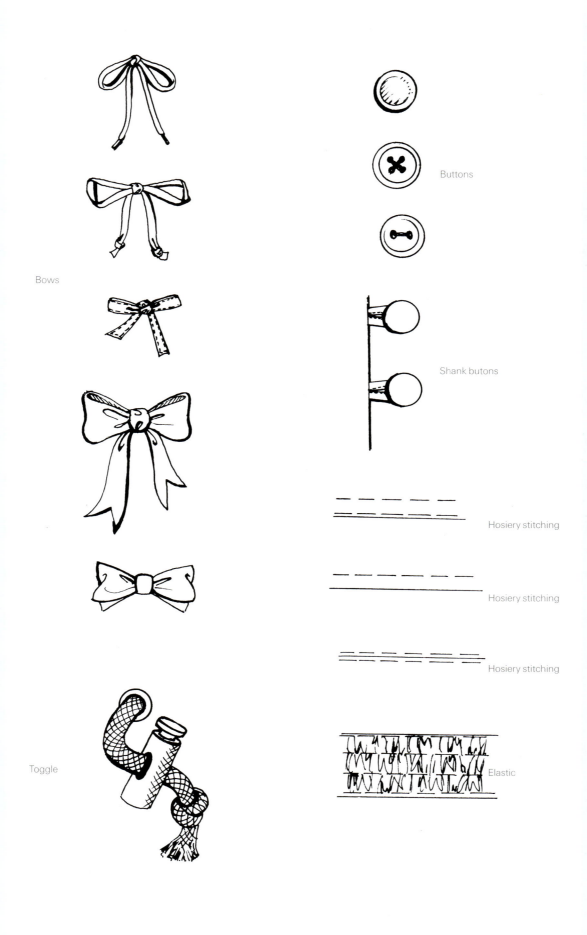

Bows

Buttons

Shank butons

Hosiery stitching

Hosiery stitching

Hosiery stitching

Toggle

Elastic

Frog

stitches

Top side	Underside		Top side	Underside

SN chain stitch

Four thread safety

SN blindstitch

Five thread safety

SN saddle stitch

Six thread safety

SN modern saddle stitch

SN lock stitch

Two needle cover

SN zig-zag lockstitch

Three needle cover

Two thread chainstitch

Four needle cover

Cording for permanent crease

Serge pearl on edge

Converse stitch

Serge stitch

Zig-Zag chainstitch

Mock safety

Modified multi zig-zag chainstitch

Hosiery stitch

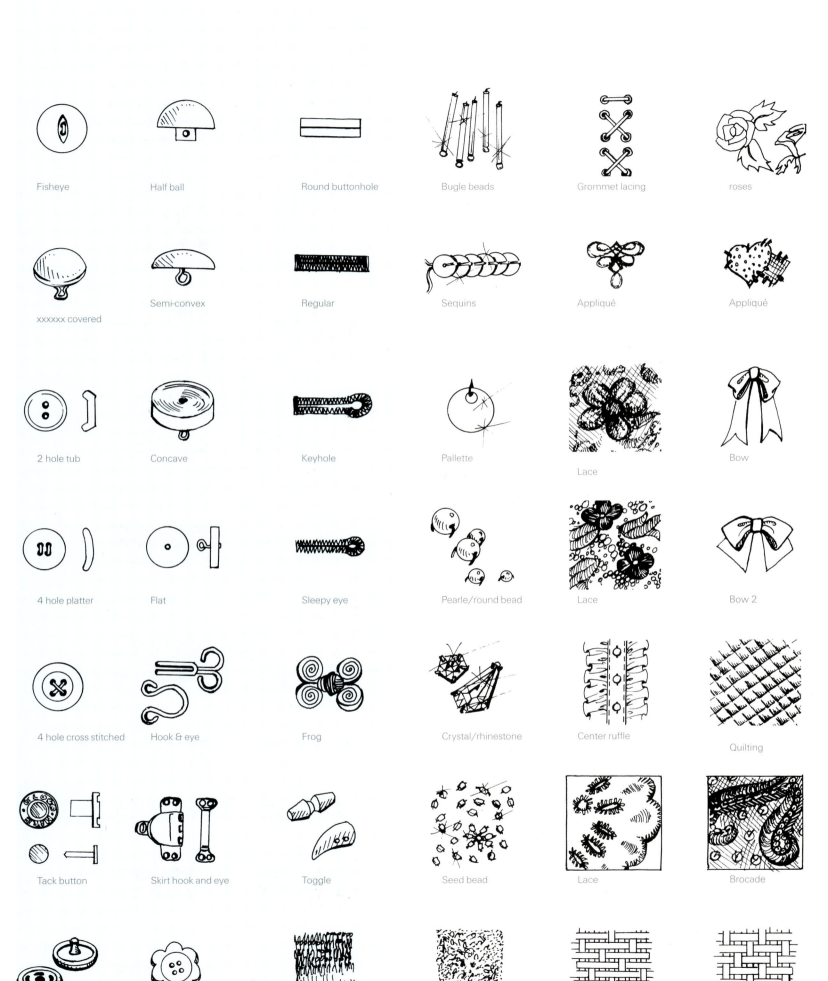

Fisheye	Half ball	Round buttonhole	Bugle beads	Grommet lacing	roses
xxxxxx covered	Semi-convex	Regular	Sequins	Appliqué	Appliqué
2 hole tub	Concave	Keyhole	Pallette	Lace	Bow
4 hole platter	Flat	Sleepy eye	Pearle/round bead	Lace	Bow 2
4 hole cross stitched	Hook & eye	Frog	Crystal/rhinestone	Center ruffle	Quilting
Tack button	Skirt hook and eye	Toggle	Seed bead	Lace	Brocade
Snap	Novelty	Velcro hook	Loop	Satin weave	Twill weave

Doctor's bag

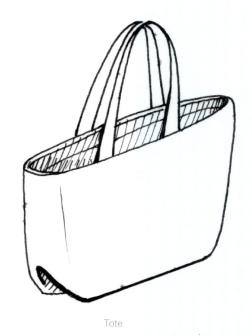

Tote

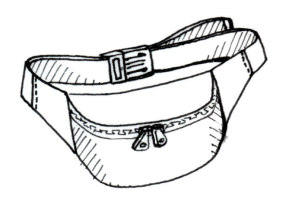

Fanny pack

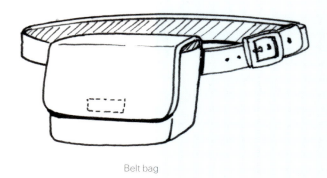

Belt bag

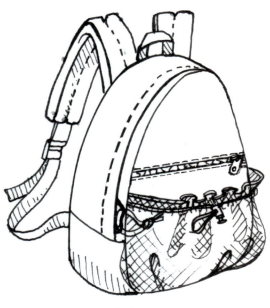

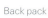

Back pack

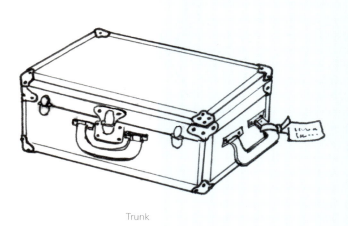

Trunk

bags

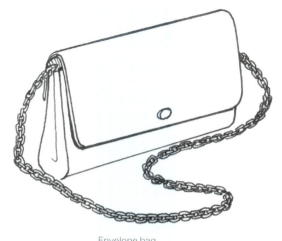

Envelope bag

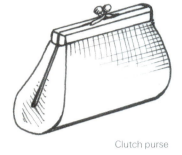

Clutch purse

Lunch box

Square tote

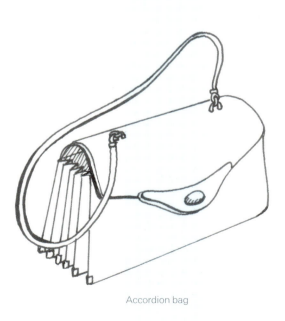

Accordion bag

Straw bag

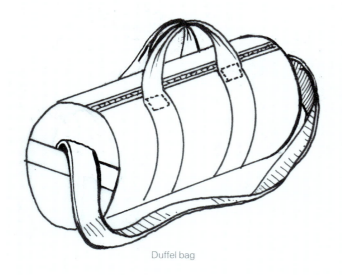

Duffel bag

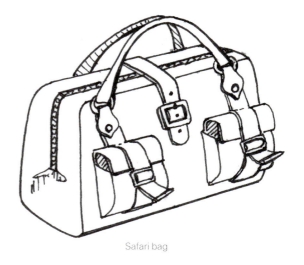

Safari bag

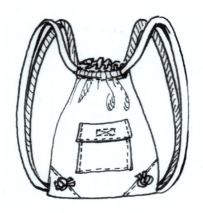

Knapsack/sack pack

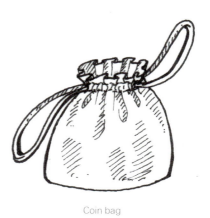

Coin bag

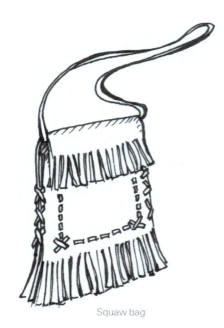

Squaw bag

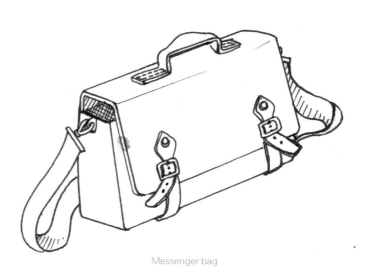

Messenger bag

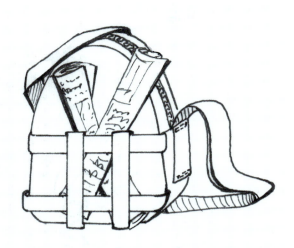

Newspaper bag

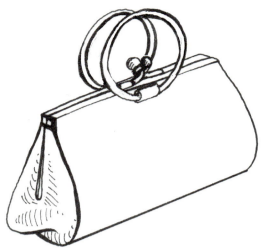

Bracelet bag

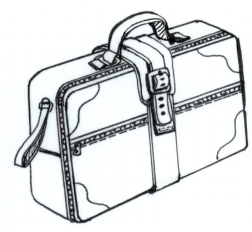

Suit case

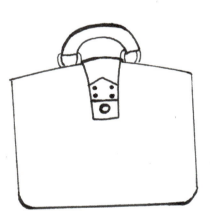

Dallas bag

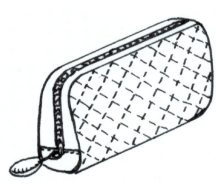

Cosmetic purse

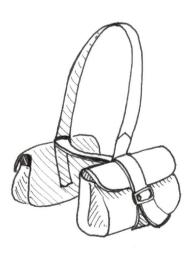

Saddle bags

fabric/folds

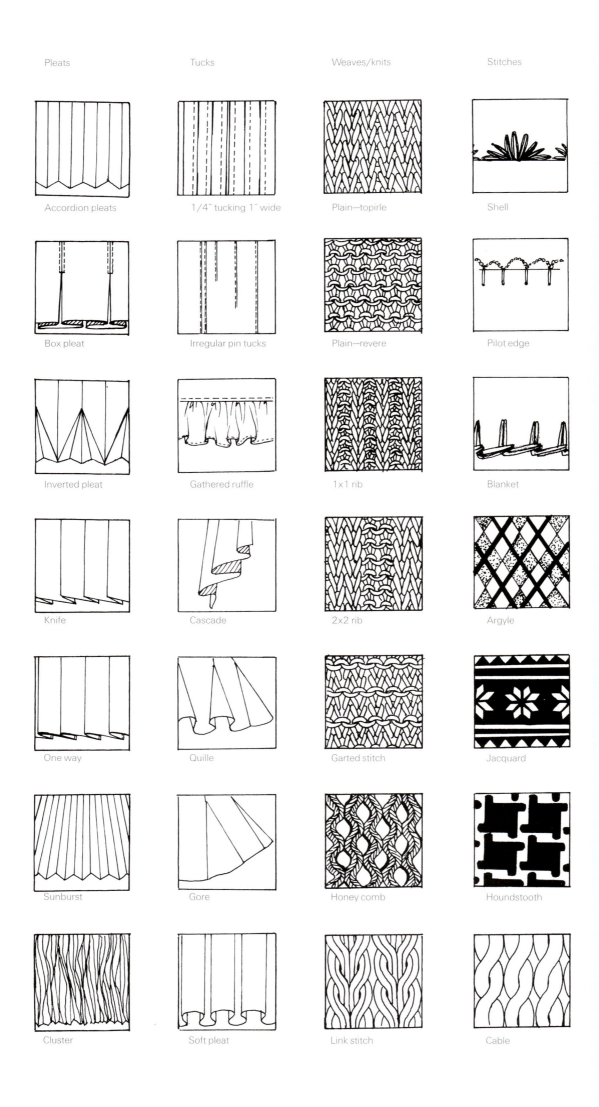

Pleats

Accordion pleats

Box pleat

Inverted pleat

Knife

One way

Sunburst

Cluster

Tucks

1/4" tucking 1" wide

Irregular pin tucks

Gathered ruffle

Cascade

Quille

Gore

Soft pleat

Weaves/knits

Plain—topirle

Plain—revere

1x1 rib

2x2 rib

Garted stitch

Honey comb

Link stitch

Stitches

Shell

Pilot edge

Blanket

Argyle

Jacquard

Houndstooth

Cable

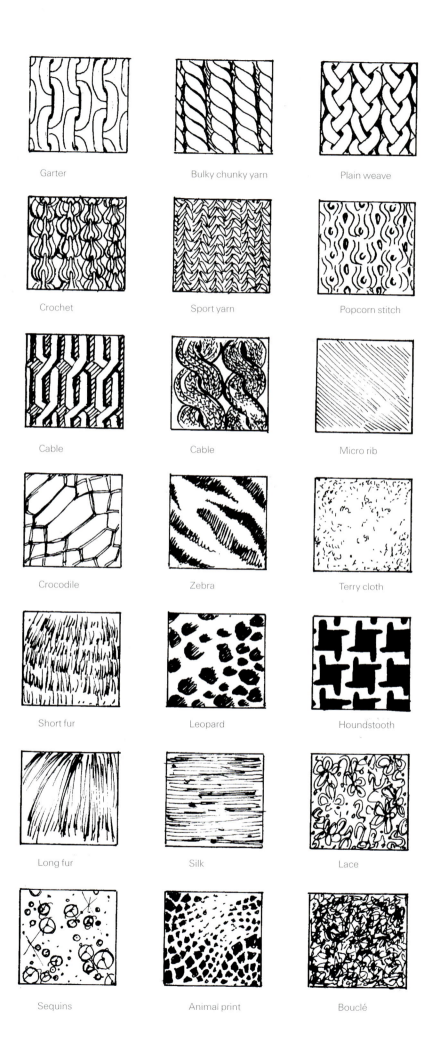

Garter

Bulky chunky yarn

Plain weave

Crochet

Sport yarn

Popcorn stitch

Cable

Cable

Micro rib

Crocodile

Zebra

Terry cloth

Short fur

Leopard

Houndstooth

Long fur

Silk

Lace

Sequins

Animal print

Bouclé

pockets

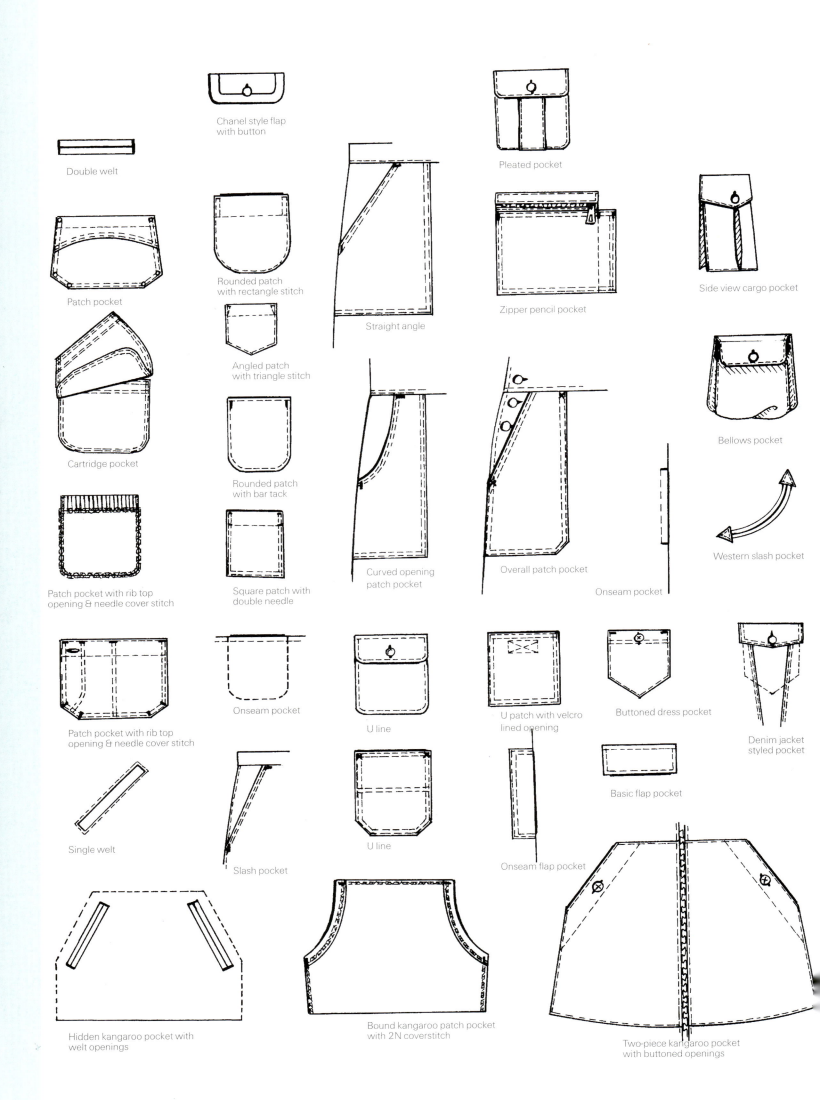

Double welt

Patch pocket

Cartridge pocket

Patch pocket with rib top opening & needle cover stitch

Chanel style flap with button

Rounded patch with rectangle stitch

Angled patch with triangle stitch

Rounded patch with bar tack

Square patch with double needle

Straight angle

Curved opening patch pocket

Pleated pocket

Zipper pencil pocket

Overall patch pocket

Onseam pocket

Side view cargo pocket

Bellows pocket

Western slash pocket

Patch pocket with rib top opening & needle cover stitch

Single welt

Slash pocket

Onseam pocket

U line

U line

U patch with velcro lined opening

Onseam flap pocket

Buttoned dress pocket

Basic flap pocket

Denim jacket styled pocket

Hidden kangaroo pocket with welt openings

Bound kangaroo patch pocket with 2N coverstitch

Two-piece kangaroo pocket with buttoned openings

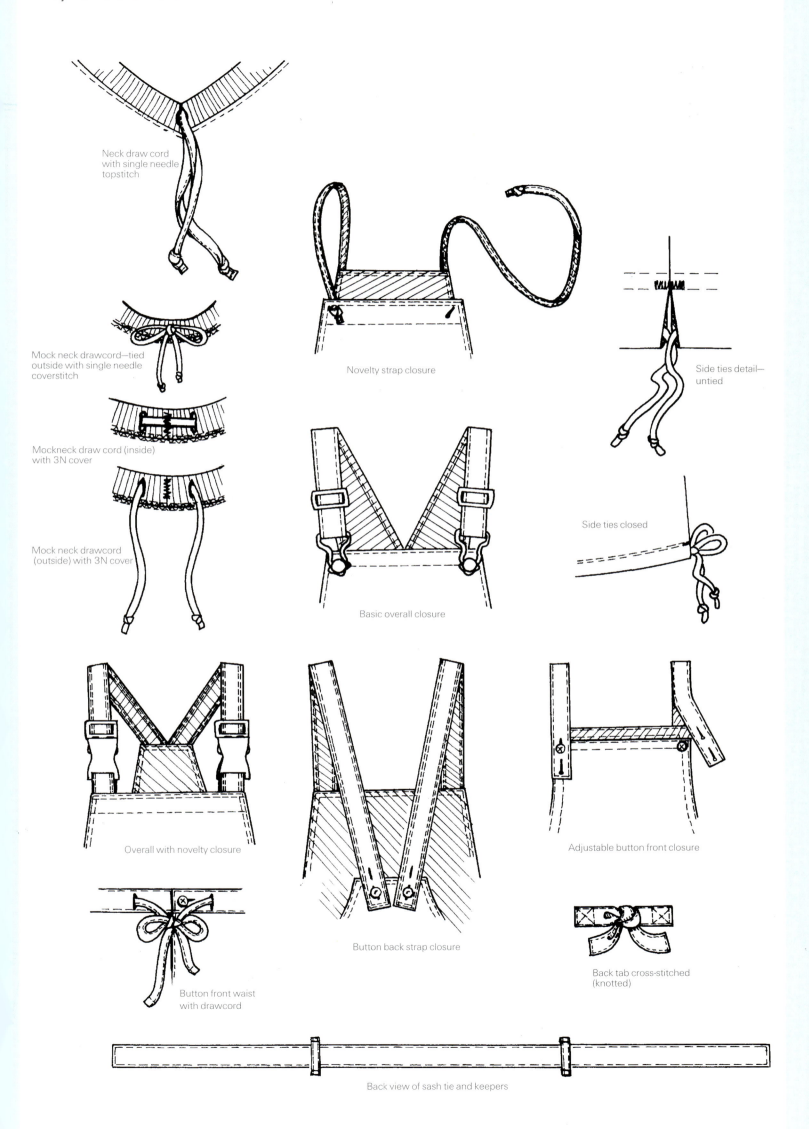

Neck draw cord with single needle topstitch

Mock neck drawcord—tied outside with single needle coverstitch

Mockneck draw cord (inside) with 3N cover

Mock neck drawcord (outside) with 3N cover

Novelty strap closure

Side ties detail—untied

Basic overall closure

Side ties closed

Overall with novelty closure

Button back strap closure

Adjustable button front closure

Button front waist with drawcord

Back tab cross-stitched (knotted)

Back view of sash tie and keepers

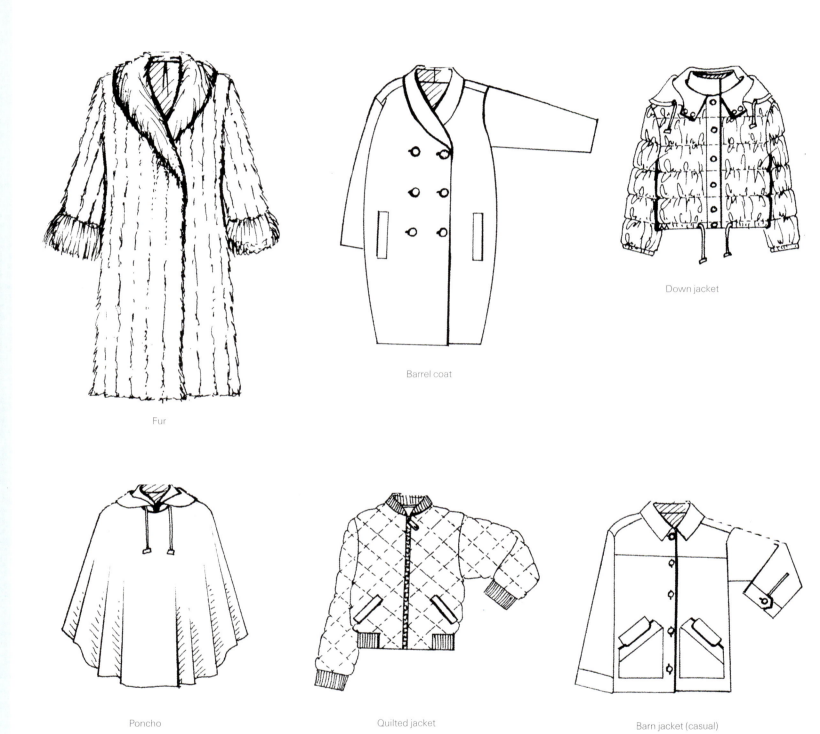

Fur

Barrel coat

Down jacket

Poncho

Quilted jacket

Barn jacket (casual)

cuffs/closures

Button cuff

Bishop flounce cuff

French

4 button cuff with flounce

Placket shirt

Elasticated

Ribbed

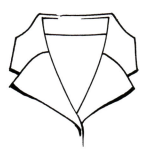

DO
–Wrap neckline
–Shadow under collar tips &
roll for depth
–Show back neckline & construction

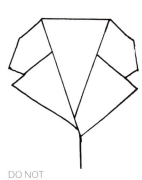

DO NOT
–Angle at neckline
–Come to point at collar roll/breakpoint

DO
–Center
–Space evenly
–Directional buttonholes
–Indicate stitch type/
button type

DO NOT
–Have placket opening on
center front
–Have bad spacing or
multiple axis

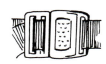

Buckle

DO
–Exposed
–Railroad
–Regular
–Invisible

DO NOT
–Zig zag
–Traintrack

Clip (bag)

Parachute clip

Zipper

silhouettes

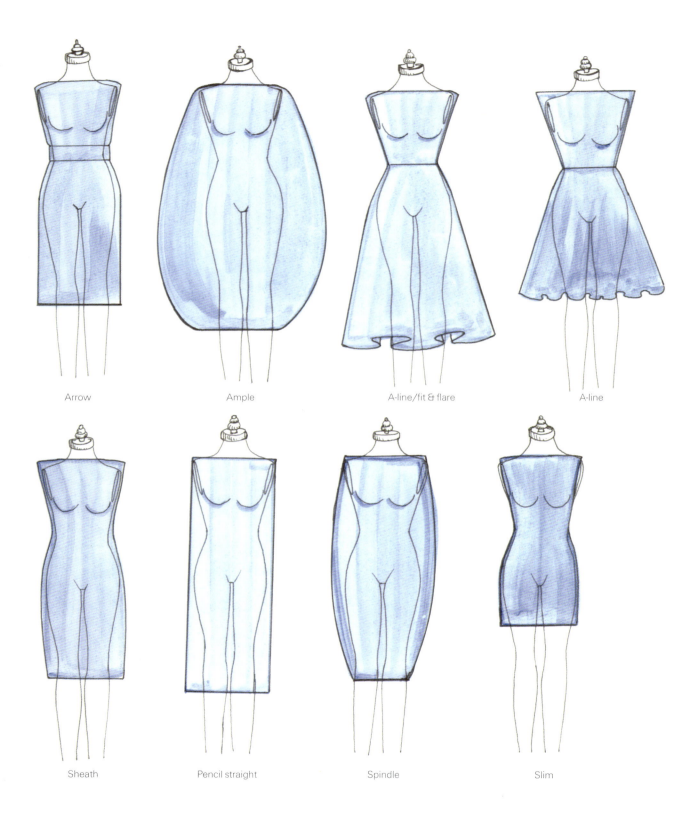

Arrow

Ample

A-line/fit & flare

A-line

Sheath

Pencil straight

Spindle

Slim

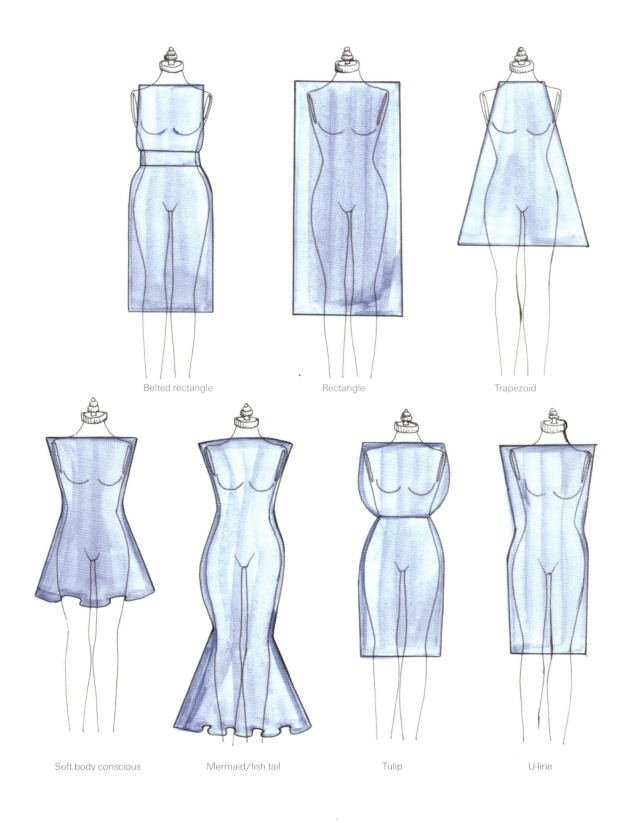

Belted rectangle

Rectangle

Trapezoid

Soft body conscious

Mermaid/fish tail

Tulip

U-line

chapter six:
how to draw textiles

how to draw textiles (rendering)

Rendering is a drawing technique for representing the texture, the folds and the reflective qualities of a surface. When employed in fashion drawing, rendering is used to indicate the type of fabric used in a garment. To begin, it is essential to look carefully at the different characteristics of a fabric—its weight, softness, crispness and sheen. Is it shiny or matt? Tight, exact renderings are impressive: the garment looks real, like a photograph. But renderings are time consuming. In the busy world of fashion a loose rendering, which captures the principal qualities of a fabric is often sufficient to get the job done (or often, a drawing will be scanned into a computer so that a variety of renderings can be added with ease).

The basics skills of rendering were covered in Chapter Two when discussing draping of the whole figure. Because the representation of draping is such an important and complex subject, it would be useful at this point to re-read that chapter before moving on to drawing specific fabrics. To recap briefly:

Observe the details of the silhouette (the outside edge of the garment).

Look at the "hand" (the feel) of the fabric, whether it is soft or crisp. Soft fabric will demand a soft edge (use the side of the pencil) and crisp will demand a sharp edge (use the point of the pencil).

Matt fabric has shadows which appear grey. Shiny fabric has shadows which have contrasts of dark and light.

TWEED: Apply a flat tone or surface using a pencil or ink wash. Add vertical and horizontal layers of sharp, quick marks (which appear as flecks, like the lines of snow or rain). To show the draping, add darker strokes where the fabric is shaded and with a white pencil apply soft light at the top of the fold.

Satin

Wool

VELVETS AND SATINS: Velvet is a soft fabric which reflects light. Draw a rich, dark, black tone through most of the garment. Using an ink wash is an excellent way of achieving this effect. A number 4B or charcoal pencil may be applied over the wash to add a smooth, soft surface. White areas are applied on the top of the folds (leaving the top of the folds white is an effective alternative). Satin is drawn with the same technique but the highlights, or white areas, have sharper edges.

LACE: Lace is a transparent fabric and should be drawn with the same technique as one draws pattern fabric (see below). Begin by painting in skin tone or the fabric which you wish to show as a lining for your lace. Plan your pattern with simple shapes which indicate the abstract pattern of the lace. For instance, a floral pattern which is repeated throughout the lace is drawn with ovals, which best describe the shape of a flower. These follow the drape of the garment. Delicately fill in the oval with the shape of your flower: the pattern does not have to be drawn in every part of the garment. If the edge of your garment is scalloped, indicate that shape. Shade the fabric to indicate the body beneath the lace. Draw a few thin parallel lines to indicate the netting which is the base fabric of the lace.

VINYL, LEATHER AND DENIM
Vinyl and leather have contrasts between very dark areas of the fold and very light areas. The tops of the folds will appear crisp and white, like white snakes. Highlights or dots of white may be used for extra shine (use a brush and typewriter "white-out" or white wash to achieve this effect). For denim, use a smooth pencil, or, if color is used, a Prussian or cobalt blue marker. The "signature" of denim is that it has many folds and creases. A darker blue or black pencil should be used to darken the insides of these folds. Add dark shadows around the crotch. Use a white pencil to create a white, smooth tone next to the dark

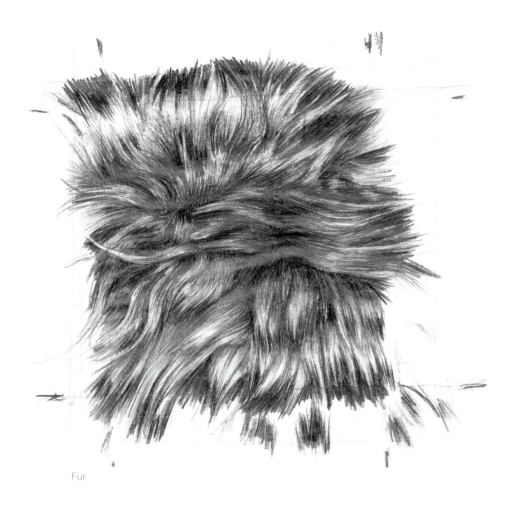

Fur

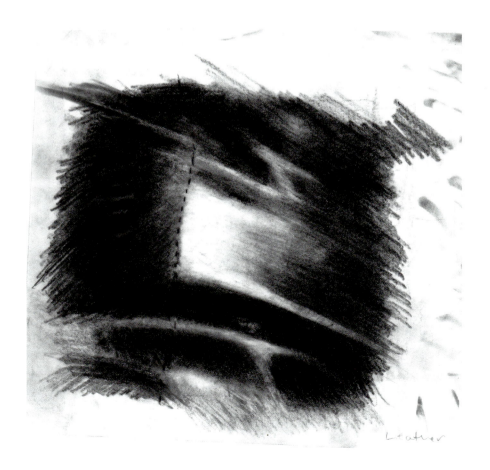

Vinyl/Leather

rendering textiles

folds. Indicate topstitching with the sharp point of a white pencil or with a white gel pen. Use a white pencil to make diagonal strokes to show the twill of the fabric.

WOOL AND CORDUROY: These are both soft, smooth fabrics. To create both wool and corduroy begin with a soft tone. Use the side of the pencil to keep shadows and folds even in tone. For corduroy, on top of this tone use a thick line referred to as a cord or "whale" . The whales move up and down along the shape of the fold. Soft shadows can be applied. Wool can be lightweight or heavyweight. Keep the base tone light and soft. Shadows are applied in wide areas between the folds. The shadows remain smooth and even in value. The size of the fold determines the weight of the fabric. Extra soft fabrics, such as angora and cashmere, require an extra-soft touch.

FUR: Fur is made with soft, wide areas of shadow. It is made of different sizes of pelts. For example, mink is a short-haired fur and must be drawn with medium-sized shadows. Fox requires a larger area of tone and longer lines. Beaver has long vertical shadows and short lines. Chinchilla is a thick, short-haired fur with smaller shadows and Persian Lamb has very large areas of shadows with thick, tight, curly lines.

SHINY, METALLIC THREAD AND SEQUIN FABRICS: Use large areas of very dark tone around the body, leaving the bust, knees and tummy folds white. Add grey and white slashes and dots to create sparkle.

CHIFFON AND TRANSPARENT FABRICS: These are very light fabrics which float around the body. Of course, the body can be seen under the garment and will appear darker in that area. Hems, seams and overlapping fabric is also drawn with a darker shadow. Remember: Fabric falls, floats, bends,caresses, protects, twists, pulls, rests against the body.

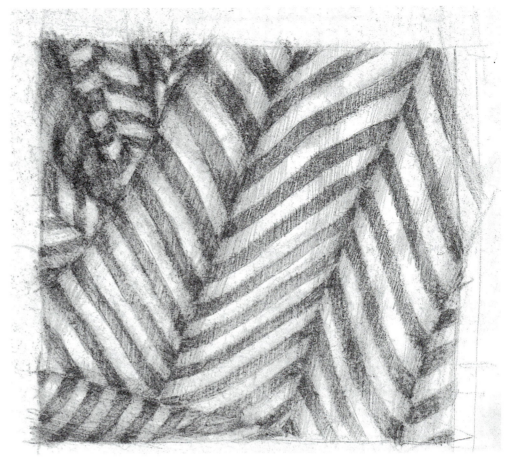

Herringbone

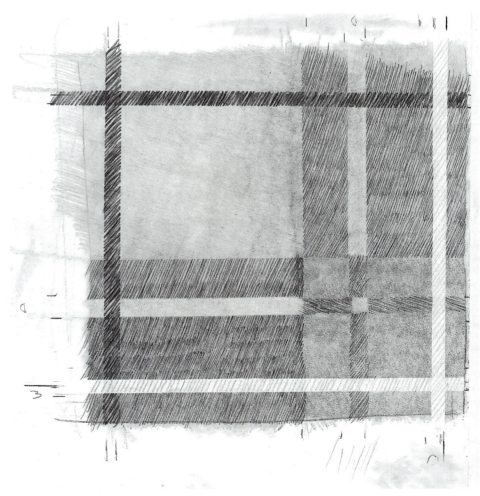

Plaid

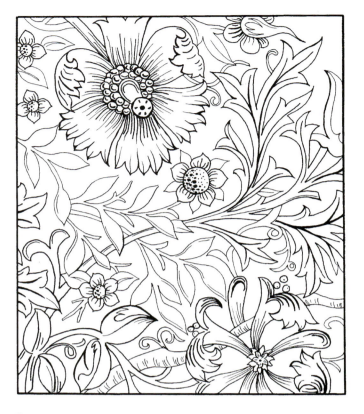

Patterns

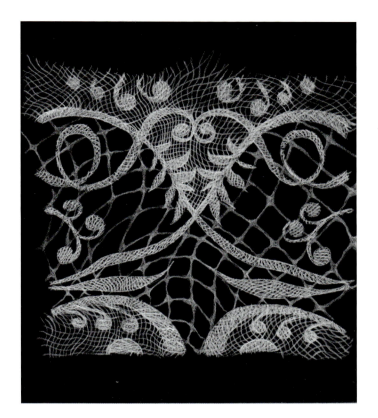

Lace

rendering textiles

STRIPES, FLORALS AND PLAIDS: Stripes follow the folds and drapes of the fabric around the body. Use the hem of the garment as a guide. Break the line of the stripe at each fold and start it again after the fold. Use stripes to create rhythm and visual interest in the garment, whether applied vertically, horizontally or diagonally. Plaids. When viewing a plaid, squint your eyes almost shut and the plaid will appear as grey tones. The first shade of grey, the lightest, is used on the background. Using the next shade of grey, a dominating stripe is applied. Add a second dominant stripe either horizontally or vertically. Where the stripes cross apply a black square. Fine black lines are then added. Remember plaids also follow the shape of the garment. Floral. Plan the size of your floral print by placing fabric against the armhole seam at your shoulder and count the number of times this pattern is repeated from side to center of your body. Double this number and you will have the number of times the pattern is repeated across your garment. The same number will be repeated both horizontally and vertically. Start by creating general shapes for your pattern and add detail lines on top of the geometric shape. Work from light to dark and from one side of the body to the other.

QUILTING: When drawing quilting, use a solid tone and draw in the same way you would a pattern, i.e. look for the direction, size and placement of the pattern of the quilt. Shade with black at the corners of each quilted section and add a white highlightnext to the black.

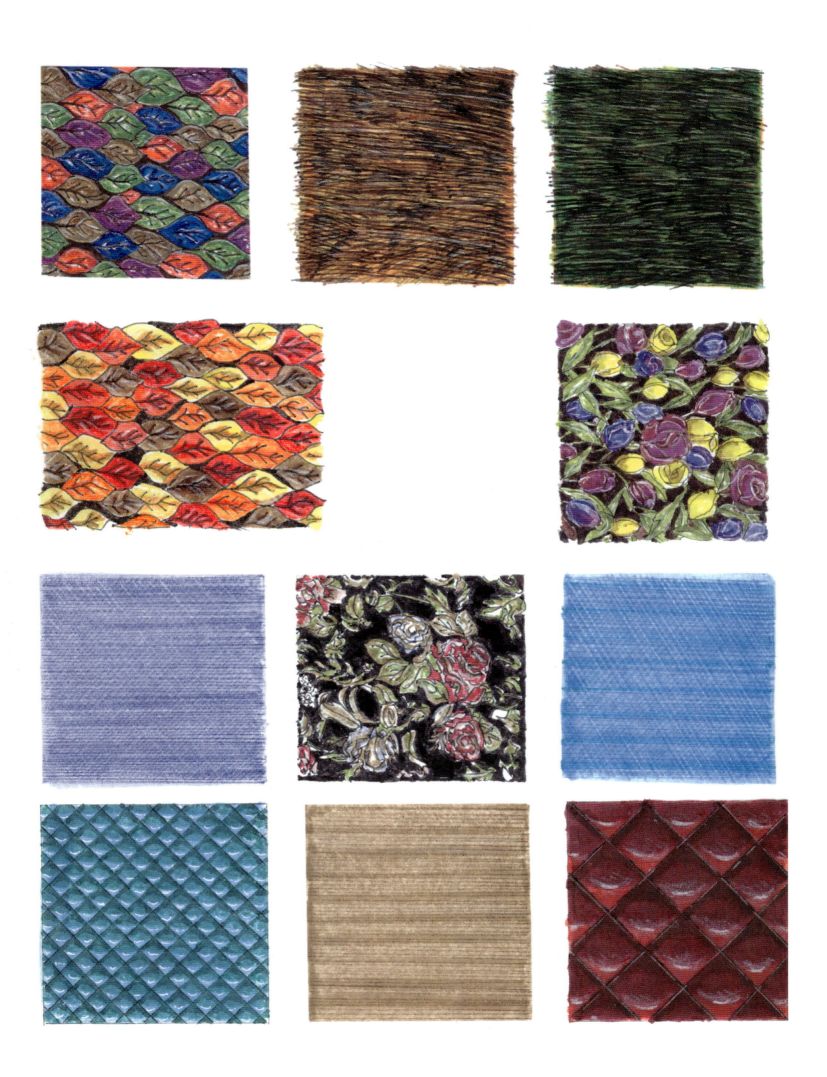

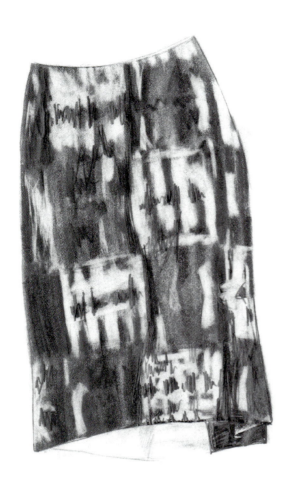

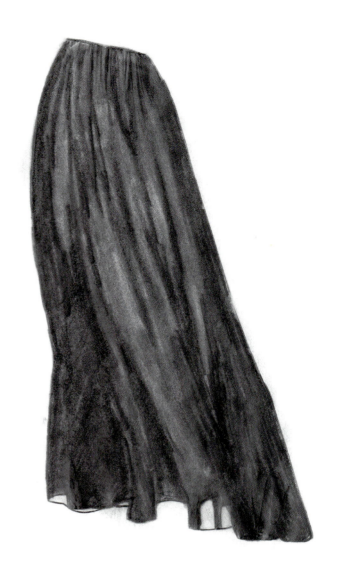

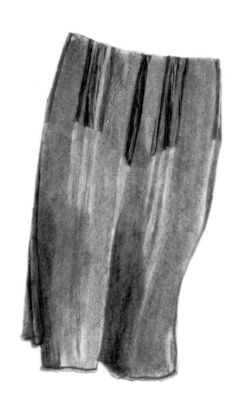

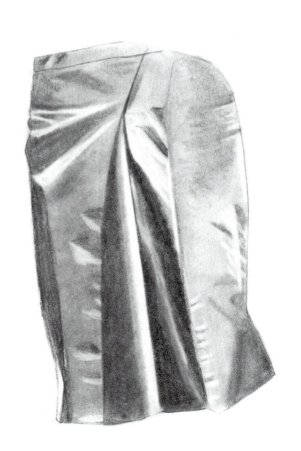

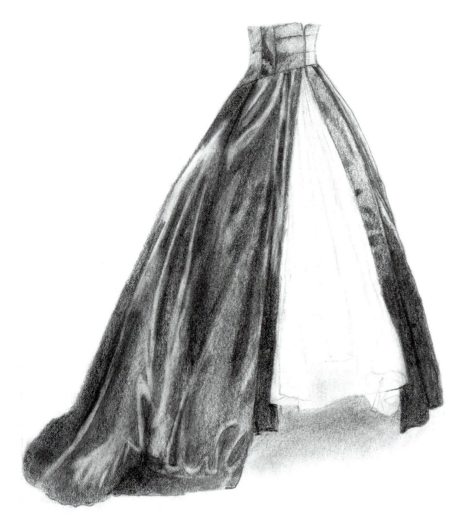

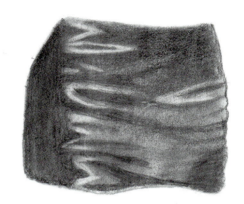

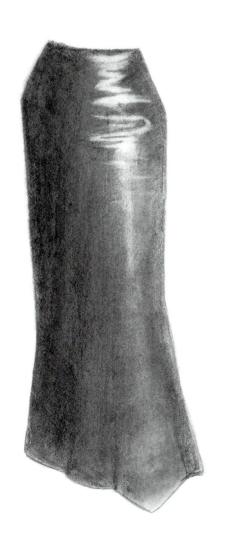

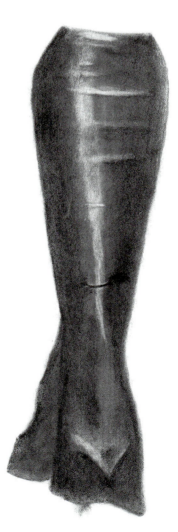

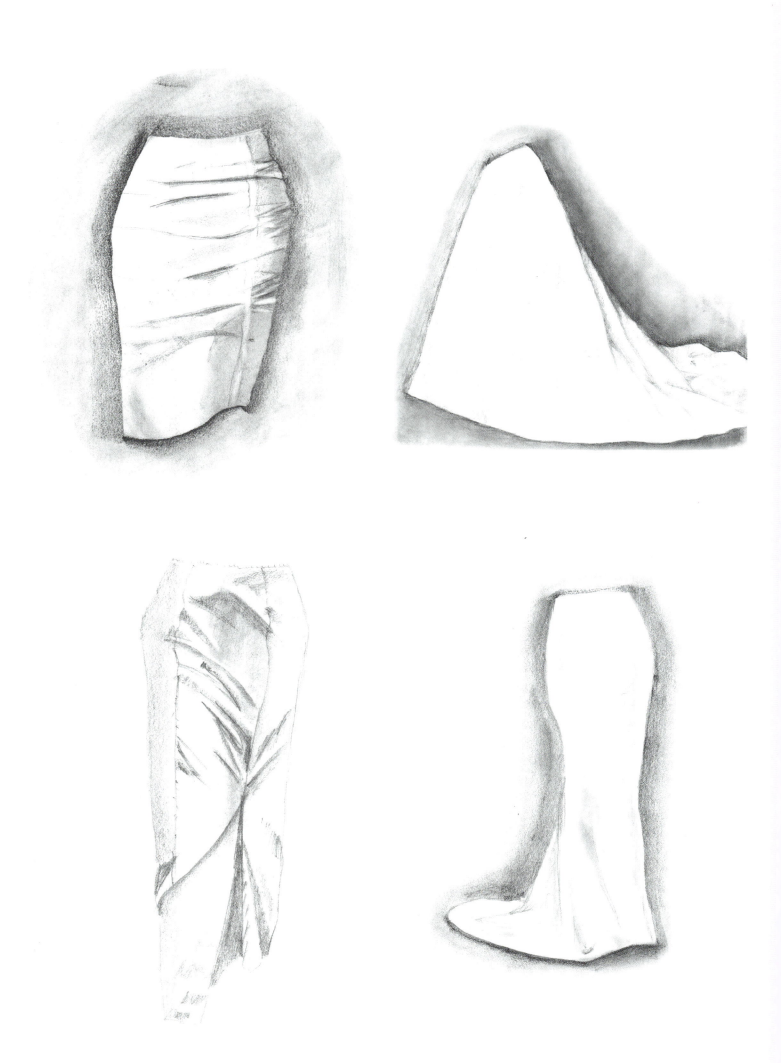

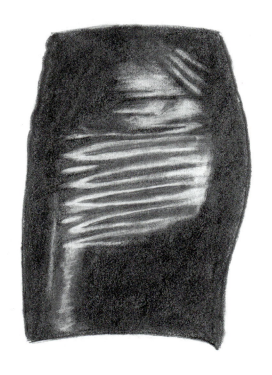

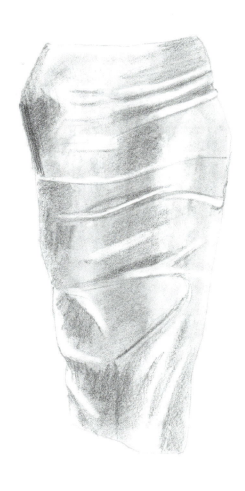

using markers

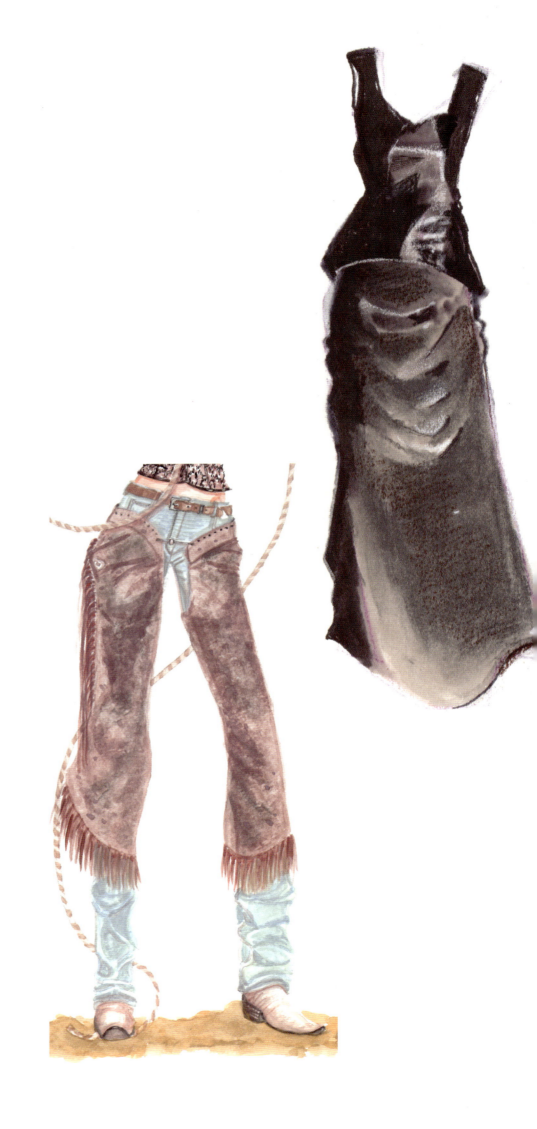

INTRODUCTION TO COLOR

Color is a vast area and the subject of many books in its own right. Here we are going to limit ourselves to markers, which have become the favored tool of modern designers because of their ease of use, quick drying time (they are alcohol based as opposed to water based) and saturation level compared to watercolors. Markers are made by a number of companies, some of the main ones being Prismacolor, Chartpak and Design Art Marker. The more colors you have available the easier it is to create exciting pictures, but the following are the essential colors, chosen from the three brands, which will serve as a good base for your collection. Color is a subjective decision and you might choose different colors from a different brand.

PRISMACOLOR
Crimson red
Yellowed orange
Canary yellow
Carmine red
Mulberry
Violet
Hot pink
Dark green
Ultramarine
Black
Dark umber
Parrot green

Accent colors which will be helpful in Prismacolor are light walnut (for skin), sand and eggshell, clear blender.

CHARTPAK
Blue grey
Pale flesh
Maize
French beige

DESIGN ART MARKER
Black

A great variety of colors are available in all these brands. To achieve a greater range of colors you can blend markers together using a piece of plastic, acetate or plastic sandwich bag as a palate. Markers may also be blended with

Prismacolor pencils. Markers can also be blended with a colorless blender to create transparent color effects which resemble water colors.

METHODS FOR USING MARKERS
1. Hold the marker lightly.
2. Draw the silhouette of your figure and garment with a grey Prismacolor pencil.
3. Apply color evenly without lifting your hand from the page.
4. For more saturated color apply more than one coat to your garment.
5. Work from light to dark.
6. To achieve intense color work with complementary hues, or colors located opposite each other on a color wheel, (for example red and green, blue and orange, yellow and violet).
7. When complementary colors are mixed they become neutral colors. Grey, beige, and brown, for example, are neutral colors. When a color is mixed with white it is called a tint.
8. The amount of color used greatly affects the visual impact of your garment. Using too many neutrals can result in a grey or dirty effect. If this should occur, add a small amount of a pure hue anywhere on the composition and it will enliven the whole picture. Remember to use color to enhance your garment. Skin tone can be natural, pink, blue, green or polka dot. Use your color creativity to enhance the theme of your garment.

PAINTING SKIN TONE AND FABRIC
1. Use your flesh tone marker to fill in the edges of your figure.
2. Now fill in the areas around the bust line, tummy, knees, muscles of the neck and across the collarbone.
3. Apply a second tone, darker than the original skin tone, along the edge of the body to create depth.
4. Follow the previous explanations of rendering fabric when pencil was used and employ the same methods when using color. Consider the dark and light areas of fabric and use the dark and light quality of color (value) to express the quality of the fabric.

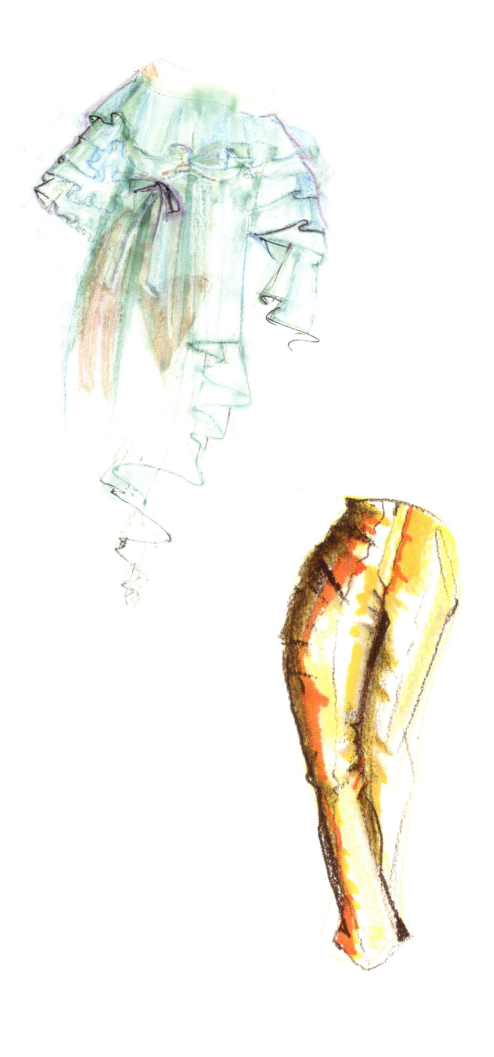

chapter seven:
how to draw
real clothes

lacroix

castelbajac

chanel

armani

banana republic

target

akira

valentino

drawing real clothes

Up to this point we have studied the skills and techniques of fashion drawing. In this chapter we look at how to apply in real situations the knowledge and skills which we have acquired.

A large part of fashion drawing is copying what is seen. Shopping in a store, at a fashion show, or simply observing everyday life we might wish to record visual ideas about an item of clothing for later use. It is important in these situations to be able to capture the essence of and important information about a garment quickly and effectively. This can only come with practice, looking at actual garments and re-creating their important features in a sketch.

Sketching real clothes is also a good discipline in itself. By making good fashion drawings of existing garments we learn not only how to reproduce what already exists but also to improve your overall sketching skills. Sketching also allows us to gain insight into the cut and construction of a garment, the textures and qualities of the fabric it is made of, and a garment's good, as well as its weak points.

This chapter shows a variety of garments covering a wide range from designer to inexpensive mass-market clothes. The clothes were chosen because they all have dramatic design elements and are lovely to behold. Accompanying the photos of the clothes are sketches. The sketches were drawn quickly, with the emphasis on recording the most important features of the garment. Study the way in which the sketches included here have been drawn and then make sketches from the same photos. Sometimes the best fashion drawings are made by drawing real clothes on oneself or on a model. Draw as much as possible from real life. When this is not possible draw the images from your idea book. The more you practice the better your sketches will become.

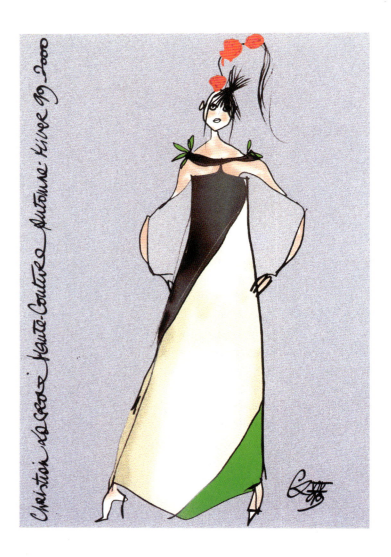

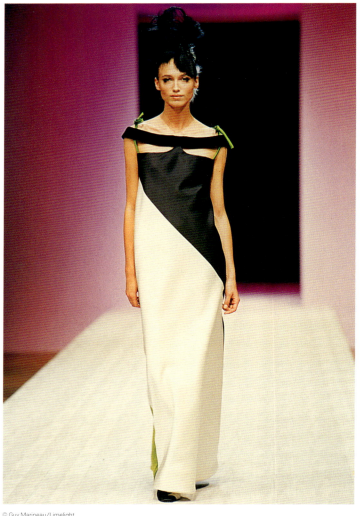

© Guy Marineau/Limelight

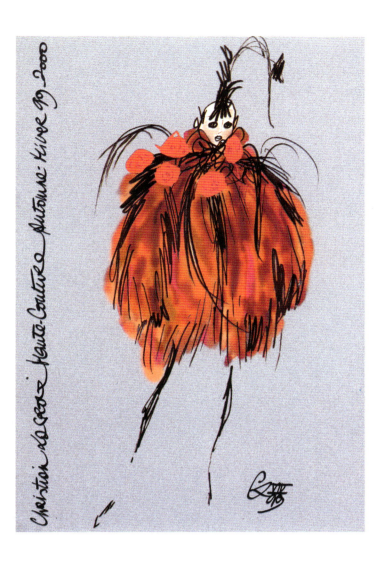

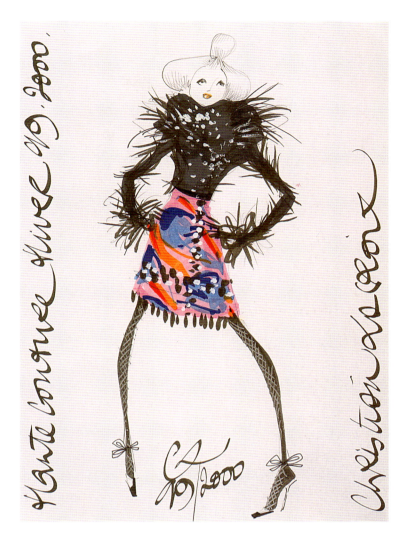

281

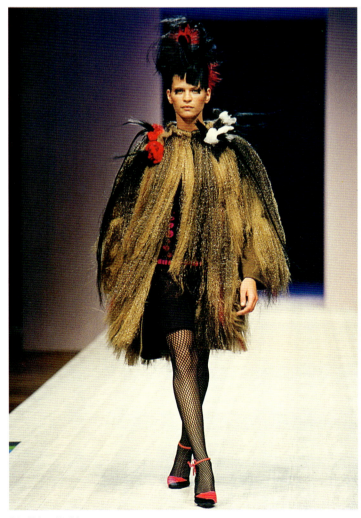

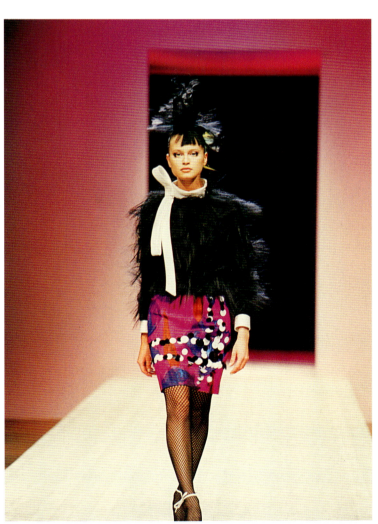

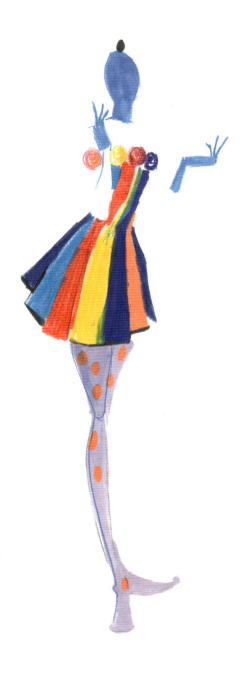

castelbajac

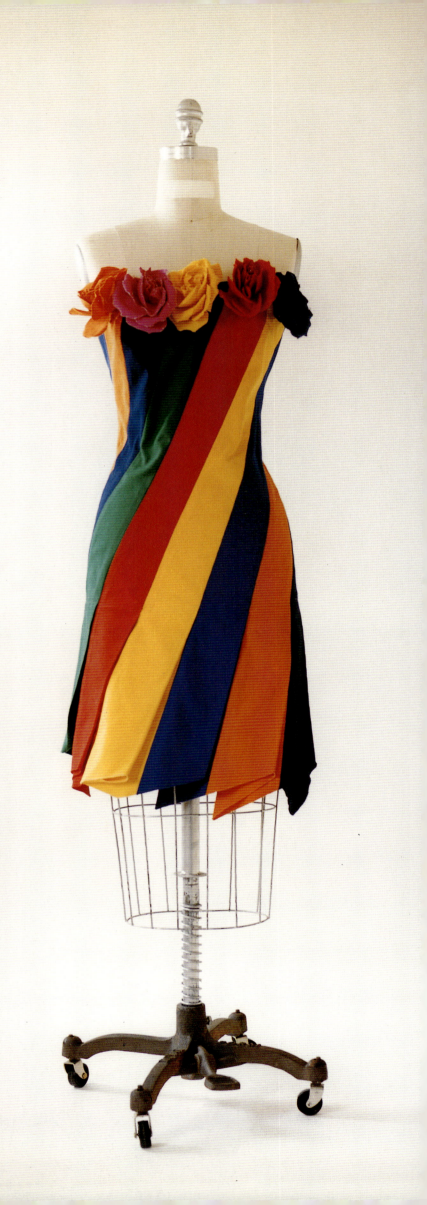

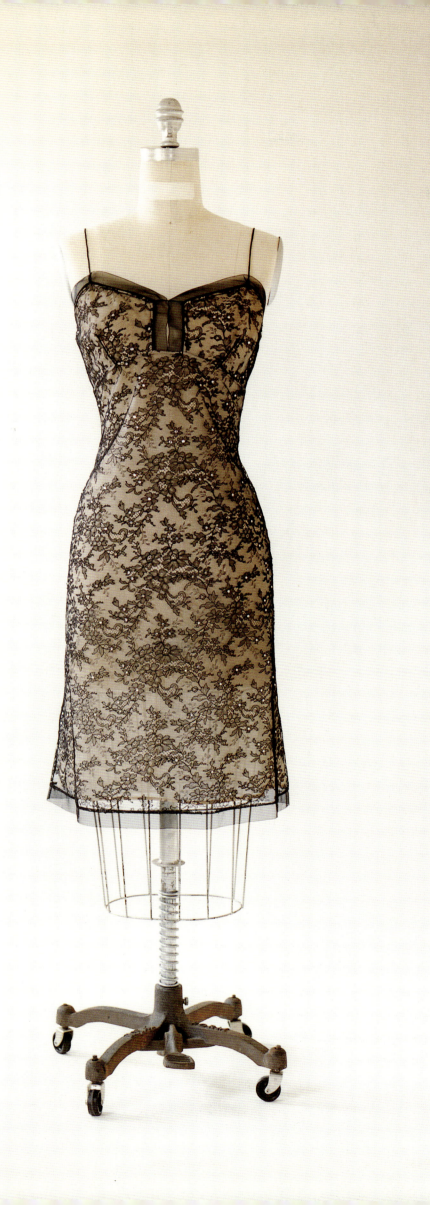

armani

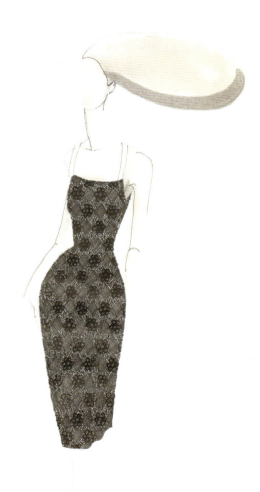

chanel

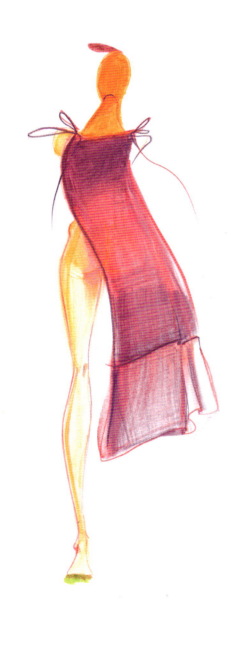

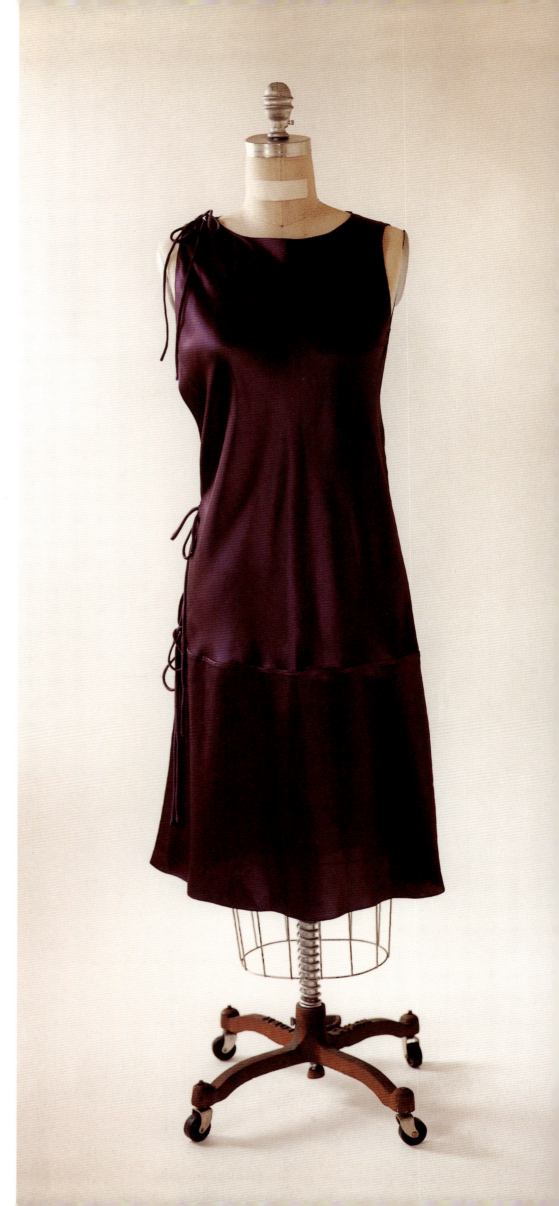

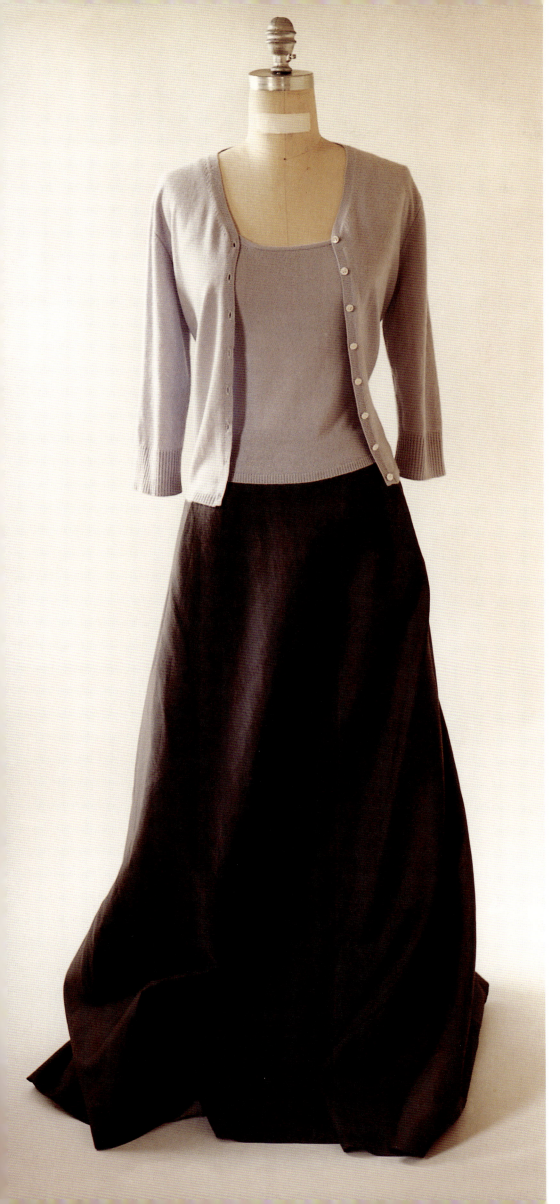

banana republic

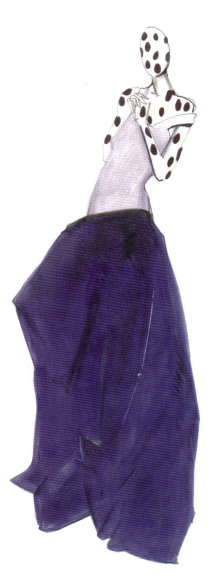

target

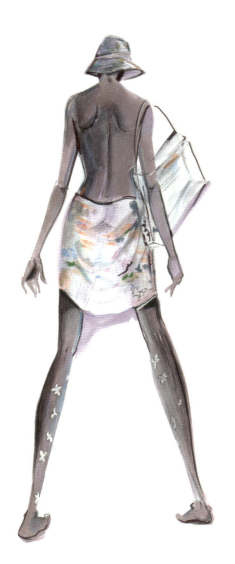

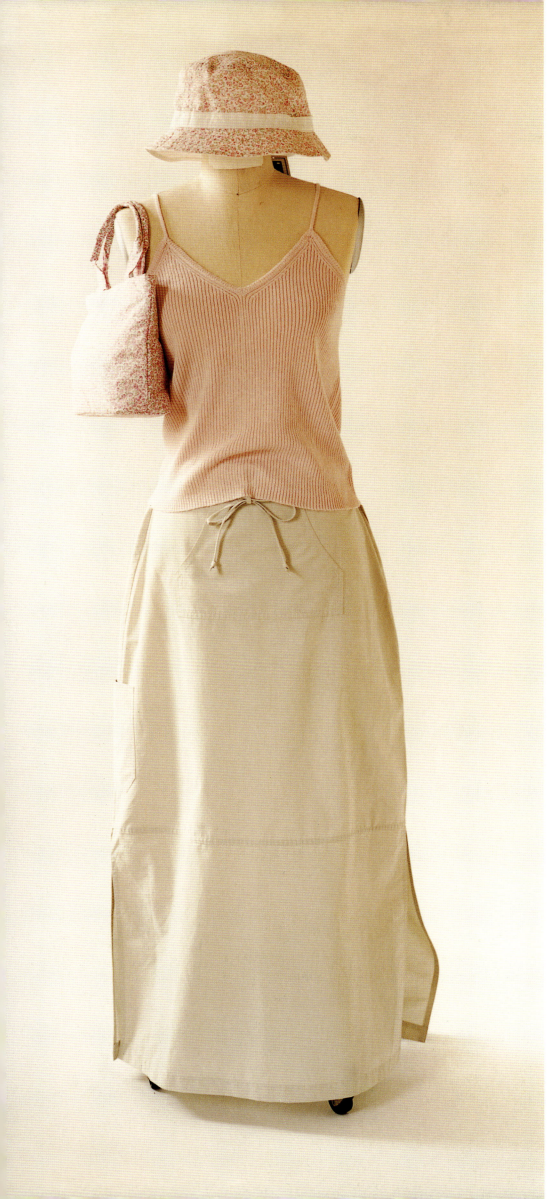

banana republic

akira

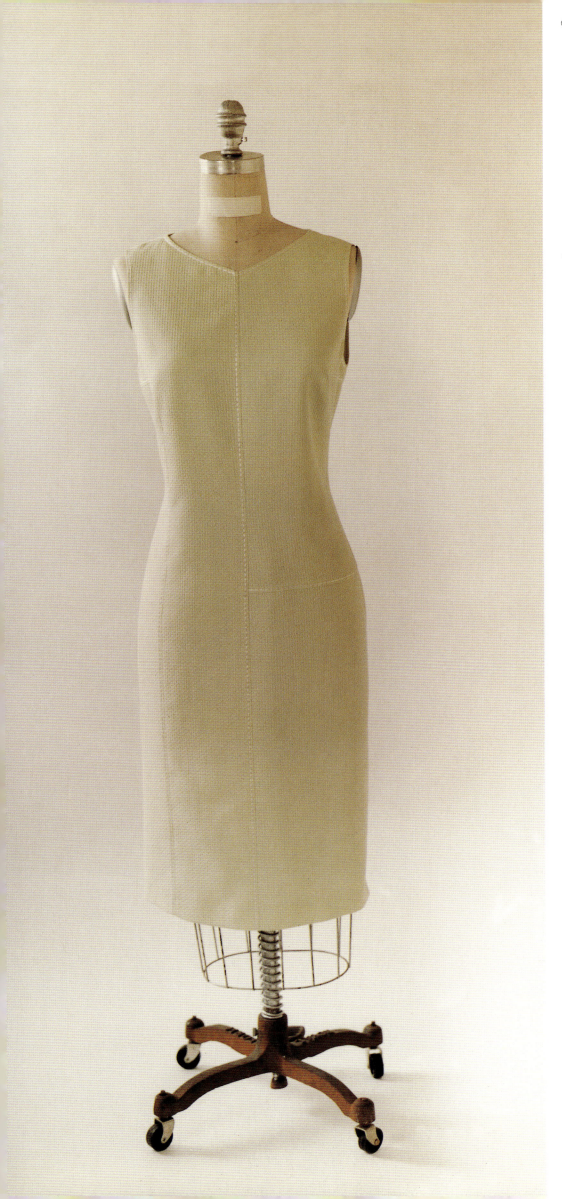

valentino

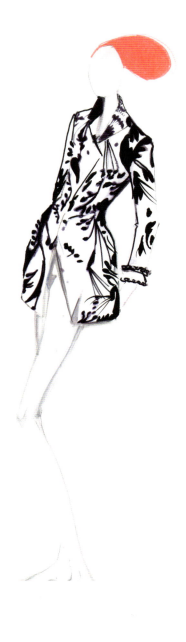

lacroix

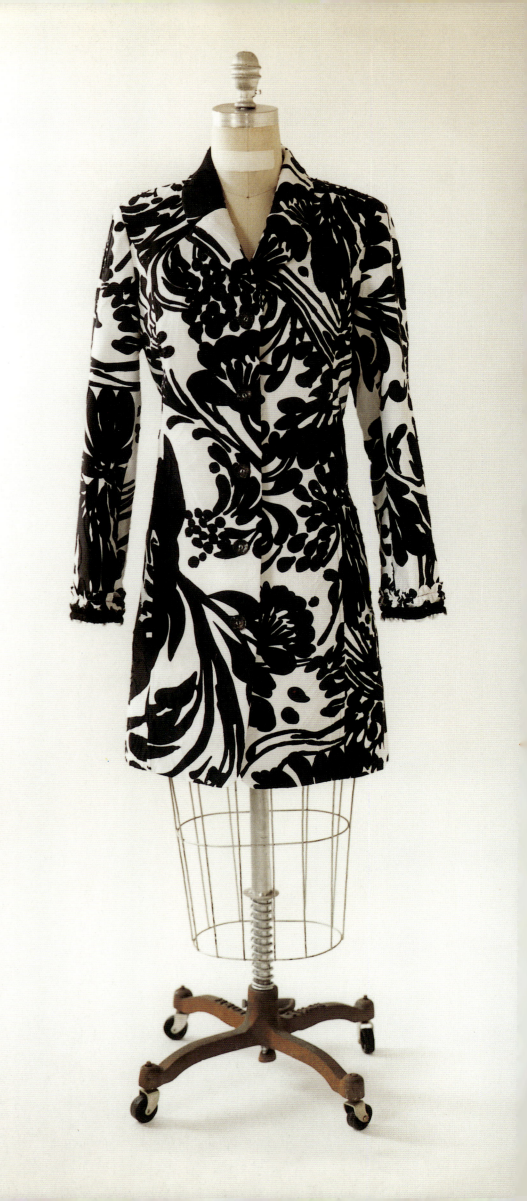

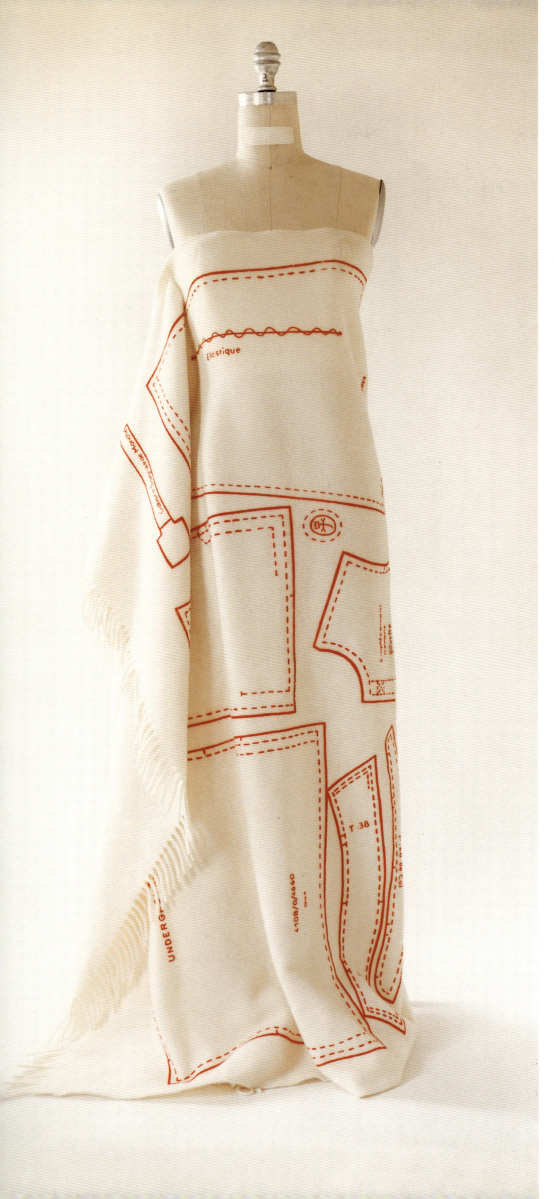

castelbajac

chapter eight:
fashion drawing
in the real world

interviews with

ruben alterio
artist, fashion illustrator, designer

mona may
film and theater costume designer

bernhard willhelm
fashion designer

jean-charles de castelbajac
fashion designer

fashion drawing in the real world

Fashion drawing is seen extensively the world over. It is a universal language used in many industries. As well as in the fashion, apparel and textile industries: we find it in the fashion press, TV, the film industry, theater, opera, multimedia, toys, advertising, publishing and many other areas of business. This chapter gives a glimpse into the lives of some people who use fashion drawing in their daily work.

The people interviewed here are from different backgrounds but are all well established in their professional careers. What they have to say will interest, and is relevant for, anyone who plans a career in fashion or who is already using fashion drawing in their daily work. Although each of those interviewed here has a strongly individualistic approach to his or her profession, shining very clearly through all the interviews is the love of fashion, the passion to express ideas about fashion and art, and the understanding of the importance of drawing as a tool of communication and self-expression in their work.

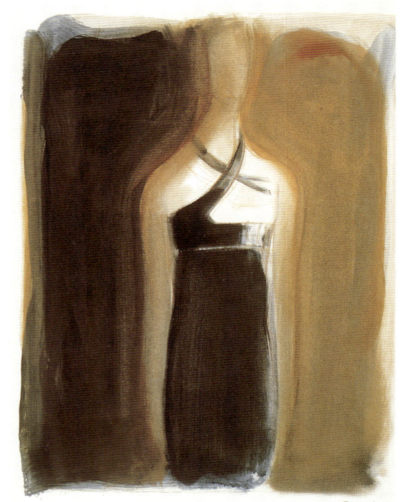

Gucci

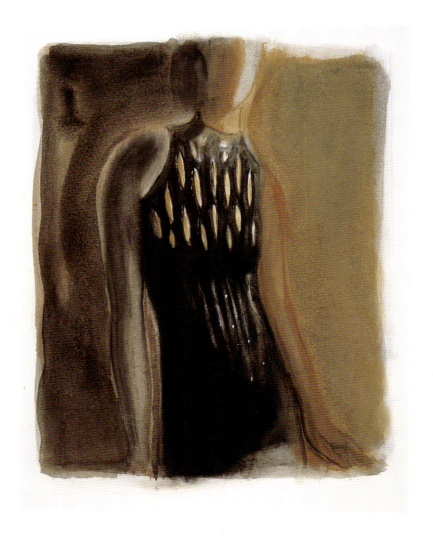

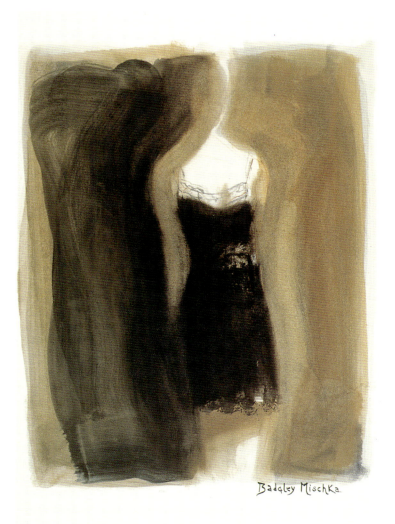

Badgley Mischka

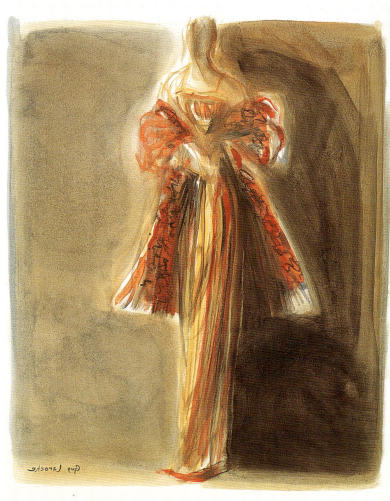

Guy Laroche

ruben alterio

NR: Don Ruben, please tell us about yourself: How did you come to be a fashion illustrator?

RA: I was born in Buenos Aires. When I was 13 years old my father, a painter, registered me in the National School of Fine Arts (Escuela Nacional de Bellas Artes) where I spent 6 happy years. In 1969, after an exhibition in Buenos Aires, I travelled to Brazil, where I learnt to live by drawing decorative objects and also from my painting. Some years later, in Paris, where I now live, I was introduced to the theater, music, poetry and other 'happenings' without leaving aside my pencils and brushes. One day, already installed in my "atelier" (studio), the editor at the time of a magazine called "Fashion in Painting" (" La mode en peinture") suggested I work there. I was surprised because my painting really did not try to be illustrative. I was doubtful, but I accepted, thinking that if I did it I should approach illustration in the same way as painting, in a minimalist manner, with few references.

NR: Were your major influences fashion designers, artists or illustrators, or maybe all three? Could you tell us some of the greatest influences on your work.

RA: My influences come from the history of art, my father and, above all else, observation.

NR: For me your work is extraordinary. It has so many abstract elements, and reminds me often of beautiful abstract expressionist paintings. Yet it conveys a wealth of information on line and silhouette, color and texture and invariably captures that intangible mood and essence of a garment. Despite the abstract elements, how important to you in your work are the basic rules of the croquis and drawing technique?

RA: They are important because they allow you to return to the essence of things in order to arrive at a freer state.

ruben alterio

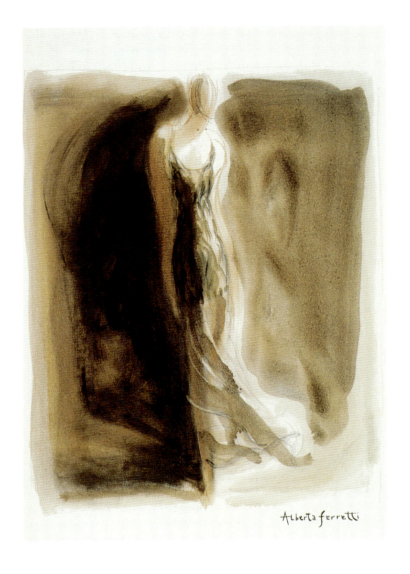

Alberta Ferretti

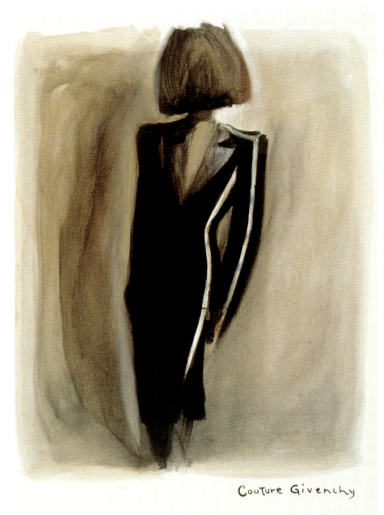

Couture Givenchy

NR: When you make a painting of a garment do you first draw it?

RA: It depends on the subject and the occasion.

NR: What is the difference in approach to drawing or painting a garment which already exists and drawing to express ideas in one's imagination?

RA: Creation or execution ? I believe there is creativitiy in the execution, but all this would take a long time to fully discuss.....

NR: Do you work directly with designers in the creation of garments, helping them to express ideas which they cannot express themselves because they lack the necessary drawing skills?

RA: No, that has never happened to me in fashion as such, but it has happened in other areas like decorative book design.

NR: How do you view the increased use of computers in fashion design? What do you think is the future of fashion illustration—does it have one?

RA: Why not let the different ways of working co-exist? Why photography yes, painting no.... cinema yes, photography no....cinema no, video yes.... and finally, eveything no and the computer yes? Enough of totalitarianisms—let the future unfold! (Voila l'avenir!)

NR: Maestro Alterio, what for you are the elements which most contribute to a fashion illustration being truly excellent? What advice would you give to someone who wishes to make good fashion drawings from their creative ideas?

RA: To show from within his or her nature as an artist the nature of the "other" as in a portrait, a landscape or other subject which we have to draw. Fashion illustration is not my principal means of creative expression— I dedicate most of my time to painting. But as in all the other "plastic" arts and expressions in which I am happily asked to collaborate with other artists, they are closely connected, like the branches of a tree, and complement each other.

NR: Thank you Don Ruben.

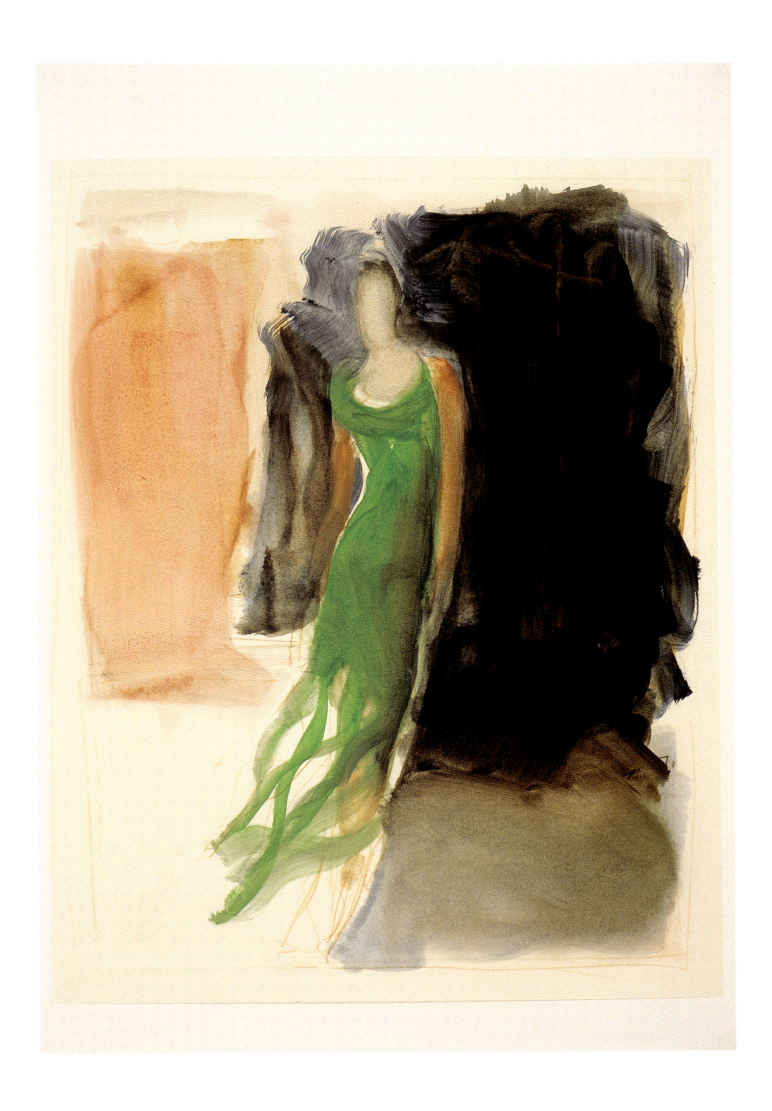

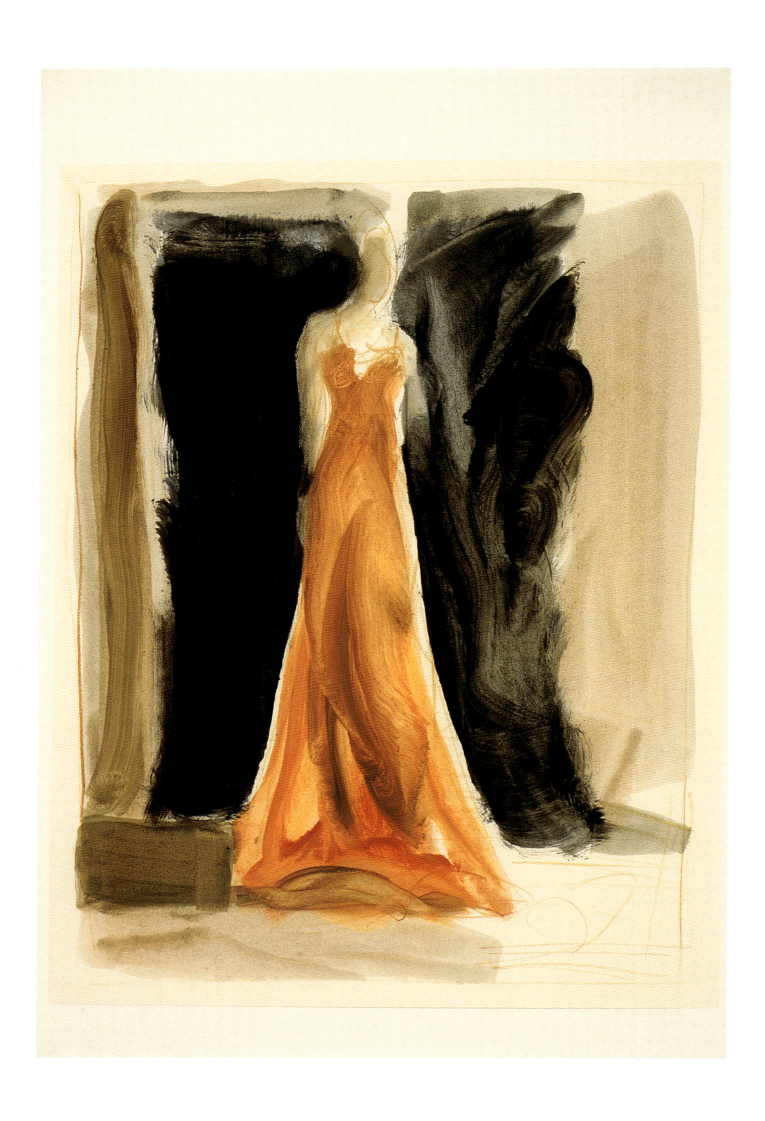

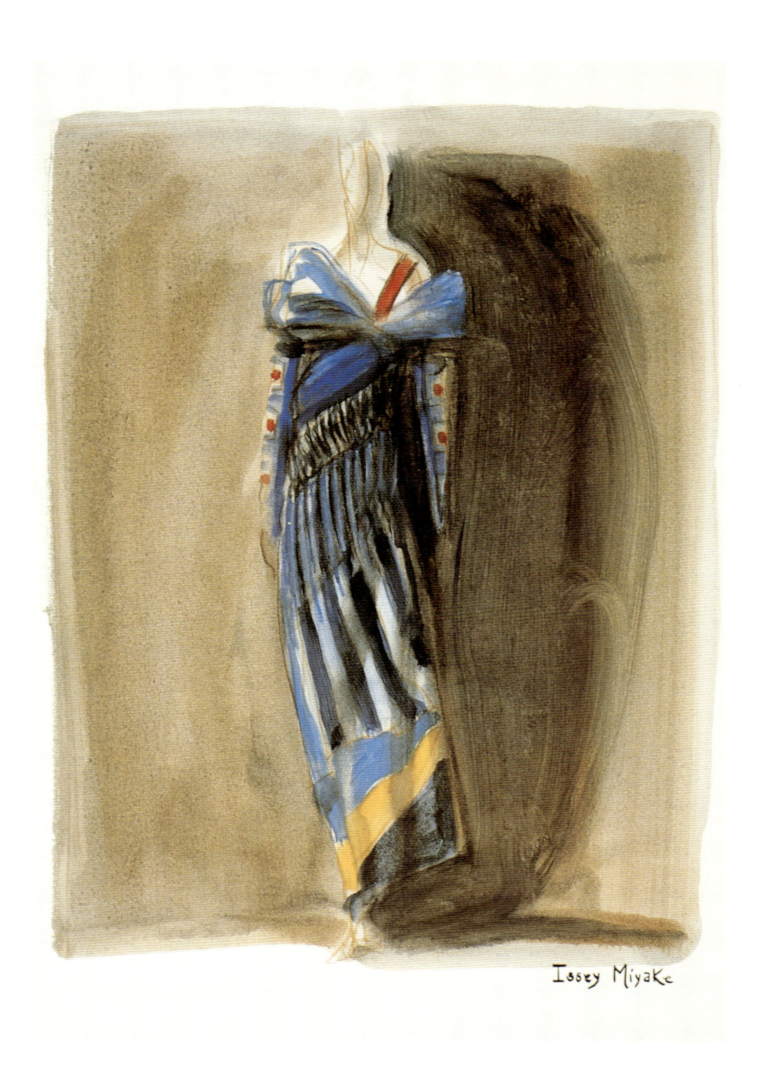

Issey Miyake

mona may

Mona May in her closet.

CAREER BACKGROUND:

Mona May graduated from the Fashion Institute of Design and Merchandising (FIDM) in Los Angeles in 1985 with a degree in fashion design. She grew up in Germany, her mother is Polish, her father German. After graduating from FIDM, she went to Berlin and worked as an apprentice fashion designer for two seasons. She returned to the LA in 1987 and started working on commercials, videos and low-budget films.

Mona returned to LA because she was in love, not because of the lure of Hollywood. At the time of her return, she had had no involvement in costume design: her return to LA set her in a new direction.

Costume designers, like many of the professions working in Hollywood, are independent freelancers. Mona's big career break came when she designed the costumes for the film *Clueless* directed by Amy Heckerling. *Clueless* was a hit and put Mona, as well as many of the actors and crew, on the Hollywood map. Mona is now much in demand by Hollywood film studios.

NR: Mona, what exactly *is* costume design for a movie?

MM: Costume design is the whole process of creating the look of the clothes used throughout a movie, TV or commercial, even if it's a contemporary and not a period movie. The clothes create the characters. They tell us what sort of people they are, where they live, where they shop, whether they buy their clothes at K Mart or buy designer clothes. It really is a matter of getting into the psychology of the characters and helping the director and actors to get across the idea, very clearly and quickly, of who a person is. The costume designer also has to show the change characters go through during the movie in the way they dress. In *Never Been Kissed*, a movie I worked on with Drew Barrymore, there were forty six costume changes. It's a great example. It's a contemporary movie and you begin seeing her as a mouse, a bookworm, then through the film you see her transformation into a beautiful, mature young woman.

NR: Mona, walk us through the process of designing costumes for a big movie.

MM: Well, first I get a request from the producer or director of a film to meet up and discuss ideas for a movie. I always read the script before I attend the

meeting, and at the meeting we discuss what the costumes should look like.

NR: And when do you put pencil to paper?

MM: Right away. Sometimes in the meeting. Sometimes I even bring my sketch artist to the meeting, if time is pressing and I have to get my ideas across. Also it depends with whom you're working. Sometimes you're working with very creative people who understand your ideas. A lot of times you can be working with men who have no idea about fashion. You have to present directors with ideas which you think are fashionable but also agree with their sensibility and vision of what the leads should look like. So straightaway I start doing very simple sketches myself or hire someone to do them for me if I don't have time. I usually have between six and eight weeks of preparation time from being hired to starting to shoot, and there is an enormous amount to do. As well as design, I am involved with budget and accounting and also supervise the making of the clothes. Besides this I have to involve the actors, shop, get swatches. I usually take 35mm photos of all the fittings and then present them to the director and the actor. It's one big elimination process until we get what we want. I also present boards with the pictures showing the scene numbers and all the possibilities we should look at.

I do a lot to prepare for a movie—more than most other designers I'm sure. That's the best part for me, doing the sketches, getting the swatches, reading *Collezioni*, finding out what's happening in Europe. The movie *Loser* was shot in New York City and I met with underground designers, people whose clothes might be seen in Barneys in a year's time. It's about taking the extra step. A lot of costume designers don't go as far as I do. Often there's no need. A small town movie, a military movie, even a James Bond movie—he wears the same beautiful Brioni suits the whole time. You just call when you need a new one. The babe has a couple of gorgeous dresses and the designers send them to you and you get a couple for the doubles because they're always getting wet.

NR: What about working with the actors?

MM: Actors can be very insecure. They see themselves on a huge screen where every imperfection is magnified a thousand times. You have to work with them so they feel comfortable in their clothes, so when they walk on the set they feel like the character and they can really do the best job possible for the director. So that's my job. If wool makes them feel itchy we can't use wool. I'm as much a psycologist as a designer. I often have to give them pep talks to make them feel good before going on set.

NR: Tell us about the clothes you design.

MM: What I do is quite wild. I often set the tone of the movie and a lot of my movies are known for the wardrobe. A movie is made a year ahead of release so I have to predict, almost as fashion designers predict, what's going to happen a year from now and what kids are going to like. I have to really be on top of things and do my research well—focus on the street life. As I go to clubs in London, Berlin or LA, I am constantly absorbing new fashion trends and ideas.

NR: And what about actually making the clothes?

MM: A film is shot over a three-month period, so you have to make sure that the clothes fit well, that they are made well, that they can be dry-cleaned several times over a period of three months. It's all about construction—it's not about creating something which looks good for five minutes and then is thrown away, as might be the case for a garment you're showing on a catwalk. You're really into detail because on the movie screen everything is big. Unless you want your stitching to look messed up for a purpose it has to be done professionally. I have to use certain people I trust for alterations. There are people I've worked with over the years who can take my sketch and make something that looks just like it. I think that's how you move ahead in this business—by providing this attention to detail.

NR: Most of your clothes are made to couture standard, then?

MM: Yes, I think so. Look at the clothes in *Clueless* for example. They all fit beautifully. Also, what I didn't mention is creating the *illusion* of beauty. You get actresses with all kinds of bodies—bigger boobs, smaller boobs, big butts, small butts. It's up to me to create the best proportion, the best fit and the best illusion of their amazing beauty (as well as

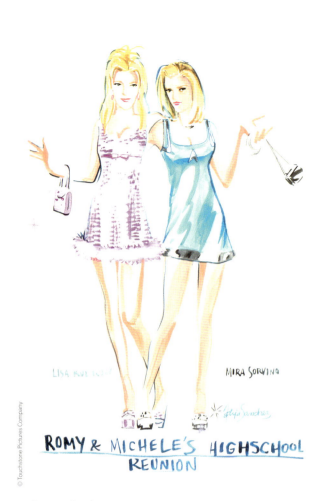

Concept drawing

Mia Sorvino and Lisa Kudrow in *Romy and Michele's Highschool Reunion*

Concept drawing for *Clueless*

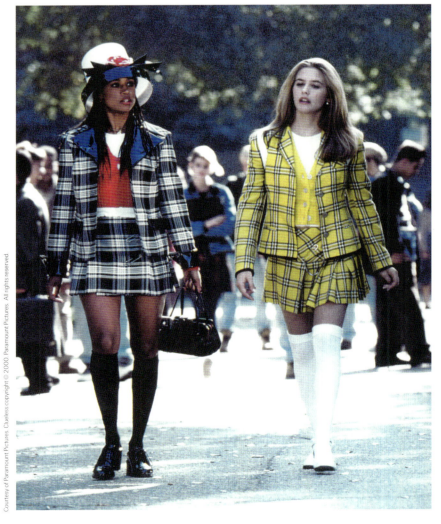

Stacey Dash and Alicia Silverstone in *Clueless*

make-up and hair). A lot of these actresses do not have a perfect body, but after going to fashion school I know what to do to make the most of their looks. Where the skirt should end, where to push the bra, where to pad.

NR: What influences you in your designs?

MM: Everything can inspire me. I travel a lot between films. I go to Asia, to India. Berlin, my home town, is one of the pulsating places in Europe. There's the most amazing underground culture going on there with the East meeting the West. It's what London once was.

NR: Do you usually come in on budget in your films?

MM: I have to take care. I will go to any lengths to get exactly what I need—it could the latest thing from Japan and I have to pay $500 for it. People know that I'm like that, but I usually come in on budget. But it's difficult to come in under budget because making clothes is expensive. Fabrics are very expensive—they can cost $150 a yard. And budgets are getting smaller—the economics of the film business is changing.

NR: I saw the movie *Romy and Michele (Romy and Micheles's High School Reunion)* and noticed the shoes. Do you have someone who builds things like that from scratch?

MM: Sometimes. Sometimes we just get the glitter and the spray paint if we don't have the actual shoes. That's movie-making: you have to be sponta-neous and ready for anything. Maybe the actress is bloated and decides that the dress she loved yes-terday now makes her look fat and she's not going to wear it. So you have to have the skills of craft and painting and making anything out of anything. A bad hair day— what can you do?—maybe divert attention with earrings or a headband. The process is also very interesting because it's group-oriented. A fashion designer can force ideas. Here, you have to work with maybe a hundred people and interact with each one of them so it comes together. Most of the films cost twenty-five million dollars. *8MM* cost sixty million. My budgets range from two hun-dred thousand to five hundred thousand and I am completely responsible for the full amount. Things have to be delivered on time. If something does not

arrive I cannot say Kasha or Irena didn't do it. It's my on the line—they'll fire *me*.

NR: How much sketching do you have to do?

MM: It depends on the film. I can make between forty and one hundred sketches per movie. It depends how much time I have, how much money I have to hire a sketch artist, how involved the design process is. For example, in the movie *The Loser* I only had two characters who had really important transformations, so I really didn't do a lot with the other characters—or example the room-mates. I really concentrated on the Loser and the love interest. Her clothes were very specific. She was a young girl who was influenced by the 80s, but in a new millenium way. She never went home, she always had a rucksack with clothes in it. She worked as a waitress in a strip bar and by day went to college. You had to believe that all her clothes were in the rucksack. Very interesting. I also do 'mini-sketches'—what happens each day with a person. Say one day she is wearing a skirt and pants, but she never went home and the next day she is wearing the skirt with tights, and it is just another outfit.

NR: Whom do you work with most on the movie?

MM: The most important person I work with is the Production Designer, and also the decorator. They set the look of the place-the exterior and interior of the house, whether the bedding is Calvin Klein or Laura Ashley. How does that go with the clothes? A character can't have dime-store clothes and Calvin Klein sheets. Everything has to work colorwise, too. We can't have someone sitting on a couch wearing green if the walls are green. We go into the details of each scene and setting.

NR: Do you use a computer in the design process?

MM: I have little personal time to sit at a computer. If I were very advanced, maybe the computer could make the design process quicker. But everything is still in early stages. What would be good is if I used a digital camera and then print the pictures from the computer and maybe have a flip book instead of my boards.

NR: There must be a lot of sensitivity to color.

Loser concept drawing with pantones

Jason Biggs in costume on the set of *Loser*

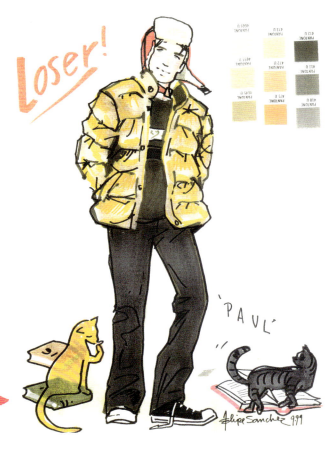

Loser!

'PAUL'

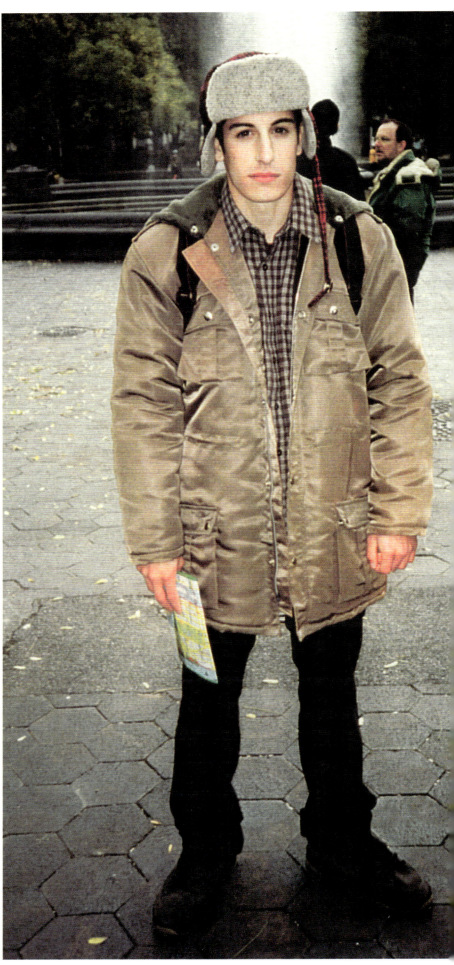

MM: Yes. I work with pantones and present those in a fan or book. The final process can be very different. I have to be fluid. The final product might be dyed and then look horrible on the actor. Or the director of photography might say, "No, with the lighting we're using you have to punch up the color". Also there is often a palette. In *Clueless* we did not use any browns or grays. As a result the film looked beautiful, just very vibrant colors. In *Loser* we did not use any blue, so we created a very warm "Fall-in-New York" type palette. The kids couldn't even wear blue jeans. The director of photography used a lot of yellow light and I used greens and burgundies. Creating a palette and texture is very important. I worked with Joel Shumacher on *8MM* and everthing in the film has been over-dyed and dirty. Everything is gray, mousy and dark, giving the film the kind of "ickyness" he wanted it to have.

NR: What skills should someone have to do what you do?

MM: Well, they have to know how to draw. At first I could not afford to hire Felipe (Felipe Sanchez, Mona's sketch artist) so I had to do everything myself. Even if they're very simple drawings or collages, sketches help you to sell an idea for a costume. A lot of times by saying
"I want to use an A-line skirt", people don't understand what you're talking about. The way you show how to draw textures is really important. Are the clothes flowing and light or are they heavy? Even if you're not a great drawer it's important to be able to get your idea over in some form. I also think you have to have the sensibility of proportion: who people are, race, culture, where they come from. Body type is important.

NR: It's important for you, then, to have drawing skills as a fashion designer?

MM: Yes. A lot of costume designers don't have those skills because a lot of times there is not a lot of preparation time, but for me drawing is important.

NR: Mona, how did you get your foot on the first rung of the ladder in Hollywood?

MM: It was just through hard work. I didn't really have a portfolio to start with. Getting started involves hustling, going to interviews, schmoozing, constantly go through the battle being creative, assisting on films a lot. I didn't get an agent until I did *Clueless*, after people could see that I could make money for them. That's what the film business is about. You have to have a sense of humor, not to take what you're doing too seriously. If Drew Barrymore comes onto the set one day and hates your costume, you can't let it get to you. If all those things got to you you would go to pieces.

NR: Which costume designers do you most admire?

MM: Edith Head is the most famous one. I'm the young Edith Head (laughs). I like Colleen Atwood. She does a lot of interesting projects: *Edward Scissorhands, Mars Attack, Sleepy Hollow*. Interesting fantasy worlds. I love the *Star Wars* costumes. Trisha Biggar should win an award for them. Sandy Powell, the designer who did the costumes for *Elizabeth, Orlando* and *Velvet Underground* is amazing.

NR: Thank you Mona.

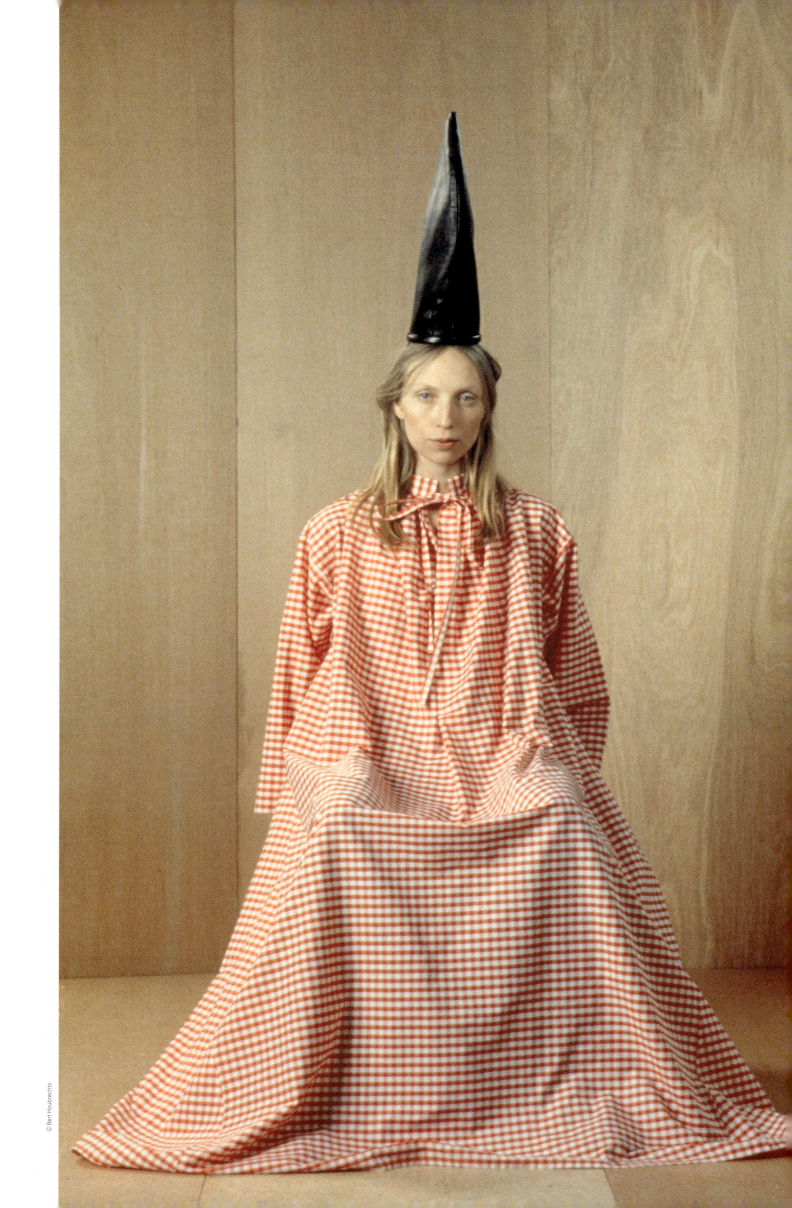

bernhard willhelm

NR: Bernhard, please tell me about your back-ground and how you came to be a fashion designer.

BW: I am from a small city in Bavaria, Germany, called Uim—right out in the countryside. I really came to fashion by accident. I actually wanted to study biology but 2 of my friends went to fashion college in Germany, and I followed them.

NR: What are the major creative influences on your work? Is art a big influence?

BW: Right now I'm most influenced by print, fabric and graphic ideas. I think patternwork, graphics and fabrics should have the same value. I'm really into craft, childrens' and embroidery books at the moment. I also like traditional German costume , which is actually still worn in the area I come from. My favorite artist right now is Attila Richard Lukacs, an artist from Canada.

NR: How does drawing feature in the creative process?

BW: An idea just can be written in a sentence.

Drawing is more for the pattern process. Normally the first sketch is the best.

NR: How important is it for a fashion designer to acquire drawing skills and be able to express his or her ideas in this medium?

BW: For me creativity works best in a team. Drawing helps you to communicate easier. I real-ized at school that I have a quite good geometric memory. For me drawing and space go well together. Even when my drawings are always looking very flat there's a three-dimensional idea behind them.

NR: Do you use computers at any point in the design process? Is there a role for computers in the design of haute couture?

BW: We don't do haute couture . We don't use computers . They are only used in making an industrial pattern from a hand drawn one to cut the garments.

Thank you Bernard.

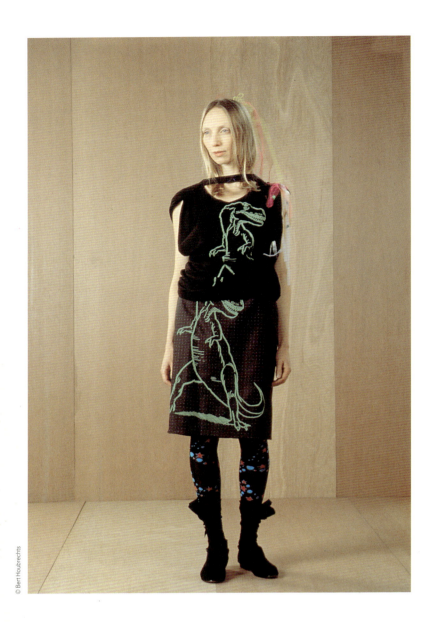

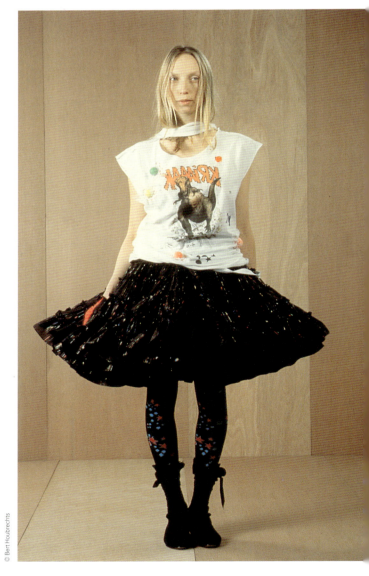

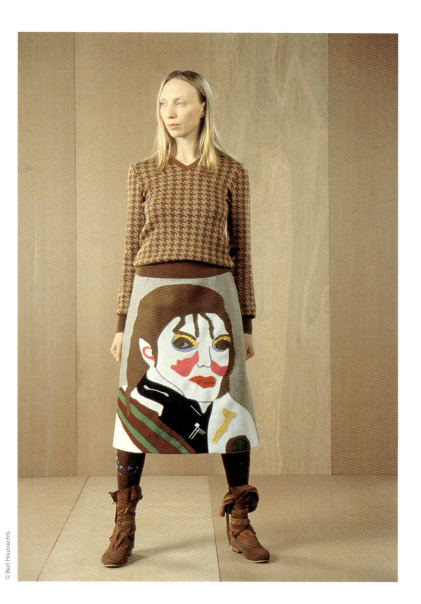

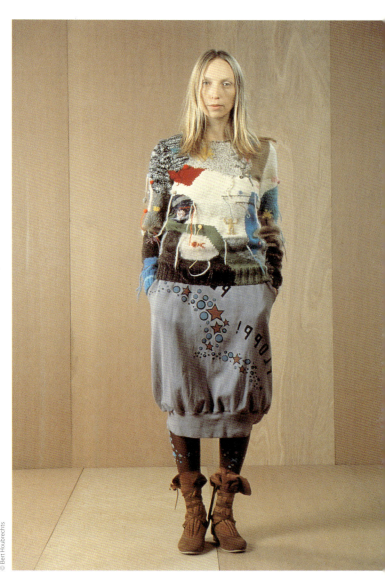

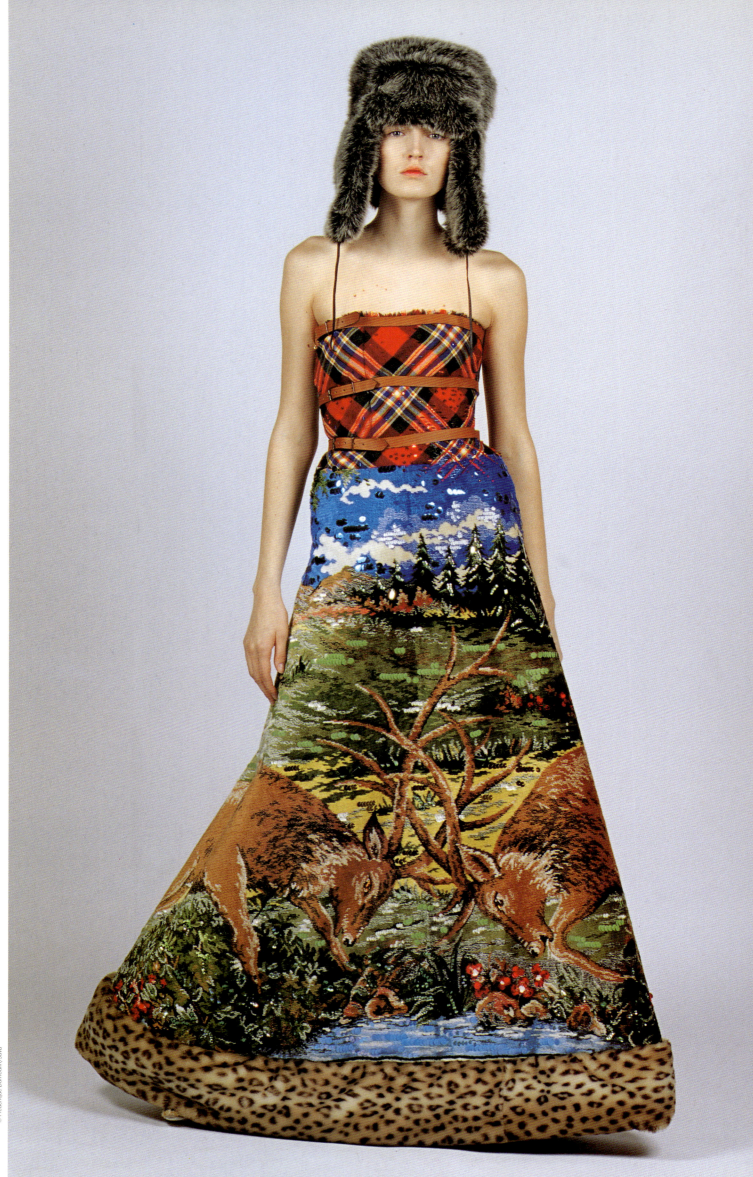

NR: Jean-Charles, please tell me about your background and how you came to be a fashion designer.

JCC: I come from a military background— my family have worn helmets for over one thousand years. Partly in reaction to that, and a wish to enter a more artistic field, I entered fashion. Also, I had a beautiful Swedish girlfriend who left me and I saw fashion as a convenient way to meet other beautiful girls.

When I was seventeen I went to Paris. It was May 1968—the time of the "év'enèments", the student troubles, like you had at Berkeley. It was a shock for me. I found everyone wearing workclothes and military fatigues. I had not even finished my high-school diploma, but I knocked on the door of Raymond Lewy and became a cutter for four days.

I created my first collection for my mother—who had a fashion house, Ko and Co, in Limoges. My inspirations were my memories from boarding school, where I had spent twelve years from the age of five. I made a raincoat from a shower curtain and a coat from a blanket. These were my roots and the beginning of a tradition. Traditions and origins are very important for me today.

NR: What are the major creative influences on your work? Is art a big influence?

JCC: Art is a great influence. When I began working in fashion I became friendly with Robert Malaval and Alain Jacquet—French "Pop" artists. Later I became friends and worked with Andy Warhol and Robert Mapplethorpe. I always asked artists to do the invitations to my shows. I have also worked with artists who drew on muslin as part of a pret-a-porter collection. I have always been influenced by the functionality of clothing. My work was popular in the 1970s in America because clothing there is so influenced by function and my work was intuitively grasped by the American public. Madame Chanel was also inspired by functional working clothes.

An example of function spilling into design was the clothing I designed for *Charlie's Angels* and Farrah Fawcett-Majors. That clothing is functional but sexy. Function is not a prison —the function of a garment can be to seduce rather than protect. I like to bring humanity to functional clothes by adding luxury—to bring back the touch of the hand which gives clothes their human quality.

NR: How does drawing feature in the creative process?

JCC: For me drawing is the magic connection between inspiration and expression. Now I draw more freely, my designs are also more free and expressive. I am now moving into couture and am less generous in my drawing—expression comes from the "moulage"—the cutting process itself. Much of my work is almost sculptural—at the moment I am working with the architecture of the square.

NR: Do you use computers at any point in the design process? Is there a role for computers in the design of haute couture..

JCC: I delegate all the computer work. For me the magic is between pen and paper. I flirt with the computer but do not make love to it. My work tends to be iconoclastic. I do not like perfection, nothing too new, nothing definite. I like to explore contradictions and harmonies. If I were to work with a computer it would be as a way of making a print, but then to hand embroider it or have it beaded by Lesage.

NR: How do you see the future of fashion drawing and illustration?

JCC: I love fashion illustration. I am greatly inspired by Milton Glaser and Paul Davis (two well-known illustrators). I think there is a big revival of fashion illustration going on in Europe—we are bored with what is produced by computer. You are beginning to see advertisements and even magazine covers

jean-charles de castelbajac

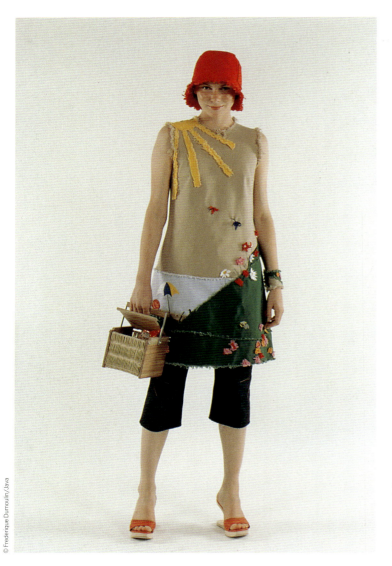

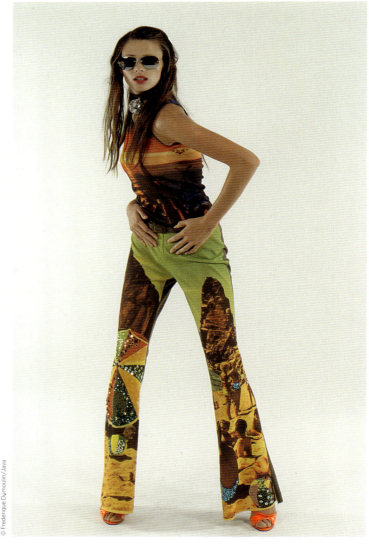

drawn by hand. There is a much greater need for individuality and experimentation. When I taught recently at St. Martin's in London I saw much more enthusiam for new graphic techniques.

I think the revival of interest in fashion drawing is the expression of a new humanity, a sensuality and revival in genuineness, individuality, in sharp contrast to what was happening in the fascist 90s with minimalism. My new collection of pret-a-porter is based on fashion illustration—there is no photography.

NR: Who and what have been your American influences?.

JCVC: I admire Charles James, Geoffrey Beene and Stephen Sprouse. They stayed true to their own inspirations and did not bend to market forces. I have a great sympathy with US designers because of their love of function. America has a tradition of

thinking how clothes must perform in the work-place. In France clothing is about fashion: Napoleon, the Musketeers, the design of their uniforms had more to do with the art of love than the art of war. They were more concerned with seducing women than being dressed for battle.

My first blanket came from Pendleton. My work can be seen as layering American functionality with French ideas of fashion.

NR. Thank you Jean-Charles.

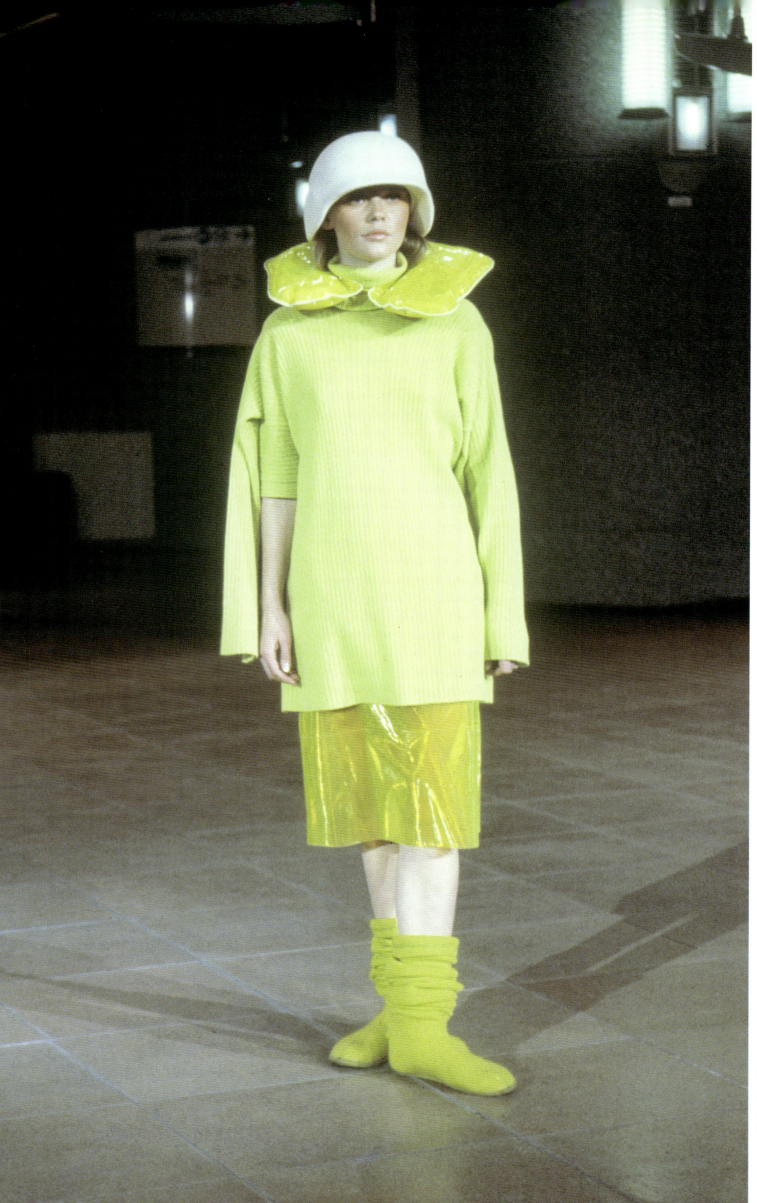

chapter nine:
the art of illustration

the art of illustration

Good technical fashion drawing is executed with flair and style, but even so rarely conveys the subtle beauty and the range of complex social signals that a garment can embody. Illustration is a way of depicting these "hard to define" qualities of a garment, the qualities which are distinct from its purely functional qualities, those which draw an emotional response from us.

Illustration is not restricted by the need to show accuracy of technical detail, which will be recorded in flats and elsewhere. As a result, the illustrator can adopt a freer hand, using a variety of styles and techniques to "interpret" the garment, emphasizing those intangible, "poetic" properties he or she finds to be most important. For example, an illustrator might feel that it is not necessary to render a whole garment, and indicate the fabric used with a variety of techniques which merely suggest the whole garment is made from the same fabric, leaving us to make a mental leap on our own. An illustrator might think it appropriate for an illustration to contain several abstract elements where color and mood take priority over form and line.

Illustration reveals the style and personality of the illustrator as much as the style and personality of his subject, and great illustrators are artists in their own right. What is common to all good illustration, as it is to all good art, is powerful insight into the subject matter, in this case the garment, and a style, elegance and originality in execution. The designer, who is often expressing ideas about a garment which does not yet exist, has to convey to the design team some of the details, cut, drape and lines of the garment, but also the mood, the intent and the overall effect.

The student of fashion drawing will soon yearn to experiment with illustration and will quickly begin to develop an individual style. It is important, though, not to run before one can walk. Great illustrators often express more with a quick flourish of the pencil than those who labor for hours, but, as was already observed, it is highly unusual for an artist or illustrator to draw intuitively, and these

"now-great" illustrators usually spent many years of study perfecting their technique. This book has striven to give the reader that essential foundation of technique and method to progress to the point where drawing the fashion croquis and the clothed figure becomes second nature. Having reached that point, the reader is equipped to begin to try drawing in a freer, looser fashion. The reader should always remember, though, that sound technique forms the basis of all good art and illustration.

This chapter contains a selection of illustrations from a variety of skilled hands. Observe and analyse the different styles, look at what the artist is expressing and how he or she achieves that expression. Think about the relation of the illustrations to the actual garments. Enjoy the illustrations and think what pleasure it is to draw or design your own garments like this!

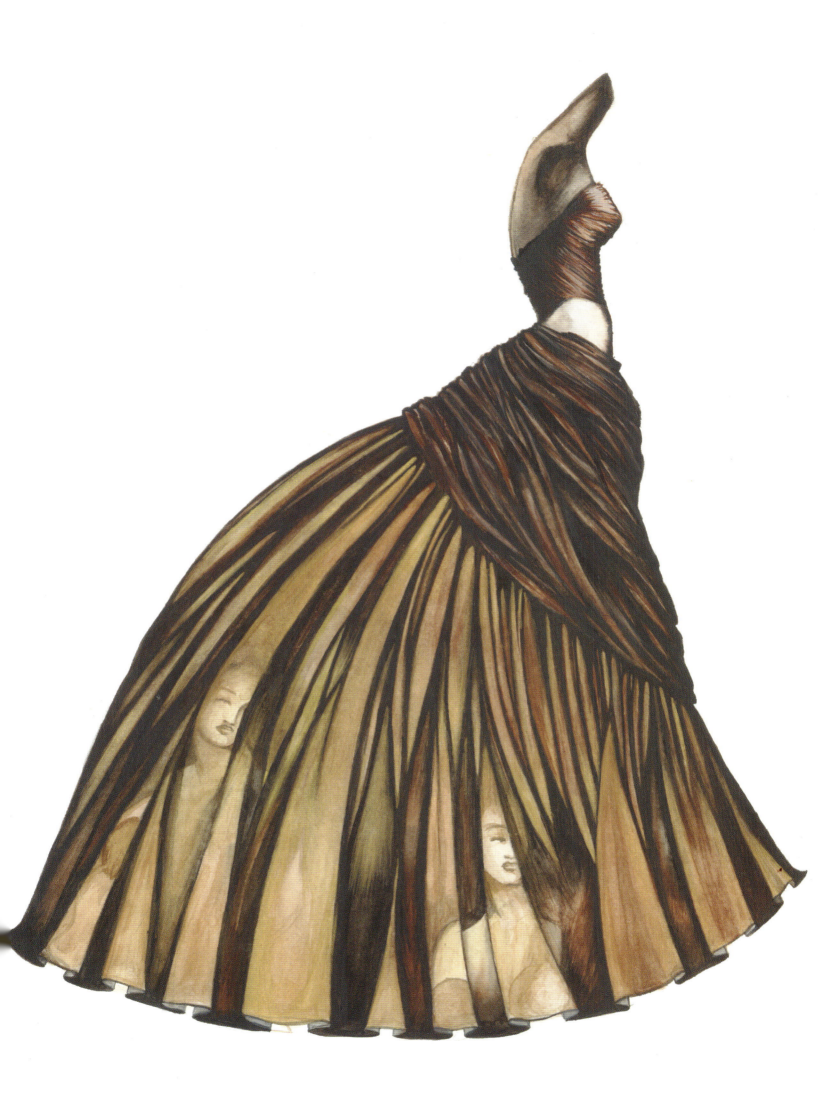

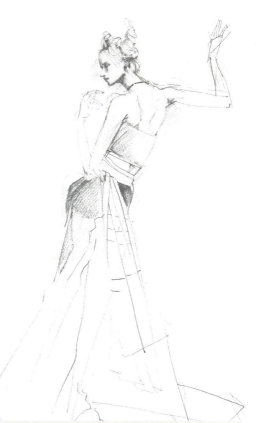

This sketch is a back three-quarter pose. Drape fabric by bending around torso.

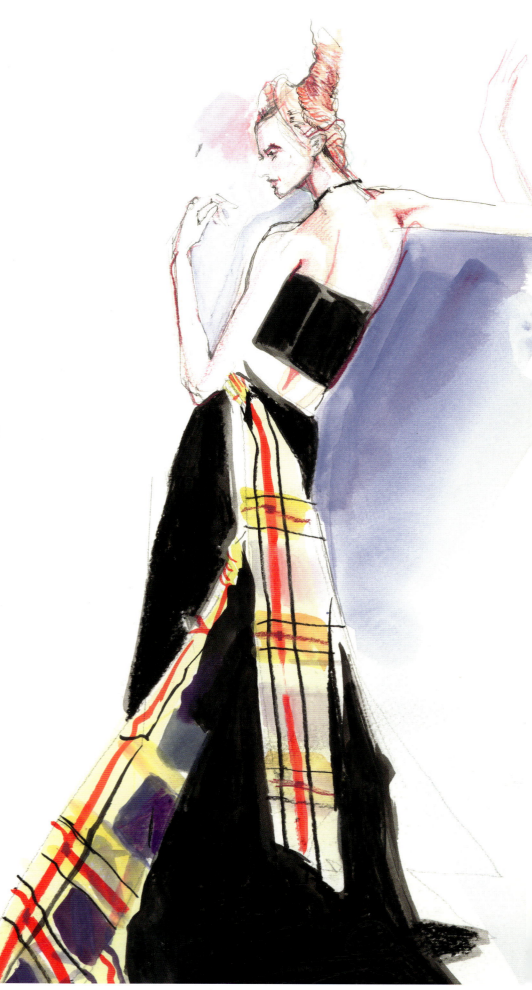

The finished drawing

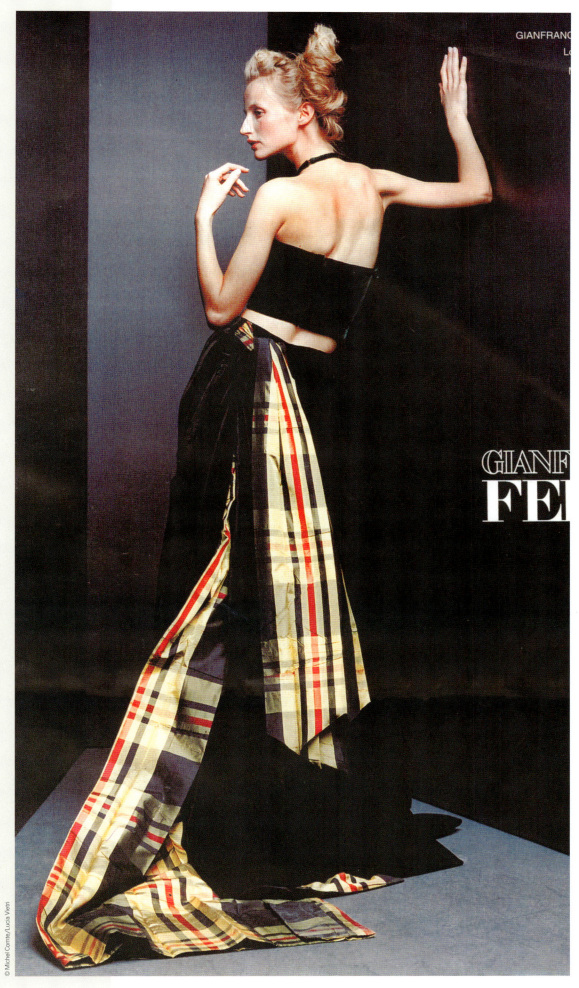

Original photo of Gianfranco Ferre design

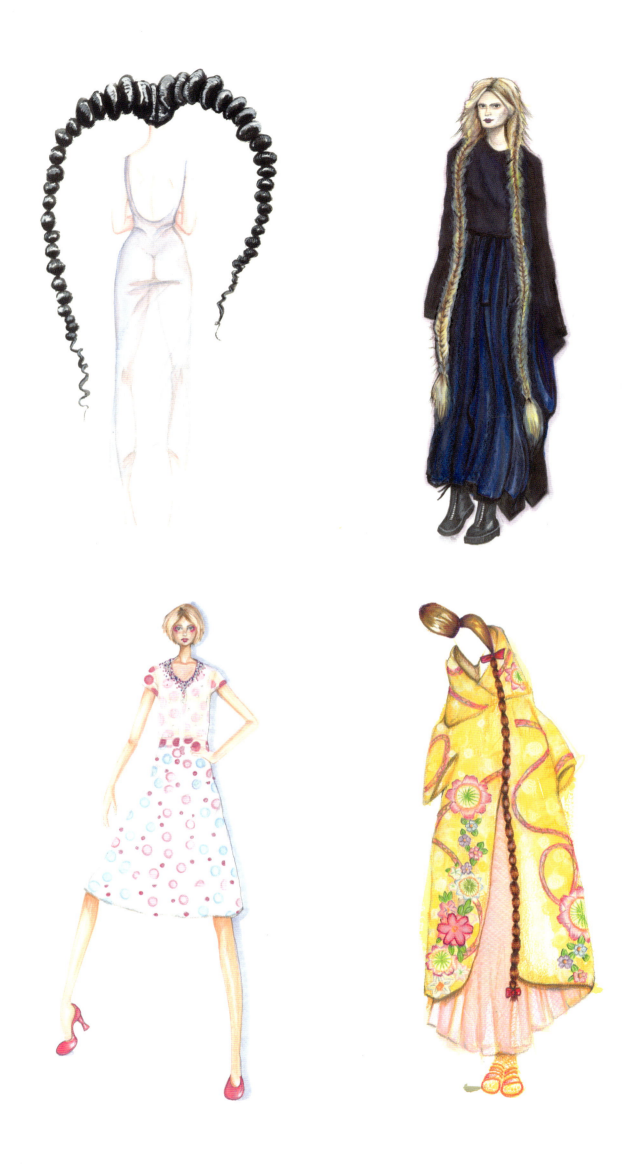

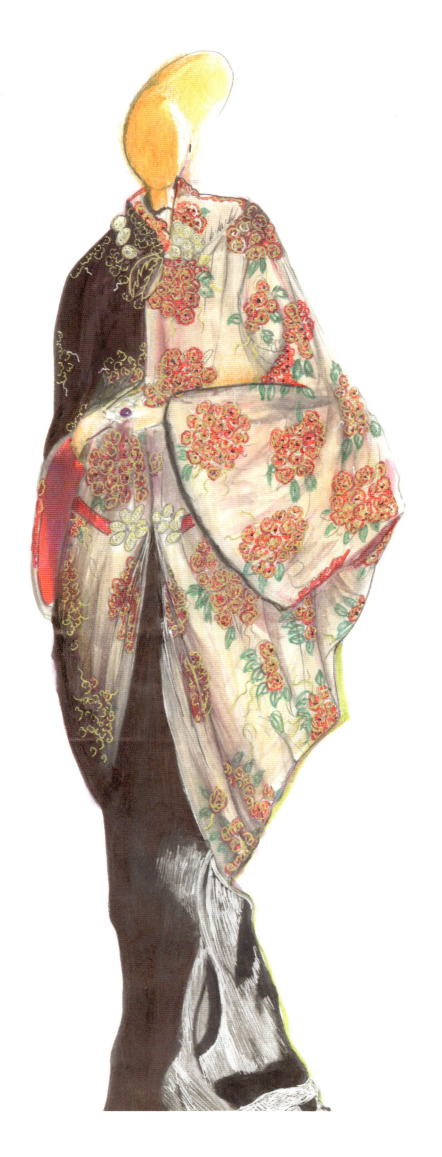

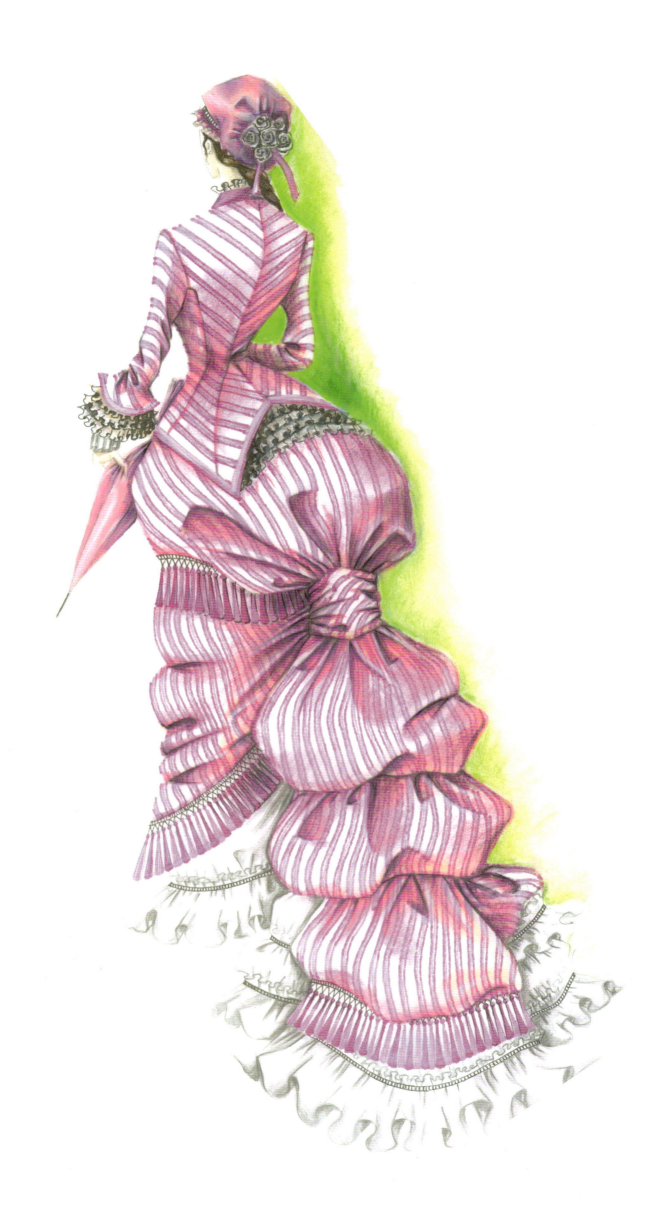

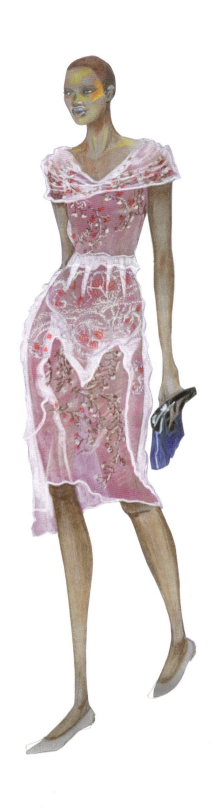

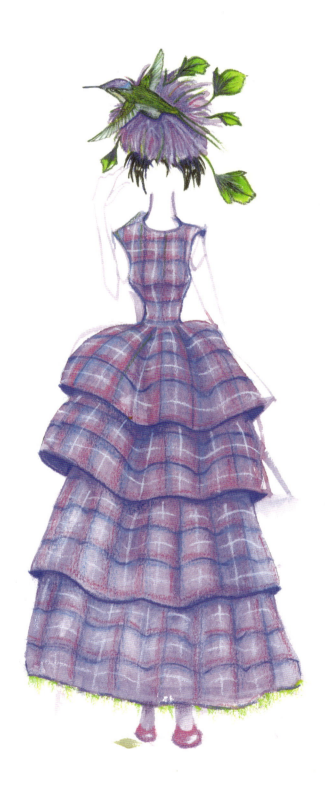

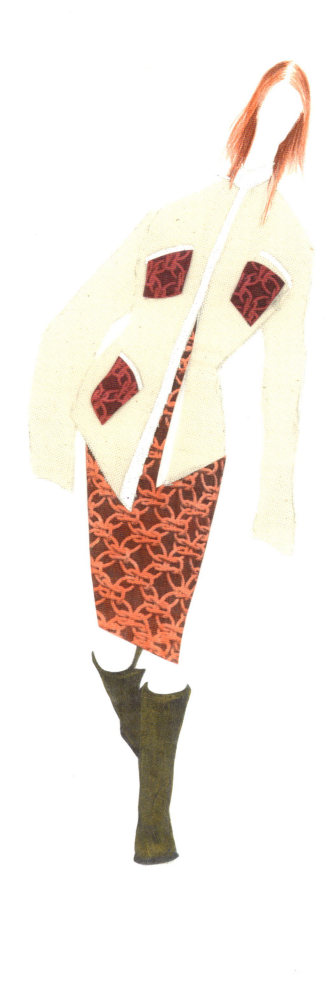

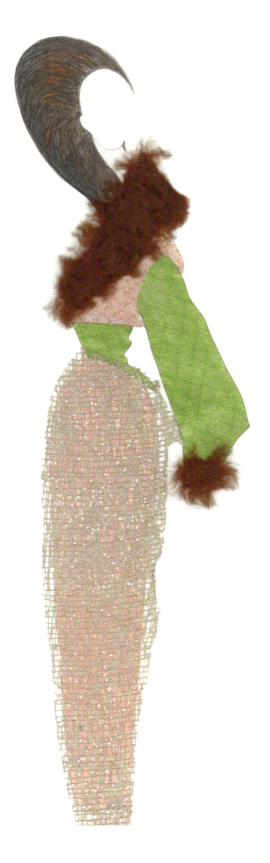

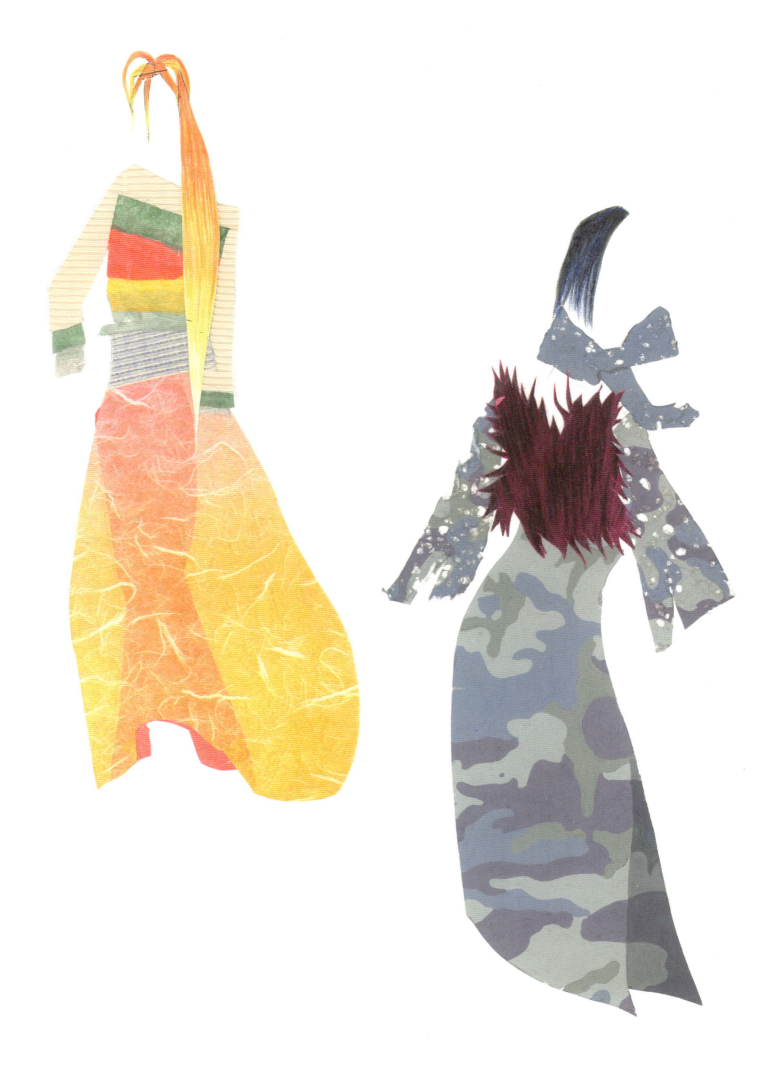

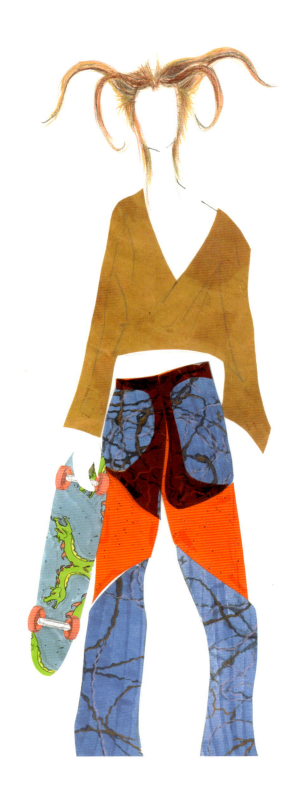
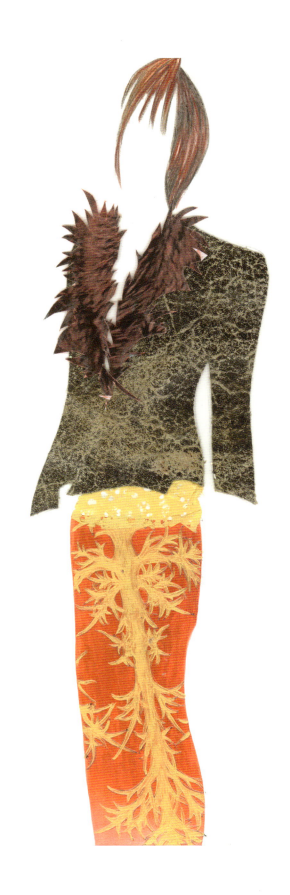

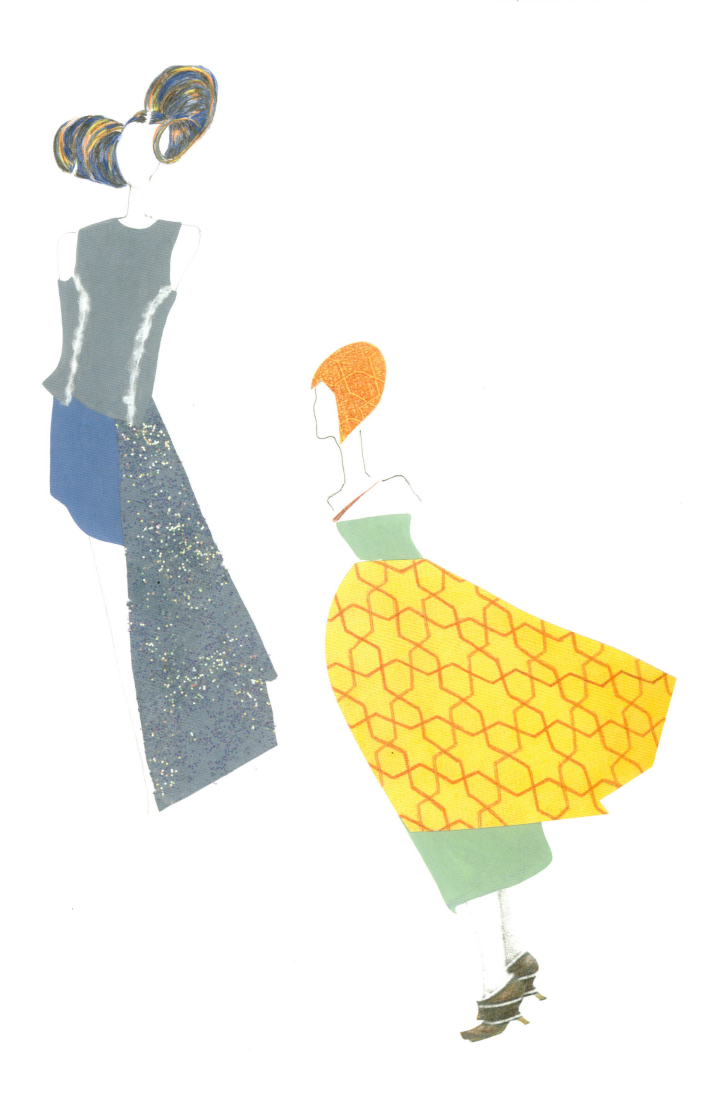

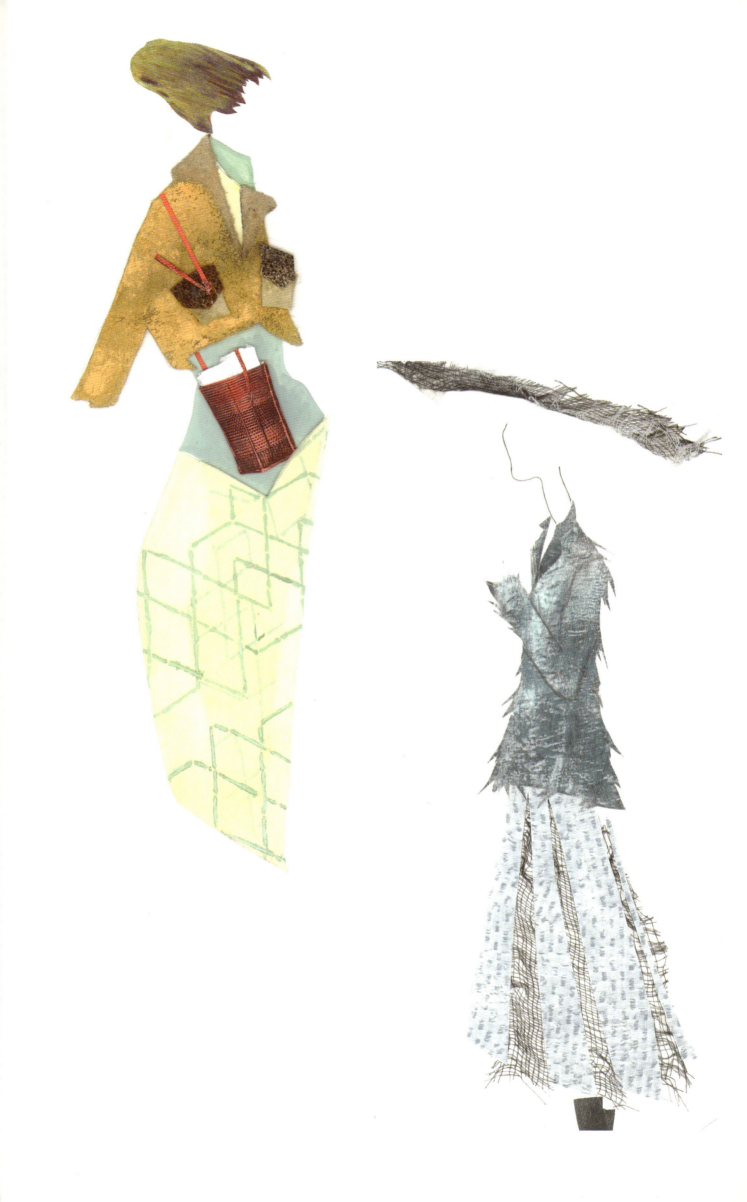

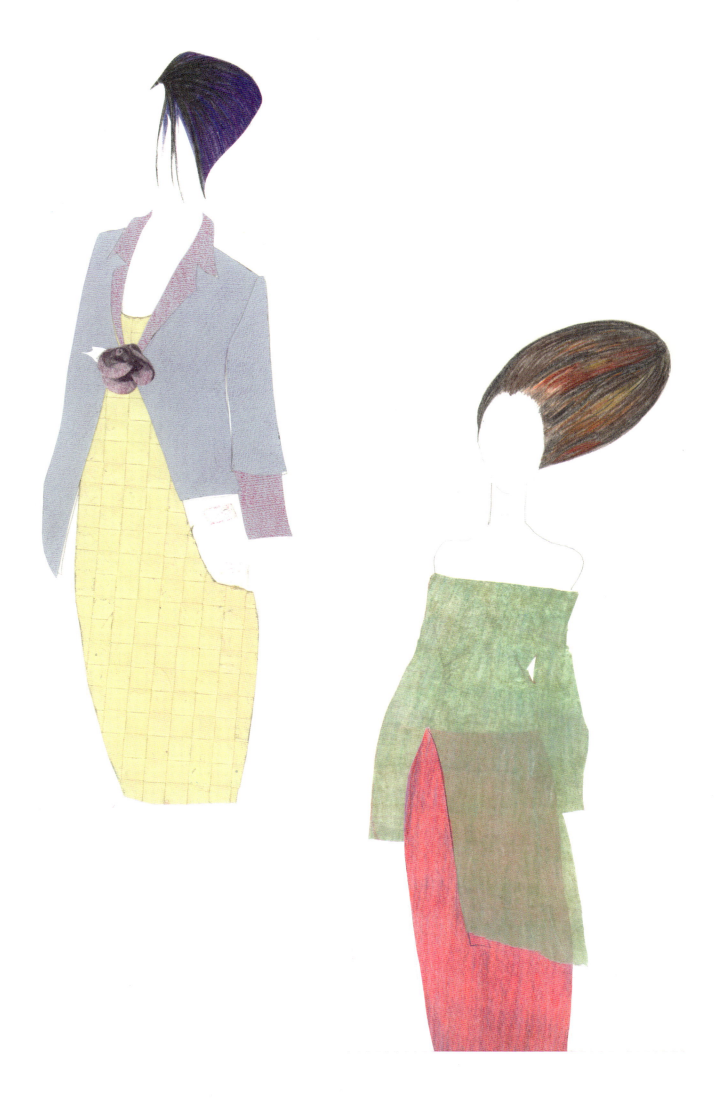

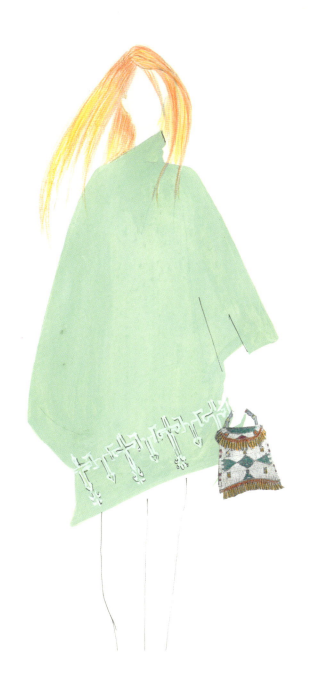
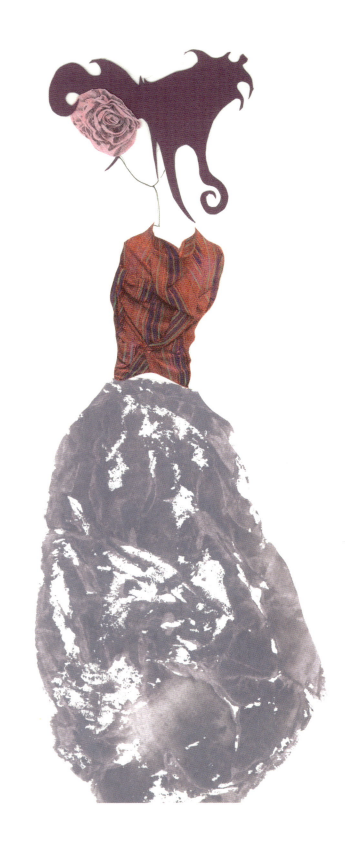

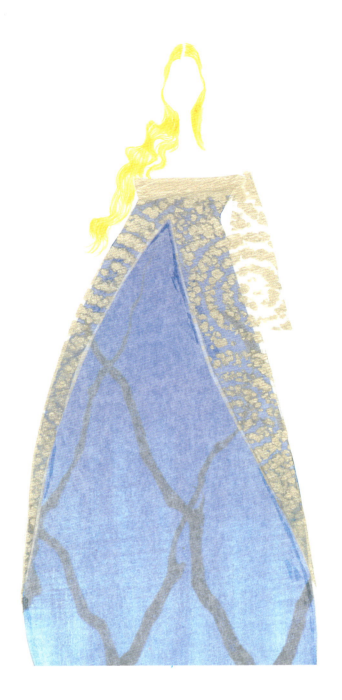

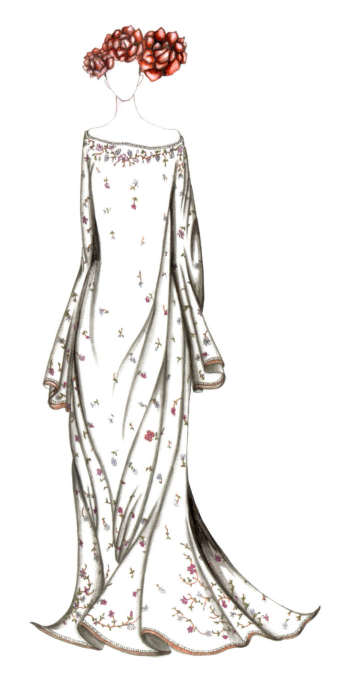

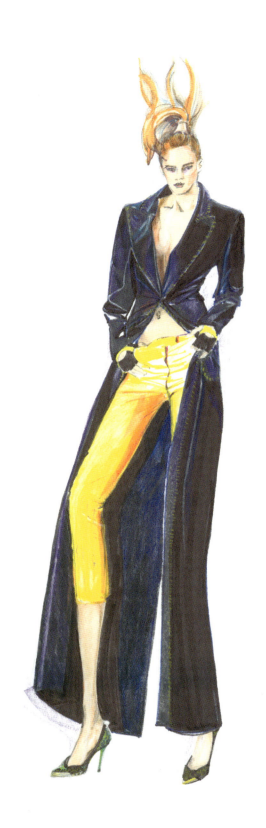

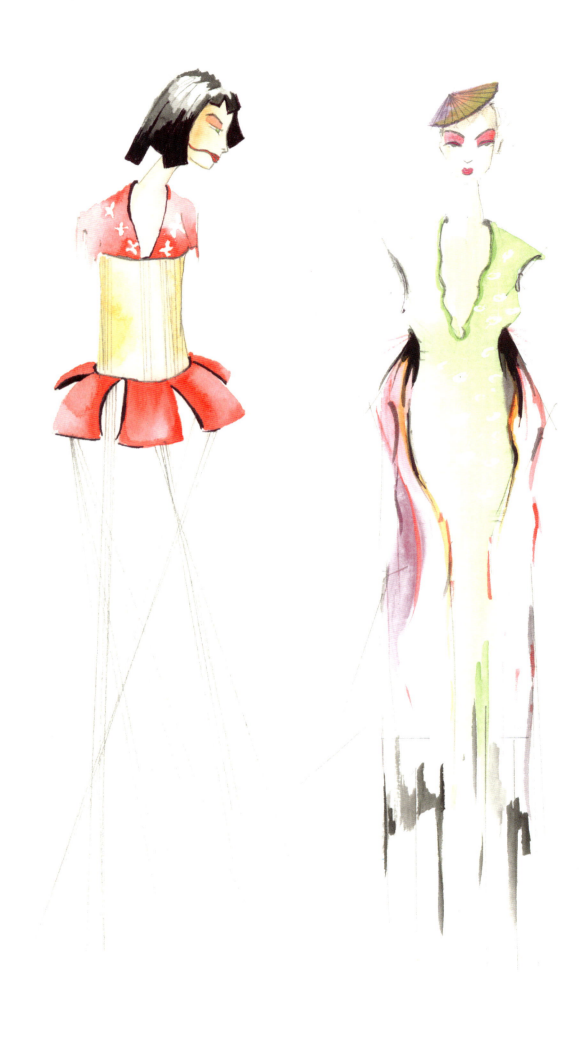

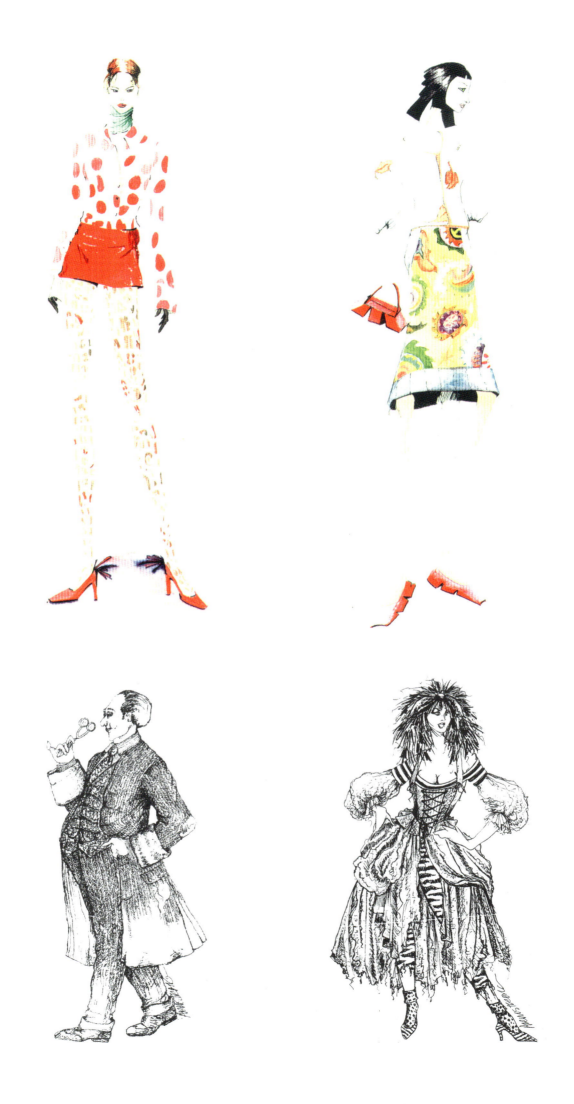

chapter ten:
computers and fashion drawing

computers and fashion drawing

INTRODUCTION

In the fashion, textile and apparel industries, computers are now used in all parts of design and production, just as in other industries. From the initial garment design through patternmaking, grading, marking and cutting of the fabric, to the final sewing and assembly processes, every stage now uses computer technology. The computer allows operations which previously required hours of intensive manual labor to be completed in a tiny fraction of the time. This automation is responsible for many of the huge reductions in costs which have occurred in the fashion and apparel businesses over the last twenty or thirty years and which have brought fashionable clothing within the reach of virtually every budget.

The computer can help us to draw and design clothes as well as to produce clothes, and it is particularly useful where the drawing is closely related to design work involving many variations on a small range of garments. This is frequently the case in the apparel industry. Today, the computer is used extensively by professional fashion designers, but the technology is now affordable and relatively easy to use for almost everyone.

It is said that the computer is a tool which yields results only as good as that of the input it receives (in the computer world this is known as GIGO— "garbage in, garbage out"). This is certainly true for the use of a computer in fashion drawing, where the soft lines and subtle textures of a garment are still particularly challenging to represent in the computer. A computer will not think for its operator and it has no imagination. Contrary to popular misconception, a computer will not draw by itself and has no skills as such. It can make drawing easier but it will only give high-quality results if operated by someone who has acquired the knowledge and skills of drawing.

The issue of what traditional skills are still relevant and necessary in the computer age is an important one, particularly so for students of fashion drawing and design who are going on to lifetime careers in the industry. It also seems appropriate to discuss this issue in a book which is devoted to teaching the traditional skills of drawing in a modern context.

Young people are now emerging into a world where computer-based skills are rapidly supplanting the often centuries-old craftsman and artist skills. While some skills are no longer necessary, (in many cases thankfully so, as they were mindless and repititious), it is important during these early decades of the computer revolution not to discard skills too quickly and readily: it may prove difficult to revive them if required again. This note of caution is particularly apt in fashion and design, where so many traditional skills are still involved . The main purpose of *9 Heads* is to teach the skills and knowledge required to draw fashion and the figure well. These skills and knowledge are as applicable and necessary when using the computer as a tool for drawing as when using pencil and sketchbook.

Using the computer in fashion drawing involves learning how to operate a number of software programs and how to use a variety of peripheral tools, such as a scanner or a graphics tablet and stylus. The set of skills required for operating the computer programs to draw fashion is different from that of fashion drawing itself, although the programs are increasingly becoming more intuitive and easier to use. A full treatment of the subject of computer skills utilized in fashion drawing would require a whole book or series of books in itself, so this chapter goes no further than providing an introduction for those who wish to begin to explore the field. Included here are some examples of the results which can be achieved with a computer. The chapter also contains a discussion with Renee Weiss Chase of some of the more important themes of the subject. Renee is a professor and head of the Fashion Design department at Drexel University in Philadelphia, with a specialization in the area of computers and fashion design. Her book *CAD for Fashion Design* (Prentice Hall) gives a comprehensive overview of the use of the computer at all stages of the fashion design process.

COMPUTERS AND FASHION DRAWING

Computers can be used to create new images by using tools and methods which simulate the actual drawing experience, and can also be used to manipulate images which have been created elsewhere and entered into the computer. Drawing in a

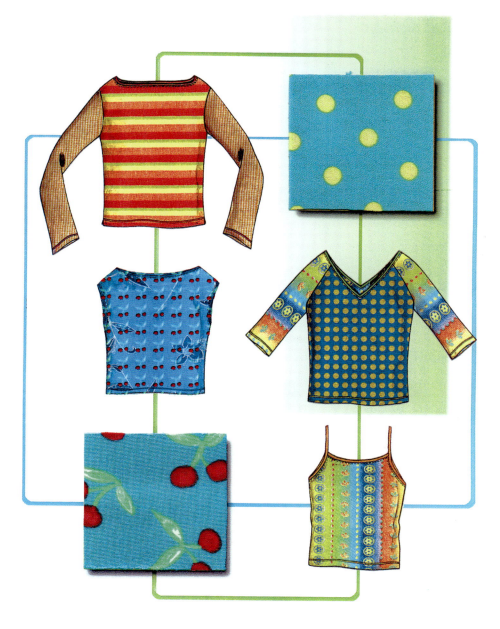

Patterned fabrics with flats

to give an endless range of garment possibilities. Building up a library of fabrics and details in the computer and applying these to different flats also stored in the computer is at present perhaps one of the most effective uses of the computer in fashion design.

There are two ways to draw directly on the computer: One is by using a pressure sensitive graphics tablet and stylus which simulates the experience of hand drawing: increasing the pressure on the stylus increases the line weight. The other is using the computer mouse itself. Both methods allows images to be stored directly in the computer and used with other software programs to develop designs.

A vector-based or object-oriented computer program is one which is used for line drawing. These programs remember the weight and location of a line drawn on the screen by a series of formulae so are free of the pixelated effects which can occur with other types of programs. Adobe Illustrator, Macromedia Freehand, Corel Draw and Deneba

Canvas are all vector-based programs. Vector-based drawing programs are useful for line drawings of flats and garments where a constant line thickness and weight and symmetry is necessary.

The other types of programs are called raster-based or paint programs. These programs create effects based on areas of colored pixels on the computer screen rather than the lines which vector programs generate. The possibilities for creating variations of color and texture with these programs are practically endless. Programs such as Fractal Design Painter and Adobe Photoshop allow the user to explore the effects achieved by a large number of drawing materials-pencil, pen, charcoal or paint for example and then render the garment selecting with ease the effects of different colors and fabric textures.

One particular area in which computers are useful in fashion drawing is in creating different groups of figures. Once drawings of figures are scanned into the computer they can be easily moved around into different combinations to show the variations

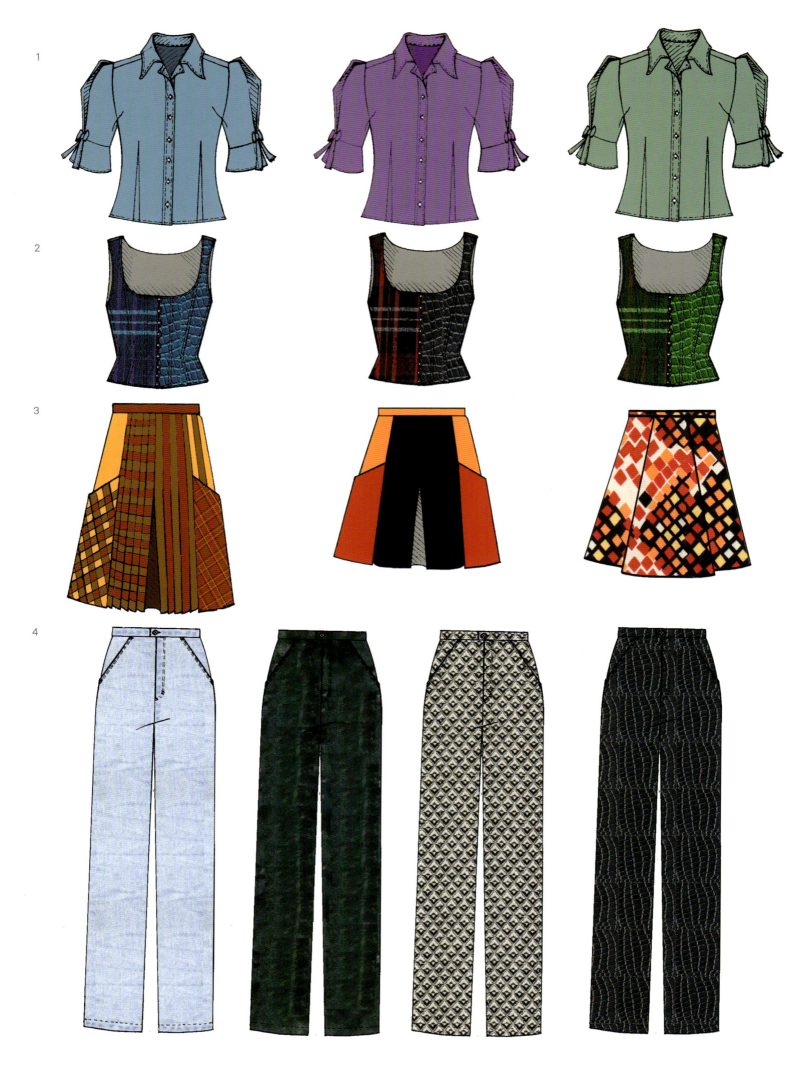

1. Flat with color variations
2. Flat with color variations
3. Flat with detail variations
4. Flat with color/fabric variations

Hand-drawn ensemble
sketch. Pen and ink.

of a basic ensemble. Figures can be manipulated to overlap each other, be increased or decreased in size to give the appearance of perspective.

The ensemble sketches shown in this chapter were created by scanning the initial hand sketch into the computer, manipulating it in Adobe Photoshop, converting it to vector format with Adobe Streamline and finally editing and coloring using Adobe Illustrator. The clean-up of the initial drawing took a skilled operator a number of hours work to complete. Once finished and stored in the computer, however, the second and third drawings showing the same garments in different colorways, were created within a few minutes. The other sets of drawings of flats and lingerie were also drawn by hand, scanned into the computer and then rendered in different colorways in Adobe Photoshop.

Those with an interest in computers as well as fashion drawing will naturally wish to combine their interests and skill sets and explore the range of possibilities which computers can open up. It is likely

that computers will continue to be increasingly used in fashion design and drawing and one should naturally keep abreast of the technological changes. It simply cannot be stressed enough, though, that to get good results from a computer one has to know how to draw. Armed with the skills learnt by serious study and practice of hand drawing the computer can be used to achieve stunning results!

interview:
renee weiss chase

*Renee Weiss Chase
is Head of the Fashion
Design Department,
Drexel University,
Philadelphia, PA.*

NR: Renee, please give us an overview of how computers are used in fashion design today. What exactly is CAD?

RWC: CAD stands for Computer-Aided Design. The term computer-aided design has become a catch-all for the use of many different types of computer systems for apparel design and production, some of which have little to do with design in its pure sense. Generally, it is safe to say that any part of the design process that can utilize the computer as a tool fits under the CAD umbrella. CAD can be separated into production systems, management systems and pre-production systems. CAD systems for production include very specialized hardware and software that is used in markermaking, patternmaking and grading. It includes robotics and garment moving technology that is used in a factory setting as well as those systems that drive weaving and knitting machinery. CAD systems extend to the management and communication of information about the design and specifications of a garment. This includes data about measurements, type of fabric and trimmings, delivery time and much more. These systems connect design rooms to production centers and to the retail environment. Pre-production systems are those used by designers to sketch garments, create flat renderings and develop textile designs. They are used for the visualization and exploration of ideas about apparel.

NR: The computer is a very powerful tool which has made many things possible which we could not have dreamt of 20 years ago. Given all the computer can do , do you think drawing skills are less relevant than they used to be?

RWC: The computer is a powerful tool, but it is just that, a tool, just like the marker or a paintbrush or a pencil. If a design is poorly conceived a computer cannot correct it. If a designer does not understand the mechanics of drawing or have an eye for line, scale, proportion and color the computer cannot rectify the product. A good designer must be able to communicate ideas through a drawing. Sometimes this means that if drawing skills are not

well developed a designer must hire someone who can communicate the ideas. There is no substitute for a beautiful drawing and the same skills that are used in rendering with a marker or pencil are used when rendering with a computer.

A computer generated image almost always looks like a computer generated image. It has a certain sensibility, esthetically speaking, that is different than a hand drawn image. This is not to say that one is necessarily better than the other; they are just stylistically different. So if it is a lovely designer's sketch or illustration that you are looking for, a computer is probably not the tool. If you are at a museum or show or shopping and you are looking for inspiration or recording design ideas for development at a later time the computer is not really helpful. Even when designing textiles it is often more advantageous to draw a flower by hand and then scan it into the computer for manipulation than to try to get the computer to generate a flower that looks hand-drawn. It is important that the designer clearly understand what he or she wants the drawing to look like and what it will be used for. Then he or she can use the appropriate tools to generate that drawing.

NR: Are designers accepting CAD more these days? Would you say it is being integrated into the design process of the great collection designers?

RWC: Designers accept CAD primarily because it can speed up the visualization and production processes. They can see a change in colorway in an instant and they can change details like pockets and collars, etc. and visualize them very quickly. Great collection designers, however, see CAD primarily for its value in production. This is because they often generate ideas from the fabric rather than by calling up a silhouette or pieces of flats on the computer and experimenting with them. Couture designers often design three-dimensionally rather than just using a pen and sketchpad. They take the fabric, their pins and scissors to the dressform and generate ideas in that way. Or they combine draping and sketching techniques. Designers are very attached to their sketch pads-recording

1

2

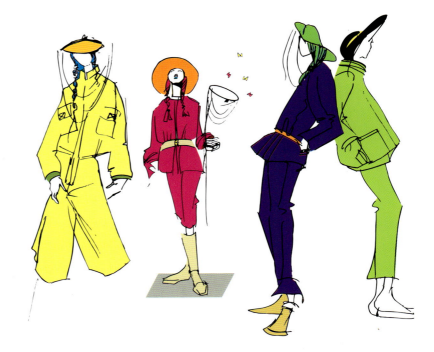

3

1. Ensemble sketch scanned into computer, converted into vector format.
2. Ensemble sketch with scale change. Colorway no. 1.
3. Ensemble sketch with scale change. Colorway no. 2.

and capturing ideas as they present themselves at any time.

NR: Do you think designers still require drawing skills? Are there other stages of the fashion design and production process where drawing skills are also necessary?

RWC: Just as a writer needs language to communicate ideas, the designer needs drawing to communicate ideas. There really is no substitute. The better the drawing skills the easier it is for others to understand and appreciate the idea. A good drawing can also romance an idea and make it more desirable to others. For example, a flat, boxy drawing of a T-shirt will never be as appealing to a customer as that same T-shirt drawn skillfully on a graceful fashion figure. If the intent is to sell the idea, the higher the level of mastery over the drawing, the better the chances for success. But there is a difference between the level of skill the designer needs for presenting original ideas as opposed to rendering flats or creating technical drawings. The latter are more formulaic, less stylized. A flat has to be a proportional, scaled version of the stylized drawing that was created by the designer. The flat is the translation of the elegant drawing into a two dimensional, technical blueprint for the production of the garment. The skills are not the same and an individual who has great difficulty doing a stylized, illustrative drawing can much more easily render a flat drawing. This is where the computer is so handy. Once the basic flats are stored in the computer they can be easily be manipulated without having to draft from scratch.

NR: From what you say you obviously feel it is important for anyone interested in fashion design to acquire the basic skills of drawing the croquis and fashion. With these basic skills, what can then be achieved at home using a simple computer and scanner?

RWC: A good drawing can be scanned and saved in a software program that will enable the designer to manipulate it in myriad ways without having to duplicate the drawing by hand. For example, if the designer draws a jacket with welt pockets and scans it into the computer he or she can quickly see what that same jacket would look like with patch pockets or flap pockets or a wider lapel. The jacket can be made longer or shorter in a moment and the color and fabrication can also be changed instantly. Various prints can be designed and used to fill the jacket outlines. Ordinarily, without the use of the computer each of these changes would require a brand new drawing that would take some time to generate. With a computer it is practically instantaneous.

NR: What software programs are available today which are relatively inexpensive and can be used in fashion design in the home? What general advice would you give to the home-based would-be designer in using her computer?

RWC: Almost any painting and drawing program can be used for fashion images. Again, the goal has to be taken into account before the software is selected. For example, if you are interested in drawing flats, a drawing or vector-based program like Illustrator should be used because the line will be smooth rather than pixelated. If the goal is to design textiles and paint with color, then a paint program will work. Programs like Photoshop have the capacity to create smooth lines as well as manipulate color so it would be a good choice. If the designer is creating a catalog or presentation then a layout program like Quark would be useful. Generally, my advice is to try to anticipate your goals. What are you trying to accomplish and how can the computer be helpful? I should mention that sometimes the home sewer is simply interested in using the computer for patternmaking rather visualizing design ideas. In this case there are some programs on the market that can be used for this specific purpose, but they tend to be more costly than off-the-shelf software.

NR: And what about the professional designer? This is moving beyond the scope of this book, and you cover it in depth in your own book on CAD and fashion design, but out of general interest please give us an idea of the range of CAD/CAM systems for the professional designer now on the market and what sorts of things they can do.

RWC: One of the exciting things that CAD has given designers is the ability to offer virtual products to the public either through electronic or traditional catalogs. Designers can conjure up a new design and test it out at retail without ever having

to make a sample. CAD has also allowed for the growth of Quick Response Technology which really means bringing a product to market in a very short turnaround time. The designer can go from sketch through production in a fraction of the time it took a decade ago. Designers have the ability to select a variety of fabrics and colors for a garment and try them out on the screen rather than taking the time and expense to make samples in each fabric and in each color. Then there is the whole area of pàttern design systems which can automatically draft patterns in a range of sizes. Some of these systems actually create patterns based on individual customer's personal measurements. All of these technological advances allow clothing to be created much more quickly and at lower expense.

NR: This book goes into the process of drawing flats in a lot of detail, and I have included numerous flats which readers can use as reference or, if they wish, scan into a computer and add their own color and fabric variations. I have not covered other uses of the home computer in fashion design. Could you give us a brief idea overview of what else the home-based designer can do on her computer.

RWC: The computer can be used as a tool to create presentations and to generate and store ideas, but it can also be used as a tool for searching for ideas. We have always thought of inspiration as coming from the outside world. The internet offers endless possibilities for designs inspiration. A designer can download images from a fashion show seen in real-time and use those for inspiration for new design ideas. Museums can be perused, fashion forecasting for a future season can be generated. The fashion universe is limited only by imagination and the computer can help the designer gain instant access and agility with that infinite universe.

NR: Thank you, Renee.

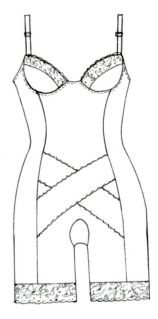
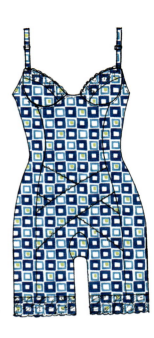
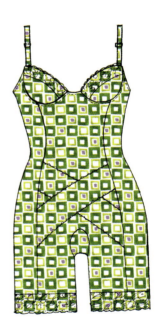
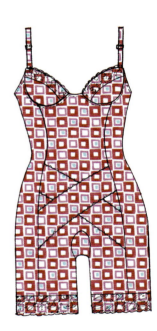

Girdles with different colorways

acknowledgments

Having trained as a fine artist at Art Center in Pasadena, my introduction to fashion drawing came about by chance when the Otis Parsons School of Design (now the Otis College of Art and Design) offered me my first job on the strength of my drawing skills. My interest in fashion began to deepen while living in Paris in the early 1980s. It was there I became friends with Paul McDonough, assistant to Hubert de Givenchy and later founder of the Paris Fashion Institute. Paul was clever, chic and extremely funny and ignited my interest in the whole spectrum of fashion. My debt of gratitude to Paul is immense and this book is dedicated to his memory. I would also like to acknowledge with gratitude the formative influence of Pierre Picot during that period.

The help, support and encouragement afforded to me during the preparation of this book by the staff and students at the Fashion Institute of Design and Merchandising (FIDM) in Los Angeles has been enormous. As head of the department of Fashion Design, Mary Stephens has been a frank and encouraging critic and mentor throughout and I extend my deep-felt thanks to her. Thanks also to the other faculty members who provided inspiration, comment and insight, in particular Susan Zarate, Barbara Guttenburg, Sarah-Jane Owen, Joanne Hwang, Darlene Lattinville, Alan Armstrong, Ofelia Montejano, Patrick Harper, Barbara Sultan and Gail Cottingham. Thank you too to the entire FIDM library staff for their help in researching this book.

Robin Pavlovsky of FIDM was a great help in providing technical assistance with the identification and labeling of the material included in the Encyclopedia of Details; she was always encouraging and supportive of the efforts behind this book. Unfortunately she passed away before seeing these efforts come to fruition and will be sorely missed by her colleagues and students.

Thanks to all my students at FIDM, some of whose work is included in the book. Special thanks are due to Sarah Co, Stephanie Egyid, Jennifer Glascock, Sergio Gonzalez, Kristin Gunnarson, Annie Heckman, Jae Jin Kim, Guillermo Jimenez, Tony Lee, Hanh Ly, Karolina Maszkiewicz, Miho, Vilija Naginevicius, Yhen Phan, Mirey Song, and Tao Wang,

For many years I have taught the history of design at Art Center, both at the main campus in Pasadena and as a representative of Art Center in a number of Asian countries. For me, Art Center has always represented the highest and most uncompromising of standards in both design education and design itself and I owe it, as an institution, a substantial debt of gratitude for what it has given me over the years, and specifically for its tangible support in the publication of this book. I would like to extend special thanks to Richard Hertz, chairman of the department of Liberal Arts and Sciences and Fine Arts Graduate Studies, Richard Koshalek, President of the School and Pierre Picot.

Because of its scope, this book required the contributions of many talented individuals whose combined efforts are represented here. First, I would like to extend a very special thank you to Melanie Denny, without whose extensive and untiring efforts the final version would look very different. Her contribution in inking in sketches and drawing flats cannot be overstated. Thanks also to Victoria Woodford for her drawing, her wonderful enthusiasm for the project, and her invaluable help in many areas; Renee Weiss Chase for her scholarly help and advice; John G. Gray and Mark J. Glancey at Corwin Unlimited for their expert help with the drawings and text in the computer chapter and Willis Popenoe for

his generous, valuable professional help and advice. Thanks also to Lee Caruso, Mary O'Grady, Vladimir Jedlicka, Sebastian Flyte, Kob Khamsanvongsy, Victor Osaka, Daniela Traub, Patricia Good, James Clay, Valli Herman-Cohen, Sabine Holland, Simon Doonan, Christine Johnson, Martin Fung, Cynthia Carlson, Mariana Mazzei-Barutti and Jane Tsukamoto.

Fashion drawing books often suffer from the monotony of style of a single illustrator, and I make no claims to a style which causes less suffering than that of anyone else. A large part of the appeal of fashion is its breathtaking richness and variety and the diversity of its inspirations. Fashion books which show only one style of drawing have always seemed to me to be at odds with the culture of fashion. I therefore decided to alleviate the monotony of a single drawing style by including drawings from a number of different hands, often with very diverse styles, and I would like to thank the designers and fine artists who were who were generous in allowing me to show examples of their work here. I would particularly thank Jean-Charles de Castelbajac, Bernard Wilhelm, Christian Lacroix, Mona May, Felipe Sanchez, Gianfranco Ferre, Dominic Montelongo, Ruben Alterio, Don Bachardy and Raymond Pettibon.

Thanks also to Bérangére Broman, Gael Prigent, Marilyn , Carolina Neri, Sylvie Faure, Ken Downing and Anne Daniels at Neiman Marcus, Julie Gustafson and Regen Projects in Los Angeles, courtesy of whom Raymond Pettibon's print is reproduced, and Studio Progettomoda, Italy who kindly allowed me to reprint the sports flats from Fashion Box S/S 2001. My thanks also go to Yann Menard and Beate Hanke at Mode-Information.

A number of designers' clothes are shown as photographs in this book. I would like to extend my thanks to all of the designers for creating such masterful garments which I was able to capture on film. In particular I would like to extend my thanks to Ron Anderson and Shiela Leiter at Target Corporation, Kim Sobel at Banana Republic, Anne Fahey at Chanel and the generosity of the companies they represent.

After the long process of preparing the drawings and text, collecting and photographing clothes, speaking with the designers, artists and the many others who contributed to this book, as an artist and teacher acutely aware of design and the design process, I approached the stage where it was all to be brought together in a single unifying design with some trepidation. My fears turned out to be unfounded, as Simon Johnston brought a rare sensitivity, creativity and dedicated professionalism to the task of designing the final version. The dialogues and discussions which took place during the creative collaborations between us were a pleasure in themselves and I extend my warm thanks to him.

Thank you finally to David Eno, my partner, mentor and supporter at every level of this project. His wit, clarity of vision and thought, along with a lot of hard work, helped to distil difficult ideas in order to produce a book with a broader and richer scope than I originally intended. Without his help this book would not exist. Thank you.

index

Introducing
9FLATS

A series of "flat" drawings of modern garments.

Flats are the basic technical blueprint drawings for modern garments, used at every stage throughout the design and manufacturing process. Flats are the basis of line sheets and presentation boards as well as the foundation for the technical sketches for production.

9 Flats is a set of 9 "flat" drawings, each with clear, concise instructions that show how to draw and develop one's own flats to a professional standard.

9 Flats clearly shows how garments are constructed as well as how they are drawn. To achieve the best and most complete sketch possible it is necessary to understand the construction of the garment and how its function will affect the sketch. Learning to sketch beautiful, complete technical flats in turn reinforces the understanding of how garments are constructed.

9 Flats is printed on strong, durable high quality art board and can be traced over many times. Shapes and details from different flats can be combined to create unique new drawings and designs.

9 Flats is an aid to professional designers, contractors and garment makers as well as students of fashion design and drawing, and anyone wishing to improve their design and drawing skills, prepare a professional portfolio or learn how modern garments are constructed. **9 Flats** is the most detailed set of technical drawings of modern garments currently available.

9 Flats is also particularly useful for the home-sewer/designer and fashion dressmaker, clearly showing those fine details which are not shown in patterns but are what give garments that "professionally-designed" look.

9 Flats : Volume 1— Jackets is the first volume in Series 1 of **9 Flats.** Each Series will consist of 6 volumes of 9 flat drawings which will cover major garment types and topics of garment design and construction.

9 Flats show interlinings, button, sleeve, construction, pockets, collars and more.
9 Flats drawings come with clear, concise instructions.
9 Flats extends the foundation work on drawing flats included in **9 Heads—a guide to drawing fashion by Nancy Riegelman.** Used together, **9 Heads** and **9 Flats** will provide a complete instructional guide for producing professional-standard flats of the quality, accuracy and detail required by the modern fashion and apparel industries.

9 Flats — Series 1

Volume 1 — Jackets. Shows the internal construction and detailing of outerwear. Front, back and internal views are included.

Volume 2 — After 5/Cocktail wear (Women). Explores the novelty treatments and fabrications usually reserved for evening-wear and its more sophisticated silhouettes.

Volume 3 — Proportion. A unique insight into the comparative proportions by showing the same garment on 9 croquis — infant, toddler, girl/boy, pre-teen, junior, Missy, Petite, Full Figure (plus size) and Designer/Contemporary.

Volume 4 — Lingerie/Sleepwear. Illustrates the construction techniques and fabrications unique to intimate apparel. Also addresses stretch bodies, lace and novelty elastics.

Volume 5 — Full Figure. Covering the whole range from outerwear to swimsuits, this volume focuses on flattering lines and basic design principles and subtle differences between regular and plus size garments.

Volume 6 — Bridal. Lace overlays, applique, tulle, sheer fabrics, beading, embroidery, boning and more—all of this along with the various standard silhouettes of the bridal industry illustrated in great detail.

3.
zip front jacket
front and back view

Note the details:

1. Many variations are possible for zip front jackets, so a detailed sketch can give the patternmaker and the merchandisers a much clearer understanding of the garment. Especially in sportswear, details are the key.

2. The zipper sits at true center front, which means that the wind flap must start to the left of it (on a woman's jacket, and to the right on a man's jacket) and extend usually the same distance on the other side. A wind flap sits over a zip; a zipper guard sits underneath.

3. If the jacket has a zipper guard as well, show an open view of the top neck opening to demonstrate this clearly.

4. Snaps must line up. The top snap on the wind flap must line up with the under-snap on the body of the jacket. Also, pay attention to the spacing of the snaps as they have been designed in the jacket.

5. Be consistent with the stitch type and gauge within the garment. Generally, a garment that has topstitching will use the same type and gauge throughout for ease of production.

6. The sleeve inseams can also be used to gauge whether or not the sleeve lengths are even, particularly in this case when it is difficult to judge by the outer sleeve.

7. The positions of the openings of the kangaroo pockets are indicated by heavier line weights.

Remember—technical sketches are practical, working drawings.

SAMPLE

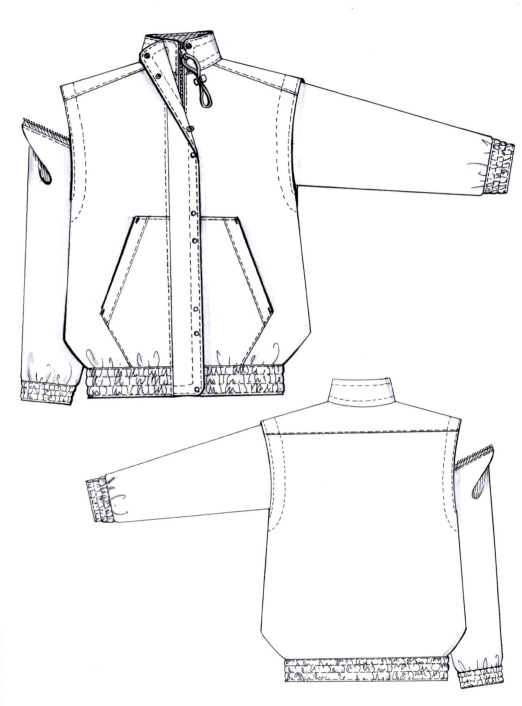

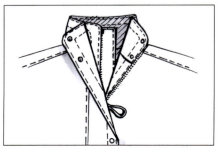

Detail — Zipper Guard

9FLATS
SERIES 1: volume 1: flat no. 3

© 9 Heads Media 2001. These drawings are for the personal use of the owner of this copy of 9 Flats. They may not be reproduced or transmitted in any form by any mechanical or electronic means.

9FLATS

SERIES 1 Volume 1— Jackets	$12.95 (shipping & handling free)
SERIES 1 Other volumes (when published)	$12.95 (shipping & handling free)
SERIES 1 Volumes 1–6 (Complete series)	$59.95 (shipping & handling free)

Your Name:

Title: (if applicable)

Institution: (if applicable)

Address:

City:

State:

Zip:

Country:

Telephone Number:

Fax Number:

Email Address:

Product ordered	Price	Qty	Total
9 Flats Series 1 Vol. 1	$12.95		
9 Flats Series 1 Vol. 1–6	$59.95		
Shipping & Handling	FREE		
CA residents please add 8% sales tax ($1.04 for single vol., $4.80 for 1–6)			
TOTAL			

() Check enclosed payable to 9 Heads Media

() Please charge to the following credit card

Card Number:

Name of Card Holder:

Expiration date:

Signature:

Mastercard/Visa/Amex (please circle one)

Please enclose Shipping Address
if different from above.

Subscribers to the full series will receive volumes already published immediately and subsequent volumes at intervals of approximately two months.

Subscribers will receive a custom 9 Flats folder to hold all 6 volumes of 9 Flats Series 1.

Please send orders by check to **9 Heads Media. PO Box 27457, Los Angeles, CA 90027-0457**.
Please send orders by credit card by fax to **323-664-8612**
For Customer service, Institutional orders, Sales and Information: Please email us at
info@9heads.com or fax us at 323 664 8612.